RE-ENVISIONING THE CONTEMPORARY ART CANON

Re-envisioning the Contemporary Art Canon: Perspectives in a Global World seeks to dissect and interrogate the nature of the present-day art field, which has experienced dramatic shifts in the past fifty years.

In discussions of the canon of art history, the notion of "inclusiveness," both at the level of rhetoric and as a desired practice, is on the rise and gradually replacing talk of "exclusion," which dominated critiques of the canon up until two decades ago. The art field has dramatically, if insufficiently, changed in the half century since the first protests and critiques of the exclusion of "others" from the art canon.

With increased globalization and shifting geopolitics, the art field is expanding beyond its Euro-American focus, as is particularly evident in the large-scale international biennales now held all over the globe. Are canons and counter-canons still relevant? Can they be re-envisioned rather than merely revised? Following an introduction that discusses these issues, thirteen newly commissioned essays present case studies of consecration in the contemporary art field, and three commissioned discussions present diverse positions on issues of the canon and consecration processes today.

This volume will be of interest to instructors and students of contemporary art, art history, and museum and curatorial studies.

Ruth E. Iskin is the author of *The Poster: Art, Advertising, Design, and Collecting, 1860s–1900s* (2014) and *Modern Women and Parisian Consumer Culture in Impressionist Painting* (2007). Her articles have appeared in the *Art Bulletin, Discourse,* and *Nineteenth-Century Art World Wide* among others and in anthologies and museum catalogues, most recently of the Guggenheim, Bilbao. A member of the Department of the Arts faculty, Ben-Gurion University of the Negev until 2014, she currently lectures and teaches in Israel and abroad.

RE-ENVISIONING THE CONTEMPORARY ART CANON

Perspectives in a Global World

Edited by Ruth E. Iskin

Routledge
Taylor & Francis Group

LONDON AND NEW YORK

First published 2017
by Routledge
2 Park Square, Milton Park, Abingdon, Oxon OX14 4RN

and by Routledge
711 Third Avenue, New York, NY 10017

Routledge is an imprint of the Taylor & Francis Group, an informa business

British Library Cataloguing in Publication Data
A catalogue record for this book is available from the British Library

Library of Congress Cataloging in Publication Data
Names: Iskin, Ruth, editor.
Title: Re-envisioning the contemporary art canon : perspectives in a global world / Edited by Ruth E. Iskin.
Description: New York : Routledge, 2017. | Includes bibliographical references and index.
Identifiers: LCCN 2016023531 | ISBN 9781138192683 (hardback : alk. paper) | ISBN 9781138192690 (pbk. : alk. paper) | ISBN 9781315639772 (ebook)
Subjects: LCSH: Art and globalization—History—20th century. | Art and globalization—History—21st century. | Canon (Art)
Classification: LCC N72.G55 R48 2017 | DDC 701/.0309048—dc23
LC record available at https://lccn.loc.gov/2016023531

ISBN: 978-1-138-19268-3 (hbk)
ISBN: 978-1-138-19269-0 (pbk)
ISBN: 978-1-315-63977-2 (ebk)

Typeset in Bembo
by Apex CoVantage, LLC

CONTENTS

ILLUSTRATIONS

CONTRIBUTORS

Elissa Auther is the Windgate Research Curator, a joint appointment at the Museum of Arts and Design and the Bard Graduate Center in New York City. She is the author of *String, Felt, Thread and the Hierarchy of Art and Craft in American Art* (Minnesota UP, 2010), editor of *West of Center: Art and the Counterculture Experiment in America* (Minnesota UP, 2012), and co-curator of *Pretty/Dirty*, a touring retrospective exhibition of the artist Marilyn Minter. She co-directs Feminism & Co.: Art, Sex, Politics, a public program about women, gender, and creative practice.

Paula J. Birnbaum is Associate Professor and Academic Director of the Museum Studies Master of Arts Program at the University of San Francisco. She is author of *Women Artists in Interwar France: Framing Femininities* (Ashgate, 2011). Her scholarship focuses on modern and contemporary art in relationship to gender and sexuality, as well as institutional and social politics. Her chapter is part of a larger project on street art and global visual culture.

Martha Buskirk, professor of art history and criticism at Montserrat College of Art, is author of *Creative Enterprise: Contemporary Art between Museum and Marketplace* (Continuum, 2012) and *The Contingent Object of Contemporary Art* (MIT Press, 2003), as well as numerous catalogue essays and articles that have appeared in *Artforum*, *October*, *Art in America*, and other venues.

Sarah Cook, Dundee Fellow at Duncan of Jordanstone College of Art and Design at the University of Dundee, is co-author, with Beryl Graham, of *Rethinking Curating, Art after New Media* (MIT), and editor of *Information* (Whitechapel Gallery, MIT).

Elizabeth Harney is an art historian/curator at the University of Toronto. Harney is the author of *In Senghor's Shadow: Art, Politics, and the Avant-Garde in Senegal*

(Duke, 2004), *Ethiopian Passages: Contemporary Art from the Diaspora* (Smithsonian Institution, 2003), and co-editor of *Inscribing Meaning: Writing and Graphic Systems in African Art* (5 Continents Press, 2007) and *Mapping Modernism* (Duke, 2016).

Ruth E. Iskin is the author of *The Poster: Art, Advertising, Design, and Collecting, 1860s–1900s* (Dartmouth Press, UPNE, 2014) and *Modern Women and Parisian Consumer Culture in Impressionist Painting* (Cambridge University Press, 2007; paperback 2014). Her articles have appeared in the *Art Bulletin, Discourse, Nineteenth-Century Contexts, Visual Resources, Nineteenth-Century Art World Wide*, among others, and in anthologies and museum catalogues, most recently of the Guggenheim, Bilbao. Her work has been translated into Chinese, Czech, Danish, Hebrew, and Spanish. A member of the Department of the Arts faculty, Ben-Gurion University of the Negev, until 2014, she currently lectures and teaches in Israel and abroad.

William Kaizen is an independent scholar and curator. His research focuses on the history and politics of new media, from video art to video games. His most recent books are *Against Immediacy: Video Art and Media Populism* (UPNE/Dartmouth University Press, 2016) and *Adventure (for) Adults* (Kayrock, 2015). He has curated exhibitions on the work of pop artist Derek Boshier and the history of pop art on film in the US and UK and has written and lectured on the work of John Smith, Nancy Grossman, Laurel Nakadate, Francesca Woodman, and Chris Marker.

Jennie Klein is Associate Professor of art history at Ohio University. She is the editor of three books: *Letters from Linda M. Montano* (Routledge, 2005), *Histories and Practices of Live Art*, co-edited with Deirdre Heddon (Palgrave, 2012), and *The M Word: Real Mothers in Contemporary Art*, co-edited with Myrel Chernick (Demeter Press, 2011). Her research interests include performance art, gender, and feminist art history.

Tirza True Latimer is Associate Professor and Chair of the Graduate Program in Visual and Critical Studies, California College of the Arts, San Francisco. Her latest book is *Eccentric Modernisms: Making Differences in the History of American Art* (University of California Press, 2016). Her published work reflects on modern and contemporary visual culture from queer feminist perspectives.

Jennifer McComas is the Curator of European and American Art at the Indiana University Art Museum, where she also manages the museum's Nazi-era provenance research project. She received her PhD from Indiana University and has published recent articles on the historic display of post–World War II German and American art in the *Journal of Curatorial Studies* and *Stedelijk Studies*.

Ronit Milano is a senior lecturer at the Department of the Arts in Ben-Gurion University of the Negev, Israel. She is author of *The Portrait Bust and French Cultural Politics in the Eighteenth Century* (Brill, 2015). Her recent articles focus on curatorial

and economic aspects of contemporary art and on the revival of historicism in contemporary art.

Jonathan T.D. Neil is Director of Sotheby's Institute of Art–Los Angeles, and of the Center for Management in the Creative Industries at the Drucker-Ito School of Management, Claremont Graduate University. He serves as associate editor for *ArtReview* magazine (UK) and as editor of the Held Essays on Visual Art for the *Brooklyn Rail* (USA). From 2008 until 2014 he was Executive Editor at the Drawing Center, in New York, and in 2005 he co-founded Boyd Level LLC, a private curatorial firm and consultancy. His columns, reviews, book chapters, catalogue essays, and other writings are archived at jonathantdneil.com.

Helena Reckitt is Senior Lecturer in Curating at Goldsmiths, University of London. A curator and critic, she has developed solo shows with artists including Yael Bartana, Keren Cytter, Hew Locke, Ryan Trecartin, and Carey Young and the group exhibitions *Getting Rid of Ourselves* (OCAD U, Toronto, 2014), *Not Quite How I Remember It* (the Power Plant, Toronto, 2008), and *What Business Are You In?* (Atlanta Contemporary Art Center, Georgia, 2005). She is the editor of *Sanja Iveković: Unknown Heroine – a Reader* (Calvert 22, 2013), *Art and Feminism* (Phaidon Press, 2001) and, with Joshua Oppenheimer, *Acting on AIDS* (Serpent's Tail, 1998).

Jordana Moore Saggese is Associate Professor of Visual Studies and affiliated faculty in the Graduate Program in Visual and Critical Studies at California College of the Arts. Her book *Reading Basquiat: Exploring Ambivalence in American Art* (University of California Press, 2014) reexamines the painting practice of the often-mythologized 1980s art star Jean-Michel Basquiat.

Wenny Teo is the Manuela and Iwan Wirth Lecturer in Modern and Contemporary Asian Art at the Courtauld Institute of Art. Guest editor of an issue on modern and contemporary Chinese art, *The Journal of Art Historiography*, she is currently revising her doctoral thesis, "One World, One Dream: Contemporary Chinese Art and the Geopolitics of Spectacle," for publication. Her research centers on identity, biopolitics, networked resistance, and activism in East Asian visual culture.

Felix Vogel is an art historian and curator. He was a faculty fellow in art history at the universities of Hamburg and Zurich and is a PhD candidate at the Université de Fribourg. He curated the fourth Bucharest Biennale. His research interests include the theory and history of exhibitions, garden architecture and knowledge culture, and the epistemology and political economy of the humanities.

Karin de Wild is a PhD candidate at Duncan of Jordanstone College of Art and Design at the University of Dundee. She is part of the curatorial team of NEoN festival and co-curator of the conference *Digital Horizons, Virtual Selves*, RCMC, Leiden.

ACKNOWLEDGMENTS

For their advice, good judgment, insights, and incisive comments on the introduction, I would like to thank Paula Birnbaum, Norma Broude, Ayelet Carmi, Nirit Ben-Aryeh Debby, Tal Dekel, Mary Garrard, Michal Iskin, Jordana Moore Saggese, Assaf Shelleg, David Sperber, Mabel O. Wilson, and Merav Yerushalmi.

It was a pleasure to work with the authors of the essays and with leaders of the discussions featured in this volume, and I am immensely grateful to each one of them for their dedication to the project and unwavering efforts to produce these specially commissioned essays and discussions. My thanks also to all the participants in the discussions for their thoughtful contributions.

I am grateful to the two editors at Routledge who supported this project – Natalie Foster in its early stages and Sheni Kruger, who saw it through to publication. For her thoughtful reading and editing of my introduction, I am indebted to Natalie Melzer. My sincere thanks to the artists and institutions that made artworks available for reproduction free of charge or at reduced rates.

And finally, my appreciation to the Polonsky Library at the Van Leer Institute in Jerusalem for providing a hospitable work environment.

INTRODUCTION: RE-ENVISIONING THE CANON

Are pluriversal canons possible?

Ruth E. Iskin

The canon of art history – the sanctioned selection of artists and artworks considered as the greatest and most significant – has been the object of much criticism in the contemporary art discourse. Indeed, for many scholars and practitioners, the term "canon" has come to acquire a negative connotation because of its systematic exclusion and under-representation of artists who are not Western white males – that is, artists of both genders working outside of the so-called Western world (by now a cultural more than strictly geographical designation), as well as women artists and artists of color in the West. This criticism is undoubtedly one of the reasons that use of the term "canon" is on the wane in discussions of contemporary art. But it is important to note that whether or not the term is applied, and despite some changes toward inclusiveness, the traditional (Western) art canon still proves to be resilient. Even when curators, critics and scholars do not use the term explicitly, they continue to refer with other words to what the term "canon" traditionally means. For example, sociologists and some art historians now use Pierre Bourdieu's term "consecration" instead of "canonization" or else expressions like the "rankings" and "degree of centrality" of artists.[1] Gallerists speak of "historically significant" art and of the artist who "is making history" and remains "historically relevant."[2] As art critic Tim Griffin notes, today artists themselves inscribe their art within histories and, thus, within canons.[3]

The traditional art canon has been a cornerstone of Western art history and for many years was accompanied by the general belief that artists are chosen for inclusion in accordance with a standard criterion. The canon has had a profound and far-reaching influence on museums' permanent collections and temporary exhibitions, as well as on art education, publications, curricula and scholarship – in other words, on the entire art field, including its various institutions and discourses.[4] The vigorous critiques of the canon in recent decades have significantly undermined the claim of a disinterested standard of quality, showing instead, as Anna Brzyski

puts it, that "all canonical rankings are bound to be partisan."[5] Today, the canon is no longer taken for granted. But while its authoritative status has been destabilized, the canon has also shown its staying power. Art critic Hal Foster made this point in 2002, acknowledging at once both the devaluation of the canon – "today the canon appears less a barricade to storm than a ruin to pick through" – and its persistence in his own work despite these changes: "all my figures are men and all my texts are canonical, but the men do not look so triumphant in retrospect."[6] To the extent that mainstream art history still focuses on the traditional canon, however, the latter is not quite ready yet to be described as a "ruin."

Canons are part of a dynamic field and never immune to changes in culture, ideology, politics, the market and geopolitics. This much seems obvious today. Yet before the theoretical discussions on canonicity and in particular on its inherently exclusionary nature, the canon was transparent in the sense that it was not yet an object of analysis, much less of critique. Several decades into this debate, bolstered by the processes of decolonialization,[7] de-patriarchalization and globalization and attended by the activism of social movements and of artists to end exclusion, it is time to re-asses the main claims that it raised in light of significant if insufficient changes that have occurred in the field.[8] What has barely been addressed is how, specifically, the canon has changed in recent decades and whether the era of globalization opens up new possibilities for rethinking the canon. In other words, it is time to consider whether it is possible today not merely to *revise* canons – that is, to remedy them in piecemeal fashion by "adding" more artists and artworks while keeping the basic structure of the canon intact – but to *re-envision* them to the core. The present volume is dedicated to these questions. It features contributions that further this task of rethinking art canons – by analyzing particular case studies and through roundtable discussions with practitioners in the art field. The essays and discussions address the issue of how canons function, form and re-form and affect particular artists and mediums, as well as the roles of museums, mass media, social media and the market.

The introduction provides an overview of the issues that define the current discourse about the canon and counter-canons and proposes new directions for conceptualizing the canon in a heterogeneous global world. It comprises four parts: first, it discusses whether canons are still needed and to what extent the art canon has changed. Second, it revisits the long-standing belief that the canon is formed by consensus, arguing that contestation plays a crucial role in canon revisions and exemplifying this claim by analyzing several instances of artists' contestations of the canon in their art. Third, it proposes the possibility of "pluriversal" canons; and fourth, it provides a brief overview of the various essays and roundtable discussions included in the volume.

Protests by artists against museums' exclusions of women and artists of color began in the US in the late 1960s and early 1970s. In 1972, Mary Beth Edelson created *Some Living American Women Artists*, Fig. I.1, the first artwork to appropriate a European masterpiece with the specific aim of subverting it in order to contest an exclusionary male Euro-American art canon. Edelson's bold re-envisioning

FIGURE I.1 Mary Beth Edelson, *Some Living American Women Artists*, 1972. Cut-and-pasted gelatin silver prints with crayon and transfer type on printed paper with typewriting on cut-and-taped paper, 28.25 × 43 in. (71.8 × 109.2 cm). MoMA, New York. Purchased with funds provided by Agnes Gund, and gift of John Berggruen (by exchange). © Mary Beth Edelson. Courtesy of the artist.

of Leonardo's masterpiece contested the canon before critics and academics critiqued the art canon and indeed before the term "canon" was in wide use (it became prevalent in literary studies in the 1980s and in the art field in the 1990s).[9] In her subversive *Last Supper*, Edelson transforms the male protagonists into women artists of her time by covering the original faces with photographic heads of women artists: a commanding Georgia O'Keeffe in the center of the composition occupies Christ's position; to the right, in the place of the disciples are positioned (left to right) Elaine de Kooning, Louise Nevelson, the craft artist M.C. Richards, Louise Bourgeois, Lila Katzen and Yoko Ono; to the left are (right to left) Nancy Graves, Lee Krasner, Alma Thomas, the Washington-based African-American artist, June Wayne, Los Angeles–based print artist, Helen Frankenthaler and Lynda Benglis.

Edelson's selection reflected her intention to include a certain diversity of race and artistic medium and to do her "part in leveling that playing field."[10] Thus she included 69 small photographs of women artists in the frame surrounding the main image, all of which are identified with their full names at the bottom of the work (no. 35 is the artist). Since she obtained the photographs directly from the artists,[11] they are casual and diverse – some are close headshots and others show the full upper body or feature the artist next to her work. The sense of informality, multiplicity, contemporaneity and collectivity conveyed by the photographs contrasts with the aura of formal history of Leonardo's canonic masterpiece. Edelson's execution is deliberately rough. She does not smooth over the collage elements: typewritten

numbers and names are pasted on the image and outside of it, highlighting this work as an unpolished, raw endeavor – a makeshift counter-canon of contemporary American women artists in 1972. Her inclusion of the word "some" in the title underscores the fact that this canon is incomplete. Edelson recalls that when women artists looked at the work in 1972, they often reacted with a burst of laughter that expressed their recognition that "we are the main actors in this, finally."[12] With this artwork, Edelson invaded multiple territories of patriarchal power: religion, the art-historical canon and the contemporary art world.

Some Living American Women Artists was created five years after the first publication of Barbara Rose's *American Art Since 1900: A Critical History*, an influential survey in which Rose mentioned 4 of the 13 artists Edelson placed in the central image of the *Last Supper*.[13] The very fact that Rose discussed three women artists in her survey – Georgia O'Keeffe, Louise Nevelson and Helen Frankenthaler (as well as a passing mention of Krasner) – reflected progress in 1967. But more significant progress is discernable in retrospect when we consider that now, more than four decades after Edelson created *Some Living American Women Artists*, almost all the women featured in the work's main scene and quite a few of those featured in the frame have in fact entered the canon or else are in the process of being acknowledged, their art exhibited or acquired by major museums.[14] Another sign of progress can be found in the 2007 exhibition *WACK! Art and the Feminist Revolution*, curated by Cornelia Butler and featuring 118 women artists and 300 works made between 1965 and 1980, including Edelson's *Some Living American Women Artists* and the four other works in the series; Butler also acquired the entire series for the Museum of Modern Art's (MoMA's) collection.[15] This indicates a slow but significant change in museums' perceptions of the kinds of works eligible to enter the art canon. Yet the fact that this exhibit remains an anomaly in the record of museum exhibitions suggests also that the transformation is still very partial.[16]

Much has changed since Edelson created her work in 1972. Today, the primary focus of contestations of the canon's exclusions has shifted from gender to geography-based exclusions (Eurocentrism) and to an advocacy of the inclusion of artists based outside of Western Europe and Northern America, as well as to a rethinking of the relationship between the canon of Western art and that of non-Western nations and regions. This relationship was the subject of Chinese artist Huang Yong Ping's work *The History of Chinese Painting and the History of Modern Western Art Washed in the Washing Machine for Two Minutes*, 1987 (remade in 1993), Fig. I.2. Unlike Edelson, Huang did not appropriate a specific artwork from the Western art canon but rather made use of Duchamp's conceptual art gestures. Creating the work while he was still living in China, Huang displayed the shredded remains of two art history tomes, representing the Western and Chinese canons respectively, after running them through his washing machine. The books were Wang Bomin's *History of Chinese Painting* and a Chinese translation of Herbert Read's *A Concise History of Modern Painting*, a work that was then one of the few Western art history books to appear in Chinese and which had great influence upon Chinese contemporary artists.[17] Letters of the Chinese alphabet and fragments of art reproductions are discernable in the casually displayed

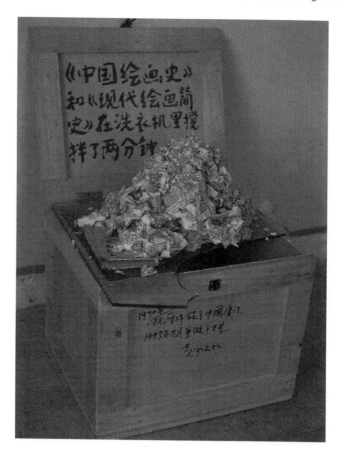

FIGURE I.2 Huang Yong Ping, *The History of Chinese Painting and the History of Modern Western Art Washed in the Washing Machine for Two Minutes*, 1987/1993. Installation, Chinese tea box, paper pulp, glass, dimensions (of the 1993 version) 30.2 × 19 × 27.5 in. (76.8 × 48.3 × 69.9 cm). © Huang Yong Ping. Courtesy of the artist and the Fei Dawei archive at Asia Art Archive.

paper rubble – a heap of washed-out, torn remains meshed together and reassembled atop a broken slab of glass that rests on a small shipping crate (the title of the work is inscribed on the lid of the crate, and the text below explains that the work was remade in 1993 after the original was accidentally destroyed).[18]

The two distinct art histories are symbolically ravaged in Huang's work and emerge as a new and entirely enmeshed dis-order. The artist explained that since cultural history "has continually been 'sullied,' it must therefore continually be washed and dried," not in order to make it purer "but rather to make it 'dirtier.' Only when there is no pure culture can 'dirty' culture become more vivacious and wide-ranging."[19] Art historian Fei Dawei regards this work as "not only a milestone in contemporary Chinese art but also a rare international contemporary art masterpiece" and reads it in the context of the intensive late-20th-century debate among

Chinese intellectuals and theorists about China's commitment to chart its own path in selecting which parts of Western culture to accept and which to reject. He takes Huang's work to show that "the mutual influence between the two cultures does not follow any method, logic, concept, or ethics, but is achieved in an uninterrupted instant."[20] In addition, I propose that Huang's drastic decimation and enmeshing of symbols of the Western and Chinese art canons is a violent contestation of each of these national canons separately as well as of the general imbalance of geopolitical cultural power in the global age.

Until 1989 Huang lived and worked in Xiamen, China, where he was a leader of the Xiamen Dada group. He settled in Paris after the Tiananmen Square massacre, which coincided with his stay in Paris for the groundbreaking Pompidou exhibition *Magiciens de la terre* (*Magicians of the Earth*), in which his work was included. Representing France at the 1999 Venice Biennale and exhibiting in numerous other biennales and exhibitions around the world, Huang's art has by now entered the international canon of contemporary art.[21]

Critics, curators and art historians, even the most legendary, are no longer seen as the sole or even primary canonizers but rather as playing one more, non-exclusive role within what Pierre Bourdieu discussed as "the field." The art field comprises artists and various mediators, including institutions, organizations that are not fully institutionalized, alternative organizations, art schools, individuals such as independent curators, museum curators, critics, art historians, academics in adjacent fields, publishers, collectors, gallerists, art advisors, art agents, auction house staff, publicists, biennale curators and art fair impresarios – all of these players operate in the social/professional spheres that constitute "the field of cultural production."[22] The making of the canon is grounded in this field, including its social, commercial and academic worlds. The belief that the best art somehow "naturally" rises to the top rather than being actively consecrated within the field is no longer taken for granted as it was in the past. Yet this view nonetheless persists, and its more systematic undermining requires art history to engage more fully in a discussion of how art is canonized in the social/professional/academic and economic fields.

The case of Giorgio Vasari offers a powerful demonstration of the mechanisms of art consecration in the social field. Vasari has long been recognized for setting the Renaissance canon and effectively establishing the beginning of Western art history.[23] In Florence of 1550 he published his monumental book *Lives of the Most Eminent Architects, Painters and Sculptors*, an encyclopedic compendium of artists' biographies counting more than 1,000 pages. But his canon and history presented a linear, geographically centered account of artistic lineage and progress that privileged the Medici and artists from Florence/Tuscany over other regions in Italy and other parts of Europe.[24] It ignored and sometimes even denigrated artists and art traditions based in other regions.[25] Vasari credited his own patron, Cosimo I de' Medici, with bringing about the rebirth of art.[26] His account was later contested for its exclusion of artists from other geographical regions and political affiliations. In 1604, Karel Van Mander's *Schilder-Boeck* was published in Antwerp, adding to Vasari's account by articulating the Northern European canon.[27] By the mid-17th century,

Vasari's *Lives* was attacked by several authors working in Italy who argued for the importance of art from regions other than Tuscany.[28]

Rather than an isolated and purely intellectual activity, Vasari's formation of the Renaissance canon was entangled in all aspects of the social/professional art world. His various positions and roles in Florence gained him the expertise, social networking and power that enabled him to write the book that defined the Renaissance art canon: he was not only a painter and architect but also a courtier, an administrator of artistic projects for the House of Medici who carried out curatorial duties, collecting and displaying the art of the Medici (he also did some collecting himself), and a central player in shaping the Accademia delle Arti del Disegno (Academy of the Arts of Drawing), founded by Cosimo I de' Medici in 1563 (the first institution of its kind in Europe). Thus, from its inception in the Renaissance, the formation of the canon was not a detached judgment of quality, free of political and patronage interests. Rather, it was firmly grounded in the patron's circle and aided by the author's intertwined practices of art-making as well as collecting and displaying art in the service of the patron. Furthermore, Vasari undertook writing *Lives* at the behest of an art collector in the Medici circle – Paolo Giovio, who specialized in collecting artists' portraits. Giovio asked his friend Vasari to write *Lives* because he wanted to add a treatise to his museum.[29] Thus we find at work here many of the same elements involved in the contemporary process of canon formation: museums, private collectors, patrons and art experts who collect for patrons, displaying artwork in the service of patrons/collectors and holding powerful positions in the academy.

It is sobering to recall that Vasari's Renaissance canon included a great deal of what was then contemporary art and whose selection was therefore based on first-hand viewing whenever possible.[30] Today there is no general agreement on the question of whether there is a canon of contemporary art. Some have espoused the view that one can only talk about "trends" (this position is expressed in the round-table discussion on the art canon and the market, Chapter 15). The fact that the term "canon" is used less frequently in the discourse on contemporary art is unsurprising insofar as the canon is traditionally understood to refer to art consecrated not in real time but long after it has been succeeded by more recent art.

Is the canon needed, and has it changed?

Critiques of the canon in art history have focused on the canon's exclusions. Yet today, the rhetoric and to a certain extent also the practice of *inclusion* prevails – a consequence of the impact of social movements advocating equality of women and artists of color in the West, geopolitical changes, postcolonialism and globalization. Nowadays, especially in large-scale international exhibitions, there is "an almost mandatory inclusiveness, based on difference and indeed decentralization of cultural power in discourse as in practice."[31] But there are also, as we shall see, clear limits to inclusiveness, visible especially in the teaching of art history surveys in the West and in the narratives of the permanent collections of museums (I return to both issues in what follows).

The field of art history was slow to address the topic of the canon compared with literary studies. In 1996, The *Art Bulletin* published "Rethinking the Canon," featuring several short articles on diverse sub-fields and interests (medieval art, colonialism and orientalism, world art studies, the new art history and theory and African art).[32] Other prominent sub-fields and issues in art history were absent from the issue such as, rather conspicuously, analysis of gender and the canon. Three years later, Griselda Pollock published a volume dedicated to a feminist critique of the canon. She defined the canon as "a discursive formation which constitutes the objects/texts [that] it selects as the products of artistic mastery, and thereby, contributes to the legitimation of white masculinity's exclusive identification with creativity and with culture."[33] Pollock concluded that it was futile to expand the canon by merely adding women to it, since this approach leaves unchallenged the canon's basic structure with its dichotomous understanding of the masculine as universal and the woman artist as its "other."[34] The prospect of deconstructing the canon is highly relevant in the era of art's globalization. The acclaimed curator Okwui Enwezor, Nigerian born and based in New York and Munich, raised the question of whether the discourse on the globalization of art cynically absorbs counter-hegemonic contemporary art practices that "seek to highlight the crucial factors of difference . . . into an already well-honed system of differentiation and homogenization."[35] In the following pages, we will ask to what extent the canon has changed, whether it merely integrated certain token additions while leaving the canon's original biases intact, whether it is necessary or indeed advisable to abolish the canon and what a transformation of the basic structure of the canon might entail.

Many scholars and curators, including some who recognize the inherently reactionary nature of the canon and the problems it raises, hold the view that abolishing the canon is not only unfeasible but also problematic. One of their arguments is that the idea of abolishing the canon reflects "a utopian desire for a sphere of discourse in which all cultural production can be received without invidious comparison to other works,"[36] whereas in practice even artists themselves "still tend to want admission to the canon rather than an undefined place in a flattened-out landscape."[37] Most importantly, many agree that canons are needed in order to provide "a framework for discourse."[38] As curator Ruth Noack writes, they are a tool for defining core interests, which is particularly important in a politically fragmented world – yet she notes in the same breath that canons must constantly be made and instantly questioned.[39] Many feminist art historians and curators recognize "the strategic necessity" of counter-canons of women's art "for the pedagogical purposes of having a common grounding and shared knowledge"[40] (on these issues, see "Troubling Canons," Chapter 14).

Has the canon changed? The extensive amounts of research and published material on artists from previously excluded groups and of exhibitions of such groups (based on gender, race, ethnicity, geography, sexuality) amount cumulatively to a significant change. Our ability to teach, write and curate outside of the boundaries imposed by the traditional canon has been fundamentally altered. Relative to the canon of four or five decades ago, the present canon is discernably revised and

expanded. Numerous artists from previously excluded or underrepresented groups have entered the canon, judging by the standard of major museum exhibitions, catalogues, monographic studies and other scholarship. The knowledge base on artists who were once outside the canon has increased steadily over the past five decades. Whereas as late as the early 1990s, many art historians at leading US universities still objected to PhD dissertations on artists who were not in the canon, this is no longer the case. Furthermore, the process of canonization is no longer transparent as it was before the emergence of critiques of the canon. The critical discourse about it, which questioned previously self-evident categories such as "greatness," "genius" and "quality," has changed art history – even while the critiqued terminology persists in some museum catalogues and in the mass media.

In the field of modern and contemporary art, the (limited) changes in art history and museum practices are evident inter alia in the increased prominence in exhibitions and publications of women and artists of color of both genders in the West and of artists outside of the West. So, for instance, observing the statistics regarding the participation over the years of artists from traditionally excluded groups in documenta, perhaps the most influential large-scale international exhibition, we find that the first documenta, held in 1955, included no artists living outside the West; the second (1959) included 3%; in documenta 11 (2002), 22% of the participants were artists living in non-Western countries and 43% were born in such countries; in documenta 12 (2007), 46% of the artists were living in non-Western countries and 56% were born outside the West.[41] Change is noticeable also in other large-scale international exhibitions, such as biennales. Although biennales have been criticized for consistently showcasing the work of the same limited circle of art-world stars, many critics agree that these exhibits have nonetheless made a major contribution to the diversity of art.[42] As early as 1999, Russell Ferguson observed that "[l]arge scale surveys of contemporary art are now almost never the virtually all male, all white affairs that they were as recently as ten or fifteen years ago."[43] A leading curator of biennales, Massimiliano Gioni, makes the point that the best biennales are revisionist insofar as they redefine a lineage or history,[44] and thus they help redefine the canon; Gioni also highlights the role of biennales in diversifying the canon: "Often they have turned around or at least shaken up the Western canon of art history by playing an essential role in increasing the biodiversity, so to speak, of the contemporary art world."[45]

Some critics have argued that the new focus on the gender and ethnic identity of non-male, non-white and non-Western artists has itself become a mechanism that foregrounds and thus perpetuates "otherness" (I return to this in what follows).[46] Today there is some evidence of a shift away from the foregrounding of "otherness" per se (as opposed to the inclusion of art and artists from groups previously defined as "other"). Whereas up to five years ago American curators' interest in black artists was limited primarily to figurative work about black experience, today it includes an increased interest in abstract art.[47] To deny the changes that have taken place over the past half century in the canon – specifically, the increased inclusion in exhibitions and publications of previously excluded groups – or to

deny more generally the current momentum toward change, is to turn a blind eye to a significant historical development. Lowery Stokes Sims, the first African-American curator at the Met and later the president of the Studio Museum in Harlem, stated recently, "I think there is a sea change finally happening. It's not happening everywhere, and there's still a long way to go, but there's momentum."[48]

Moreover, international exhibitions and art fairs of contemporary art are now held across a wider geographical territory, reaching beyond the Art Basel fair in Switzerland (founded in 1970), the Venice Biennale (founded in 1895), documenta, Kassel (founded in 1955), the São Paulo Biennale (founded in 1951) and the Biennale of Sydney (founded in 1973). Anthony Gardner and Charles Green have proposed that the global history of biennales includes several waves: the first, in the 1890s; a second from the 1950s through the mid-1980s, which included biennales in Latin and South America, Asia, Australia and the Middle East, whose orientation was re-imaging the regional and establishing trans-local networks that complicate the Cold War binaries of East and West;[49] during the 1980s (still in the second wave) biennales were launched in Havana (focused on the Third World)[50] and in Istanbul. The third wave of biennales, according to Gardner and Green, began in the 1990s. During this time, international biennales were launched in, among other places, Shanghai, Taipei and Gwangju, South Korea; Dakar, Senegal (with a focus on the African continent) and Johannesburg (now defunct); Mexico City, focused on artists from the Caribbean, Latin America, the Middle East, Africa and Asia; Dubai, the United Arab Emirates and Kochi in the state of Kerala, India.[51] In the 2000s, still more biennales were launched (some, including in New Delhi and Dhaka, with earlier precedents) including in Yokohama, Singapore, New Delhi and Marrakesh; in 2012, the Dhaka Art Summit in Bangladesh (the largest contemporary art event in South Asia) was launched; and in 2017, the Pakistani city of Lahore will hold its first biennale. Additional biennales have also been launched in Europe, among them Manifesta, an itinerant biennale held in Europe, usually away from traditional art centers.

Biennales have also been criticized for branding cities and promoting above all a revenue-producing tourism that serves the political and economic interests of corporate sponsors and more generally for amounting to artistic playgrounds for the spectacle culture of global neoliberalism and imperialist politics.[52] But other critics, without necessarily denying the foregoing critique, see biennales also as agents of potential change internationally, regionally and locally, for instance through their ability to draw local practitioners into a global network,[53] and by drawing an audience from their local communities and not only from the milieu of the travelling art-world professionals.[54] Gardner and Green have argued that the success of biennales depends in part on our ability to move beyond the binary view of these events as either good or bad to an understanding that neoliberalism and criticality are not mutually exclusive pathways.[55] And moreover, in light of the great cultural, political, financial and ideological differences among the estimated 200 biennales now established worldwide, any wholesale condemnation or extolment of the phenomenon will most likely err in the direction of oversimplification.

The wide geographic range of biennales today is an important factor in the international consecration of art from diverse regions and continents. Although the museum is traditionally the site for "authoritative pronouncements, classification, canonization, and preservation," with the biennale cast in the role of a site for experimentation,[56] this division of labor is subtly shifting. So, for example, some museum exhibitions now resemble biennales in their selection of a wide range of emerging contemporary artists from far-flung locations, and several recent biennales have included distinctly historical components of the sort typically associated with museums. Moreover, nowadays the biennale exhibition is "*the* medium through which most contemporary art comes to be known"[57] and it plays an important role in the consecration of contemporary art and artists – both Western and non-Western, in part because entering the international canon today requires an artist to establish an international status. Yet as Enwezor explains, biennales hold special importance for artists from peripheries, "hoping to leap outside the under-funded contexts and into the resource-rich pastures of the global space."[58] Of course, in isolation, no biennale can single-handedly catapult an artist into the canon of contemporary art, since the rankings of artists are still greatly influenced by their exhibition record in museums and commercial galleries. Although globalization is unequal across countries,[59] for artists from peripheries, gaining international exposure is crucial, especially because the infrastructure of museums and the market for contemporary art in peripheries is sparse compared with the West. This sparsity explains, to a large extent, why internationally renowned artists from peripheries, like the Nigeria-based El Anatsui or the Benin-based Georges Adéagbo, have many more exhibitions in the West than in Africa. Finally, although the West still plays the dominant role in the canonization of contemporary art and artists, the fuller picture does by now include significant influence by non-Western actors, like non-Western curators in Western institutions and again the numerous biennales and other large-scale international exhibitions held outside the West.

The contemporary art canon as formed in large-scale exhibitions and art fairs may also be affected by the geographical diversification of new art market centers. No longer located only in North America and Europe, significant art markets have emerged in Asia – including Hong Kong, Singapore, Shanghai, Beijing and New Delhi – and in several other regions, like Moscow and Abu Dhabi.[60] In 2014, no fewer than 180 major art fairs with an international element took place.[61] As Olav Velthuis points out, major art fairs (which nowadays typically host several hundred art dealers) and auctions (including special sales by Christie's and Sotheby's dedicated, separately, to art from India, from Russia, from China and from Latin America) all contribute to a de-territorialization of the exchange of art, providing alternatives to the local social structure of the gallery dealer even as the latter persists.[62] The Internet has also contributed to this shift by enabling the quick global dissemination of the art discourse and by facilitating sales. Some gallery sales are now based on JPEGs of the artworks. The first online art fair to include many established dealers was held in 2011, and the use of the Internet to auction modern art has gained significant momentum in some locations, notably in India.[63] In 2014, online sales constituted about 6% of the global art and antiques sales.[64]

Current statistics show that the global art market is still dominated by Western nations: in 2013, the US ranked first (with 38% of the sales) and the UK third (with 20%) – but China was the second-largest market (24%).[65] In 2014, China and the UK each constituted 22% of the global market and the US 39%.[66] As for the gender axis, the art market is still far from parity. So, for example, of the 6,889 artists who participated in Art Basel (the most important art fair) between 2005 and 2012, only 1,801 (26%) were women.[67] Taken as a whole, these figures are a sign of significant yet inadequate progress.[68]

The field of collecting contemporary art is also showing signs of significant change, though it, too, continues to be dominated by the West. New collectors of contemporary art have sprung up all around the world as the practice of collecting contemporary art becomes part of a neo-liberal economy and a lifestyle of new economic elites, some of whom see art collecting largely as an investment opportunity.[69] Of the most prominent private art collectors, 63% are still located in North America and Europe, but an impressive 24% are in Asia, 8% in Latin America, 5% in the Middle East and 0.1% (16 collectors) in Africa.[70] While these figures show a gradual geographic diversification in the make-up of collectors, it remains to be seen how, and how much, the decentralization of the art market and of the collector make-up will impact the geographic diversity of artists that enter the contemporary art canon.[71]

The increasing visibility of a wide range of cultures in large-scale international exhibitions and art fairs, as well as in museum exhibitions, points to a state of transition. As was the case when the status of American art in the Western canon rose in tandem with the increased political and economic power of the US after World War II, today's rise in the status of contemporary art from Asia, Africa, India, South America, Australia/Oceania and East Europe forms part of a much broader process of economic and cultural globalization.[72]

The changes of the last several decades are visible also in art history survey books used to teach undergraduates, which have been revised to be more inclusive, though they, too, are still far from meeting the standards of critics of the canon's biases.[73] Today, students learning art history from these surveys will encounter some women artists, whereas their counterparts up to the 1970s would not have found a single woman artist in major surveys such as Janson's, but by and large, survey books of modern and contemporary art still tend to present the traditional exclusionary canon. For instance, art historians have criticized *Art Since 1900: Modernism, Antimodernism, Postmodernism*, written by some of the leading US art historians of modern art,[74] for presenting the traditional canon with only minor additions, thereby misrepresenting it as a universal history of modern art.[75] Moreover, the biases of teachers in the classroom affect how art history survey books are used. So, for example, Princeton Professor Chika Okeke-Agulu reported that in practice, the sections on non-Western art are often skipped in order to avoid leaving out some sections about Western art. He concludes that "Despite the professed desire for a more inclusive survey, an art history long-premised on the idea of an extant family tree can expand on the condition that new members justify their inclusion without

disrupting the genealogical narrative."[76] The fact that such criticisms, of textbooks and of teaching practices, are voiced in the field of art history today is itself a sign of change, but the persistence of the traditional modern canon – in an influential survey book such as *Art Since 1900* and in the practices of a leading teaching institution – also underscore the need for more revisionist narratives.

Change is visible also in the emergence of so-called counter-canons, the result of the cumulative work of many scholars and curators, which forms part of a broader political and cultural effort to redefine excluded groups, nations, regions or continents. If one agrees with the view that "[t]here is no way to practice a canon-free art history,"[77] then establishing, researching, publishing and exhibiting art that lies outside *the* authoritative canon and in this way establishing multiple counter-canons is vital for the empowerment of traditionally excluded groups. And indeed, the constitution of counter-canons such as of African-American art, contemporary African art, Latin American art, Chinese art, feminist art and women's art – has proven useful in combating the ongoing exclusion of these bodies of work from survey books.

Counter-canons, then, are an effective strategic tool: they undermine the exclusivity of the traditional canon by acting as a "supplements" to it. Their aim, of course, despite their specialized focus, is not to promote segregation but, on the contrary, to provide an alternative, even if ad hoc, to blatant exclusions and to build a knowledge base that will enable teachers, curators and future authors of survey books to broaden their interests and practices. To the extent that artists featured in such counter-canons may remain ghettoized in specialized exhibitions, books and so on, the critique of ghettoization arguably deserves to be addressed not to those who study, teach or exhibit artists who are excluded from the mainstream but to those who still limit their focus to what is increasingly recognized as a partial Western art canon.

With respect to the closely related concern that such counter-canons may encourage a stereotyped view of the given group, race, ethnicity, gender or geography, research has shown that the essentializing tendency exists quite independently of counter-canons insofar as artists from marginalized groups tend to be essentialized in art history surveys and narratives in the context of the overall canon of art history.[78] Speaking about British film, scholar Kobena Mercer argued that "the idea of speaking as a 'representative of the race' reinforces the myth, on which ideologies of racism actually depend, that 'the black community' is a homogenous monolithic or singular entity defined by race and nothing but race."[79] Likewise, scholars and critics of American art tend to "insist upon the intimate, symbiotic relationship between African American art and African American subjectivity."[80] This kind of essentializing practice results in "limiting the inquiry, and flattening out complexity."[81] Moreover, such an inquiry keeps art by African Americans apart from many of their contemporaries and reinforces the exclusion of such artists by separating them from the discussion of connections, interactions and lineages that are central to legitimation processes in art history generally and in canon formation in particular. As with race, so in the case of gender we find that independently of

counter-canons, an androcentric viewpoint continues to stereotype women artists in ways that limit our understanding of their oeuvres. It also obscures the connections of women artists to their contemporaneous artistic circles and removes them from lineages of artists and movements so that their contribution to art's evolution goes unacknowledged. The result is that women artists are excluded from the connections established by historical accounts, connections that are crucial to establishing an artist's place within a canon.

Another area that shows change is the growing number of temporary exhibitions in Western museums featuring a large number of artists regarded as "others." A good example is the exhibit *elles@centrepompidou*, curated by Camille Morineau at the Centre Pompidou, Paris (May 2009–February, 2011). It was the most ambitious survey exhibition yet of modern and contemporary art by women, occupying the museum floors normally dedicated to the standard (white male) canon of Western artists, while the latter's works were put into storage. It featured some 500 works in a wide range of media by 200 women artists. Although the exhibition was presented as a re-hanging of the museum's permanent collection and was indeed entirely drawn from that collection, it functioned more like a temporary exhibition in the sense that it presented an exhibition entirely different from any permanent collection in this or any other museum (though its duration was longer than the typical temporary exhibit and was further extended due to popular demand). Once it was over, however, the permanent display of the Pompidou's collection reverted right back to its usual institutional gender bias, which was unchanged (approximately 10% women, 90% men).[82]

The same holds true of another major exhibition at the Centre Pompidou, *Multiple Modernities, 1905–1970*, curated by Catherine Grenier (October 2013–January 2015).[83] Informed by postcolonial studies and by globalization, the exhibition presented diverse artistic modernities not confined to Western Europe and North America and included 1000 works by more than 400 artists from 41 countries. Like *elles@centrepompidou*, it was drawn entirely from the permanent collection of the Musée National d'Art Moderne (housed in the Pompidou) and presented itself as a fresh look at this collection. The curator's aim here was bold: to provide "an initial proposal for renewing the conventional approach to modern art"[84] and "the foundations for a fresh view of history."[85] However, the leadership of the Centre Pompidou and the Musée National d'Art Moderne was quick to reassure its audiences that *Multiple Modernities* was merely a temporary experiment and did not reflect a permanent change.[86] Alain Seban, the chairman, director and CEO of the Centre Pompidou, explained the goal of the exhibition thus: "We are fully entering a new era of cultural globalization, while at the same time renewing the primordial mission of the museum inspired by the humanist and universalist philosophy of the Age of Enlightenment."[87] Thus the museum reasserted its commitment to the Eurocentric tradition.

Since the *Multiple Modernities* exhibit, the Centre Pompidou has not significantly changed its display of the permanent collection, which continues to emphasize a Eurocentric and androcentric narrative of modern and contemporary art.

Furthermore, *Multiple Modernities* itself did not significantly challenge the museum's standard gender bias: it featured a total of 50 women artists, constituting only 12% of all exhibited artists. The women artists were from 19 countries, which meant that 28 countries were represented by an all-male cast. In other words, Grenier did not integrate gender equality into her post-colonial curatorial vision.[88]

These exhibitions indicate that when certain curators and their institutions take bold steps to change the status quo, these steps tend to have (that is, they tend to be allowed) only a temporary impact on the museum's regular display. Arguably, major modern and contemporary Western art museums play a double game when they claim their place in an era of globalization by mounting such "revisionist" exhibitions without giving up their universalist, European Enlightenment tradition. On the one hand, they align themselves with up-to-date, dynamic global developments through occasional temporary exhibitions featuring a variety of "others"; on the other hand, they keep these exhibitions separate and enact very little change in the display of their permanent collections, which retain the claim to supposedly tell us "the" story of modern and contemporary art. Moreover, specialized museum exhibitions that break the mold of the traditional canon are entirely dedicated to "others," and as such, they too, at least to date, do not offer a balance between traditionally marginalized artists and traditionally privileged ones. Thus, the resilience of the canon is not only challenged but also sustained through the phenomenon of occasional specialized temporary museum exhibitions that "renew" or "take a fresh look at" permanent collections. The exhibits remain a passing event, while the master narrative of permanent collection display proceeds unchallenged.

In sum, looking at the state of survey books, art-historical scholarship and teaching, the practice of establishing counter-canons, specialized temporary exhibitions in museums and the display of permanent collections, we find a complex picture that includes significant changes and gradual de-stabilizing trends but also a resilient traditional canon.

Re-constituting canons: artists' contestation versus consensus

The myth that the canon is formed through the "consensus" of disinterested professional judges of quality has been sustained by a belief in the "naturalness" of this process, a belief that disavows the actual processes of canonization of art in the field. It is increasingly clear, however, that this view of the canon as formed by a long historical consensus about "the greatest" – that is, innately superior – artworks and artists is a fiction. Indeed, as I have been arguing here, the canon is shaped and revised to a large extent by contestation.

In searching for a theoretical base in which to ground and frame the importance of contestation in canon formation and revision, Chantal Mouffe's ideas about the political and its prevailing condition of contestation, conflict and antagonism in a plural world are useful.[89] A political theorist, Mouffe does not specifically discuss canons, but her theory is applicable to our discussion insofar as it demystifies the

idea of arriving naturally at a consensus – in her case, political consensus, which is so central to the thought of many Western political theorists (for example, Jürgen Habermas, who envisions the public sphere as producing consensus).[90] Mouffe stresses "the antagonistic dimension that is persistently disavowed" in liberal theories. She argues that the semblance of a dominant consensus is always based on exclusion[91] and is "a temporary result of a provisional hegemony, as a stabilization of power."[92] The same is true of the process of canon formation and revision: contestation of the canon's exclusions plays a constant role in what is (mis)represented as consensus. Canon contestation is not limited to the art world but is integral to social movements (like the civil rights movement and the women's movement, for example) and to multiple economic and cultural processes (like globalization). In this sense, Mouffe's theories stand to broaden our understanding of the struggles, conflicts and competition that Bourdieu discusses as characterizing the art field.[93] Despite the common myth of a consensus, when we look at concrete cases in art history, what we find is contestation on the grounds of exclusion.

Artists have always played a major role in the contestation of exclusion. European modernist artists of the 19th century provide a good example of this tendency. Contesting the restrictions of the art establishment, Gustave Courbet and Edouard Manet each organized their own independent retrospective exhibitions, bypassing the art-world gatekeepers of their time. Likewise, the Impressionists organized their own group exhibitions in order to exercise their independence in making and exhibiting art without conforming to the academic standard. These artists contested the exclusionary policies of academic painters whose position of power in the Parisian art world allowed them to control the selection of art for the annual Salon exhibition, thereby conferring upon the selected artists and works a stamp of quality, and to perpetuate academic artistic standards through their teaching posts in the academy. Thus, while Courbet, Manet and the Impressionists are now occupying central positions in the canon of modern art, they got there partly by actively contesting (with significant help from their supporters among art critics, gallery owners and collectors) the academic art canon and the art-world power structure it reflected.

In the second half of the 20th century, artists once again played a key role in the political contestations of museums' exclusions of artists based on race and gender. As we will see, artists were among the first to recognize the need for an expansion of the canon. In the following pages, I discuss several cases of men and women, including American, African American, Japanese and Chinese artists who (like Edelson and Huang discussed earlier) have contested the canon's exclusions in their own artworks. Although other artists appropriate canonical artworks, our discussion focuses on those artworks that contest the canon's exclusions rather than on issues of appropriation more generally.

Beginning in the 2000s, African American artist Kehinde Wiley focused his prolific production of monumental-scale, figurative paintings on subverting masterpieces from the European canon by replacing the central white figures with contemporary African Americans who assume the same pose and exude the aura

of status and authority of the white figures in the original paintings. Wiley's monumental painting *Napoleon Leading the Army over the Alps*, 2005, for instance, based on Jacques-Louis David's *Bonaparte Crossing the Alps*, 1801, Fig. I.3, is a good example of his typical manner of glorifying and heroicizing anonymous contemporary young black men and fusing the European high-art tradition with contemporary hip-hop culture and street clothing. With these re-envisioned canonical paintings, Wiley, born in 1977, entered the canon of contemporary American art and gained international acclaim at a young age, soon after completing his graduate studies

FIGURE I.3 Kehinde Wiley, *Napoleon Leading the Army over the Alps*, 2005. Oil on canvas, 108 × 108 in. (274.3 × 274.3 cm). Brooklyn Museum, New York, partial gift of Suzi and Andrew Booke Cohen in memory of Ilene R. Booke and in honor of Arnold L. Lehman, Mary Smith Dorward Fund, and William K. Jacobs, Jr. Fund, 2015.53. © Kehinde Wiley. Courtesy of the artist and Sean Kelly Gallery.

at Yale in 2001. Since then, he has had numerous gallery exhibitions and several museum exhibitions, including a recent mid-career retrospective at the Brooklyn Museum.[94]

Wiley's paintings portray strangers (usually young black men) whom the artist encounters by chance, a process he calls "street casting." He shows them his work, and if they consent to have their portrait painted by him, he consults them about which of the paintings they review together in art books they would like to enact, a process the artist describes as "starting a conversation about power." Wiley's paintings are based on photographs of the subjects' enactment in Wiley's studio and usually present the male figure in front of a flat ornamental background. In these paintings, Wiley repeatedly performs an act of subversive inclusion designed to redress the historical exclusion of dark-skinned figures from central positions in European masterpieces. In this sense, the bulk of Wiley's oeuvre re-envisions the white Western canon. Many of his paintings are also a tribute to a homoerotic gaze, which is distinct from the hetero-normative gaze of the male artist at the female body that has dominated Western art.

Wiley began his series *The World Stage* in 2006 in China and continued it in Lagos and Dakar (2008), Brazil (2008–2009), India and Sri Lanka (2010), Israel (2011), France (2012), Jamaica (2013) and Haiti (2014). In each city he set up a studio and depicted young dark-skinned men from these multiple locations worldwide, often appropriating poses from artworks of the country in which he is currently painting as well as local motifs for the decorative background. In addition to his Brooklyn studio, Wiley now maintains a studio in Beijing and in Senegal, where many of his paintings are executed with the help of local assistants who paint the backgrounds. He is not alone in occupying studios in more than one location around the globe: Ai Weiwei currently has studios in Beijing and Berlin and recently opened a studio on the Greek Island of Lesbos (a prominent point of entry for refugees into Europe) in order to create a series of works on the refugee crisis. The phenomenon of holding studios in more than one continent and making art that addresses issues pertinent to these diverse locations is one more facet of globalization in the art field (some street artists create in different locations around the globe without studios, a phenomenon discussed in this volume in the essay "Street Art," Chapter 8).

Some 20 years before Wiley began his work, African-American artist Faith Ringgold began a 12-piece series called *The French Collection*, including the work *Dinner at Gertrude Stein's*, 1991, which inserted into the cosmopolitan art circle of Gertrude Stein's Paris salon a fictional African-American artist-model (whose fictional biography describes her as having worked as a model for two canonical French artists before becoming an artist herself). Ringgold chose the mediums of quilt and paint, "in the service of hybridity."[95] Merging the high-art tradition of painting with the popular-culture tradition of quilt making, Ringgold's fictional scene contests the modern white masculine high-art canon by inserting her invented African American female expatriate into Stein's Salon gathering, as well as by introducing craft into painting.

Unlike Wiley, who contests the white canon by appropriating well-known European masterpieces and inserting into them anonymous contemporary black men, Ringgold invents her scene and some of its figures without appropriating a particular masterpiece; instead, she re-invents a pivotal moment and circle in the formation of the modern art canon. She situates Gertrude Stein directly under Picasso's famous portrait of her and includes an equal number of black and of white figures in this salon gathering of 10 people, all of whom are featured seated under a display of some of the most prominent artworks in the canon of modern art. In this re-envisioning of Stein's salon, Ringgold invents a fully integrated Parisian art world into which she inserts her surrogate artist while at the same time flattening out the hierarchy that casts painting as a high art and quilting as a (mere) craft. This artistic contestation was created some 30 years after Ringgold played a leading role in the demonstrations of black artists against the Whitney Museum of American Art and participated in demonstrations of the Art Workers Coalition.[96] She has since had numerous exhibitions and received numerous honorary doctorates.

Wiley's paintings are discussed by him and by critics as making direct reference to the European art canon. In the catalogue of his recent mid-career retrospective at the Brooklyn Museum, he was not only credited with "inserting the urban black male figure into the art-historical canon," thereby bringing the canon "up to date" while questioning its "centuries-long exclusion of such figures,"[97] but also with having "altered the narrative of art history, reshaping the canon by inserting Wiley firmly into it."[98] Yet the commentaries that read his works as conversing with canonic paintings of the Renaissance and the Baroque periods overlook their important relationship to a lineage of contemporary artists – namely, the rarely credited lineage of feminist and in particular African American feminist artists, in this case, Edelson and Ringgold. Stylistically, his paintings are unlike theirs, but conceptually the work of these three artists has much in common insofar as it combines a critique of the canon's exclusions with self-empowerment of an excluded group, achieved by inserting its members into paintings from the Western art canon, or, in Ringgold's case, into art circles central to the modern canon.[99] There are other important differences. Wiley has made this type of work a central tenet of his oeuvre over many years, whereas Ringgold and Edelson have not. Wiley, unlike them, uses monumental scale; he paints his subjects in ways that connote both dissonance and smooth incorporation into a Western canon rather than primarily dissonance as in the case of Edelson's rough collage and Ringgold's merging of craft and art, and he applies a process that mixes the historical sources of the canonic paintings with interactions with young contemporary men whose portraits he paints.

Edelson's *Some American Living Women Artists* was distributed as a printed poster that was widely available for purchase. Two years later, Judy Chicago, then living in Los Angeles, began work on *The Dinner Party*, an installation artwork featuring a "canon" of historically significant women, only a few of whom are artists. In contrast to Edelson's print, Chicago's artwork was an ambitious monument – its scale called for a museum exhibition onto itself, and its production involved hundreds of volunteers. At a large-scale triangular table, Chicago arranged elaborate place

settings for 39 women, all represented by controversial sexual imagery and through the feminized and traditionally discredited craft mediums of ceramics and embroidery. In addition, on luminous tiles that covered the floor, she featured the names of a further 999 women creators in diverse fields and from different historical periods. With *The Dinner Party*, Chicago consciously intended to create a work of art that would itself "enter history." As Amelia Jones points out, by making a heroicizing monumental work, "Chicago both challenged and reinforced patriarchal conceptions of history."[100] *The Dinner Party*, 1974–1978, was contested from many different directions, from far-right politicians and critics loyal to modernist artistic standards to post-modernist critics and diverse feminists.[101] Elizabeth A. Sackler acquired *The Dinner Party* and donated it to the Brooklyn Museum, where it has been on display since 2007. Thus, today *The Dinner Party* occupies 30,000 square feet in a major museum, and in 2007 it also entered Janson's survey, *History of Art*.[102] That the artist and *The Dinner Party* have indeed entered history is clear, yet the inclusion of this work in the art canon may prove to be exceptional in Chicago's oeuvre. Both Edelson's and Chicago's canon-related works were early steps in what became the feminist art movement's influential effort and accomplishment – namely, the project of critiquing the exclusionary canon and producing new research, including books, articles and exhibition catalogues, on women artists, all of which formed the basis for a counter-canon and for the entry of some women into art history survey books and exhibitions.

Unlike Chicago and Edelson, whose works feature individual artists (and, in Chicago's case, also other major female contributors to culture) within a collectivity, Hannah Wilke, who began working in New York in the late 1960s, contested the male canon by inserting into it images of herself, often in the nude, interacting with artworks by Marcel Duchamp. A prominent example is her video *Through the Large Glass*, 1976, in which she strips bare in front of Duchamp's *The Bride Stripped Bare by her Bachelors Even*, 1915–1923, at the Philadelphia Museum of Art.[103] When Wilke made this work, in the 1970s, there were almost no contemporary female artists in the canon, whereas images of nude women have been prevalent in canonic artworks for centuries. Wilke utilizes this tradition of the female nude while at the same time critiquing it by stressing the active nature of her own stance in the work – that is, by re-playing the female nude role with a critical difference.

Another artist who uses his naked body in a contestation of the Western canon is Lin Jiahua, a member of the Chinese Xiamen Dada group. Just one year after Huang created his work contesting the separate Western and Chinese art canons, Lin performed *To Enter Art History – Slide Show Activity* (1988) at an event of the same title organized by Lin himself and featuring work by various Chinese artists, Fig. I.4. His own work projected slide images of canonic Western artworks onto his naked body.[104] Like Wilke before him, Lin thus inserted himself, and by extension an excluded group, in his case Chinese artists, into the canon of Western art. And like Huang (with whose work and ideas Lin was intimately familiar), Lin contested the complete separation between the Western and Chinese art canons. Lin's *To Enter Art History* occurred on the cusp of a shift from the artistic trends of

FIGURE I.4 Lin Jiahua, *To Enter Art History – Slideshow Activity*, 1988. © Lin Jiahua. Courtesy of the artist and the Fei Dawei Archive at the Asia Art Archive.

the 1980s, when Chinese artists translated and appropriated Western art, to those of the 1990s, when they entered the field as players in their own right and their focus changed accordingly from interpreting and using Western art history from the outside to the question of "how they conceptualized their relationship to it."[105] The 1990s was the decade in which Chinese artists recognized the necessity of an art market,[106] having concluded, as art critic Huang Zuhan asserted in 1991, that "in this era of art history, commercialization is the most basic means for artists and artworks to enter history."[107]

Like Wilke and Lin, the Japanese artist Yasumasa Morimura uses his own body to claim a space within the Western art canon in works that combine performance

and photography. Since 1985, Morimura has developed an extensive body of work of color photographs in which he impersonates figures in well-known paintings from the Western canon, from Leonardo, Velasquez, Vermeer and Rembrandt to Van Gogh, Manet, Duchamp, Frida Kahlo and Cindy Sherman. In his color photograph *Portrait* (Futago), 1988, Morimura appropriates Manet's Olympia, impersonating both the white female nude and the dark-skinned maid. With his slim nude male body, donning a blond wig, his face covered in makeup that makes his Asian features look more European, Morimura changes Olympia's gender, race, and sexual orientation as he gazes out with a serious expression, Fig. I.5. Olympia's naked body, no longer female but not manifestly masculine, leans toward the effeminate, projecting a sense of hybridity. Impersonating the dark-skinned maid, the artist wears a sumptuous light-pink dress that accentuates the figure's dark face as she looks intently at Olympia. He thus produces a cross-cultural, cross-gender, cross-race and cross-sexuality interaction with Manet's painting. Morimura's appropriations of numerous paintings from the Western art canon have been interpreted as his response to the dominant status of Western art in Japan. Having studied primarily Western art masters in the course of his art history education in Japan, Morimura observes that he developed "sensibilities" that are not "healthy or well balanced."[108] The sense of strangeness or queerness one encounters in his paintings is grounded

FIGURE I.5 Yasumasa Morimura, *Portrait (Futago)*, 1988. Color photograph, chromogenic print with acrylic paint and gel medium, 82 ¾ in. × 118 in. (210.19 cm × 299.72 cm). © Yasumasa Morimura. Photo courtesy of the artist and Luhring Augustine, New York.

in a disorientation that stems from the collision of the expectation to see the famil-
iar Western art masterpiece with Morimura's performance within it – which is
neither Asian nor European, neither male nor female. His works are invasions of
the Western art canon, but they are also contestations of the clear-cut dichotomies
of gender, race and European and Asian identities, all of which are subjected to
destabilizing transgressions in his work. A certain ambiguity remains about just
what Morimura is contesting: an exclusion from the European canon of a Japanese
queer artist's body and self, surely, but also perhaps a broader contestation of the
strictly defined identities of the European male and female figures within such
masterpieces.

Morimura, Wiley, Edelson, Huang, Ringgold, Chicago, Wilke and Lin all exem-
plify the important roles that artists have played, through their artwork, in con-
testing the constraints of the traditional Western canon.[109] Each of these artists
deploys a different strategy of inclusion to intervene in the traditional canon and
re-envision it. Each one of them critiques the Western canon from the particular
point of view of the excluded group to which s/he belongs. Only in looking at
their works as a group does it become clear how together they establish a multi-
vocal critique of the partial and biased nature of the Western art history canon.

Are pluriversal canons possible?

The term "canon" has several shortcomings in the context of present-day art his-
tory. First, it gives the erroneous impression of a closed system, as is the case with
the canon of sacred texts that constitutes the Bible. This suggests that the canonical
status of the art and artists in the canon is assured forever and that no new art and
artists can be admitted, when in fact this has never been true of the art canon: the
canon is always open to inclusions of new art, and while many artists are entrenched
in it for centuries, the canon has also undergone changes through the "dethroning"
of certain canonized artists.[110] Second, the term "canon" is associated still with the
traditional ideas of universality and timelessness, implying that it is detached from
any particular interests, art-world institutions, the art market and geopolitics. And
finally, as I have been discussing here, the term "canon" may no longer be adequate
because the traditional canon relies on a narrative of linear progress within a limited
(European) geographical area, a structure that is anachronistic in today's postcolo-
nial global world.

With these shortcomings in mind, I propose the term "pluriversal canons" as an
alternative concept better suited to a period of transition characterized by plurality,
heterogeneity, postcolonialism and globalization. The term "pluriversality" is bor-
rowed from the Argentine-born scholar Walter D. Mignolo, one of several Latin
American scholars who employ the term. Mignolo, who defines himself as a non-
European thinker and de-colonial intellectual, uses the notion of "pluriversality" to
counter the assumption of universality[111] and argues that the universalization of the
regional (as in the universalization of the European) is a consequence of Western
imperial/colonial expansion.[112] For Mignolo, pluriversality plays a necessary role in

an epistemic shift that de-colonizes knowledge.[113] He explains that pluriversality is not cultural relativism because "it is not a world of independent units" but rather "a world entangled through and by the colonial matrix of power,"[114] namely "different colonial histories entangled with imperial modernity."[115]

Though Mignolo does not specifically discuss them, the kind of epistemic shift from "uni-versality" to "pluri-versality" that he describes would include art history and its canon. *Pluri-versal* canons may be an alternative to the *uni-versal* Western art canon for several reasons. First, the claim of the Western art canon (as of Western culture as a whole) to universality is increasingly recognized as problematic in an era of globalization that aspires to post-androcentric societies and stresses also the cultural diversity of societies within Western nations. Another reason that pluriversal canons are a necessary step beyond the supposedly universal Western art canon is that while revision of the canon (by creating knowledge about marginalized artists) is and has been an essential project, it cannot in principle undo the claim to universality that underlies the traditional Western canon. To move beyond *revising* to *re-envisioning* canons, a concept other than uni-versality is called for, one that represents not a single grand narrative but a plurality of narratives and canons that are interrelated in multiple and complex ways, not linearly and not uni-directionally.

The notion of pluriversality can further a re-envisioning of the art canon first by suggesting that the binary opposite of the universal is not necessarily just the particular or the partial, as is traditionally assumed. According to this traditional view, as long as the Western canon is considered universal, alternatives to it are always particular – whether local, regional, national, ethnic, gender-based and so on. And while counter-canons serve significant purposes, they are always already positioned as "other" relative to the main (Western male) canon. Thus, for those who dismiss them, counter-canons are assumed to reflect a "special interest" or to be "political," labels that diminish their status and question their aesthetic quality – the supposedly objective standard that a traditional idea of the canon espouses. New possibilities emerge when we move beyond the universal/particular binary and consider the universal/pluriversal in tandem.

Furthermore, the idea of pluriversal canons helps move beyond the anachronistic assumption of a single standard for artistic quality. Adopting the notion of pluriversal canons corresponds not just with the fact of heterogeneity but also with the fragmentation it implies and the tensions that exist among very different traditions of art, culture, and knowledge. As curator Francisco Bonami points out, "the concept of globalization is often used to define the world as a unified territory, which it is not. We experience fragmentation in the world."[116] With the term "pluriversality," I suggest that heterogeneity, plurality, and the absence of a single standard have positive value rather than reflecting a symptom of dysfunction, the end of art or the end of history, as has often been assumed. Finally, even in the face of the great impact of globalization and transculturalism, "[i]t is still necessary," as Geeta Kapur writes, "to ask how art situates itself in the highly differentiated national economies/political societies that bear the name of countries; and how, from those sites, it reckons with divergent forces at work within globalization."[117]

It is important to note that pluriversal canons are not synonymous with the idea of a post-canon. The former does not abandon the task of evaluating which works of art are the most historically significant within different cultural frameworks, whereas a "post-canon" implies the absence of any selection along with a disavowal of the very fact of the traditional canon's persistence. The term "post-canon" is misleading insofar as the traditional Western art canon is in fact still alive and kicking even where some change is noticeable. As I argued earlier, for instance, while several major Western museums – such as the Centre Pompidou, Paris, and Amsterdam's Stedelijk Museum – have recently held exhibitions that were not primarily based on the Western canon, to conclude that such exhibitions constitute a "post canon" is premature not only because such exhibitions are the rare exception but also because they are specialized exploratory projects designed from the outset as temporary interruptions of the canon-dominated permanent collections of Western museums.[118]

Pluriversal canons are also not synonymous with a mere plurality of currently existing canons (canons based on periods, such as the Renaissance canon or the Modern canon; or on nations, such as the French canon, American canon, Chinese canon, Indian canon; or on media, such as the canon of photography, performance etc.). Nor are pluriversal canons synonymous with specific counter-canons (e.g., canons of black artists, Latino/a artists, women artists etc.). For one, the status of all such canons, whether based on periods, nations, regions, media or underrepresented groups, is that of a supplement to the major authoritative canon. And moreover, they tend to maintain a certain homogeneity that results from their relatively narrow focus, even while there is stylistic diversity within each category.

A look at large-scale international exhibitions, such as biennales, may help us gain a more concrete sense of the potential of pluriversal canons. Over the past two to three decades, the curatorial field – and especially the curation of large-scale international exhibitions – has tended toward what I have been describing as pluriversality. As Enwezor notes, biennales and other international exhibitions play an important role in "a transnationalization, translocalization and denationalization of the contemporary art economy."[119] The extraordinary global proliferation of such exhibitions since the 1990s, the curatorial and critical discourse that has accompanied them and the experimentations they occasion with the exhibition of art with a global range in multiple regions and continents all suggest steps toward a more pluriversal understanding of art and its canons.

Biennales and other large-scale temporary international exhibitions lend themselves to this kind of change much more readily than museums. As Gioni notes, they are "more permeable . . . they are spheres where changes can be more easily made, categories more freely mingled."[120] Hired for a single exhibition and free of concerns about the long-term impact of the exhibition on a museum as an institution and about their own long-term position, biennale curators are able to experiment more and compromise less.[121] Furthermore, biennales tend to be more spatially expansive, spilling over from the boundaries of the museum into parts of the city that can be appropriated by various groups and publics and in any case are less tightly governed by boards and directors than any institutional spaces.

Today, large-scale international exhibitions constitute an important component in the kind of practices that are necessary for pluriversal canons. Biennales contribute to the establishment of pluriversal canons in several ways. First, the diversity of both their curators and the sites (often non-Western) of such exhibitions has produced important instances of resistance to the Western narrative.[122] Prominent examples include Gerardo Mosquera's curation of the first Havana Biennale (1984), which focused on Third World art, and the Dak'Art biennale in Dakar, oriented toward global and especially pan-African art.[123] Second, prominent curators of large-scale international exhibitions have themselves become "a new establishment that is beginning to feel its influence and to propose its own canon of artists."[124] If, for example, documenta 11 (2002) can be said to establish its own canon, under the leadership of its artistic director, Enwezor, then this canon indeed differs significantly from any Western canon of contemporary art, with about half of its artists based in the developing world or born outside of the West and many from countries never before represented in documenta.

Third, as Enwezor, Kapur and others have recognized, large-scale international exhibitions constitute global public spheres,[125] which in turn are instrumental to the development of a discourse that contributes to the formation of pluriversal canons. These international exhibitions have increasingly featured symposia, discussions, lectures and the like. In the case of Enwezor's documenta 11, the 2002 exhibition in Kassel was conceived as one of five platforms, the other four being conferences, lectures and discussions held in Vienna and Berlin, New Delhi, the West-Indian island of Saint Lucia and Lagos, Nigeria. The goal was to mount a global post-colonial event that reaches beyond Europe and creates a trans-national public sphere. As Enwezor states, he is interested in using "the exhibition space as this space of encounter, between many contending notions of artistic practice; as a space in which knowledge systems, aesthetic systems and artistic systems converge, sometimes in harmony and sometimes in great disharmony."[126] Terry Smith likewise stresses that the exhibition "actively seeks to stage the relationships, conjunctions, and disjunctions between different realities."[127] In staging such encounters, large-scale international exhibitions and the educational events and discourses that accompany them play an important role in facilitating global public spheres.

Fourth, biennales impact not only how we currently perceive art but also how we historicize it. Being at their core a global phenomenon, biennales influence the ways in which contemporary art is written about, prompting the writing of a global art history.[128] Moreover, our perception of global art history and of global canons is directly influenced by specific biennales that foreground alternative narratives to that of Western art. Okeke-Agulu observes that biennales like those held in Havana, Dakar, Johannesburg, Istanbul and Gwangju have shown the "impossibility of genealogical narratives that supposedly provided the most compelling accounts of art across time and cultures."[129] Therefore, the positions of artists in pluriversal canons would also be affected by their exhibition in biennales held in so-called peripheries.

For pluriversal canons to develop, then, art historians need to play an active and important role, as the task of envisioning these canons requires new and updated

practices of art history. In recent years, in an effort to conceive of a global art history, scholars have indeed explored new directions in the field, placing particular emphasis on cultural exchanges.[130] This task is pursued, for example, by art historians from India and China, who in the process are revising the history of the relationship between art in the West and in the East.[131] Scholars are also pursuing global art history by studying large-scale international exhibitions from the point of view of the global south, avoiding the constraints of a "Northern bias,"[132] exploring their regional and horizontal axes of dialogue and rethinking "complexities of trans-local relations."[133] Scholars in the fields of European art as well as in American art are also pursuing studies on cultural exchanges that reposition these fields within a global art history.[134]

Prominent characteristics of art history practices that promote pluriversal canons include the following: abandoning the view of Western art as the innovating center that influences peripheries in favor of an exploration of the rich ways in which art in "peripheries" draws on local traditions and reckons with culture-specific local concerns; moving beyond the "nation" as the primary unit of reference for art-historical analysis and the mono-cultural linear progressive narrative as its basic framework; instead, focusing on cross-cultural encounters and exchanges and performing comparative art history that emphasizes "contact zones" and reciprocal influences;[135] recognizing local canons and local value systems; studying the contribution of artists from previously excluded groups; practicing a "horizontal art history" that investigates "peripheries" and "centers" on an equal footing and investigates diverse peripheries comparatively, whether or not they have any direct connections with each other;[136] studying museums, exhibitions and biennales as a history of art that is not artist centered; studying biennales as genealogies of transcultural exchanges and as intersections of political theory, art and exhibition histories.[137]

To conclude: In an era defined to a large extent by globalization, the fields of art history and curatorship are clearly in transition. In this ongoing process, multiple complexities co-exist. The traditional canon is being destabilized in several current directions in art history and curatorial work (for example, in certain specialized temporary exhibitions and in large-scale international exhibitions; in new scholarly directions that focus on cultural exchanges across and within geographical areas), yet it persists in others (like the displays of permanent museum collections and mainstream art-historical survey books). At the same time, as traditional practices in art history persist, new directions focus on cultural encounters and exchanges among Western, Eastern, and Central Europe, the West and Africa, the West and the East, the South and North, as well as cultural exchanges on the same continent. These are revising a traditional Western linear narrative, building what might be called a global pluriversal art history. This work reflects an understanding that canons do not represent a single, fixed and immutable standard that applies to all art and cultures and are not free of the multiple interests that operate in the social, cultural, political, economic and geopolitical realms and within the professional fields in which canons are made, revised and potentially re-envisioned.

Counter-canons are also dynamically evolving in a pluriversal direction, as they are increasingly oriented toward a more inclusive mixing of underrepresented groups. (For example, a counter-canon of women artists is becoming global and diverse in terms of ethnicity, geography and sexuality; and a counter-canon of African American art increasingly includes more art by women and is in dialogue with Caribbean and Latin American art.)

To conceive of a single pluriversal canon would be to mimic the idea of the Western canon and remain beholden to many of its limitations. Thus, pluriversal canons can only exist in the plural. They are distinct from the recent so-called global art canon insofar as the latter is still primarily composed of male Western artists with more or less token additions of women artists, artists of color in the West and non-Western artists. Rasheed Araeen's argument for disentangling "multiculturalism from the idea of a culturally plural society" is useful in thinking about pluriversal global canons: in a plural society (as opposed to a multicultural society), "all [of society's] culturally different components are considered equal, not necessarily quantitatively but conceptually, so that they form a heterogeneous whole. This heterogeneous whole must then define the whole society, without the notion of majority and minority cultures."[138] Likewise, I propose here that pluriversal canons potentially form a heterogeneous global whole composed of equally valued and (following Mignolo) entangled cultures. No single coherent narrative encompasses this heterogeneous whole, nor can it be represented by one universal canon. Yet the definition and self-definition of each part in the heterogeneous whole includes a recognition of its valuable place within the whole during the processes of integration that characterize this whole in the era of globalization.

With pluriversal canons, we are no longer limited by a paradigm based on the political fiction of a "universal" canon. To become fully real, such canons will require more experimentation – artistic, scholarly and curatorial – and they will also benefit from further geopolitical changes. At the present point in time, they may still seem utopian to some, but as I tried to argue here, they are already in the process of formation.

★★★

This book comprises 12 specially commissioned essays based on case studies and three commissioned roundtable discussions about the art canon, grouped around three themes: (1) Artists, (2) "Mediums/Media" and (3) Exhibitions, Museums, Markets. These complement each other and address important areas in the field of art. The first part examines individual artists, because art history is still based to a very large extent on individual artists and their work despite critiques of the paradigm of the "singular genius" and the critiques of authorship initiated by Barthes and Foucault. The essays in this part examine the canonization of specific artists over the last several decades, including discussions of such issues as geopolitics, capitalism, race, gender, sexuality, the changing craft/high art divide and social media.

In her essay "Claude Cahun and Marcel Moore: Casualties of a Backfiring Canon?" Tirza Latimer demonstrates the canon's bias toward single authorship by examining the case of Cahun, the French female artist who was rediscovered posthumously during the 1980s and assimilated into the canon as a singular artist, whereas in fact, as Latimer argues, her oeuvre was the result of a creative collaboration with her partner, Marcel Moore. In "Jean-Michel Basquiat and the American Art Canon," Jordana Moore Saggese interrogates the relationship between international market appeal and critical acclaim by exploring the unique position of Jean-Michel Basquiat as a contemporary artist who enjoyed phenomenal success in the international art world yet whose success was marked by foregrounding race in the American context.

Elissa Auther's essay "Sheila Hicks and the Consecration of Fiber Art" examines the slow process of canonization of American artist Sheila Hicks in the context of an art world that dismissed fiber as a legitimate art medium up to the 1990s. Wenny Teo's "The Elephant in the Church: Ai Weiwei, the Media Circus and the Global Canon" examines Ai's canonization as well as his use of social media and argues that the nearly unparalleled status of the dissident Chinese artist in the contemporary global art canon reflects longstanding geopolitical anxieties and prejudices. Elizabeth Harney's "El Anatsui's Abstractions: Transformations, Analogies and the New Global" poses questions about the smooth assimilation of this Nigerian-based artist into the contemporary global art canon, asking whether his inclusion signals a significant shift in how art histories can be narrated or re-inscribes "governing fictions of 'otherness,' 'Africa' and 'modernity' into art world discourse."

The second part, "Mediums/media," tackles the canon's relationship with artistic mediums beyond the traditionally accepted mediums of painting and sculpture. Case studies in this section deal with TV/video art, performance art, street art and new media art. William Kaizen's "The Apotheosis of Video Art" traces the history of the canonization of video art, showing how technologies and techniques related to television became one of the art world's central concerns and discussing the theorization of the medium in relation to early video art and the later rise of the black-box gallery as the current signal form of video art in galleries around the world. In "Performance Art: Part of the Canon?" Jennie Klein traces the evolution of performance art from an alternative art form during the 1970s to a global art form that has been incorporated into many museum exhibitions, art fairs and biennales. She argues that still today, some performance art, namely the kind that takes place in non-art-world venues such as international festivals, continues to function outside of the art establishment and to aim at social change. Paula J. Birnbaum's "Street Art: Critique, Commodification, Canonization" compares the cases of the British and the American graffiti artists Banksy and Swoon, examining their distinct methods of engagement with museums and with the larger art-world economy. The essay analyzes the process of street art's entrance into the global art market and canon and asks whether commodification has become synonymous with canonization. The second part concludes with "New Media Art and Canonization," a conversation among Mark Daniels, director of New Media Scotland, in Edinburgh, Charlotte

Frost, an art historian of contemporary art based in Hong Kong, Axel Lapp, Director of the *Kunsthalle* in Memmingen, Germany, and Addie Wagenknecht, a new-media artist based at the F.A.T. Lab, New York. Led by Sarah Cook, a scholar and curator of new media, and Karin de Wild, an art history PhD candidate, both based in Dundee, Scotland, the discussion touches on a range of issues facing practitioners in the field of new media from the perspectives of artists, art historians, critics, and curators.

The third part, "Exhibitions, Museums, Markets," examines the institutional influence of exhibitions, museums and art markets on the art canon. Felix Vogel's essay "On the Canon of Exhibition History" analyzes the contemporary process of establishing a canon of exhibitions and of curators, exploring the parallels between the emergence of exhibition history and the rise of the exhibition as artistic medium and showing how both are related to issues of canonization. In "Canonizing Hitler's 'Degenerate Art' in Three American Exhibitions, 1939–1942," Jennifer McComas analyzes the process of the canonization of German Expressionism in exhibitions held in New York City and Boston. She discusses the ways in which museum curators and art dealers in the US have worked together to establish the political and aesthetic significance of German Expressionism after its demonization by the Nazi regime. Martha Buskirk's article "Museum Relations" discusses a range of political work by artists and argues that even while the contemporary art world has become more inclusive in certain respects and the contemporary canon has absorbed relational aesthetics and institutional critique, there are ongoing areas of tension and exclusion within an increasingly global network of museums and biennale-type exhibitions, especially when it comes to political work. In "The Commodification of the Contemporary Artist and High-Profile Solo Exhibition: The Case of Takashi Murakami," Ronit Milano argues that in the 21st century, not only art and artists are commodified but also the high-profile art exhibition as an entity in its own right and suggests that such exhibitions have become a political instrument in the hands of certain governments.

This third part concludes with two roundtable discussions that feature professionals from various areas of the art field and multiple geographic locations, representing a wide range of voices: "Troubling Canons: Curating and Exhibiting Women's and Feminist Art," a conversation led by art historian and curator Helena Reckitt and including the Berlin-based artists Pauline Boudry and Renate Lorenz, Edinburgh-based art historian Angela Dimitrakaki, London-based curator Kerryn Greenberg, Dakar-based curator and artistic director Koyo Kouoh, Paris-based curator Camille Morineau and Mirjam Westen, a curator based in Arnhem, the Netherlands; and "The Contemporary Art Canon and the Market," a conversation led by the Los Angeles and New York critic, editor and director of educational programs Jonathan T. D. Neil, with New York-based art critic Ben Davis and curator Alma Ruiz, Princeton-based art historian and curator Chika Okeke-Agulu, two sociologists of the art field, the San Francisco-based Sarah Thornton and Amsterdam-based Olav Velthuis.

Based as it is primarily on specific case studies, this volume cannot aim at completeness – of topics, artists or global diversity. I hope nonetheless that it will

make a contribution to contemporary discourse and stimulate interest among students and scholars of art history in integrating issues related to the consecration of artists and the formation of art canons into teaching and scholarship. The volume addresses issues of interest to curators and students in curatorial studies programs who would like to think about charting narratives that go beyond Eurocentrism and androcentrism in a globalizing world. Finally, the volume aims to contribute to the contemporary discourse in the fields of art criticism, art making, art history and museum and exhibition studies by exemplifying in concrete terms how practitioners in these fields are all active agents in the processes of forming, revising and re-envisioning canons.

Notes

1 Pierre Bourdieu, *The Field of Cultural Production*, ed. and intro. Randal Johnson (New York: Columbia University Press, 1993); Stefano Baia Curioni, Laura Forti, and Ludovica Leone, "Making Visible: Artists and Galleries in the Global System," *Cosmopolitan Canvases: The Globalization of Contemporary Markets for Contemporary Art*, Olav Velthuis and Curioni, eds. (Oxford: Oxford University Press, 2015), 55–77.

2 Andrea Rosen cited in Alexander Dumbadze and Suzanne Hudson, "Three Perspectives on the Market: Mihai Pop, Sylvia Kouvali, and Andrea Rosen," *Contemporary Art*, Dumbadze and Hudson, eds. *Contemporary Art: 1989 to the Present* (Chichster, West Sussex: Wiley-Blackwell, 2013), 379–87, at 386–87.

3 Tim Griffin cited in Hal Foster, "Contemporary Extracts," *e-flux Journal*, no. 12 (2010): 3.

4 For a critical discussion of the traditional art canon, see Gill Perry and Colin Cunningham, eds., *Academies, Museums and Canons of Art* (New Haven: Yale University Press and The Open University, 1999).

5 Anna Brzyski, ed., *Partisan Canons* (Durham: Duke University Press, 2007), 6.

6 Hal Foster, "Archives of Modern Art," *October* 99 (Winter, 2002): 81–95, at 81.

7 See Walter D. Mignolo, on coloniality, decoloniality, and a de-colonial epistemic shift, "Delinking," *Cultural Studies* 21, no. 2 (2007): 449–514.

8 Globalization includes integrated markets and a flow of capital and is defined as the "expansion, concentration, and acceleration of worldwide relations," Jürgen Osterhammel; Niels P. Petersson, *Globalization, A Short History*, trans. Dona Geyer (Princeton: Princeton University Press, 2005), 5.

9 It is thus not surprising that Edelson did not use the term "canon" when discussing this artwork, describing it rather as a critique of "organized religion cutting women out of positions of power and authority." Interview by the author with Mary Beth Edelson, New York, November 9, 2014.

10 Mary Beth Edelson, "Direct Access: Edelson Comments on the Last Supper," *The Art of Mary Beth Edelson* (New York: Seven Cycles, 2002), 33. Reflecting on this work recently, she said that at the time she was "considering political and practical implications of the selection" of artists featured in the central image. Edelson, correspondence with author, February 14, 2016.

11 Ibid.

12 Edelson, Interview by the author.

13 Barbara Rose, *American Art Since 1900: A Critical History* (New York: Praeger Publishers, 1972), 224–26, 146.

14 For example, Yoko Ono had her first solo exhibition at MoMA in 2015, and works by the African-American abstractionist Alma Thomas (who appears in the main scene) were first acquired by MoMA in 2015. Randy Kennedy, "Black Artists and the March into the Museum," *The New York Times*, November 28, 2015.

15 Cornelia Butler and Lisa Gabrielle Mark, eds., *WACK! Art and the Feminist Revolution, exh. cat.* (Los Angeles: Museum of Contemporary Art/Cambridge MA: MIT Press, 2007).

16 The exhibition was displayed in MoCA, Los Angeles, and traveled to the National Museum of Women in the Arts, Washington DC (September–December 2007); PS.1 Contemporary Art Center, Long Island City, New York (by then affiliated with MoMA) (February–May 2008); and Vancouver Art Gallery, Vancouver BC (October 2008–January 2009).

17 Orianna Cacchione, "To Enter Art History – Reading and Writing Art History in China during the Reform Era," *Journal of Art Historiography* 10 (June 2014): 1–22, at 14.

18 My thanks to Wenny Teo for clarifying this.

19 Cited in Fei Dawei, "Two-Minute Wash Cycle Huang Yong Ping's Chinese Period," *Walker Art Magazine*, October 1, 2005, Trans. Tzu-Wen Cheng, http://www.walkerart.org/magazine/2005/two-minute-wash-cycle.

20 Ibid.

21 Philippe Vergne and Doryun Chong, eds., *House of Oracles: A Huang Yong Ping Retrospective* (Minneapolis: Walker Art Center, 2005). See also Gao Minglu, *Total Modernity and the Avant-Garde in Twentieth-Century Chinese Art* (Cambridge, MA: MIT Press, 2011).

22 Bourdieu, *The Field*.

23 David Cast, *The Delight of Art: Giorgio Vasari and the Traditions of Humanist Discourse* (University Park, PA: Pennsylvania University Press, 2009).

24 Nannette Salomon, "The Art Historical Canon: Sins of Omission," repr. Donald Preziosi, *The Art of Art History* (Oxford: Oxford University Press, 1998), 344–355.

25 Edward L. Goldberg, *After Vasari: History, Art, and Patronage in Late Medici Florence* (Princeton, NJ: Princeton University Press, 1988), 8.

26 Vasari's 1568 expanded edition elaborated on the Medici ruler's patronage, making it a central motif. Ibid., 5.

27 Walter S. Melion, *Shaping the Netherlandish Canon: Karel van Mander's Schilder-Boeck* (Chicago: University of Chicago Press, 1991), 117.

28 Goldberg, *After Vasari*, xv. Competing accounts were published in Rome (Baglione 1642, Bellori, 1672), Venice (Ridolfi, 1648), Genoa (Soprani, 1674), and Bologna (Malvasia, 1678), Ibid., 10–14.

29 Cast, *Delight of Art*, 67–8.

30 On Vasari's travel and interviews, see Cast, *Delight of Art*, 77–9.

31 Geeta Kapur, "Curating in Heterogeneous Worlds," *Contemporary Art*, Dumbadze and Hudson, eds., 178–91, at 182. On inclusion, see Kobena Mercer "Introduction," *Cosmopolitan Modernisms*, Mercer, ed. (London: Institute of Contemporary Visual Arts/Cambridge, MA: MIT, 2005), 7–23, at 7–9.

32 Michael Camille, Zeynep Celik, John Onians, and Adrian Rifkin, "Rethinking the Canon," *Art Bulletin* 78, no. 2 (June 1996): 198–217.

33 Griselda Pollock, *Differencing the Canon: Feminist Desire and the Writing of Art Histories* (London: Routledge, 1999), 9. For analysis of the canon in the British context, see Perry and Cunningham, eds., *Academies*.

34 Pollock, *Differencing*, 9–10.

35 Okwui Enwezor, "Mega-Exhibitions and the Antinomies of Transnational Global Form," *The Biennial Reader*, Elena Filipovic, Marieke Van Hal, Solveig Øvstebø, eds. (Bergen, Norway: Kunsthalle/Ostfildern, Germany: Hatje Cantz Verlag, 2010), 426–45, at 428.

36 Russell Ferguson, "Can We Still Use the Canon?" *Art Journal* 58, no. 3 (Summer, 1999): 4.

37 Ibid.

38 Ibid.

39 Angela Dimitrakaki and Lara Perry, eds., "Constant Redistribution: A Roundtable on Feminism, Art and the Cultural Field," Angela Dimitrakaki and Lara Perry eds., *Journal of Curatorial Studies* 2, no. 2 (2013): 218–41, at 225.

40 Katrin Kivimaa, ibid., 226.

41 Lotte Philipsen, *Globalizing Contemporary Art* (Aarhus Denmark: Aarhus University Press, 2010), 37, 120–23. Philipsen's category of non-West includes Africa, Latin America, Asia (including Japan but not Australia) and East European nations, formerly part of USSR.

42 For a critique of uniformity in contemporary art and in Biennales and their reflecting the global neoliberal economy, see Julian Stallabrass, *Contemporary Art, A Very Short Introduction* (Oxford: Oxford University Press, 2006), Ch. 2.

43 Ferguson, "Can We," 4.

44 Massimiliano Gioni, "In Defense of Biennials," *Contemporary Art*, Dumbadze and Hudson, eds., 171–77, at 176.

45 Ibid. 172.

46 See, for example, the analysis of Anne Ring Petersen, "Identity Politics, Institutional Multiculturalism and the Global Artworld," *Third Text* 26, no. 2 (2012): 195–204.

47 Ibid.

48 Kennedy, "Black Artists."

49 Anthony Gardner and Charles Green, "Biennials of the South on the Edges of the Global," *Third Text* 27, no. 4 (2013): 442–55, at 453.

50 Gerardo Mosquera, "The Havana Biennial: A Concrete Utopia," *Biennial Reader*, Filipovic et al. eds., 198–207; Gardner and Green, "South as Method? Biennials Past and Present," in Making Biennials in Contemporary Times; Essays from the World Biennial Forum no. 2, São Paulo, 2014, Galit Eilat et al., eds. (Amsterdam and São Paulo: Biennial Foundation, Fundação Bienal de São Paulo and Instituto de Cultura Contemporânea, 2015), 28–36, at 28.

51 On Biennales, see also "Biennials Without Borders?" *Tate Papers*, no.12 (Autumn 2009), http://www.tate.org.uk/research/publications/tate-papers/12/biennials-without-borders; Gioni, "In Defense of Biennials," Kapur, "Curating," and Tim Griffin, "Worlds Apart: Contemporary Art, Globalization, and the Rise of Biennials," *Contemporary Art*, Dumbadze and Hudson, eds., *Contemporary Art: 1989 to the Present* (Chichster, West Sussex: Wiley-Blackwell, 2013), 171–77, 178–191, 7–16.

52 For example, Peter Schjeldahl, "Festivalism," *The New Yorker*, July 5, 1999: 85–86; Stallabrass, *Contemporary Art*.

53 Gardner and Green, "Biennials of the South;" Enwezor, "Mega-Exhibitions."

54 Interview with Marieke van Hal, *Contemporary and, Platform for International Art from African Perspectives*, February 12, 2015, http://www.biennialfoundation.org/2015/02/interview.

55 Gardner and Green, *Biennials, Triennials, Documenta: The Exhibitions that created Contemporary Art* (Chichester, UK: Wiley-Blackwell, 2016).

56 Ibid., Filipovic et al., "Biennialogy," 20.

57 Reesa Greenberg, Bruce W. Ferguson and Sandy Narine, "Introduction," in *Thinking about Exhibitions*, idem eds. (London: Routledge, 1996), 2.

58 Enwezor, "Mega-Exhibitions," 157.

59 Peter H. Lindert, Jeffrey G. Williamson, "Does Globalization Make the World More Unequal?" *Globalization in Historical Perspective*. Michael D. Bordo, Alan M. Taylor and Jeffrey G. Williamson, eds. (Chicago: University of Chicago Press, 2003), 227–71, see esp. 263–64.

60 On the global art market, see Olav Velthuis, "Globalization and Commercialization of the Art Market," *Contemporary Art*, Dumbadze and Hudson eds., 369–78; Jonathan Harris, "Gatekeepers, Poachers and Pests in the Globalized Contemporary Art World System," *Third Text* 27, no. 4 (2013): 536–48.

61 Claire McAndrews, TEFAF Art Market Report, 2014, https://news.artnet.com/art-world/2015-tefaf-art-market-report-key-findings-275328

62 Velthuis, "Globalization," *Contemporary Art*, Dumbadze and Hudson, eds., 369–78, at 372–73.

63 Velthuis, ibid., 372. Mukti Khaire, "Art without Borders? Online Firms and the Global Art Market," *Cosmopolitan Canvases*, Velthuis and Curioni, eds., 102–128, see also 19–20.

64 The online market is dominated by "the middle market," sales between $1,000 and $50,000. McAndrews TEFAF Art Market Report, 2014.

65 India, Brazil, Turkey, Russia, Mexico and many other countries, account together for 6% of the global art market. Figures are by TEFAF, reproduced in *Cosmopolitan Canvases*, 16, see discussion and Figure 1.2 Global art market share percent by value (2013), ibid. On canons and China see, Francesca Dal Lago, "The 'Global' Contemporary Art Canon and the Case of China," in *ARTMargins* 3, no 3 (October 2014): 77–97.

66 McAndrews TEFAF Art Market Report, 2014,

67 Curioni, Forti, and Leone, "Making Visible," 61.

68 For statistics on the exhibition of women artists in Western museums and galleries, see Maura Reilly, "Taking the Measure of Sexism: Facts, Figures and Fixes," *Art News*, June 2015, http://www.artnews.com/2015/05/26/taking-the-measure-of-sexism-facts-figures-and-fixes/

69 Velthuis and Curioni, "Making Markets Global," *Cosmopolitan Canvases*, Velthuis and Curioni, eds., 1–28, at 9.

70 Ibid., 23.

71 According to the recent *Kunstkompass* (Art Compass) ranking of the top 100 contemporary artists worldwide, the 10 highest-selling contemporary artists include 3 from the US, 1 from South Africa and 6 from Europe; 3 of the 10 are women. Will Bongard has been compiling this ranking since 1970, based on 200 major international museums and institutions, 120 most important group exhibitions worldwide (such as the Venice Biennale), reviews and coverage in the international specialist press and acquisitions by museum collections. The list is published by *Weltkunst* of the German publishing house *Zeitkunsverlag*, since 1970. http://www.blouinartinfo.com/news/story/1122460/gerhard-richter-leads-kunstkompass-ranking-for-top-100. For *Kunstkompass* rankings of 2014 and 2015, see https://de.wikipedia.org/wiki/Kunstkompass#Kunstkompass_2014_und_2015

72 On the political dimensions of the shifting of the art center from Europe to the US, see Eva Cockcroft, "Abstract Expressionism, Weapon of the Cold War," *Artforum* 12, no. 10 (June 1974): 39–41, repr. in Francis Francina, ed., *Pollock and After: The Critical Debate* (London: Harper & Row, 1985), 125–33; Serge Guilbaut, *How New York Stole the Idea of Modern Art: Abstract Expressionism, Freedom, and the Cold War* (Chicago: Chicago University Press, 1983).

73 For a quantitative analysis of illustrations in textbooks as reflecting the changing status of 19th-century artists in the canon, see Robert Jensen, "Measuring Canons: Reflections on Innovation and the Nineteenth-Century Canon of European Art," *Partisan Canons*, Brzyski, ed., 27–54. For a discussion of art history survey courses in the US, see the *Art Journal* (October 1995). For an analysis of the various editions of Janson's *The History of Art*, 1962 to 1995, see Robert S. Nelson, "The Map of Art History," *Art Bulletin* 79, no. 1 (March 1997): 28–40.

74 Hal Foster, Rosalind Krauss, Yve-Alain Bois, and Benjamin Buchloh, *Art Since 1900: Modernism, Antimodernism, Postmodernism* (London: Thames and Hudson, 2004).

75 Partha Mitter, "Interventions: Decentering Modernism: Art History and Avant-Garde Art from the Periphery," *Art Bulletin* 90, no. 4 (December 2008): 531–48.

76 Chika Okeke-Agulu, "Globalization, Art History, and the Specter of Difference," *Contemporary Art*, Dumbadze and Hudson, eds., 447–56, at 447.

77 Steven Nelson, "Turning Green into Black: Or How I Learned to Live with the Canon," *Making Art History, A Changing Discipline and its Institutions*, Elizabeth C. Mansfield, ed. (London: Routledge, 2007), 54–63, at 55.

78 Kymberly N. Pinder, "Black Representation and Western Survey Textbooks, *Art Bulletin* 81, no. 3 (September 1999): 533–38.

79 Kobena Mercer, "Black Art and the Burden of Representation," *Welcome to the Jungle: New Positions in Black Cultural Studies* (New York: Routledge, 1994), 250.

80 Nelson, "Turning Green," 56.

81 Ibid.

82 Reilly, "Taking the Measure."

83 *Multiple Modernities, 1905–1970*, exh. cat., Catherine Grenier, ed. (Paris: Centre Pompidou, 2014).

84 Grenier, "An Upside-Down World?" *Multiple Modernities*, 15–31, at 15.

85 Ibid.

86 Alfred Pacquement, "Preface," *Multiple Modernities*, 13.

87 Alain Seban, "Forward," *Multiple Modernities*, 11.

88 By contrast, major exhibitions of art by women have attempted to correct the Eurocentric bias: 50% of the artists in *WACK!* were from outside the US, and 50% of the artists in *Global Feminisms*, curated by Linda Nochlin and Maura Reilly at the Brooklyn Museum in 2007, were from non-Western countries. Helena Reckitt, "Unusual Suspects: Global Feminisms and WACK! Art and the Feminist Revolution," *n. paradoxa* 18 (2006): 34, 37.

89 Chantal Mouffe, "Artistic Activism and Agonistic Spaces," *Art & Research, A Journal of Ideas, Contexts and Methods* 1, no, 2 (Summer 2007), http://www.artandresearch.org.uk/v1n2/mouffe.html.

90 Ibid; Mouffe, *Hegemony, Radical Democracy, and the Political*, ed. James Martin (London: Routledge, 2013), 6.

91 Mouffe, "Art as an Agnostic intervention in Public Space," in *Art and Democracy*, Open, no. 14, *Art as a Public Issue*, (2008): 6–15, at 12. For Mouffe's discussion of exclusion from political order, see "Artistic Activism."

92 Mouffe, "Deliberative Democracy or Agonistic Pluralism," Political Science Series, Institute for Advanced Studies, Vienna (December 2000), 1–17, at 17.

93 Bourdieu, *The Field*, 188.

94 Eugenie Tsai, ed., *Kehinde Wiley: A New Republic* (New York: Brooklyn Museum, 2015), exb. cat., February 20-May 24, 2015.

95 Susan Gubar, *Critical Condition: Feminism in the Turn of the Century* (New York: Columbia University Press, 2000), 39. On the French Collection, see Dan Cameron, et al., *Faith Ringgold's French Collection and Other Story Quilts*, exh. cat. (New York: New Museum of Contemporary Art, 1998).

96 Faith Ringgold, "Chronology," http://www.faithringgold.com/ringgold/chron_rev.pdf

97 Connie H. Choi, "Kehinde Wiley: The Artist and Interpretation," *Kehinde Wiley: A New Republic*, Eugenie Tsai, ed. New York: Brooklyn Museum, in association with Prestel, Munich, 2015, 20–36, at 20.

98 Eugenie Tsai, "Introduction," *Kehinde Wiley*, 19.

99 African-American artist Robert Colescott's *George Washington Carver Crossing the Delaware: Page from an American History Textbook*, 1975, also appropriates a canonical painting and populates it with black figures, but the latter are represented through demeaning historical caricatures of black people. On Colescott, see Ellen Wiley Todd, "Two Georges and Us: Multiple Perspectives on the Image," *American Art* 17, no. 2 (Summer 2003): 13–17.

100 *Sexual Politics: Judy Chicago's Dinner Party in Feminist Art History*, Amelia Jones, ed. (UCLA, Los Angeles: Armand Hammer Museum of Art and Cultural Center, 1996), 108.

101 See Jones for an in-depth analysis of the reception of *The Dinner Party*, "The 'Sexual Politics' of *The Dinner Party: A Critical Context*," *Sexual Politics*, 82–118.

102 *The Dinner Party* was also exhibited in two museums before entering the Brooklyn Museum, the San Francisco Museum of Art in 1979 and the Hammer Museum, Los Angeles, in 1996.

103 On Wilke's oeuvre, see Nancy Princenthal, *Hannah Wilke* (Munich: Prestel, 2010).

104 Cacchione, "To Enter Art History."

105 Ibid., 4.

106 Ibid., 17–19.

107 Zhuan Huang, "Who Is Going to Sponsor the History?" originally published as "Shei lai zanzhu lishi," in *Yishu ★ Shichang*, no. 6 (September 1991), translated by Peggy Wang,

Contemporary Chinese Art: Primary Documents, Wu Hung, ed. (New York: The Museum of Modern Art, 2010), 292, cited by Cacchione, ibid., 18.

108 Donald Kuspit, *Daughter of Art History: Photographs by Yasumasa Morimura* (New York: Aperture, 2003), 113.

109 See also the discussion of Basquiat's appropriation of the *Mona Lisa* in Jordana Moore Saggese's chapter in this volume (Chapter 2).

110 Perry and Cunningham, eds., *Academies*, 12; Pollock, *Differencing*, 3.

111 Mignolo, "On Pluriversality," http://waltermignolo.com/on-pluriversality/; Mignolo, "Delinking," 497–98; Mignolo, *The Darker Side of Western Modernity: Global Futures, Decolonial Options (Latin America Otherwise)* (Durham: Duke University Press, 2011).

112 Mignolo, "Delinking," 497.

113 Ibid., 498.

114 Mignolo, "On Pluriversality."

115 Mignolo "Delinking," 498.

116 Bonami, cited in Griffin, "Worlds Apart," *Contemporary Art*, Dumbadze and Hudson eds., 12.

117 Kapur, "Curating," 184.

118 For example, the Stedelijk exhibition "How Far How Near – The World," curated by Jelle Bouwhuis and Kerstin Winking as part of the three-year project "Global Collaborations" (2013–15); The Tate Britain's "Tate Encounters: Britishness and Visual Culture," a three-year project (2007–10), created in response to the museum's difficulty in implementing the government-led cultural diversity policy, requiring attendance of minority audiences. See Victoria Walsh, "Tate Britain: Curating Britishness and Cultural Diversity," *Tate Encounters [E]dition 2* (February, 2008), http://www2.tate.org.uk/tate-encounters/edition-2/TateEncounters2_VictoriaWalsh.pdf; Andrew Dewdney, David Dibosa, Victoria Walsh, *Post-Critical Museology: Theory and Practice* (London: Routledge, 2013).

119 Enwezor, "Mega-Exhibitions," 433.

120 Gioni, "In Defense of Biennials," *Contemporary Art*, Dumbadze and Hudson, eds., 171,

121 Ibid., 173, 177.

122 Ranjit Hoskote, "Biennials of Resistance: Reflections on the Seventh Gwangju Biennial," *Biennial* Reader, Filipovic et al., eds., 306–21.

123 See Gerardo Mosquera, "The Havana Biennial;" Yacouba Konaté, "The Invention of the Dakar Biennial," *Biennial Reader*, Filipovic et al. eds., 104–21; Ugochukwu-Smooth C. Nzewi, "Curating Africa, Curating the Contemporary: The Pan-African Model of Dak'Art Biennial," *SAVVY: Journal of contemporary African Art*, no. 4 (November 2012): 40–50.

124 Adam Shatz, "His Really Big Show," *New York Times*, June 2, 2002, http://www.nytimes.com/2002/06/02/magazine/his-really-big-show.html?pagewanted=all

125 Kapur, "Curating," 184; Enwezor, "Mega-Exhibitions," 433; Jim McGuigan, "The Cultural Public Sphere," *European Journal of Cultural Studies* 8, no. 4 (2005): 427–43. Nikos Papastegiadis and Meredith Martin, "Art Biennales and Cities as Platforms for Global Dialogue," *Festivals and the Cultural Public Sphere*, Liana Giorgi, Monica Sassatelli and Gerard Delanty (London: Routledge, 2011).

126 Victoria Lynn, interview, "Okwui Enwezor: A Space of Encounter," *Art & Australia*, July 2008, http://www.artandaustralia.com/news/interview/from-the-archives-okwui-enwezor-a-space-of-encounter

127 Smith, "Contemporary Art and Contemporaneity," *Critical Inquiry* 32, no. 4 (Summer 2006): 681–707, at 694.

128 Filipovic, van Hal and Øvstebø "Biennialogy," *Biennial Reader*, Filipovic et al. eds., 22. See John Clark, "Biennials as Structures for the Writing of Art History: The Asian Perspective," *Biennial Reader*, 164–83.

129 Okeke-Agulu, "Globalization," 453.

130 For debates on globalization, art and the contemporary art world, see, for example, James Elkins, ed., *Is Art History Global?* (London: Routledge, 2007); Hans Belting and

Andrea Buddensieg, eds., The Global Art World: Audiences, Markets, and Museums (Ostfildern, Germany: Hatje Cantz, 2009); Terry Smith, *What Is Contemporary Art?* (Chicago: University of Chicago Press, 2009); Enwezor, "Mega-Exhibitions," Filipovic et al. eds., *Biennial Reader*, 426–45; Jonathan Harris, ed., *Globalization and Contemporary Art*, (Chichester: Wiley-Blackwell, 2011).

131 Partha Mitter, "Frameworks for Considering Cultural Exchange: The Case of India and America," Cynthia Mills, Lee Glazer, and Amelia A. Goerlitz, eds., *East-West Interchanges in American Art – A Long A Tumultuous Relationship*, Washington, DC: Smithsonian Institution Scholarly Press, 2011; Cacchione, "To Enter Art History," 1–4; Guo Hui, "Canonization in Early Twentieth-Century Chinese Art History," *Journal of Art Historiography* 10 (June 2014): 1–16.

132 Gardner and Green, "Biennials of the South."

133 Gardner and Green, "South as Method," 29.

134 *Internationalizing the History of American Art*, Barbara S. Groseclose and Jochen Wierich, eds. (University Park, PA: Pennsylvania State University Press, 2009). Paul Wood's *Western Art and the Wider World* (Chichester, UK: Wiley Blackwell, 2014) focuses on episodes of cross-cultural dialogue, stopping short of questioning the Western canon of art but does recognize that the canon should not be set up as a standard for judging other cultures. See also James Elkins, Zhivka Valiavicharska and Alice Kim, eds., *Art and Globalization* (University Park, PA: Pennsylvania State University Press, 2010).

135 Okeke-Agulu, "Globalization," 453–54.

136 Piotr Piotrowski, "Towards a Horizontal Art History," *Writing Central European Art History, Patterns – Travelling Lecture Set*, 2008/09, ERSTE Foundation, Reader no. 01, (2008/09): 4, http://www.erstestiftung.org/patterns-travelling/content/imgs_h/Reader.pdf; Richard Kosinsky, Jan Elantkowski, Barbara Dudás (Lublin) "A Way to Follow: Interview with Piotr Piotrowski," *ArtMargins* (January 2015): n.p. http://www.artmargins.com/index.php/5-interviews/758-a-way-to-follow-interview-with-piotr-piotrowski

137 Gardner and Green, *Biennials*.

138 Rasheed Araeen, "A New Beginning," *Third Text* 14, no. 50 (2000): 3–20, at 16.

Bibliography

Araeen, Rasheed. "A New Beginning," *Third Text* 14, no. 50 (2000): 3–20.

Belting, Hans and Andrea Buddensieg, eds. *The Global Art World: Audiences, Markets, and Museums*. Ostfildern, Germany: Hatje Cantz Verlag, 2009.

"Biennials Without Borders?" *Tate Papers*, no.12 (Autumn 2009). http://www.tate.org.uk/research/publications/tate-papers/12/biennials-without-borders

Bourdieu, Pierre. *The Field of Cultural Production*, ed. and intro. Randal Johnson. New York: Columbia University Press, 1993.

Brzyski, Anna, ed. *Partisan Canons*. Durham: Duke University Press, 2007.

Butler, Cornelia and Lisa Gabrielle Mark, eds. *WACK! Art and the Feminist Revolution*, exh. cat. Los Angeles: Museum of Contemporary Art/Cambridge MA: MIT Press, 2007.

Cacchione, Orianna. "To Enter Art History – Reading and Writing Art History in China during the Reform Era," *Journal of Art Historiography* 10 (June 2014): 1–22.

Cameron, Dan, Richard J. Powell, Michelle Wallace, Patrick Hill, Thalia Gouma-Peterson, Moira Roth, and Ann Gibson. *Faith Ringgold's French Collection and Other Story Quilts*, exh. cat. New York: New Museum of Contemporary Art, 1998.

Camille, Michael, Zeynep Celik, John Onians, and Adrian Rifkin. "Rethinking the Canon," *Art Bulletin* 78, no. 2 (June 1996): 198–217.

Cast, David. *The Delight of Art: Giorgio Vasari and the Traditions of Humanist Discourse*. University Park, PA: Pennsylvania State University Press, 2009.

Choi, Connie H. "Kehinde Wiley: The Artist and Interpretation," *Kehinde Wiley: A New Republic*, Eugenie Tsai, ed. New York: Brooklyn Museum, in association with Prestel, Munich, 2015, 20–36.

Clark, John. "Biennials as Structures for the Writing of Art History: The Asian Perspective," *Biennial Reader*, vol. 1, 2010, 164–83.

Cockcroft, Eva. "Abstract Expressionism, Weapon of the Cold War," *Artforum* 12, no. 10 (June 1974): 39–41.

Curioni, Stefano, Baia, Laura Forti, and Ludovica Leone. "Making Visible: Artists and Galleries in the Global System," *Cosmopolitan Canvases*, Velthuis and Curioni, eds., 55–77.

Dewdney, Andrew, David Dibosa, and Victoria Walsh. *Post-Critical Museology: Theory and Practice*. London: Routledge, 2013.

Dimitrakaki, Angela and Lara Perry, eds. "Constant Redistribution: A Roundtable on Feminism, Art and the Cultural Field," *Journal of Curatorial Studies* 2, no. 2 (2013): 218–241.

Dumbadze, Alexander and Suzanne Hudson, eds. *Contemporary Art: 1989 to the Present*. Chichster, West Sussex: Wiley-Blackwell, 2013.

———— "Three Perspectives on the Market: Mihai Pop, Sylvia Kouvali, and Andrea Rosen," *Contemporary Art: 1989 to the Present*, Dumbadze and Hudson, eds., Chichester, UK: Wiley-Blackwell, 2013, 379–87.

Edelson, Mary Beth. "Direct Access: Edelson Comments on the Last Supper," *The Art of Mary Beth Edelson*. New York: Seven Cycles, 2002, 32e.

Elkins, James, Zhivka Valiavicharska, and Alice Kim, eds. *Art and Globalization*. University Park, PA: Pennsylvania State University Press, 2010.

Enwezor, Okwui. "Mega-Exhibitions and the Antinomies of Transnational Global Form," *The Biennial Reader*, Filipovic et al. eds., 426–445.

Fei, Dawei. "Two-Minute Wash Cycle Huang Yong Ping's Chinese Period," *Walker Art Magazine* (October 1, 2005), trans. Tzu-Wen Cheng. http://www.walkerart.org/maga zine/2005/two-minute-wash-cycle.

Ferguson, Russell. "Can We Still Use the Canon?" *Art Journal* 58, no. 2 (Summer 1999): 4.

Filipovic, Elena, Marieke Van Hal, Solveig Øvstebø, "Biennialogy," *The Biennial Reader*, Filipovic, Elena, Marieke Van Hal, Solveig Øvstebø, Bergen, Norway: Kunsthalle/ Ostfildern, Germany: Hatje Cantz Verlag, 2010, 13–27.

Foster, Hal. "Archives of Modern Art," *October* 99 (Winter 2002): 81–95.

———. "Contemporary Extracts," *e-flux Journal*, no. 12 (2010): 3

Foster, Hal, Rosalind Krauss, Yve-Alain Bois, and Benjamin Buchloh. *Art Since 1900: Modernism, Antimodernism, Postmodernism*. London: Thames and Hudson, 2004.

Francis Francina, ed. *Pollock and After: The Critical Debate*. London: Harper & Row, 1985.

Gardner, Anthony and Charles Green, "Biennials of the South on the Edges of the Global," *Third Text* 27, no. 4 (2013): 442–455.

———. "South as Method? Biennials Past and Present," *Making Biennials in Contemporary Times; Essays from the World Biennial Forum no. 2, São Paulo, 2014*, Galit Eilat, Nuria Enguita Mayo, Charles Esche, Pablo Lafuente, Luiza Proença, Oren Sagiv and Benjamin Seroussi, eds., 28–36. Amsterdam and São Paulo: Biennial Foundation, Fundação Bienal de São Paulo and Instituto de Cultura Contemporânea, 2015.

———. *Biennials, Triennials, Documenta: The Exhibitions That Created Contemporary Art*. Chichester, UK: Wiley-Blackwell, 2016.

Gioni, Massimiliano. "In Defense of Biennials," *Contemporary Art*, Dumbadze and Hudson, eds., 171–177.

Goldberg, Edward L. *After Vasari: History, Art, and Patronage in Late Medici Florence*. Princeton, NJ: Princeton University Press, 1988.

Greenberg, Reesa, Bruce W. Ferguson, and Sandy Narine, eds. *Thinking about Exhibitions*. London: Routledge, 1996.

Grenier, Catherine. "An Upside-Down World?" *Multiple Modernities, 1905–1970*. Grenier, ed., 15–31. Exh. cat., Paris: Centre Pompidou, 2014.

Griffin, Tim. "Worlds Apart: Contemporary Art, Globalization, and the Rise of Biennales," *Contemporary Art*, Dumbadze and Hudson, eds., 7–16.

Griffin, Tim and Hal Foster, "Contemporary Extracts," *e-flux Journal*, no. 12 (2010): 3.

Gubar, Susan. *Critical Condition: Feminism in the Turn of the Century*. New York: Columbia University Press, 2000.

Groseclose Barbara S. and Jochen Wierich, eds. *Internationalizing the History of American* Art. University Park, PA: Pennsylvania State University Press, 2009.

Guilbaut, Serge. *How New York Stole the Idea of Modern Art: Abstract Expressionism, Freedom, and the Cold War*. Chicago: University of Chicago Press, 1983.

Harris, Jonathan, ed. *Globalization and Contemporary Art*. Chichester, UK: Wiley-Blackwell, 2011.

Hoskote, Ranjit. "Biennials of Resistance: Reflections on the Seventh Gwangju Biennial," *Biennial Reader*, Filipovic et al., eds., 306–321.

Huang, Zhuan. "Who Is Going to Sponsor the History?" translated by Peggy Wang, *Contemporary Chinese Art: Primary Documents*, Wu Hung, ed., 292. New York: The Museum of Modern Art, 2010.

Hui, Guo. "Canonization in Early Twentieth-Century Chinese Art History," *Journal of Art Historiography* 10 (June 2014): 1–16.

Jones, Amelia. "The 'Sexual Politics' of *The Dinner Party: A Critical Context*," *Sexual Politics: Judy Chicago's Dinner Party in Feminist Art History*, UCLA, Jones ed., 82–118. Los Angeles: Armand Hammer Museum of Art and Cultural Center, 1996.

Jensen, Robert. "Measuring Canons: Reflections on Innovation and the Nineteenth-Century Canon of European Art," *Partisan Canons*, Brzyski, ed., 27–54.

Kapur, Geeta. "Curating in Heterogeneous Worlds," *Contemporary Art*, Dumbadze and Hudson, eds., 178–191.

Kennedy, Randy. "Black Artists and the March into the Museum," *New York Times* (November 28, 2015).

Khaire, Mukti. "Art without Borders? Online Firms and the Global Art Market," *Cosmopolitan Canvases*, Velthius and Curioni, eds., 102–128.

Kosinsky, Richard, Jan Elantkowski, and Barbara Dudás (Lublin). "A Way to Follow: Interview with Piotr Piotrowski," *ArtMargins* (January 2015): n.p. http://www.artmargins.com/inde// x.php/interviews-sp-837925570/758-a-way-to-follow-interview-with-piotr-piotrowski

Kuspit, Donald. *Daughter of Art History: Photographs by Yasumasa Morimura*. New York: Aperture, 2003.

Lago, Francesca Dal. "The 'Global' Contemporary Art Canon and the Case of China," *ART-Margins* 3, no. 3 (October 2014): 77–97.

Lindert, Peter H. and Jeffrey G. Williamson. "Does Globalization Make the World More Unequal?" *Globalization in Historical Perspective*, Michael D. Bordo, Alan M. Taylor and Jeffrey G. Williamson, eds., 227–71. Chicago: University of Chicago Press, 2003.

Lynn, Victoria. Interview, "Okwui Enwezor: A Space of Encounter," *Art & Australia*, July 2008. http://www.artandaustralia.com/news/interview/from-the-archives-okwui-enwezor-a-space-of-encounter

McGuigan, Jim. "The Cultural Public Sphere," *European Journal of Cultural Studies* 8, no. 4 (2005): 427–43.

Melion, Walter S. *Shaping the Netherlandish Canon: Karel van Mander's Schilder-Boeck*. Chicago: University of Chicago Press, 1991.

Mercer, Kobena. "Black Art and the Burden of Representation," *Welcome to the Jungle: New Positions in Black Cultural Studies*, 233–258. New York: Routledge, 1994.

———. "Introduction," *Cosmopolitan Modernisms*, Mercer, ed., 7–23. London: Institute of Contemporary Visual Arts/Cambridge, MA: MIT, 2005.

Mignolo, Walter D. "Delinking," *Cultural Studies* 21, no. 2 (2007): 449–514.

———. "On Pluriversality," http://waltermignolo.com/on-pluriversality/.

Mitter, Partha. "Interventions: Decentering Modernism: Art History and Avant-Garde Art from the Periphery," *Art Bulletin* 90, no. 4 (December 2008): 531–548.

———. "Frameworks for Considering Cultural Exchange: The Case of India and America," *East-West Interchanges in American Art – A Long A Tumultuous Relationship*, Cynthia Mills, Lee Glazer, and Amelia A. Goerlitz, eds., Washington, DC: Smithsonian Institution Scholarly Press, 2011

Mosquera, Gerardo. "The Havana Biennial: A Concrete Utopia," *Biennial Reader*, Filipovic et al., eds., 198–207.

Mouffe, Chantal. "Deliberative Democracy or Agonistic Pluralism," *Political Science Series, Institute for Advanced Studies, Vienna* (December 2000): 1–17.

———. "Artistic Activism and Agonistic Spaces," *Art & Research, A Journal of Ideas, Contexts and Methods* 1, no. 2 (Summer 2007). http://www.artandresearch.org.uk/v1n2/mouffe.html.

———. "Art as an Agnostic Intervention in Public Space," *Art and Democracy, Open*, no. 14, *Art as a Public Issue*, (2008): 6–15.

———. *Hegemony, Radical Democracy, and the Political*, ed. James Martin. London: Routledge, 2013.

Nelson, Robert S. "The Map of Art History," *Art Bulletin* 79, no. 1 (March 1997): 28–40.

Nelson, Steven. "Turning Green into Black: Or How I Learned to Live with the Canon," *Making Art History, a Changing Discipline and Its Institutions*, Elizabeth C. Mansfield, ed., 54–63. London: Routledge, 2007.

Nzewi, Ugochukwu-Smooth C. "Curating Africa, Curating the Contemporary: The Pan-African Model of Dak'Art Biennial," *SAVVY: Journal of Contemporary African Art*, no. 4 (November 2012): 40–50.

Okeke-Agulu, Chika. "Globalization, Art History, and the Specter of Difference," *Contemporary Art*, Dumbadze and Hudson, eds., 447–456.

Papastegiadis, Nikos and Meredith Martin. "Art Biennales and Cities as Platforms for Global Dialogue," *Festivals and the Cultural Public Sphere*, Liana Giorgi, Monica Sassatelli and Gerard Delanty, eds. London: Routledge, 2011, 45–62.

Perry, Gill and Colin Cunningham, eds. *Academies, Museums and Canons of Art*. New Haven: Yale University Press and The Open University, 1999.

Petersen, Anne Ring. "Identity Politics, Institutional Multiculturalism and the Global Artworld," *Third Text* 26, no. 2 (2012): 195–204.

Petersson, Niels P. *Globalization, A Short History*, trans. Dona Geyer. Princeton: Princeton University Press, 2005.

Philipsen, Lotte. *Globalizing Contemporary Art*. Aarhus Denmark: Aarhus University Press, 2010.

Pinder, Kymberly N. "Black Representation and Western Survey Textbooks," *Art Bulletin* 81, no. 3 (September 1999): 533–538.

Piotrowski, Piotr. "Towards a Horizontal Art History," *Writing Central European Art History, Patterns – Travelling Lecture Set*, 2008/09, ERSTE Foundation, Reader no. 01 (2008/09): 4. http://www.erstestiftung.org/patterns-travelling/content/imgs_h/Reader.pdf.

Pollock, Griselda. *Differencing the Canon: Feminist Desire and the Writing of Art Histories*. London: Routledge, 1999.

Princenthal, Nancy. *Hannah Wilke*. Munich: Prestel, 2010.

Reckitt, Helena. "Unusual Suspects: Global Feminisms and WACK! Art and the Feminist Revolution," *n. paradoxa* 18 (2006): 34, 37.

Reilly, Maura. "Taking the Measure of Sexism: Facts, Figures and Fixes," *Art News* (June 2015). http://www.artnews.com/2015/05/26/taking-the-measure-of-sexism-facts-figures-and-fixes/.

Rose, Barbara. *American Art Since 1900: A Critical History*. New York: Praeger Publishers, 1972.

Salomon, Nannette. "The Art Historical Canon: Sins of Omission," in *The Art of Art History*, repr. Donald Preziosi, ed. 344–355. Oxford: Oxford University Press, 1998.

Schjeldahl, Peter. "Festivalism," *The New Yorker*, July 5, 1999: 85–86.

Seban, Alain. "Forward," *Multiple Modernities*, Grenier, ed., 10–11.

Shatz, Adam. "His Really Big Show," *New York Times* (June 2, 2002). http://www.nytimes.com/2002/06/02/magazine/his-really-big-show.html?pagewanted=all

Smith, Terry. "Contemporary Art and Contemporaneity," *Critical Inquiry* 32, no. 4 (Summer 2006): 681–707.

———. *What Is Contemporary Art?* Chicago: University of Chicago Press, 2009.

Stallabrass, Julian. *Contemporary Art, a Very Short Introduction*. Oxford: Oxford University Press, 2006.

Todd, Ellen Wiley. "Two Georges and Us: Multiple Perspectives on the Image," *American Art* 17, no. 2 (Summer 2003): 13–17.

Tsai, Eugenie, ed. *Kehinde Wiley: A New Republic*. Exh. cat. New York: Brooklyn Museum, 2015.

Van Hal, Marieke, interview, Biennial Foundation, *Contemporary and, Platform for International Art from African Perspectives* (February 12, 2015). http://www.biennialfoundation.org/2015/02/interview.

Velthuis, Olav. "Globalization and Commercialization of the Art Market," *Contemporary Art*, Dumbadze and Hudson eds., 369–378.

Velthuis, Olav and Stefano Baia Curioni, eds. *Cosmopolitan Canvases: The Globalization of Contemporary Markets for Contemporary Art*. Oxford: Oxford University Press, 2015,

Velthuis, Olav and Stefano Baia Curioni. "Making Markets Global," *Cosmopolitan Canvases*, idem, eds., 1–28.

Vergne, Philippe and Doryun Chong, eds. *House of Oracles: A Huang Yong Ping Retrospective* (Minneapolis: Walker Art Center, 2005).

Walsh, Victoria. "Tate Britain: Curating Britishness and Cultural Diversity," *Tate Encounters [E]dition 2* (February 2008). http://www2.tate.org.uk/tate-encounters/edition-2/TateEncounters2_VictoriaWalsh.pdf

Wood, Paul. *Western Art and the Wider World*. Chichester, UK: Wiley Blackwell, 2014.

PART I

Artists

Part I: Artists

The first part of the volume focuses on case studies of the canonization processes of artists, since the individual artist continues to occupy a central place in the art field, despite the significant influence of critiques by Roland Barthes ("The Death of the Author") and Michel Foucault ("What Is an Author?"), which advocated shifting focus from the individual author to the reader and to the "author function" respectively. The analysis offered here of the canonization of specific artists, however, focuses not merely on the individual artist but on his/her canonization within the field of artistic production, discourse, exhibition, dissemination, collecting and consumption – in other words, within the institutional, social and market contexts. The individual artist's centrality is shown to be reinforced by mass media attention, as in the cases of two of the artists analyzed in this section whose respective artworks and media personas are intertwined in powerful ways: Jean-Michel Basquiat, who during his lifetime was a popular mass media subject, and Ai Weiwei, who has become an international celebrity.

The case studies selected in this section address a wide range of issues relevant to the present-day processes of the canonization of artists, from art-world discourses and social, ethnic and gender issues to geopolitics in an era of increased globalization in the field of art. None of the artists discussed here were part of the art canon several decades ago, and all but one are contemporary artists. Two are based outside the West (El Anatsui in Nigeria and Ai Weiwei in China), and two are women (Cahun and Hicks). Thus, the five artists discussed in this section were chosen to reflect the pluralization that has occurred in the art world. Claude Cahun, active in the first half of the 20th century and discovered posthumously after four decades of total obscurity, burst onto the contemporary scene in the mid 1990s. Tirza Latimer's essay "Claude Cahun and Marcel Moore: Casualties of a Backfiring Canon?" argues

that in Cahun's case, the ingrained pattern of canonizing individual artists overpowered the actual reality of a team of two artists who worked collaboratively. Jordana Moore Saggese's "Jean-Michel Basquiat and the American Art Canon" examines the key roles of capitalism, race and the mass media in the canonization of Jean-Michel Basquiat, an American artist of Haitian and Porto Rican descent who began as a graffiti artist before developing his oeuvre of paintings and entering the American art canon.

In "Sheila Hicks and the Consecration of Fiber Art," Elissa Auther reconstructs the process of Hicks's canonization, aligning it with the change of attitude in the art field toward the medium of fiber, which was still regarded as strictly a craft medium during the 1960s, when Hicks was setting out on her career, but was increasingly accepted as an art medium during the 1990s. Auther's analysis also demonstrates the impact of specific art-world actors within the changed attitude to fiber and craft. Wenny Teo's essay "The Elephant in the Church: Ai Weiwei, the Media Circus and the Global Canon" argues that the canonization of the dissident Chinese artist in the global art canon reflects longstanding geopolitical anxieties and prejudices. Discussing Ai's use of social media, she questions whether his larger-than-life public persona has overpowered the social-political and critical import of his art and activism. In the final essay, "El Anatsui's Abstractions: Transformations, Analogies and the New Global," Elizabeth Harney examines the consecration of the Nigerian-based artist in the West-dominated global contemporary art canon, stating that current "canon-talk" in established art centers posits new modes of "universalism," imagined as a cosmopolitan globalism that re-thinks the geo-temporal coordinates of the art world. She questions whether Anatsui's inclusion signals a significant shift in the manner in which histories of art can now be narrated or whether it simply re-inscribes governing fictions of "otherness" into the contemporary art-world discourse.

1

CLAUDE CAHUN AND MARCEL MOORE

Casualties of a backfiring canon?

Tirza True Latimer

Claude Cahun, rediscovered posthumously after four decades of total obscurity, burst onto the contemporary scene as a prescient harbinger of postmodernism. In 1995, the Musée d'art Moderne de la Ville de Paris organized an exhibition show-casing hundreds of Cahun's theatrical "self-portraits." The contemporary relevance of these photographs stunned audiences in Europe and the U.S. An exhibition cata-logue essay by the French critic Elisabeth Lebovici adroitly mobilized Judith But-ler's then newly published writings about the relationship between gender and drag to illuminate the photographs, which pictured Cahun posing in various guises.[1] The images appeared to propose gender as a socially codified masquerade perfor-mance. So easily did this body of work align with the feminist, queer, and identity politics agendas of the 1990s that it attracted international attention.

Scholars of modernism, historical avant-gardes, and photography considered the ways the discovery of this oeuvre altered dominant art-historical narratives and expanded art-historical canons.[2] Feminist and queer cultural historians lauded Cahun as one of the rare female surrealists practicing in France between the two world wars and a vanguard image maker who challenged the gender norms of her day. Why hadn't we heard of this remarkable artist before? Feminist scholars, from Mary Ann Caws to Laura Cottingham, attributed Cahun's historical marginality to misogyny and homophobia.[3] This is not an entirely inaccurate assessment, but the artist's compensatory canonization a generation after her death (her photographs are now preserved in the collections of first-tier museums and sell on the art market for tens of thousands of dollars) may have done her legacy as much harm as good. Cahun's apotheosis distorted her creative enterprise in significant ways.

First, the exhibition of Cahun's photographs in major museum retrospectives and production of accompanying monographic catalogues (mechanisms of her canonization) framed her as a visual artist. In her own era, though, she was rec-ognized primarily for her literary efforts. The scion of a bourgeois literary family,

Cahun had, in adolescence, already published reviews and editorials in her father's newspaper and his literary journal. Born Lucy Renée Mathilde Schwob, Cahun adopted a more gender-neutral pen name in her early twenties. Her father, Maurice Schwob, was a prominent Nantes publisher. Her uncle, Marcel Schwob, was a renowned symbolist author and co-founder of the prestigious literary journal *Mercure de France*. Cahun published in *Mercure* at an early age. Her work also appeared in such surrealist reviews as *Minotaure*. In addition to signing seventy-five articles, poems, editorials, pamphlets, manifestos, and works of short fiction between 1914 and 1936, Cahun wrote two books: *Vues et visions* (1919), a symbolist-inspired artist book, and *Aveux non avenus* (1930), a surrealist anti-autobiography. Cahun's lifelong partner Suzanne Malherbe (*nom d'artiste* Marcel Moore) illustrated both books. The publications made the division of labor within the couple clear. Cahun created texts; Moore, a trained visual artist, created images.

Their first collaborative effort, *Vues et visions* (*Views and Visions*), was printed as a collector's edition in a run of 460 copies. The book consists of verses by Cahun embedded in symbolist-inspired visual frames penned in black ink, in the style of Aubrey Beardsley, by Moore. The title *Vues et visions* describes the book's structure. Each two-page spread features a worldly "view" of the present and, on the facing page, an idealized "vision" of the classic past. The latter incarnates ideals of art, romantic friendship, and same-sex eroticism that might inspire certain readers to imagine an equally golden future. Moore's graphics frame and reinforce the poetics of Cahun's texts. Although the title page acknowledges Cahun as the book's author, the dedication justly acknowledges the importance of Moore's complicity. "I dedicate this puerile prose to you," Cahun writes to Moore, "so that the entire book belongs to you and in this way your designs may redeem my text in our eyes."[4] The interlacing of possessive articles here, like the interlacing of text and images in the book, acknowledges collaboration as the operative creative paradigm.

The same collaborative ethos – an ethos at odds with myths of individual artistic genius – also characterizes the later and better-known publication *Aveux non avenus* (*Disavowed Confessions*). The book's title references and negates the conventional premise (following Jean-Jacques Rousseau) of biographical writing: the "confession" or revelation. *Aveux non avenus*, rather than illuminating the essential facts of the author's life, offers only fragments. Visual collages created by Moore accompany the textual collage composed by Cahun. Here, as in the earlier publication, the book's textual and visual components function in tandem. These elements work together to deconstruct the very genres they cite: biography and portraiture – genres conceived to immortalize the "great men" whose stories constitute world histories and artistic canons.[5] Cahun's skepticism, evident here, about great-men scenarios renders her contemporary pantheonization ironic, at the very least.

Perhaps the most consequential distortions Cahun's work has suffered in the course of (and, indeed, as a condition of) her canonization concern the terms and contexts of the photographic oeuvre's production. The most celebrated works, the collages illustrating *Aveux non avenus* and the related archive of so-called self-portraits, were not made by Cahun alone but rather by Moore and Cahun together.

It is obvious that many of the now-canonical photographs – those picturing Cahun immersed in a tide pool, curled up in a wardrobe, or with her head in a bell jar, to cite just a few examples – resulted from some sort of collaboration. Cahun could not have realized these shots without assistance, even with a cable release. This observation alone suffices to compromise the word "self" in the generally accepted formulation "self-portrait." Some shots, moreover, picture first Cahun and then Moore posing alternately in the same setting and, in certain photographs of Cahun, traces of Moore – a shadow or reflection – appear within the picture's frame. At a minimum, "self" should be dropped from the descriptive formulation.

Yet, in fact, these photographs are not "portraits" at all. They would be more accurately described as documentation of performances. Most of Cahun's performances were staged in the privacy of the homes and gardens she and Moore shared, in Paris, in Le Croisic, on the Isle of Jersey. However, during the photographically prolific decade of the 1920s, Cahun and Moore also actively took part in the life of Paris's avant-garde theater. They participated in the productions of the Théâtre Esotérique, founded by Berthe D'Yd and Paul Castan, and then joined Le Plateau, a company directed by Pierre Albert-Birot. In 1929, Cahun performed in several Albert-Birot productions: as Satan (Le Diable) in an adaptation of a twelfth-century mystery play about Adam and Eve, *Les Mystères d'Adam*; Blue Beard's wife (Elle) in a feminist parable, *Barbe bleue*; and the character Monsieur in a satire titled *Banlieu*. Moore documented all of these performances photographically. Describing such images of Cahun costumed for theatrical roles as "self-portraits" or even "portraits," as most publications and exhibition labels do, effaces the important historical contexts of their production. Awareness of the couple's engagement with experimental theater, moreover, enables us to understand the theatrical photographs they produced in private settings as performance documents as well.[6]

The insistent representation of this oeuvre as self-portraiture not only misleads by placing emphasis on Cahun as a singular subject but also privileges the photographic prints as art objects. Cahun never sought to display (let alone sell) these works in galleries.[7] The cult of the individual artist-genius and reverence for rarefied art objects is precisely the ideology that Cahun and Moore worked to oppose. Since canonization demands singular artworks and singular artists, Cahun's canonization amounts to a misunderstanding of her work's politics at best, and at worst a betrayal.

In order to understand how and why this deformation occurred, some background on the building of Cahun's contemporary reputation is indispensible. Cahun's biographer, the philosopher and poet François Leperlier, became aware of her existence in the late 1960s through the discovery of her text *Les Paris sont ouverts* (*Bets Are On*), a pamphlet defending the revolutionary potential of poetry and art. Years later, in the 1980s, he stumbled upon *Aveux non avenus* (1930). Intrigued, he began to search for the author's historical traces. His research led him to the Isle of Jersey and to the man who had purchased at public auction the remains of the estate belonging to Cahun and Moore.

The couple, Leperlier found, had moved from Paris to the channel island of Jersey in the late 1930s as the political situation across Europe degenerated and

divisions within their surrealist milieu deepened. During the German occupation of Jersey in the early 1940s, they staged creative acts of resistance. They were eventually captured, tried for insurrection, and condemned to death. Narrowly escaping deportation, they were liberated by the Allied forces. After the war, they lived out the rest of their lives on the island. Cahun died in 1954, bequeathing all of her possessions to Moore. After Moore's death in 1972, the belongings were auctioned. A Jersey book and ephemera dealer, John Wakeham, acquired a trove of avant-garde publications, experimental photographs (negatives and prints), letters, manuscripts, drawings, and photocollages for twenty-one pounds sterling. Wakeham, in turn, consigned select pieces to auction.[8]

Leperlier set himself the task of writing Cahun's biography and thus expanding the history of surrealism by revealing her as a respected collaborator of André Breton and other leaders of the movement. Leperlier interviewed those who had known Cahun during her lifetime – from members of her milieu in Paris (including Breton's second wife, the artist Jacqueline Lamba, with whom Cahun enjoyed a close friendship) to neighbors on the island of Jersey. Eventually Leperlier tracked down John Wakeham and discovered the photographic oeuvre. While Cahun's publications had earned her literary recognition during her lifetime, the photographs were an unanticipated find. Leperlier played a major role in launching Cahun's posthumous career as a visual artist. "Little known during her lifetime, forgotten after her death, Claude Cahun, photographer, still had her whole career in front of her," he later reflected.[9]

Dealers (Zabriskie in Paris and New York, Berggruen in San Francisco, Givaudan in Geneva) began to acquire pieces as they appeared on the market. Photographs and collages entered museum collections. A few appeared in the milestone 1985 exhibition "L'Amour Fou: Photography and Surrealism" at the Corcoran Gallery of Art, Washington, DC, and "Explosante-Fixe" at the Centre Georges-Pompidou, Paris. On Jersey, the Jersey Heritage Trust assumed stewardship (and, later, ownership) of Wakeham's archive. In 1992, the year Leperlier published the biography *Claude Cahun, l'écart et la metamorphose*,[10] Virginia Zabriskie organized a small but groundbreaking exhibition, first in New York and then in Paris, devoted to the photographs she had purchased. Thus began the institutionalization of the photographic oeuvre and the canonization of Claude Cahun.

Two influential publications called international attention to the oeuvre. First, Honor Lasalle and Abigail Solomon-Godeau published "Surrealist Confessions: Claude Cahun's Photomontages" in the widely respected journal of photography *Afterimage*.[11] The essay elides Moore's collaboration with Cahun, contributing to the singularization of the artist, even though the collage faceplate of *Aveux non avenus* (source of the works discussed by Lasalle and Solomon-Godeau) clearly bears Moore's signature. A month later, in *Artforum*, Therese Lichtenstein's "A Mutable Mirror: Claude Cahun" appeared.[12] This article introduced the contemporary art journal's international readership to Cahun's "self-portraits," reinforcing the default narrative of individual authorship. The *Afterimage* and *Artforum* articles gave Cahun a profile within Anglophone critical literature.

Institutional exposure accelerated. In 1993, the Jersey Museum exhibited examples of the photographs in its holdings. The Institute of Contemporary Art in London organized a comparative exhibition, "Mise-en-scène: Claude Cahun, Tacita Dean, Virginia Nimarkoh," in 1994, juxtaposing photographs attributed to Cahun with those of two artists on the contemporary British scene. The Musée des Beaux Arts de Nantes and Musée d'Art Moderne de la Ville de Paris organized major shows in 1994 and 1995 respectively.[13] Leperlier contributed essays to the ICA and Nantes catalogues and, for the Musée d'Art Moderne de la Ville de Paris retrospective, assumed responsibility for the production of a catalogue raisonné, *Claude Cahun, photographe*.[14] This exhibition and catalogue cemented Cahun's worldwide reputation as both a canonical artist and counter-cultural icon.

The catalogue itself is now a collector's item, selling for hundreds of dollars. Its cover features a photograph of Cahun dressed to the nines in dandy-aesthete attire. She poses against a jerry-rigged backdrop – a rectangle of dark cloth tacked to the wall. Her rejection of gender conventions can be read in every detail. She shaved her head and eyebrows for the photograph (razing conventional gender signifiers). Her dandyesque tux-like costume, her defiant gaze, and the swagger-portrait pose she adopts (one arm akimbo, hip sprung) contribute this visual statement of gender non-conformity. No wonder Cahun's work struck a chord with late-twentieth-century viewers. And no wonder the photographs upstaged her literary legacy. In contrast to Cahun's esoteric writings (part symbolist, part surrealist), the photographs appeared both intelligible and highly relevant to viewers radicalized by the culture wars and identity politics movements of the era. The images not only synced with theories of alterity and gender performativity but appeared to anticipate the representational strategies of the postmodern Pictures Generation. Hal Foster and others described Cahun as "a Cindy Sherman *avant la lettre*."[15]

Leperlier remained dedicated to deepening the historical investigation of Cahun's literary career and anti-fascist political activities, as well as the visual oeuvre. However, the majority of scholars publishing on Cahun, influenced by a growing string of museum exhibitions, focused asymmetrically on the artist's visual legacy and on its resonance with contemporary art and critical theory (particularly feminist and queer theory).

Four major exhibitions in the late 1990s enabled wider audiences to view the photographs firsthand. In 1997, Jennifer Blessing's Guggenheim Museum exhibition "Rose is a Rose is a Rose: Gender and Performance in Photography" presented Cahun in a comparative framework with both historical and contemporary figures – from Marcel Duchamp and Hannah Höch to Lyle Ashton Harris, Yasumasa Morimura, and Cindy Sherman – to establish a kind of global gender-dissident lineage.[16] In Whitney Chadwick's exhibition "Mirror Images: Women, Surrealism, and Self-Representation" at San Francisco Museum of Modern Art in 1998, Cahun appeared within a three-generation surrealist matrilineage along with Louise Bourgeois, Eva Hesse, Frida Kahlo, Yayoi Kusama, Ana Mendieta, Meret Oppenheim, Cindy Sherman, and Kiki Smith.[17] Also in 1998, Catherine de Zegher's sweeping curatorial project, "Inside the Visible: An Elliptical Traverse of the 20th Century

Art in, of, and from the Feminine" toured venues in Belgium and the U.S.[18] This ambitious exhibition spanned five decades of feminist intervention into the visual culture of Europe and the Americas from the 1930s to the 1990s. Focusing on critiques of the objectification, fetishization, and dismemberment of women's bodies in visual culture, de Zegher presented Claude Cahun alongside Hannah Höch, Sophie Taeuber-Arp, Louise Bourgeois, Eva Hesse, Nancy Spero, Francesca Woodman, Lygia Clark, Ellen Gallagher, and Mona Hatoum. Finally, in 1999, New York University's Grey Gallery placed Cahun in dialogue with two other women artists: the avant-garde filmmaker Maya Deren and post-modern shape shifter Cindy Sherman. The comparison illuminated similarities and, perhaps more starkly, the differences among the three. As Shelly Rice points out in her curatorial essay,

> Cahun is often compared to Cindy Sherman, often seen as her precursor in the continually reedited film of art's history. Yes, *but*: anyone who has seen one of Cahun's tiny, black-and-white prints next to gargantuan, garish color photographs by Sherman knows that there's more to this comparison than meets the eye.[19]

Rice rightly sounded a note of caution about comparing works executed in different media and born of very different cultural historical contexts. Despite this protestation, the net effect of the comparative curatorial gambit was to obfuscate differences by instating the three artists in the same feminist lineage. Cahun's satirical sketches "Heroines" (tongue-in-cheek retellings of culturally foundational narratives about women, from Sappho to Eve) were translated and reproduced in the Grey Gallery exhibition catalogue. These writings augmented Cahun's feminist credentials.[20] The aptness of her critical strategy, at a time when feminist and queer retellings of history animated the cultural scene, helped cast her as a contemporary cultural heroine, despite (or perhaps because of) her manifest criticality of heroic narratives.

All four of these path-breaking U.S. exhibitions owe a debt to Leperlier's 1995 Paris show, either directly or indirectly. The organizers of "Inverted Odysseys" openly acknowledged that the inspiration for the Grey Gallery exhibition dated from "the summer of 1995 when Lynn Gumpert visited the first retrospective of the work of Claude Cahun at the Musée d'Art Moderne de la Ville de Paris."[21] All four exhibitions reproduce baseline assumptions about the oeuvre generated by the MAM exhibition and catalogue – most importantly, the assertion of singular authorship. An expanding English-language bibliography on Cahun accompanied her exposure in these high-profile exhibitions, deepening the emerging narrative through lines about the artist's prescience and singularity.

By now, more than twenty major solo exhibitions around the globe have showcased the photographic oeuvre. The English-language literature and filmography, especially, highlight Cahun's radical gender politics and interpret the photographs as statements of radical feminism, gender queerness, and/or lesbian identity.[22] Let us consider one of the earliest and most nuanced contributions to this literature:

Abigail Solomon-Godeau's essay for the Grey Gallery catalogue, "The Equivocal 'I': Claude Cahun as Lesbian Subject." The essay compensates for a perceived lacuna in the historical scholarship (presumably Leperlier's work) on Cahun.[23] Contra Leperlier, Solomon-Godeau considers "lesbianism as far more than a biographical anecdote" and not "a factor to be subsumed within either the extreme introversion or the narcissism that Cahun herself acknowledged as important facets of her being."[24] She argues that because Cahun lived most of her life with "and was evidently inseparable from Suzanne Malherbe ("l'autre moi," as Cahun described her), an artist and illustrator who also adopted a masculine name for her professional and artistic identity (Marcel Moore)," the partnership could not be considered incidental to Cahun's artistic output.[25] The essay corrects Solomon-Godeau's earlier misrepresentation of the ten plates illustrating *Aveux non avenus* as "Claude Cahun's Photomontages." Here, the author acknowledges, "some of Cahun's most singular work, such as the ten photocollages reproduced in *Aveux non avenus*, were active collaborations between the two women."[26] She suggests that the lack of critical focus on the partnership may be "due to art history and criticism's implicit bias against collaborative art making."[27] To my knowledge, this is the first publication to point out Moore not only made the exposures but was the first audience for whom Cahun struck her poses. Rather than considering the photographs "solely within the category of self-representation in its more solipsistic sense," Solomon-Godeau adopts a more "transactional" interpretive approach.[28]

Following Solomon-Godeau, Catherine Gonnard and Elisabeth Lebovici factored co-authorship into their analysis of the oeuvre in a catalogue essay for Juan Vicente Aliaga's exhibition at IVAM, Valence, in 2001, as did I in the exhibition "Acting Out: Claude Cahun and Marcel Moore," in 2005, and related publications.[29] The brochure for "Acting Out" reproduced two images – one of Cahun, one of Moore – striking identical poses before a mirror. This pair of photographs initially interested us because they effectively document the collaborative nature of their production. At the time of the "Acting Out" exhibition, the "iconic" photograph of Cahun posing before a mirror had already been widely reproduced. (It served as the cover of Jennifer Blessing's "Rose is a Rose is a Rose" exhibition, for instance.) However, the matching photo of Moore standing in front of the same mirror had never been published. Placing the two identically framed images side by side brought the reciprocity of the photographic enterprise into focus. After hanging the two pictures together in the exhibition, moreover, we saw them both differently. As mirror images of mirror images, they appeared to open infinite perspectives rather than reproducing the customarily closed visual circuit of narcissism. As pendants, the two images appear to invite complicity into the interpretive frame.[30]

Several films have subsequently taken Cahun's creative partnership with Moore as a focus and incorporated the mirror-image pendants. *Lover Other: The Story of Claude Cahun and Marcel Moore*, by the lesbian independent filmmaker Barbara Hammer, premiered at the Museum of Modern Art in 2006, and Lizzie Thynne's *Playing a Part: The Story of Claude Cahun* was included in the 2011 exhibition *Claude Cahun* at the Jeu de Paume, Paris. Fabrice Maze's documentary, *Claude Cahun, Elle*

et Suzanne, screened for the first time in Nantes during the exhibition Claude Cahun, co-organized, 2015, by Bibliothèque Municipale and the Musée des Beaux Arts. Also in 2015, the Nunnery Gallery, London, presented a film by Sarah Purcell in the exhibition "Magic Mirror." All of these films, which embroider on images from the celebrated photographic archive, figure Moore prominently as Cahun's lover and creative accomplice. Yet they "play a part" in Cahun's assent to the canon, not Moore's.

The label "self-portraiture" (with its ideology of singularity) persists, perpetuating misconceptions about the work's attribution and the artist's cultural politics. Solomon-Godeau's observation about "art history and criticism's implicit bias against collaborative art making" provides a key for understanding what amounts to a willful misrepresentation of an artistic project that was not only conceived collaboratively but was also, in many ways, *about* collaboration. The thematic of collaboration throughout the oeuvre, along with Moore's co-authorship, has been reductively interpreted as evidence of Cahun's gender dissidence. This half-truth obscures a larger issue – which concerns not only gender and sexual non-normativity but also the constraints of patriarchal norms and hierarchies more generally. Cahun's gender dissidence, in an era marked by feminist and queer cultural intervention, accelerated her inscription in an art-historical canon then under serious revision by feminists and queers. Allegations of co-authorship, which run counter to Western narratives of artistic greatness and creative legitimacy, conflict with the project of canonization (revisionist or not), which demands the complicity of institutional collectors and art marketeers.[31] It is as if acknowledgment of co-authorship would literally cheapen the work that museums strive to valorize.

Conventions of museum display, including labeling, groomed art objects to fit canonical templates. The intimate photographs featuring Cahun (mostly $4\frac{1}{2} \times 3\frac{1}{4}$-inch or $4\frac{5}{8} \times 4\frac{5}{8}$-inch contact prints), identically matted and framed, are typically displayed in a linear manner at eye level. Taken out of sequence and isolated by expanses of white matt and white gallery wall, each image appears unique. Any sense of the live performance context and its temporality is lost. Institutional installation procedures discipline the oeuvre into conformity with established art-historical protocols. Curators tend to arrange the photographs thematically (to underscore such recurrent tropes as the mirror, the mask, or travesty), by genre (self-portrait, still life . . .), or, more rarely, according to chronology. The IVAM, Valencia, exhibition and the Magnes, Berkeley, exhibition embraced the logic of chronology. If the chronological option has the advantage of restoring a sense of history to the presentation, it risks reinforcing a linear understanding of the oeuvre's development, detached from collective contexts of cultural or social production. Inevitably, all of these display conventions enable, to a greater or lesser extent, the valorization of singular objects created by a singular artist.

Paradoxically, Cahun and Moore's rejection of singularity could hardly have been more evident in the work, as the art historian Jennifer Shaw, in her writings on *Aveux non avenus*, has demonstrated. Cahun and Moore's critical intervention into the myth, metaphor, and pathology of narcissism is just one case in point. Cahun

and Moore, theorizing a sort of narcissism *à deux*, transformed Narcissus (narrowly associated with sterile self-regard – especially that of women and homosexuals) into an alternative model of creative subjectivity. In *Aveux non avenus*, the biographical subject and his/her mirror image form a dyad that emblematizes not self-sufficiency or self-referentiality but solidarity and teamwork. As a twosome, Cahun and Moore used photography, collage, performance, wordplay, and even typography to imagine the radical potential of "mutual mirroring and a collaborative process of making as the origins of art."[32] The conceptual thread of intersubjectivity, Shaw argues, runs through *Aveux non avenus* to recast cultural production "not as a product of an artist's singular self-examination and self-expression" but as an interpersonal alternative to "dominant paradigms of both artistic creativity and human subjectivity more generally."[33] Rather than attempting to parse out (or prove) which artist made what, Shaw looks instead at the themes of collaboration developed in words and images throughout the book. She attends closely to the book's text, its ruptures and repurposing of Western cultural tropes and myths, alongside the disjointed collage illustrations, for resonances and intertextual relations between and among the fragments. She argues convincingly that "the intertextuality of words and images" in the book proposes "intersubjectivity as a new paradigm for imaging the self and its relationship with others."[34] Despite persuasive internal evidence of Cahun and Moore's dialogical approach to cultural production, conventions of museum display and monographic scholarship discourage recognition of their collaboration and its radical implications. Moreover, institutional interests are better served by preserving myths of artistic genius.

Since the 1990s, the Internet has fostered new forms of cultural production along with alternative channels for the circulation of historical information and images. The Internet enables users to bypass traditional gatekeepers (scholars, curators, critics, connoisseurs, appraisers, art dealers) and elaborate fresh perspectives. Not surprisingly, online resources have made the Cahun/Moore oeuvre globally accessible.[35] Without a doubt, the Internet has contributed to the escalation of Cahun's contemporary reputation. Among contemporary feminist, lesbian feminist, and queer communities, whether or not they have viewed Cahun and Moore's work in person or had access to the existing scholarship, the apparent subversiveness of the photographs featuring Cahun has made her an icon among cultural troublemakers. At the same time, the expressive power and edginess of the images has convinced even the most conservative collectors, art dealers, and curators of her art star quality. Iconicity is the point at which these trajectories (one subversive, the other recuperative) converge.[36] Icons are by nature singular. And singularity, I have argued, is canonization's one absolute prerequisite. Cultural activists espousing diversity in all its forms have opened the gates of previously male/white/straight art citadels. But work produced collaboratively (and what work isn't produced collaboratively?) still rarely registers in cultural histories or achieves institutional recognition. We must conclude that collaboration poses a profound threat to the survival of a value system fueled by – and bent on reproducing – myths of individual achievement.

Notes

1 The first edition of Judith Butler's *Gender Trouble: Feminism and the Subversion of Identity* was released in 1990.

2 Three early publications introduced Cahun to contemporary readers interested in surrealism and historical avant-gardes: Nanda van den Berg, "Claude Cahun: La Révolution individuelle d'une surréaliste méconnue," *Avant-Garde* no. 7 (Juillet 1990): 71–92; a single-focus journal issue edited by François Leperlier, "Dossier Claude Cahun," *Pleine Marge* 14 (1991); and Jennifer Blessing, "Resisting Determination: An Introduction to the Work of Claude Cahun, Surrealist Artist and Writer," *Found Object* 1, no. 1 (1993): 68–78.

3 See Mary Ann Caws, *The Surrealist Look: An Erotics of Encounter* (Cambridge, MA: MIT Press, 1997); Laura Cottingham, *Seeing Through the Seventies: Essays on Feminism and Art* (New York: G+B Arts International, 1999); and Laura Cottingham, *Chercher Claude Cahun*, trans. Anne Renon (Marseilles: Carobella Ex-Natura, 2001).

4 Cahun, dedication, *Vues et visions* (Paris: Editions Georges Crès and Cie, 1919), n.p. *À Marcel Moore: Je te dédie ces proses puériles / afin que l'ensemble du livre / t'appartienne et qu'ainsi / tes dessins nous fassent / pardonner mon texte.*

5 In "The Hero as Divinity," *Heroes and Hero-Worship* (London: Chapman Chatto, 1840), Thomas Carlyle popularized the so-called Great Man theory, explaining world history in terms of the impact of exceptionally gifted and powerful individuals. According to Carlyle, "The history of the world is but the biography of great men."

6 Miranda Welby-Everard elaborates on the theatrical aspect of Cahun's career in "Imaging the Actor: The Theatre of Claude Cahun," *Oxford Art Journal* 29, no. 1 (2006): 3–24.

7 The Librairie José Corti's displayed a few works in its window for the launch of *Aveux non avenus* in 1930. To my knowledge, this was the only public "exhibition" of the photographs and photomontages.

8 For a detailed history of the holdings in the Jersey Historical Trust, see Louise Downey, "Introduction," *Don't Kiss Me: The Art of Claude Cahun and Marcel Moore.*

9 Leperlier, "L'Assomption de Claude Cahun," *Claude Cahun, l'Exoticisme Intérieur* (Paris: Fayard, 2006), 455.

10 Leperlier, *Claude Cahun, l'écart et la metamorphose* (Paris: Jean-Michel Place, 1992). Leperlier substantially revised the biography in light of new archival evidence. The reprise, *Claude Cahun: L'Exotisme intérieur*, was published by Fayard in 2006.

11 Honor Lasalle and Abigail Solomon-Godeau, "Surrealist Confessions: Claude Cahun's Photomontages," *Afterimage* 19, no. 8 (March 1992): 10–13.

12 Therese Lichtenstein, "A Mutable Mirror: Claude Cahun," *Artforum* 30, no. 8 (April 1992): 64–7.

13 Henry-Claude Cousseau et al., "Le Rêve d'une ville: Nantes et le surréalisme," Musée de Beaux-Arts de Nantes, 1994; Leperlier, "Claude Cahun, photographe," Musée d'Art Moderne de la Ville de Paris, 1995.

14 A related retrospective, "Claude Cahun, Bilder," opened at the Kunstverein, Munich, in 1997.

15 Hal Foster, "Amour faux," *Art in America* (January 1986): 127.

16 The richly illustrated exhibition catalogue circulated widely and is still in print. Blessing, ed., *Rose is a Rose is a Rose: Gender and Performance in Photography* (New York: Solomon R. Guggenheim Museum, 1997).

17 The *Mirror Images* catalogue includes an essay by Katy Kline elaborating the comparison between Cahun and Cindy Sherman. Katy Kline, "In or Out of the Picture: Claude Cahun and Cindy Sherman," *Mirror Images: Women, Surrealism, and Self-Representation*, Whitney Chadwick, ed. (Cambridge, MA: MIT Press, 1998), 68–81. One of Leperlier's earliest catalogue essays, "Cahun, La gravité des apparances," in *Le Rêve d'une ville: Nantes et le surréalisme* (Paris and Nantes: Réunion des musées nationaux/ Musée des Beaux-Arts de Nantes, Bibliothèque Municipale de Nantes, 1994): 261–289, made the same comparison.

18 The exhibition originated at the Kanal Art Foundation, Kortrijk, Belgium, and traveled to the Institute of Contemporary Art, Boston, and the National Museum of Women in the Arts, Washington, DC.

19 Shelly Rice, "Inverted Odysseys," in *Inverted Odysseys: Claude Cahun, Maya Deren, Cindy Sherman*, Rice, ed. (Cambridge, MA: MIT Press, 1999), 24.

20 Vignettes from the "Héröines" manuscript appeared in *Le Mercure de France* and *Le Journal Litéraire* in 1925. The complete ensemble of texts (in English translation) and their typographic embellishments was reproduced in the Grey Gallery exhibition catalogue for the first time. In 2006, a volume presenting these writings in their original French language, edited and commented by Leperlier, became available: Claude Cahun, *Héröines* (Paris: Mille-et-une Nuits, 2006).

21 Bonnie Clearwater, Lynn Gumpert, and Rice, "Foreword," Rice, *Inverted Odysseys*, vi.

22 Publications contributing to this line of investigation include, in addition to Solomon-Godeau's Grey Gallery catalogue essay, Laurie J. Monahan, "Radical Transformations: Claude Cahun and the Masquerade of Womanliness," *Inside the Visible: An Elliptical Traverse of Twentieth Century Art in, of, and from the Feminine*, M. Catherine de Zegher, ed. (Cambridge, MA: MIT Press, 1996), 125–133; Laura Cottingham, "Considering Claude Cahun," *Seeing Through the Seventies: Essays on Feminism and Art* (Amsterdam: G+B Arts International, Gordon and Breach, 2000), 189–213; Tirza True Latimer, "Looking Like a Lesbian: Portraiture and Sexual Identity in 1920s Paris," in *The Modern Woman Revisited: Paris Between the Wars*, Whitney Chadwick and Latimer, eds. (New Brunswick: Rutgers University Press, 2003), 127–44; Latimer, "Visions émancipatrices, Portraiture et identité sexuelle dans le Paris des années 20," *Clio: Histoire, Femmes, et Sociétés*, 22 (Presses Universitaires du Mirail, 2005). The photographs have also engendered dozens of American, British, French, and Spanish dissertations and theses in the course of the last decade.

23 Solomon-Godeau, "The Equivocal 'I': Claude Cahun as Lesbian Subject," in *Inverted Odysseys: Claude Cahun, Maya Deren, Cindy Sherman*, Rice, ed. (Cambridge: MIT Press, 2000), 111–25.

24 Solomon-Godeau, "The Equivocal 'I'", 116.

25 Ibid.

26 Ibid.

27 Ibid.

28 Ibid.

29 Catherine Gonnard and Elisabeth Lebovici, "Como pudieron ellas decir yo," in *Claude Cahun*, Juan Vicente Aliaga, ed. (Valence: IVAM, 2001), 67–77. The exhibition "Acting Out: Claude Cahun and Marcel Moore," organized by the Judah L. Magnes Museum, Berkeley, CA, in collaboration with the Jersey Historical Trust, opened at the Magnes Museum in 2004, traveled to the Frye Gallery, Seattle, and concluded its tour at the Jersey Museum, Isle of Jersey, in 2005. Related publications include Latimer, "'Narcissus and Narcissus': Claude Cahun and Marcel Moore," in *Women Together/Women Apart: Portraits of Lesbian Paris* (New Brunswick, NJ: Rutgers University Press, 2005), 68–104; Latimer, "Entre Nous: Between Claude Cahun and Marcel Moore," *GLQ: A Journal of Lesbian and Gay Studies* 12, no. 2 (2006): 197–216; Latimer, "Entre Claude Cahun et Marcel Moore," *Paragraphes* 23 (Université de Montréal, 2007): 31–42; Latimer, "Acting Out: Claude Cahun and Marcel Moore," *Don't Kiss Me: The Art of Claude Cahun and Marcel Moore*, Downey, ed. (London: Tate Publications, 2006), 56–71.

30 Shaw and Oberhuber have also made significant contributions to the literature of collaboration. Shaw has generated a raft of publications in English, and Oberhuber in French, exploring the oeuvre as a dialogical play of images and texts between Cahun and Moore and, at the same time, a kind of "talking back" by Cahun/Moore with the long history of their inherited visual and literary culture. See Jennifer Shaw, "Narcissus and the Magic Mirror," in *Don't Kiss Me: The Art of Claude Cahun and Marcel Moore*, Downey, ed. (London: Tate Publications, 2006), 33–45; and Shaw, *Reading Claude Cahun's Disavowals* (Burlington, VT: Ashgate, 2013); Oberhuber, "Aimer, s'aimer, à s'y prendre? Les jeux spéctaculaires de Cahun-Moore," *Intermédialités* 4 (automne 2004): 87–114; and Oberhuber, ed., *Claude Cahun, contexte, posture, filiation: Pour une esthétique de l'entre-deux* (Montréal: Université de Montréal, 2007).

31 Recently, two major museums in the U.S. re-attributed works in their collections: New York's Museum of Modern Art and San Francisco Museum of Modern now credit the photographs in their holdings to both Cahun and Moore and label the pictures as "untitled" (rather than "self-portrait"). However, the narrative blurb in MoMA's catalogue still describes the photos as Cahun's "inventive self-portraits." See Museum of Modern Art, online catalogue of collections.

32 Shaw, "Narcissus and the Magic Mirror," 44.

33 Shaw, *Reading Claude Cahun's Disavowals*, 3, 19.

34 Ibid., 21.

35 "Héritages de Claude Cahun et Marcel Moore," a site created by Oberhuber and Alexandra Arvisais (respectively, professor of literature and doctoral candidate at the University of Montreal) is one of the more rigorous online resources. The site (URL http://cahun-moore.com/entre) diffuses information about articles, books, exhibitions, artistic projects, and conferences deepening understanding of the Cahun/Moore collaboration. While the "Héritages," with its links to scholarly references and conferences, advances the investigation of the "entre" (the in-between) as a site of creativity and contestation, the vast majority of web-only resources advance only Cahun as icon and a singular genius.

36 Aliaga makes this plain in his thoughtful analysis of the literature and exhibition history. See Aliaga, "La Fabrication d'une icône: Propos sur la reception de l'expérience photographique de Claude Cahun depuis sa redécouverte," in *Claude Cahun*, Aliaga, ed. (Paris: Hazan/Jeu de Paume, 2011), 157–77. Agnès Lhermitte also undertook extensive bibliographic legwork in the earlier study, "Panorama critique autour de Claude Cahun," *Mélusine* 29 (février 2009): 309–22.

Bibliography

Aliaga, Juan Vicente, ed. *Claude Cahun*. Valence: IVAM, 2001.

———. ed. *Claude Cahun*. Paris: Hazan/Jeu de Paume, 2011.

———. "La Fabrication d'une icône: Propos sur la reception de l'expérience photographique de Claude Cahun depuis sa redécouverte," *Claude Cahun*, Aliaga, ed., 157–77. Paris: Hazan/Jeu de Paume, 2011.

Berg, Nanda van den. "Claude Cahun: La Révolution individuelle d'une surréaliste méconnue," *Avant-Garde* no. 7 (Juillet 1990): 71–92.

Blessing, Jennifer, ed. "Resisting Determination: An Introduction to the Work of Claude Cahun, Surrealist Artist and Writer," *Found Object* 1, no. 1 (1993): 68–78.

———. *Rose Is a Rose Is a Rose: Gender and Performance in Photography*. New York: Solomon R. Guggenheim Museum, 1997.

Butler, Judith. *Gender Trouble: Feminism and the Subversion of Identity*. New York: Routledge, 1990.

Cahun, Claude. *Héroïnes*. Edited and commented by Francois Leperlier. Paris: Mille-et-une Nuits, 2006.

Cahun, Claude and Marcel Moore. *Aveux non avenus*. Paris: Editions du Carrefour, 1930.

———. *Vues et visions*. Paris: Editions Georges Crès and Cie, 1919.

Caws, Mary Ann. *The Surrealist Look: An Erotics of Encounter*. Cambridge, MA: MIT Press, 1997.

Cottingham, Laura. *Seeing Through the Seventies: Essays on Feminism and Art*. New York: G+B Arts International, 1999.

———. "Considering Claude Cahun," *Seeing Through the Seventies: Essays on Feminism and Art*, 189–213. Amsterdam: G+B Arts International, Gordon and Breach, 2000.

————. *Chercher Claude Cahun*, trans. Anne Renon. Marseilles: Carobella Ex-Natura, 2001.

Cousseau, Henry-Claude, with Patrice Allain, Agnès Marcetteau-Paul, and Vincent Rousseau, "Le Rêve d'une ville: Nantes et le surréalisme," Musée de Beaux-Arts de Nantes, 1994.

Downey, Louise, ed. *Don't Kiss Me: The Art of Claude Cahun and Marcel Moore*. London: Tate Publications, 2006.

Foster, Hal. "Amour faux," *Art in America* (January 1986): 116–129.

Gonnard, Catherine and Elisabeth Lebovici. "Como pudieron ellas decir yo," *Claude Cahun*, Juan Vicente Aliaga, ed., 67–77. Valence: IVAM, 2001.

Kline, Katy. "In or Out of the Picture: Claude Cahun and Cindy Sherman," *Mirror Images: Women, Surrealism, and Self-Representation*, ed. Whitney Chadwick, 68–91. Cambridge, MA: MIT Press, 1998.

Lasalle, Honor and Abigail Solomon-Godeau. "Surrealist Confessions: Claude Cahun's Photomontages," *Afterimage* 19, no. 8 (March 1992): 10–13.

Latimer, Tirza True. "Acting Out: Claude Cahun and Marcel Moore," *Don't Kiss Me: The Art of Claude Cahun and Marcel Moore*, Downey, ed., 56–71. London: Tate Publications, 2006.

————. "Entre Claude Cahun et Marcel Moore," *Paragraphes* 23 (2007): 31–42.

————. "Entre Nous: Between Claude Cahun and Marcel Moore," *GLQ: A Journal of Lesbian and Gay Studies* 12, no. 2 (2006): 197–216.

————. *Le Rêve d'une ville: Nantes et le surréalisme*. Paris and Nantes: Réunion des musées nationaux/Musée des Beaux-Arts de Nantes, Bibliothèque Municipale de Nantes, 1994.

————. "Looking Like a Lesbian: Portraiture and Sexual Identity in 1920s Paris," in *The Modern Woman Revisited: Paris Between the Wars*, Whitney Chadwick and Latimer, eds. (New Brunswick: Rutgers University Press, 2003), 127–44

————. "'Narcissus and Narcissus': Claude Cahun and Marcel Moore," *Women Together/ Women Apart: Portraits of Lesbian Paris*, 68–104. New Brunswick, NJ: Rutgers University Press, 2005.

Leperlier, François. *Claude Cahun, l'écart et la metamorphose*. Paris: Jean-Michel Place, 1992.

————, ed. *Claude Cahun, photographe*. Paris: Jean-Michel Place/Musée d'Art Moderne de la Ville de Paris, 1995.

————. *Claude Cahun, l'Exoticisme Intérieur*. Paris: Fayard, 2006.

————. "Dossier Claude Cahun," *Pleine Marge* 14 (1991)

Lhermitte, Agnès. "Panorama Critique Autour de Claude Cahun," *Mélusine* 29 (février 2009): 309–22.

Lichtenstein, Therese. "A Mutable Mirror: Claude Cahun," *Artforum* 30, no. 8 (April 1992): 64–67.

Monahan, Laurie J. "Radical Transformations: Claude Cahun and the Masquerade of Womanliness," *Inside the Visible: An Elliptical Traverse of Twentieth Century Art in, of, and from the Feminine*, M. Catherine de Zegher, ed., 125–33. Cambridge, MA: MIT Press, 1996.

Oberhuber, Andrea. "Aimer, s'aimer, à s'y prendre? Les jeux spéctaculaires de Cahun-Moore," *Intermédialités* 4 (automne 2004): 87–114.

————, ed. *Claude Cahun, contexte, posture, filiation: Pour une esthétique de l'entre-deux*. Montréal: Université de Montréal, 2007.

Rice, Shelly, ed. *Inverted Odysseys: Claude Cahun, Maya Deren, Cindy Sherman*. Cambridge, MA: MIT Press, 1999.

Shaw, Jennifer. "Narcissus and the Magic Mirror," *Don't Kiss Me: The Art of Claude Cahun and Marcel Moore*, Downey, ed., 33–45. London: Tate Publications, 2006.

————. *Reading Claude Cahun's Disavowals*. Burlington, VT: Ashgate, 2013.

Solomon-Godeau. "The Equivocal 'I': Claude Cahun as Lesbian Subject," *Inverted Odysseys: Claude Cahun, Maya Deren, Cindy Sherman*, Rice, ed., 111–25. Cambridge: MIT Press, 2000.

Welby-Everard, Miranda. "Imaging the Actor: The Theatre of Claude Cahun," *Oxford Art Journal* 29, no. 1 (2006): 3–24.

Whitney Chadwick, ed. *Mirror Images: Women, Surrealism, and Self-Representation.* Cambridge, MA: MIT Press, 1998.

Zegher, Catherine de, ed. *Inside the Visible: An Elliptical Traverse of Twentieth Century Art in, of, and from the Feminine.* Cambridge, MA: MIT Press, 1996.

2

JEAN-MICHEL BASQUIAT AND THE AMERICAN ART CANON

Jordana Moore Saggese

Despite his death at the age of twenty-seven, Jean-Michel Basquiat has lived many artistic lives. Before he was a fixture in the downtown art scene, the young artist was better known as one-half of the artistic persona SAMO – an acronym for "Same Old Shit." Beginning in May 1978, two years before Basquiat's first exhibition, he and high school friend Al Diaz wrote maxims, jokes, and prophecies in marker and spray paint on subway trains throughout New York City (particularly the "D" train that took him from downtown Manhattan back home to Brooklyn),[1] as well as in lower Manhattan on the walls, buildings, and sidewalks around the School of the Visual Arts and in the SoHo and Tribeca neighborhoods, where there were many prominent art galleries. From the very beginning, Basquiat (as SAMO) demonstrated his awareness of the institutions and the processes of canonization. While the artist's struggle for recognition in the canon of art history constituted a persistent theme in the work, as he moved from the street to the studio, Basquiat's place within the American art canon is one of constant instability and revision, determined as much by the art market as by art history.

The tensions around commercial and critical success that began to emerge in Basquiat's era continue to inflect our present moment. According to Olav Velthius, "we have moved into a situation where wealth is the only agreed upon arbiter of value."[2] With widespread media coverage of every contemporary art auction, the explosion of art biennials in far-flung locales, the economies of art have indeed begun to function as measures of artistic achievement. The processes of canonization have seemingly moved outside the grasp of art historians and critics and into the art market. Yet the fact that Basquiat never achieved critical success in his lifetime, despite his overwhelming market value, complicates this narrative. Collectors who tried to donate his work to major New York museums during the artist's lifetime were rejected, and he received his first major museum retrospective only five years after his death. While few have questioned Basquiat's status in

the international art market, scholars have yet to determine the degree to which it eclipsed his relationship to the critical "canon" – both during and after his lifetime. This chapter explores Basquiat's work in relation to the shifting processes and economies of canonization in the last several decades. Through a careful analysis of the artist's works and methods, I frame Basquiat's appropriative strategies and his repeated exploration of currency, capital, and fame as part of a larger interrogation of the relationship among international market appeal, exploitation, and critical acclaim. Looking toward our contemporary moment, I also consider the ways in which Basquiat's posthumous fame in popular culture has expanded against the previously drawn boundaries of the artistic canon. The case of Basquiat forces us to consider the complexity of contemporary modes of recognition and success in a global art market, whose parameters are increasingly defined by popular culture as much as by the academy.

From the street to the studio

The tenuous relationship between art and commerce was certainly not a new development, but in the 1980s it became more explicit. As art critic Lisbet Nilson described it in 1985, the New York art world of this period was "less a business than an industry."[3] As unprecedented amounts of money flooded the art market, prices climbed precipitately. For example, Julian Schnabel's *Notre Dame*, which sold in 1980 for $3,500, was acquired by a private collector for just over $93,000 at Schnabel's 1983 auction debut.[4] In response, artists made more and bigger work, and dealers began to organize two-gallery exhibitions to keep up with demand.[5] Large banks (and even some auction houses) facilitated loans for art purchases, and financial institutions accepted fine art as collateral against loans.[6] This art industry was serviced by a cadre of professionals, including corporate curators and advisors, art lawyers, tax experts, public relations consultants, and artists' agents. Meanwhile, many critics from the period expressed fear that the marketplace had become too influential, usurping the role formerly played by critics and art historians in establishing the critical reception of art and artists.

Basquiat had almost unprecedented market power very early in his career. In a review of the 1980 "Times Square Show" – his first public exhibition of works on canvas – art dealer Jeffrey Deitch drew attention to the artist's work, calling it "a knockout combination of de Kooning and subway scribbles."[7] The following year, Basquiat sold works both to the major collector Christophe de Menil and to Henry Geldzahler, the commissioner of cultural affairs in New York City. By 1982, at the age of twenty-one, Basquiat had solo exhibitions in galleries in Italy, New York, and Los Angeles. He was represented by the international art dealer Bruno Bischofberger, who introduced him to his most famous client: Andy Warhol. Basquiat's career followed the rapid trajectory of Wall Street, which boomed from 1983 to 1987. His work appeared in *GQ* and *Esquire*, he was interviewed for the new music television cable network MTV, and he walked in a Commes-des-Garcons

fashion show.[8] In 1985, Basquiat appeared on the cover of the *New York Times* magazine alongside the banner caption: "New Art, New Money: The Marketing of an American Artist."

As a painter caught in this moment, Basquiat (along with Keith Haring) was of particular interest in this overhyped art market because of his early association with the graffiti movement and the East Village art scene – both of which were suddenly thrust to the center of the financially driven New York art world in the early 1980s. But unlike Haring, Basquiat was black. This meant that his success would always be marked by race. During his lifetime and after, this manifested in the tropes and stereotypes of primitivism that characterize the criticism surrounding his work. For example, his early and brief work as a street writer were extrapolated into the legend of an artist who "misspent his youth spraying graffiti on subway trains," despite his middle-class upbringing by an accountant father.[9] Basquiat was frequently positioned as the wild, untrained naïf; critics called him "the Black Picasso." On a personal level, Basquiat and his friends often recounted stories of the artist's difficulty navigating New York's elite culture, even after his commercial success. In a 1987 interview, the artist even spoke of his frustrated attempts to hail a cab: "I go on the street, wave my hand and they just drive past me . . . A few taxi companies tell their drivers not to pick up blacks."[10] Many of the artist's works focused specifically on the place of black people in the world. Black figures appear throughout Basquiat's oeuvre – as prisoners (*Obnoxious Liberals*, 1982), servants (*Untitled [Maid from Olympia]*, 1982), cooks (*Eyes and Eggs*, 1983, and *Farina*, 1984), janitors (*Untitled*, 1981), and slaves (*The Nile*, 1983). However, the absence of references to black artists in this body of work is particularly poignant given Basquiat's position (and that of many black artists) as an outsider to the processes of canonization.[11] For example, unlike his contemporaries like Julian Schnabel or David Salle – two other successful artists of the 1980s – Basquiat never received a large solo exhibition at a New York Museum during his lifetime.[12]

Despite his popularity and his profitability on the auction block, Basquiat had trouble entering the American art canon. According to art historian Isabelle Graw, "in recent years, whether or not an artwork was considered artistically relevant depended to a greater extent on its market value. But this market value still needs the assumption of a 'symbolic value' for ultimate legitimacy."[13] An artist cannot solely be legitimized by market value alone. In Graw's example, the work of Andreas Gursky maintains its artistic legitimacy through its abundance of art-historical references, which secure its symbolic value. "Without symbolic value," Graw claims, "there is no market value."[14] And it is the historians, the critics, and the curators who determine symbolic value. Working from this paradigm, it makes sense then that Basquiat's commercial success was not enough to gain critical acceptance. This gap between commercial and critical success was one that seemed to occupy Basquiat from the very beginnings of his brief but explosive career. We might, in fact, read his preoccupation with icons like the *Mona Lisa* as both a meditation on the commodity value of art and an attempt to establish his own symbolic value.

Mona Lisa and **Mary Boone**

Leonardo's *Mona Lisa* has been fodder for many artists, who have questioned not only the status of the art object more generally but also the relationship of this particular icon to the art-historical canon. In the early twentieth century, Marcel Duchamp, Francis Picabia, and Salvador Dalí all appropriated this image; in the postwar period, American artists Jasper Johns, Andy Warhol, Robert Rauschenberg, and Suzanne Lacy, among others, again took up the *Mona Lisa* as subject. In 1983, Basquiat made his own version of Leonardo's masterpiece, clearly inserting his own perspective into this history of appropriation, Fig. 2.1.

In this large painting on canvas, Basquiat has carefully replicated the pose of Leonardo's sitter while eliminating much of the scenery in the background. In Basquiat's version, the imaginary landscape of Leonardo has been reduced so

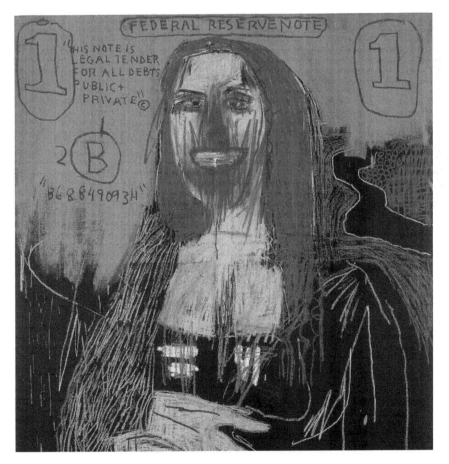

FIGURE 2.1 Jean-Michel Basquiat, *Mona Lisa*, 1983. Acrylic and pencil on canvas, 66¾ × 60⅘ in. (169.5 × 154.5 cm). Private collection. © The Estate of Jean-Michel Basquiat/ADAGP, Paris/ARS, New York 2016.

that only a vague suggestion of the winding paths and lagoon behind Madame Gioconda remains, and it becomes an outlined section of black paint. Basquiat has covered the remainder of background with a layer of yellow paint that starts just above this black path to the right of the sitter's head and extends over to the other side, reaching just below the left shoulder. Onto this yellow ground the artist has drawn the numbers, letters, and legal notices associated with United States federal currency. Two number 1s sit inside large ovals in the upper left and the upper right of the canvas. To the immediate left of the sitter's head we read the official proclamation: "THIS NOTE IS LEGAL TENDER FOR ALL DEBTS PUBLIC + PRIVATE," for which Basquiat has also provided the notice of copyright. The artist also includes a Federal Reserve seal ("B") and serial number ("B68849093H") on his *Mona Lisa*. By including these markers of U.S. currency, Basquiat transforms Leonardo's portrait into legal tender in and of itself. Unlike previous fine art appropriations of this most famous painting, which tend to focus on the representation of the figure itself, Basquiat's revision of *Mona Lisa* reorients the focus toward the economy of the image and perhaps toward the artist's own position within this economy.

Basquiat's appropriations of *Mona Lisa* in other canvases from this period, including *Lye* (1983) and *Crown Hotel (Mona Lisa Black Background)* from 1982, similarly reveal connections among celebrity, commodification, and the art world. Basquiat's *Boone* shows us yet another appropriation of Leonardo – this time via a photocopy that the artist has pasted onto a large Masonite panel. The theme of commodification that Basquiat attached to previous appropriations of *Mona Lisa* appears here as well by including the word "BOONE," written in marker directly below the pasted reproduction – a position that emphasizes its function as a caption and identifies the sitter as the prominent New York art dealer Mary Boone. While Boone may have born some resemblance to La Gioconda with her shoulder-length brown hair, Basquiat's conflation of the two women is more than a formal exercise. The aggression with which Basquiat has blackened the eyes of his figure and later covered the entire portrait in red marker is apparent. The outlining of the figure's lips in a wide red arc likens her more to a clown than a great beauty.[15]

Basquiat painted portraits of many other influential dealers and collectors in his orbit, including Bruno Bischofberger, Henry Geldzahler, and Robert Fraser.[16] These portraits seem to emphasize even further the pivotal and perhaps problematic role of galleries and dealers in Basquiat's burgeoning career. Basquiat often publicly commented on the difficult relationships he had with his dealers, telling an interviewer in 1985 that he despised the assembly-line production into which he was often coerced. According to the artist, "They [the dealers Annina Nosei, Emilio Mazzoli, and Bruno Bischoberger] set it up for me, so I'd have to make eight paintings in a week, for the show next week . . . It was like a factory, a sick factory."[17] Calling to mind the Factory model of Andy Warhol, Basquiat flatly rejects the connections between making art and making commodities.

In the age of the yuppie, art quickly became another chic consumer good; critics grew increasingly anxious, and many shifted the debate from the issues of commerce to those of aesthetics. In the early 1980s, Benjamin Buchloh, Douglas

Crimp, and Craig Owens filled the pages of the journal *October* with their reactions against the emerging Neo-Expressionism, which they considered to be reflective of and perhaps even complicit with bourgeois values. In a special issue of *October* titled "Art World Follies," for example, Crimp declared "the end of painting," choosing to instead champion in his essay conceptual art practices that were critical of the art market.[18]

Hal Foster similarly denounced the painting of Basquiat and his contemporaries in essays published in two special issues of *Art in America* devoted to "The Expressionism Question."[19] In his essay "The Expressive Fallacy," Foster argued that the core idea of expressionism itself – pure expression of an authentic, core self – was in fact an impossibility, and therefore a fruitless (and presumably unworthy) endeavor.[20] The avant-garde artist, in their estimation, was one who worked against the modernist values of originality and, most important, remained somehow divorced from the spectacles of commerce and celebrity. Conceptual art and photography were the ultimate examples here, as both media carried the potential rejection of the object as a commodity.[21] Foster specifically called out the work of Eric Bogosian, James Casebere, Jenny Holzer, Jasper Johns, Roy Lichtenstein, Matt Mullican, Richard Prince, Gerard Richter, Peter Nadin, and Cindy Sherman as worthy examples.[22] In a 1982 essay, Foster called out Basquiat, sardonically noting, "In a March show, the stylish street-artist SAMO became Jean-Michel Basquiat, the new art-world primitive." In Foster's view, Basquiat (like Keith Haring) was just another example of an outmoded primitive fantasy.[23] More important, any success Basquiat had in the gallery was mitigated by this negative criticism, which only served to reinforce his already tenuous position in the contemporary canon.[24]

The currency of Jean-Michel Basquiat

Basquiat's recognition of the conflicting experience of canonization – that is, in the disparity between his own artistic and commercial value – connects to his ongoing preoccupation with currency, such as his 1983 painting *Mona Lisa*. In *Untitled (Arm and Hammer II)* – a collaboration with Andy Warhol from 1985—Basquiat comments on the relationship between the economic and artistic worlds even more explicitly, Figure 2.2. Basquiat masked the most identifiable portions of the silk-screened Arm & Hammer logo on the left side of the composition, painting out the interior circle of the logo that contains the line drawing of a disembodied muscular bicep and forearm clutching a hammer and redacting the identifying text ("ARM & HAMMER") above and below with large black bars. In the center of this circle, Basquiat has painted the head and bust of a dark-skinned figure on the white ground. A saxophone emerges from this figure's clenched teeth and extends past the boundary of the former logo. The year 1955 appears below the drawn figure, identifying him as saxophonist Charlie Parker. It was the year of the musician's tragic death. Basquiat's inclusion of the word "LIBERTY" above Parker's head, as well as the phrases "COMMEMERITVE" [sic] and "ONE CENT" in the black bars above and below the white interior circle, transforms the portrait into a commemorative coin.

FIGURE 2.2 Jean-Michel Basquiat and Andy Warhol, *Untitled (Arm and Hammer II)*, 1985. Acrylic, oil paintstick, and silk screen on canvas, 66 × 112 in. (167 × 285 cm.) Bischofberger Collection, Switzerland. © The Estate of Jean-Michel Basquiat/ADAGP, Paris/ARS, New York 2016/ © 2016 The Andy Warhol Foundation for the Visual Arts, Inc./Artists Rights Society (ARS), New York.

Although the United States Mint never released such a coin in its commemorative coin program, Basquiat himself designates Parker as worthy of such memorializing. More important, in this composition, Basquiat seems caught between marking Parker as an important historical figure – that is, one worthy of commemoration (indeed canonization) – and critiquing the musician's reduction to just another commercial product.

Basquiat's interest in coins and currency extended beyond memorializing Parker. Several other works contain images of coins and dollar signs, seeming to critique the commodification of blackness and of its cultural products. Most of Basquiat's "coins" are dated either 1955 (the year of Parker's fictional commemorative issue) or 1951 (the year that half dollars commemorating the historical black figures George Washington Carver and Booker T. Washington were issued). Drawings of such coins appear, for example, in *In Italian* (1983), *Liberty* (1982–83), and *Skin Head Wig* (1982–83). Basquiat also included the image of the seventh U.S. president Andrew Jackson (1767–1845), adapted from the front of the twenty-dollar bill (where his image has appeared since 1928) in 1982's *Untitled (Jackson)*. In other areas of the drawing appear the names of other important American politicians and historical figures, including "WASHINGTON," "LINCOLN," and Alexander Graham Bell – referenced here by the words "GRAHAM BELL" sketched in ballpoint pen ink directly above that dark-red serial number. Read in the context of the currency markings (as well as the multiple references to "Stockbrokers" throughout),

we are asked to look beyond the political legacies of these men to consider their capitalist enterprises as well. This calls to mind, for example, Jackson's and Washington's roles in the sale of black bodies for their own economic gain at the Hermitage Plantation in Tennessee and at Mount Vernon, respectively.[25] Basquiat highlights the founding fathers' problematic position as both champions of economic freedom and beneficiaries of exploitation.

Basquiat's methods of appropriation, which relied extensively on technologies of photographic reproduction, also addressed more implicitly the overwhelming commodity fetishism of the 1980s art market. For one, Basquiat's appropriative practices complicated the commodity value of his work. The singularity of an art object makes it a special type of commodity, and the artist's use of copies and imitations reveals its instability – a prominent discussion in the wake of the Pictures Generation.[26] In his works, Basquiat revealed an interest in issues of commerce and trade. Richard Marshall, the curator of Basquiat's 1992 retrospective at the Whitney Museum, observed the artist's "frequent references to petroleum and its by-products (tar, oil, petrol, gasoline) and to 'peso neto' (meaning 'net weight')."[27] As Marshall has claimed, the significance of words like "tar" is multiple; it simultaneously signifies a petroleum by-product ("a natural element of monetary value and chemical manipulation") and a racist epithet, while also being an anagram for the word "art". Basquiat's frequent use of the words "tar" and "peso neto", according to Marshall, brings our "attention to the earth's natural resources, those that ideally are owned by all the earth's inhabitants, but which have been seized and monopolized, becoming objects of power and wealth of the few at the expense of the well being of all mankind."[28]

For Basquiat, the history of colonization and resource extraction was indeed a major concern – one that we see reflected in his near-constant study of Africa. Basquiat's 1982 canvas *Natives Carrying Some Guns, Bibles, Amorites on Safari* explicitly calls our attention to the economic exploitation that typically follows (or even initiates) colonization. On the left side of the canvas, a black figure raises a large crate overhead labeled: "ROYAL SALT INC ©." In this work, Basquiat uses language to highlight the exploitative intentions of colonizers; although he has written the word "MISSIONARIES" twice at the top right of his canvas, it is "POACHERS" that he boldly outlined in a rectangular box. Across the canvas, Basquiat also wrote (and often crossed out) the words "TUSKS" and "SKINS" – two of several sources of colonial wealth. In some of these words, the artist made the link between commodity and commercial profit even more explicit by transforming the "s" into dollar signs. Basquiat cleverly remarks in the lowest right corner: "I WON'T EVEN MENTION GOLD (ORO)." The artist's bilingualism here underscores the global nature of imperialist greed. *Natives Carrying Some Guns, Bibles, Amorites on Safari* certainly performs a critique of colonization and of exploitation, but this work pushes these concerns beyond natural resources to include the black body and the art world as well. When read in the context of the black laboring figure on the left side of Basquiat's canvas, we might ask if the "animals" being poached are indeed black men.

In several works, the artist places the discourses of blackness and of commerce in parallel. *Obnoxious Liberals*, 1982, also bears several marks of currency via the

dollar signs covering the body of the rightmost figure and the "gold" positioned directly below an incarcerated figure on the left so as to appear excreted from that body. Between this "cowboy" figure with the characteristic ten-gallon hat and the chained prisoner stands one figure in black, arms raised to the sky, whose body is clearly marked "NOT FOR SALE." Basquiat's *The Nile* from 1983 also highlights the artist's concerns with the repeated effects of the commercial exploitation of black people worldwide, Fig. 2.3. On the rightmost panel, a black figure appears with the word "SLAVE" written several times across the torso and crossed out.[29] On the left panel of this triptych, Basquiat has included the word "SALT," outlined it with a box, and then crossed out the first letter – a reference to the trade of salt throughout the continent. Read in the context of the artist's multiple references to Egypt, "SALT" may also refer to renowned collector and Egyptologist Henry Salt (1780–1827). Salt's collection is cited in captions for works illustrated in the catalogue for the exhibition, *Akhenaten and Nefertiti*, which was hosted by the Brooklyn Museum in 1973. One such caption reads: "Acquired by Henry Salt, perhaps in the Memphis Region, in 1826."[30] Like many of Basquiat's words, this "SALT" performs a double function, connecting commercial trade and art under the umbrella of export. Here, the artist connects the problems of exploitation in both the industrial and the art-world context, referring simultaneously to the mining and export of salt and the collecting of African art. These examples center on the transfer of goods between Africa and the Americas, but perhaps more important, they prompt the viewer to consider the power relationships that are re-inscribed through these trades. The point here for Basquiat is the connections between the industrial world and the art world via their shared exploitation of blackness.

FIGURE 2.3 Jean-Michel Basquiat, *The Nile* (also known as *El Gran Espectaculo* and *History of Black People*), 1983. Acrylic and oil paintstick on canvas mounted on wood supports, three panels, 68 × 141 in. (172.5 × 358 cm.) overall. Private collection. © The Estate of Jean-Michel Basquiat/ADAGP, Paris/ARS, New York 2016.

The afterlife of Jean-Michel Basquiat

The processes of canonization in the church and in the art world share death as a precondition. In the twenty-seven years since Basquiat's death, the artist has certainly gained far more institutional recognition than during his lifetime. This, however, has manifested mostly in the form of temporary retrospective exhibitions, including the first, in the winter of 1992 at the Whitney Museum of American Art, which subsequently traveled to the Menil Collection in Houston, the Des Moines Art Center, and the Montgomery Museum of Fine Arts in Alabama. In contrast, his artwork is not well represented in the permanent collections of major museums. Opened in October 2015, the Broad Museum in Los Angeles has thirteen of Basquiat's works in its collection – the most Basquiat works of any public art institution. However, these thirteen works have been part of the private collection of Eli and Edythe Broad for more than thirty years and were not purchased by a public museum. For the sake of comparison, the Whitney Museum of American Art in New York holds six Basquiat works, four of which are works on paper. The Museum of Modern Art has eleven works in its permanent collection (ten drawings and one silkscreened print), while the Metropolitan Museum of Art has two works on paper.

The majority of Basquiat's works remain in the hands of private collectors and dealers. Thus short-term exhibitions, while well attended, are the main points of access for both the general and scholarly publics. Complicating matters is the fact that most of these exhibitions include the same works. Despite the fact that the artist produced nearly 2,000 works in his short career, the same 150 or so works are in public circulation, while the majority of works remain inaccessible in private estates and dealer warehouses, surfacing only momentarily during auction season. Moreover, as a result of this lack of access to most works by the artist, the scholarship on Basquiat has been scant, consisting predominantly of short essays for museum and gallery exhibition catalogues rather than the more prototypical scholarly monograph.[31] Basquiat, nevertheless, continues to bring high prices on the auction block, where his 1981 canvas *The Field Next to the Other Road* recently sold for $37.1 million.[32]

In 1992, during the first retrospective of his work at the Whitney Museum of American Art, curator Richard Marshall lamented, "Jean-Michel Basquiat first became famous for his art, then he became famous for being famous, then he became famous for being infamous – a succession of reputations that often overshadowed the seriousness and significance of the art he produced."[33] As we have seen, Basquiat's overwhelming success in the economies of the art market was always tempered by his assertion of his symbolic value (and by extension his legitimacy as an artist). His repeated exploration of the boundaries between the art market and the art object produced a series of works that highlighted the problematic relationship among popularity, fame, and exploitation via an examination of the signs and symbols of commodification. Ironically, Foster and other critics of this moment missed Basquiat's careful critique of commodity culture and, by extension, his engagement with the conceptual art practices that they so admired.

Basquiat's most emphatic presence today continues to be in popular culture rather than in art museums. After his death, Basquiat's presence has been continually felt in the mass media. Julian Schnabel's biopic of the artist, first released in 1996 starring Jeffrey Wright as Basquiat and David Bowie as Andy Warhol, has since become a cult classic. The 2000 Cannes Film Festival saw the premier of *Downtown 81* – a film made in 1980–81 as *New York Beat*, which starred Basquiat as a struggling young artist. Ten years later, Tamra Davis and Becky Johnston released footage of a 1986 interview with Basquiat, which they later developed into the 2010 film *Jean-Michel Basquiat: The Radiant Child*, which was a selection for the Sundance Film Festival that year. Basquiat's drawings also populate the fronts of mass-produced T-shirts and hoodies, while rap superstars pay homage to him in their songs and supermodels brand themselves with his image.[34] There have even been rumors of a Broadway show: *Basquiat the Musical*.[35]

The record-breaking attendance at international exhibitions of Basquiat's work certainly proves the growing popularity of the artist. In the last five years alone, the work of Basquiat has been featured in blockbuster exhibitions in Basel, Paris, Bonn, Rio de Janeiro, Toronto, New York, and Spain.[36] These exhibitions – all curated by Dieter Buchhart – bring the work to wider audiences but leave few lasting effects. Beyond the chic opening parties and shiny exhibition catalogues, the same paintings and drawings circulate internationally ad nauseam but have yet to find permanent places in public institutions. The sustained study of this artist is often inhibited by the lack of a dedicated archive, as well as access to works.[37]

In the intervening years since Basquiat's death as his fame has grown, the world of pop culture and mass media has threatened to usurp the traditional processes of art-historical canonization. With the rapid circulation of images and ideas via social media, artists have become less dependent on the traditional image machine of art criticism for visibility. The line between popular and critical culture has become increasingly porous, as popular musicians like Björk secure solo exhibitions at major art institutions like MoMA and artists take up YouTube (e.g., Ryan Trecartin and Kalup Linzy) as a medium.[38] Similarly, the parameters of traditional art history have expanded, as scholars look more broadly at visual culture outside of the boundaries of traditional high art. The work of Basquiat exists in this expanded reality, where canonization is not performed by a singular formula, that is collector + institutions (galleries, museums, auction houses) + art criticism, but rather is a popularized process in which the media and pop culture visibility play a large role. In this new type of American canon, Jean-Michel Basquiat certainly has entered the pantheon.[39]

Notes

1 Jean -Michel Basquiat, "Art: From Subways to SoHo: Jean-Michel Basquiat," interview by Henry Geldzahler, *Interview*, January 1983. Repr. in Luca Marenzi et al., *Basquiat* (Milan: Edizioni Charta, 1999), lvii. Page references are to the 1999 publication.
2 Olav Velthuis, "Accounting for Taste," *Artforum* (April 2008): 306.

3 Lisbet Nilson, "Making it Neo," *ARTnews* 82 (January 1983): 64.

4 Michael Stone, "Off the Canvas: The Art of Julian Schnabel Survives the Wreckage of the Eighties," *New York Magazine* (May 18, 1992): 34.

5 Painters Julian Schnabel and David Salle, who were represented by gallerist Mary Boone, had grown so popular in the early 1980s that Boone gave each a dual exhibition, using her own first-floor gallery space at 420 West Broadway and the Leo Castelli Gallery upstairs. Castelli also lent his gallery to give double show coverage to Robert Longo (represented by Metro Pictures) and Sandro Chia (represented by Sperone Westwater). Nilson, "Making it Neo," 69.

6 In 1979, Citibank founded its art advisory service, offering its wealthiest clients assistance with building and managing large fine art collections.

7 Jeffrey Deitch, "Report from Times Square," *Art in America* 68 (September 1980): 61.

8 An August 1983 issue of *GQ* magazine included work by Basquiat in a fashion spread. References to Basquiat also appeared in the December 1985 issue of *Esquire* and he appeared on the MTV "ArtBreak" series in 1985.

9 Waldemar Januszczak, "Voodoo Meets Graffiti in the Twilight World of SAMO," *The Guardian* (August 25, 1988).

10 Jean-Michel Basquiat, "Waiting for Basquiat," interview by Isabelle Graw, *Wolkenkratzer Art Journal* (Frankfurt), no. 1 (January-February 1987), repr. in Luca Marenzi, et. al., *Basquiat* (Milan: Edizioni Charta, 1999), lxvii.

11 In published interviews, Basquiat reinforced the critical silence around African-American artists, citing instead artists like Franz Kline, Jasper Johns, Robert Rauschenberg, Cy Twombly, and Andy Warhol. Basquiat's portrait of African-American photographer James Vanderzee in 1982 was an exception.

12 *Julian Schnabel: Paintings 1975–1986* opened at the Whitney Museum of American Art in 1988 – a year after David Salle's retrospective exhibition.

13 Isabelle Graw, *High Price: Art Between the Market and Celebrity Culture* (Berlin: Sternberg Press, 2009), 21.

14 Ibid. "Symbolic value" is a term used by sociologist Pierre Bourdieu to describe value that exceeds measurement in economic or material terms.

15 Basquiat's aggression toward Boone is not limited to this one painting. Her name is also inscribed on a punching bag from 1984–85 – that is, a year before she and Basquiat parted ways. *Untitled (Mary Boone)*, 1984–85 is illustrated in *Jean-Michel Basquiat*, vol. 2, 3rd edition, edited by Richard D. Marshall and Jean-Louis Prat (Paris: Galerie Enrico Navarra, 2000), 59.

16 Jean-Michel Basquiat, *Henri Geldzahler*, c. 1981. Graphite, oil and paper collage on canvas, 28⅞ × 10 inches. Galerie Lucien Durand, Paris; Jean-Michel Basquiat, *Bruno in Appenzell*, 1982. Acrylic and oilstick on canvas mounted on tied wood supports, 55 × 55 inches. Collection Bruno Bischofberger, Zurich. Jean-Michel Basquiat, *Robert Fraser*, 1984. Acrylic and Xerox collage on canvas, 86 × 68 inches. Private Collection; Jean-Michel Basquiat, *Larry*, 1985. Acrylic, oilstick and Xerox collage on canvas, 88 × 77 inches. Private Collection, Paris. We might also read these portraits as part of a longer tradition of artists painting their dealers and collectors (e.g., Picasso's portraits of Kahnweiler and Gertrude Stein).

17 Phoebe Hoban, *Basquiat: A Quick Killing in Art* (1998. Reprint, New York: Penguin, 2004), 116.

18 Douglas Crimp, "The End of Painting," in *October* 16 (Spring 1981): 69–86.

19 These special issues were published in December 1982 and January 1983.

20 Hal Foster, "The Expressive Fallacy," *Art in America* 71 (January 1983): 80–83, at 137. Repr. in Foster, *Recodings: Art, Spectacle, Cultural Politics* (Port Townsend, WA: Bay Press, 1985).

21 On the other side of the debate, critics like Donald Kuspit, Hilton Cramer, and Suzi Gablik argued for expressionism's potential to reunify the fractured modern self, restoring faith to art via its emphasis on spontaneity and subjectivity. In their estimation,

conceptualism traded creative authenticity for intellectual cynicism. Donald B. Kuspit argues in favor of expressionism in "Flack from the Radicals: The American Case against German Painting," in *Expressions: New Art from Germany*, Jack Cowart, ed. (Saint Louis Art Museum, in association with Prestel Verlag, 1983), 137–52. See also Kuspit, *The New Subjectivism: Art in the 1980s* (Ann Arbor: UMI Research Press, 1988); Suzi Gablik, *Has Modernism Failed?* (London: Thames and Hudson, 1984).

22 Despite Foster's influence, many of the artists he celebrated in the 1980s are ironically much less well known today. Their absence from the canon proves the almost over-whelmingly powerful forces of the market and of popular culture in the last several decades.

23 For more discussion of the critical reception of both Jean-Michel Basquiat and Keith Haring, see Alison Pearlman, *Unpackaging Art of the 1980s* (Chicago: University of Chicago Press, 2003), 69–104.

24 I have argued elsewhere that Basquiat's critical reception suffered for its illegibility within the rigid conceptualism versus expressionism binary of 1980s art criticism. See Jordana Moore Saggese, *Reading Basquiat: Exploring Ambivalence in American Art* (Berkeley: University of California Press, 2014), 2–4, 114–18.

25 At the time of his death in 1845, Jackson owned approximately 150 people, who lived and worked on the Hermitage plantation. At the time of George Washington's death, the enslaved population at his Mount Vernon estate numbered 318 people. Basquiat also focuses on the image of Thomas Jefferson's Monticello plantation, which appears on the back of the U.S. five-cent piece, in his 1986 work on canvas *Monticello*.

26 For a more thorough discussion of the artist's use of appropriation, see Saggese, *Reading Basquiat*, 60–108.

27 Marshall, "Repelling Ghosts," in *Jean-Michel Basquiat*, Marshall, ed. (New York: Whitney Museum of American Art, 1992), 16.

28 Ibid., 16.

29 For a more detailed discussion and analysis of this work, see Saggese, *Reading Basquiat*, 41–44.

30 Cyril Alred, *Akhenaten and Nefertiti* (New York: Brooklyn Museum, distributed by Viking Press, 1973), 49.

31 Saggese, *Reading Basquiat* was the first monograph on the artist published by an academic press.

32 Brian Boucher, "$81.9 Million Rothko Leads Christie's Frenzied $658.5 Million Contemporary Art Sale," *Artnet News* (May 13, 2015). https://news.artnet.com/market/christies-658-million-sale-record-rothko-89-million-297476.

33 Marshall, "Repelling Ghosts," 15.

34 In 2015, for example, the U.S.–based clothing retailer The Gap collaborated with Junk Food Clothing Company to issue a collection of sportswear with licensed designs by Jean-Michel Basquiat and Keith Haring. The rapper Jay-Z's 2013 album, *Magna Carta Holy Grail*, included several references to Basquiat, such as the line "I'm the new Jean-Michel" in the second track: "Picasso Baby." See also Bianca Soldini, "Ruby Rose unveils a tribute tattoo of controversial street artist Jean-Michel Basquiat after she was criticized for inking his work across her chest," *Daily Mail*, June 18, 2014, http://www.dailymail.co.uk/tvshowbiz/article-2661861/Ruby-Rose-unveils-tribute-tattoo-controversial-street-artist-Jean-Michel Basquiat-criticised-inking-work-chest.html#ixzz3dMP9bhF1.

35 In 2013, there were several reports of a private reading of the script. The credits for *Basquiat the Musical* include Chris Blisset (music and lyrics), Matt Uremovich (lyrics), and Larry Tobias (book). The musical is to be directed by Paul Stancato, who also conceived the show. See "Eric LaJuan Summers and Felicia Finley to Star in BASQUIAT THE MUSICAL Reading, 6/24," *Broadway World*, June 10, 2013. http://www.broadwayworld.com/article/Eric-LaJuan-Summers-and-Felicia-Finley-to-Star-in-BASQUIAT-THE-MUSICAL-Reading-624–20130610

36 For example, the Basquiat retrospective that traveled to the Musée d'Art Moderne de la Ville de Paris in 2010 drew 360,000 visitors – a record for that institution at the time.

The *Now's the Time* exhibition, mounted at the Art Gallery of Ontario in 2015, drew more than 150,000 people, placing it in the top fourteen of the AGO's most popular exhibitions.

37 The Estate of Jean-Michel Basquiat is currently managed by the artist's two sisters, who took over as executors in 2014, after the death of their father Gerard Basquiat. What remains of the artist's papers and personal records is divided between private collectors and the estate. Unlike many other notable American artists, there is no dedicated publicly accessible archive for Basquiat.

38 The exhibition *Björk*, curated by the director of MoMA PS1, Klaus Biesenbach, was on display at the Museum of Modern Art, New York from March 8 until June 7, 2015.

39 This line is an homage to and a revision of the last line of Hoban's book on the artist, where she writes, "If fame was indeed his primary goal, Basquiat has entered the pantheon." Hoban, *Basquiat*, 344.

Bibliography

Alred, Cyril. *Akhenaten and Nefertiti*. New York: Brooklyn Museum, distributed by Viking Press, 1973.

———. "Art: From Subways to SoHo: Jean-Michel Basquiat," Interview by Henry Geldzahler. *Interview* (January 1983): 44–46. Repr. Luca Marenzi et al., *Basquiat* (Milan: Edizioni Charta, 1999).

Basquiat, Jean-Michel. "Waiting for Basquiat," Interview by Isabelle Graw. *Wolkenkratzer Art Journal* (Frankfurt) no. 1 (January–February 1987): 44–51, 106–107.

Boucher, Brian. "$81.9 Million Rothko Leads Christie's Frenzied $658.5 Million Contemporary Art Sale," *Artnet News* (May 13, 2015). https://news.artnet.com/market/christies-658-million-sale-record-rothko-89-million-297476

Brentjes, Burchard. *African Rock Art*. New York: Clarkson N. Potter, 1970.

Crimp, Douglas. "The End of Painting," *October* 16 (Spring 1981): 69–86.

Deitch, Jeffrey. "Report from Times Square," *Art in America* 68 (September 1980): 58–63.

Foster, Hal. "Between Modernism and the Media," *Art in America* 70 (Summer 1982): 13–17.

———. "The Expressive Fallacy," *Art in America* 71 (January 1983): 80–83, at 137. Repr. in Foster, *Recodings: Art, Spectacle, Cultural Politics* (Port Townsend, WA: Bay Press, 1985).

Gablik, Suzi. *Has Modernism Failed?* London: Thames and Hudson, 1984.

Glueck, Grace. "On Canvas, Yes, but Still Eyesores," *New York Times* (December 25, 1983).

Graw, Isabelle. *High Price: Art Between the Market and Celebrity Culture*. Berlin: Sternberg Press, 2009.

Hoban, Phoebe. *Basquiat: A Quick Killing in Art*, 1998. Repr. Penguin, 2004.

Hughes, Robert. "Three from the Image Machine: In SoHo, a Trio of Rising Reputations but Uneven Talents," *Time* (March 14, 1983).

Januszczak, Waldemar. "Voodoo Meets Graffiti in the Twilight World of SAMO," *The Guardian* (August 25, 1988).

Kramer, Hilton. "Expressionism Returns to Painting," *New York Times* (July 12, 1981).

Kuspit, Donald. "Flack from the Radicals: The American Case against German Painting," *Expressions: New Art from Germany*, Jack Cowart ed. Saint Louis: Saint Louis Art Museum, in association with Prestel Verlag, 1983, 43–55.

———. *The New Subjectivism: Art in the 1980s*. Ann Arbor: UMI Research Press, 1988.

Marshall, Richard, D., ed. *Jean-Michel Basquiat*. Exh. Cat. New York: Whitney Museum of American Art, 1992.

Nilson, Lisbet. "Making It Neo," *ARTnews* 82 (January 1983): 62–70.

Pearlman, Alison. *Unpackaging Art of the 1980s.* Chicago and London: University of Chicago Press, 2003.

Saggese, Jordana Moore. *Reading Basquiat: Exploring Ambivalence in American Art.* Berkeley: University of California Press, 2014.

Stone, Michael. "Off the Canvas: The Art of Julian Schnabel Survives the Wreckage of the Eighties," *New York Magazine* (May 18, 1992).

Velthuis, Olav. "Accounting for Taste," *Artforum* (April 2008): 306.

3

SHEILA HICKS AND THE CONSECRATION OF FIBER ART

Elissa Auther

This chapter examines the reception of fiber in the art world through a case study of the weavings and three-dimensional fiber sculpture of Sheila Hicks, Fig. 3.1. In the late 1960s and 1970s, an extraordinary number of artists working in the U.S. – including post-minimalists such as Eva Hesse and Robert Morris, fiber artists such as Sheila Hicks and the Swiss-born but New York–based Françoise Grossen, and feminists like Judy Chicago and Faith Ringgold – experimented with or adopted fiber as a primary medium. Such work demonstrated a profound shift in artists' interest in and approach to fiber, which previously had been dismissed for its historical associations to "the decorative," "craft," or "women's work." However, the use of fiber in each of these spheres of practice – whether post-minimalist, fiber-based, or feminist – was received in dramatically different ways, variously shaped by institutional, curatorial, and other local, social forces tied to the longstanding art/craft divide. For artists self-identifying or labeled as "fiber artists," whose backgrounds in textiles and weaving positioned them outside the mainstream art world in this period, the art/craft divide – that is, the subordination of craft to art or its outright dismissal as "non-art" – was an obstacle to professional recognition. The primary strategy adopted by fiber artists and curators of the period to negotiate this situation involved redefining fiber as a medium of "high art" rather than craft. Although this strategy met with limited success from the 1960s through the 1980s, artists such as Sheila Hicks still helped set the stage for the art world we inhabit today in which the medium of fiber is used much more freely by artists, often without regard to the debates surrounding the hierarchy of art and craft that stymied the careers of an older generation. And some artists of this older generation, like Hicks, have experienced a new surge of interest in their work within this changed context, highlighting in the process a set of factors important to artistic consecration and canonization.

FIGURE 3.1 Sheila Hicks, *The Principal Wife Goes On*, 1968. Linen and silk, dimensions variable. Collection of the Museum of Arts and Design. Courtesy of Museum of Arts and Design.

In the case of Hicks, the process of elevating one's work from craft to art was not an overnight maneuver. This case study of the reception of Hicks's work begins with its debut in the 1960s in craft- and design-based contexts and ends with her inclusion in the prestigious 2014 Whitney Museum of American Art's Biennial, a career-making exhibition for artists in the contemporary art world. The extended trajectory of the reception of Hicks's work addresses a number of questions about the social and institutional dynamics that determine how art is defined and valued and broadly addresses the role of museums, critics, curators, dealers, scholars, and even artists in the consecration of art.

Shortly before Hicks's appearance in the 2014 Whitney Biennial, a colleague of mine remarked that her new found visibility in the contemporary art world was no surprise, as it seemed to fit the pattern of the revival of interest in the work of women artists in their later years, from Lynda Benglis to Yoko Ono (to name only the first two that come to mind). The explanation seems logical enough except for the fact that Hicks's work was, until very recently, hardly known (as opposed to simply forgotten) in the contemporary art world. By contrast, Hicks's work is renowned and

admired within the fields of craft and design, where she has worked steadily since the 1960s. Hence, the rush of attention coming from the contemporary art world is more accurately defined as a new market for her work, and I would argue that for this new market to appear in a realm where traditional craft media have been regarded with skepticism if not outright disdain, additional forces beyond those behind the typical revival of a long-established but overlooked woman artist are at work.

In my study about the hierarchy of art and craft in the American art world, *String, Felt, Thread*, I examined the reception of artists working in fiber through three case studies: that of fiber artists, process or post-minimalist artists, and feminist artists.[1] Despite their very different relations to power in the art world and orientations toward the medium of fiber, these artists utilized it with the shared aim of altering the dominant definition of art of the 1960s and 1970s. For instance, fiber artists such as Sheila Hicks and Françoise Grossen used fiber to create non-woven, three-dimensional work that, in their view, liberated the medium from the loom and thereby released their work from the confines of fiber's historically low position in the art world. Their goal was to win recognition for fiber as a medium with the same expressive power attributed to the traditional media of painting or sculpture. By contrast, artists associated with anti-form, process, or post-Minimalist art of the 1960s and 1970s such as Robert Morris and Eva Hesse found forms of fiber such as rope or felt attractive for its ordinariness and other "non-art" attributes, the very attributes fiber artists struggled to free themselves of. Indeed, to the extent that they embraced fiber's everyday utility, the post-Minimalists worked at cross-purposes with fiber artists, undermining the latter's belief in art's autonomy, preciousness, and durability. Finally, feminist artists took yet another approach to fiber, openly embracing fiber's relationship to craft and women's artistic traditions. For Judy Chicago and Harmony Hammond, among others, fiber, in the form of found textiles, quilts, or needlework, offered evidence of a distinct female artistic tradition that challenged the legitimacy of the hierarchy of the arts that subordinated craft to art.

Hicks's trajectory and reception are representative of the formation of the field of fiber art in the 1960s and 1970s and its bid for legitimacy as fine art as opposed to craft, design, or interior décor. Her earliest exhibitions took place in a variety of contexts, including the Knoll showroom in Mexico City (1961), the Antonio Souza Gallery in Mexico City (1961), the Knoll showroom at the Chicago Merchandise Mart (1963), and the Department of Textiles at the Art Institute of Chicago (1964). Her work entered the collection of the Museum of Modern Art in 1960, but in the Department of Architecture and Design. By the mid-1960s, Hicks was fulfilling commissions for large wall- and room-sized installations at various corporate headquarters, from the Ford Foundation (1967) to CBS's New York headquarters.[2]

There were two defining moments for Hicks in the late 1960s. The first came in 1967 when she was invited to exhibit in the prestigious *Biennale Internationale de la Tapisserie* in Lausanne, Switzerland. Hicks's submission caused an existential crisis within the organization. Hicks recalls,

> I showed something I had just made in Chile, out of linen, with clusters of long, free-hanging cords suspended from the ceiling . . . At the opening a

television crew arrived, led by a certain Madame Cuttoli, a patron of tapestry and a fabulous character. She walked up to me and said in French, 'Mademoiselle, I hear you are exhibiting a tapestry,' I replied, 'Yes, Madame, here it is.' And she said, 'I do not see a tapestry.' It became a running joke . . . What is tapestry and what is not?

Hicks continued,

I was moving around between different techniques – of stitching, wrapping, braiding, weaving, twining – exploring all these different thread languages . . . so my work was equated with a kind of graffiti . . . For some, I was persona non grata, and for others I was the heroic pirate.[3]

A second break that further ensconced Hicks within the avant-garde of the fiber movement was the inclusion of her work in the 1969 MoMA group show *Wall Hangings*. This groundbreaking exhibition was curated by Mildred Constantine from the department of Architecture and Design, the figure behind Hicks's MoMA acquisition and the commission for CBS's New York City headquarters. *Wall Hangings* featured an international stable of artists whose work radically reconsidered weaving, and thus the potential of fiber, as a material of high art. Radical as it was as a challenge to deep-rooted prejudices toward fiber as craft, *Wall Hangings* received only a single review in the national art press, commissioned from the sculptor Louise Bourgeois for the magazine *Craft Horizons*. Bourgeois's response to the works in the exhibition, which she argued, "rarely liberate themselves from decoration,"[4] illustrates what is sometimes referred to in reception theory as the "horizon" or structure of expectations that, in this case, members of the art world brought to works in fiber (and by extension craft) in this period.[5] The pejorative connotations of the term "decoration" or "the decorative" situated the work as the opposite of art, and in an interview the following decade, Bourgeois herself warned, that "when you work in the school of abstraction, you have to avoid . . . the decorative,"[6] demonstrating her familiarity with the category as a threat to the identity and critical purpose of art.[7] Was it Constantine's institutional and professional associations with the field of design, *Wall Hangings* startling new approach to a medium historically dismissed as a feminine craft, Bourgeois's own fear of her work being engulfed by the decorative, or the intersection of these factors that resulted in Bourgeois's lukewarm reception of this work? All of the above? Bourgeois's family's history in the field of tapestry restoration, as well as the haptic, sensual quality of her work of the mid- to late 1960s, made her an interesting, potentially sympathetic critic. Indeed, it was her family background and her inclusion in exhibitions such as Lucy Lippard's *Eccentric Abstraction* of 1966, which featured a number of works in soft, malleable materials such as fiber, that led the editor of *Craft Horizons* to commission the review from Bourgeois. Nevertheless, she concluded, "A painting or a sculpture makes great demands on the onlooker at the same time that it is independent of him. These weaves, delightful as they are, seem more engaging and less demanding. If they must be classified, they would fall somewhere between fine and applied art."[8]

Regardless of its lukewarm reception in the art world, *Wall Hangings* initiated a flurry of fiber-based exhibitions and books in the 1970s and 1980s that participated in the creation of the American fiber movement through the shared goal of legitimizing fiber as a medium of high art.[9] Yet despite the energy expended over the decade, the positive reception of this work outside of the fiber movement itself was slim, and the campaign plateaued by the late 1980s. I argue elsewhere that it was the feminist elevation of craft in the same period – a project that politicized the hierarchy of art and craft – that proved more successful at challenging the art world's prejudices against fiber than the efforts of supporters of the fiber movement.[10] To be sure, the art world within which feminist artists sought recognition despised most of their craft-themed work at the time of its production. Nevertheless, their exposure of the gendered and racial politics maintaining the subordination of craft to art as well as the related insistence that women's experience and artistic traditions were legitimate subjects for art making laid the foundation for fiber's acceptance as a fine art medium. The feminist objective – to deflate the negative associations surrounding craft – played an important role in what would become by the early 1990s a very changed art world vis-à-vis the art/craft divide.

The evolution of art-world attitudes towards craft picks up again in the early 1990s with the appearance of the widespread embrace of fiber in contemporary art. Numerous artists could be illustrated here, but perhaps most notable is Louise Bourgeois, who in 1990 began cutting up and sewing a lifetime of stored clothing, linens, and fabric remnants to make a large body of new work consisting of stuffed heads, human figures, reproductions of her slender, stacked sculptures from the 1950s, and unique fabric-on-fabric books, Fig. 3.2.[11] This turn to fiber suggests that the boundary once separating art from craft and presumably informing her earlier rejection of fiber-based art in 1969 had all but disappeared.

The embrace of fiber by artists in the 1990s creates a picture of a significantly altered art world. Three interconnected forces fueling the more hospitable environment for fiber in art can be isolated. The first concerns the feminist art movement's legitimization of women's everyday experience as a subject for art, which gave artists permission to draw openly from not only craft's aesthetic properties but also its social and cultural meanings pertaining to gender. This move away from a formalist or self-referential approach to materials resulted in an unprecedented expansion of artistic form and practice. Related to this expansion, there was the rise of installation art in the 1990s, a genre that, like feminist art, allowed artists to further draw upon a medium's extra-aesthetic associations in the production of meaning. Related to this expansion, Bourgeois spoke about her fiber-based work as expressing some of the most time-honored extra-aesthetic associations connected to the medium – its connection to history and memory. "I want to re-experience the past, I try to reconstruct it," she stated.[12] Regarding the fabric books, Bourgeois's longtime assistant Jerry Gorovoy explained that for her, "They are about the idea of restoration, reconciliation, of holding things together in the face of fear of disintegration."[13] Finally, amongst curators of contemporary art in the 1990s, the relevance

FIGURE 3.2 Louise Bourgeois, *Untitled*, 2002. Tapestry and aluminum, 17.96 × 11.96 × 11.96 in. (43.1 × 30.4 × 30.4 cm). Courtesy Cheim and Reid, New York.

of the modernist preoccupation with hierarchies and boundaries that historically categorized art in craft media as non-art, kitsch, or mere decoration began to wane. "In the '90s," Okuwi Enwezor argued,

> Contemporary art took an entirely new direction, as a coalescing of postcolonialism and globalization changed the principles under which curatorial practice advanced artistic and critical analyses of aesthetic and cultural canons. There was a shift in curatorial language from one whose reference systems belonged to an early twentieth-century modernity to one more attuned to the tendencies of the twenty-first century.[14]

One such tendency was the use of fiber in contemporary art, especially in the case of artists raised in cultures where textiles are not classified as craft or non-art. Artists Kimsooja, Sheela Gowda, and Yinka Shonibare (South Korean, Indian, and

Nigerian, respectively), who have variously thematized issues of loss, migration, race, and colonialism through their use of fiber, immediately come to mind.

The changed cultural context created by these factors is essential for understanding Hicks's expanded reception and her new market in the contemporary art world, but it still took the actions of various art-world actors from different professional spheres to create the increase in recognition she enjoys today outside of craft and design circles. This new level of recognition begins with a particular body of work, a book, and an exhibition. Together, this constellation of objects, events, and the actors behind them redirected Hicks's work away from the world of textiles and design to the more high-profile, and still more valued world, of contemporary art. The body of work in question is the more than 1,000 miniature weavings Hicks has produced over the course of her career as visual recordings of her travels, formal experiments with color, texture, and form, and preliminary notes for large-scale commissions and works. Some 150 of these works – what Hicks refers to as her "minimes" – were exhibited in 2006 at the Bard Graduate Center (BGC) Gallery, an institution dedicated to, like the Graduate Center itself, the history of material culture, design, and the decorative arts. The exhibition was sponsored by Target, one of Hicks's corporate clients, and curated by BGC's director and chief curator Nina Stritzler-Levine. The exhibition was the first to bring the miniatures together as a critical mass, but based on my casual (admittedly unscientific) conversations with colleagues in the contemporary art world, it was the exhibition's catalog, *Sheila Hicks: Weaving as Metaphor* or more specifically, its exquisite design (it is an artwork in and of itself) that captured their attention, Fig. 3.3.[15] Designed by Irma Boom, the well-known Dutch graphic designer, the book's dimensions – 6 × 8 inches – mirrors the scale of Hicks's miniature weavings. Its intimate size is complemented by a soft rag paper, which produces a rich, haptic quality that is psychologically and culturally associated with the handmade. Its monochromatic white cover and eye-catching serrated, deckle edge was mentioned repeatedly by my informants as the feature that led them to pick up the book in the first place.[16] It too visually relates to the seemingly casual yet artful quality of the weavings inside. A year after its publication, months after it had sold out, the book won a gold medal at the 2007 Leipzig Book Fair for the "Most Beautiful Book in the World."[17]

Joan Simon, independent curator and contributing author to the book *Weaving as Metaphor*, went on to co-curate the artist's – amazingly – first retrospective, which opened at the Addison Gallery of American Art at Phillips Academy in 2011.[18] The exhibition and its accompanying catalog *Sheila Hicks: 50 Years* provided the first overview of the artist's large-scale work designed to reach a broad art-world audience.[19] The exhibition continued to the ICA Philadelphia, which was also crucial to Hicks's exposure and "discovery" within elite circles of the contemporary art world totally unaware that such work existed, let alone had been produced as early as the mid-1960s. The show was brought to the ICA Philadelphia by curator Jenelle Porter, who had encountered Hicks's work through BGC's *Weaving as Metaphor*. Porter's disregard for the baggage that usually surrounds the contemporary art world's skepticism toward craft illustrates the waning relevance of modernist

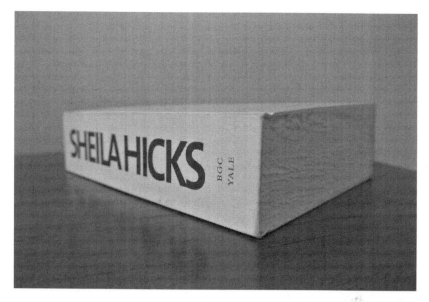

FIGURE 3.3 *Sheila Hicks: Weaving as Metaphor*, 2006. Exhibition Catalogue. Courtesy Elissa Auther.

theoretical preoccupations over the art/craft divide at least in some curatorial circles. Whereas Hicks's Bard exhibition was reviewed exclusively within the pages of journals and magazines devoted to the field of fiber and craft – from *FiberArts* to *Textile* – her retrospective made the pages of *Artforum*, *ArtNews*, and the *New York Times* in addition to these medium-specific venues. Her work was positively assessed for its relationship to post-minimalist approaches to materials and process, and Hicks was praised for her "omnivorous curiosity and . . . allergy to academic distinctions."[20]

Thus far I have considered the role of curators, critics, art historians, and one graphic designer in the creation of a new visibility for Hicks's work within the contemporary art world. However, young, contemporary artists also played an important role in this new formation, and the case of Hicks provides a rare opportunity to consider the importance that artists themselves play in the reception of their peers or elders within the contemporary art world. For Hicks, the first opportunity came in the form of a group exhibition titled *Come Through* that opened in the summer of 2009 at Sikkema Jenkins & Co., a principal player in the high-profile world of contemporary art galleries in New York City's Chelsea district. The show was curated by artists Fabienne Lasserre and Molly Smith and included their work alongside that of Hicks, Ree Morton, Jessica Dickinson, Siobhan Liddell, and Emily Do. Smith graduated in 1999 from the Rhode Island School of Design, an institution with artists on the faculty working in fiber and textiles, and had been exposed to Hicks's work as a student.[21] It was she who introduced Hicks to Lasserre. As Lasserre explained to me, to her (and Smith), Hicks's work reflects a

life-long practice of flexibility and cross-disciplinarity, a characteristic of her career that worked against her in the art world she came up in but that is now very attractive to a younger generation of artists much more comfortable with hybridity and open about working between and across disciplines, categories and fields, even if the art market has yet to fully embrace it. For Lasserre, Hicks's work "operates on and between the edges of various disciplines and stretches these categories."[22] She continues,

> The work of Sheila [Hicks] and [Ree] Morton [the elders in the group] toy with the decorative, the domestic, and fantasy (all too often considered easy, backwards, regressive) and make radical strides in form and format. The materials they use feel close to home and familiar, yet the results are complex, sophisticated, and disconcerting. That play with the familiar, that prosaic use of material, is . . . important to us. For Molly and I, Hicks . . . offered a very different definition of success as an artist than the one prevailing in today's market-driven art world . . . [Her] practice seems flexible and self-generating . . .; as much an outlook on life as on art.[23]

It's also very telling that Hicks was paired with Ree Morton (who died at the age of 41 in 1977) as the elder stateswomen of the exhibition. For Lasserre and Smith, both artists represent an approach to abstraction and process that openly embraced personal experience as legitimate subject matter for art. In *String, Felt, Thread*, I examined fiber artists like Hicks and feminist artists like Ree Morton in separate case studies. In the period I examined – the 1960s and 1970s – it made sense given the wall that isolated the two groups from each other in the art world and their different sensibilities toward overturning or deflating the hierarchy of art and craft in that period. That Lasserre and Smith can bring these two artists together in an exhibition in 2009 (which was inconceivable in the period I examined) on the basis of a freshly perceived, shared interest in process, everyday materials, personal content, and artistic practice as a form of lifestyle provides interesting evidence for the agency of artists in a system or network of market-oriented power relations otherwise viewed as antagonistic to their interests. The very rise of the artist-curator, organizing exhibitions in museums and elite galleries of contemporary art in the past ten years, suggests the extent to which this antagonism has evaporated.[24] It also illustrates the extent to which the divisions that once divided artists like Hicks from Morton are now meaningless to artists educated in a post-disciplinary context. In a 2011 *New York Times* profile on Hicks, Alison Gingeras, then chief curator at the Palazzo Grassi in Venice confirmed: "[Her work] has mostly been received and absorbed into a craft and design world. But so much of it speaks to what younger artists are thinking about [now]."[25] If the work included in *Come Through* is any indication, one thing on their minds is the innovative use of humble materials that flouts historical prescriptions defining the high and the low in art and culture. Critic Lauren O'Neill-Butler, writing for *Artforum* on the exhibition *Come Through*, saw in Hicks's work "a meditation on the experience of following one's intuition

without the expectations for a definitive result or conclusion."[26] The statement accurately reflects Hicks's working philosophy and also resonates with a generation of artists and viewers fatigued by the demands of a market that seems to call for ever-higher production values in terms of scale and materials, often necessitating the use of outside fabricators.

In 2011, Hicks was invited to join the roster at the prominent Chelsea gallery of contemporary art, Sikkema Jenkins & Co., a first for an artist of her generation working in fiber. As I have demonstrated, getting to this point involved the efforts of numerous players in the art world whose positions and relations to the market and other centers of cultural power mirror the full social structure of the art world. All of them – from curators to critics to book designers to other artists – affected Hicks's status and recognition in ways that expose the way art moves through a conflicted but ever-changing world. However, the question of outcomes for Hicks and her place within the canon still remains.

Despite numerous queries, I was not able to ascertain why Sikkema Jenkins & Co. invited Hicks to join the gallery, and it is difficult to pinpoint exactly how her work complements the gallery's "brand" beyond the fact that it is known for, among other qualities, taking the time to develop the careers of women and artists of color who might otherwise be overlooked in today's flashy market.[27] Described another way, Sikkema Jenkins & Co.'s brand is non-celebrity artists at the forefront of the field. The only thing that is certain is that Sikkema Jenkins & Co. recognized an opening in the contemporary art market for Hicks's work and valued the work accordingly, that is to say at prices higher than what the artist's work would sell for as craft or design.[28]

There is evidence that the gallery's bet on Hicks has resulted in a transformation of her reputation and the legitimacy of her work in fiber as contemporary art. For instance, since Hicks's association with Sikkema Jenkins & Co., her work has been exhibited in a wide range of contemporary art contexts and venues, most notably the 2014 Whitney Museum of American Art Biennial, a vehicle of consecration if there ever was one in American contemporary art. Other prestigious exhibitions include a solo installation at the Palais de Tokyo in Paris, the *International Biennale of Contemporary Art* in Cartagena de Indias, Columbia, the group show *Pliage/Fold* at Gagosian Gallery in Paris, and the groundbreaking survey exhibition *Fiber Sculpture – 1960s to the Present* at the ICA Boston, among many other trend-setting venues catering to contemporary art audiences.[29] Beyond exhibitions that included Hicks's work, in 2014 the autumn auction season in London opened with the "selling exhibition" *Stitched Up* at Sotheby's. *Stitched Up* was described by the auction house as "a benchmark exhibition exploring the growing movement towards the use of fabrics and techniques such as weaving, knitting and embroidery in contemporary art today."[30] Although it did not include the work of Hicks, the exhibition is important evidence of the market seeking to capitalize on a contemporary trend that in turn creates additional visibility or "buzz" around the use of fiber in art.

For the 2014 iteration of the Whitney Biennial, the three floors of the exhibition were individually organized, and Hicks was included in the section curated

by Michelle Grabner, an artist and professor of painting at the School of the Art Institute of Chicago. Grabner's painting practice, which is inspired by the repetitive patterns found throughout our everyday world – from the handmade crochet of the afghan to the simple, plain weave of the dish towel – shares an affinity with textile and craft cultures as well as associations to the domestic sphere and the decorative. Not surprisingly, given these interests, Grabner included Hicks alongside others who have been "fundamentally important to me as an artist over the years."[31] Her inclusion of Hicks's monumental free-hanging work, *Pillar of Inquiry/ Supple Column* (2013–14)[32] was about highlighting it within a Biennial context that emphasized how artists are currently working across disciplines in a wide array of materials. Grabner boldly integrated ceramics and fiber (by artists with and without formal training in these mediums) alongside painting and conceptual art, and her curatorial vision represents another important example of an artist shaping the conversation about what counts as art today. Like Smith and Lasserre, who curated the 2009 exhibition at Sikkema Jenkins & Co., Grabner conceived of her section of the Biennial as self-reflexive space that opened up a dialogue between artists who might otherwise never share the same public stage. In doing so, she fostered a more dynamic discussion about cross-disciplinarity and the different ways contemporary artists approach the use of traditional craft media today.

Significantly, Hicks's piece for the Biennial, *Pillar of Inquiry/Supple Column* (2013–14), was acquired by MoMA for the modern and contemporary collection, whereas the museum's previous acquisitions of her work beginning in the 1960s were made for the Department of Design and Architecture. The Department of Design and Architecture at MoMA continues to collect Hicks's work, most recently acquiring *Ribbons* (1964). Adding her work to the permanent collection of modern and contemporary art reflects the dramatically changed reception of fiber as a legitimate medium of art. In addition, given Hicks's long-standing membership within craft and design circles, these recent MoMA acquisitions demonstrate how she uniquely bridges the art/craft divide without having to give up one position for the other, a privilege not available to her or her fiber-art peers in the 1960s and 1970s but a more accurate picture of artistic practice today.

In an interview on the occasion of her inclusion in the Whitney Biennial, Hicks brilliantly turns the table on this whole issue of hierarchy and exclusion in the art world by making the center (the contemporary art world, to which she refers as a "cloistered" realm of practice) look more like the periphery. When asked why and how she resisted changing her practice to better fit the contemporary art market over the past fifty years, Hicks answered,

> Well I haven't been in [the contemporary art world] . . . And a way of not being in it was to blow that scene. Don't forget I've been working in the trenches, not in the art milieu. I've been working in factories, design offices, and on architectural projects. I haven't been cloistered in the so-called art world with its terminology and its hierarchies.[33]

The interview goes on: "And as much as you haven't been cloistered, have you felt excluded?" In her characteristically witty style of rejoinder that deflects the politics behind what I have addressed as the hard-won respect for fiber in art over the past forty years, Hicks answers, "I've always been pleasantly surprised to be included."[34]

Notes

1 Elissa Auther, *String, Felt, Thread and the Hierarchy of Art and Craft in American Art* (Minneapolis: University of Minnesota Press, 2010).

2 These commissions continue today. See for instance Hicks's work, *May I Have This Dance* (2002–3) for Target Corporation Headquarters in Minneapolis (de-installed and reconfigured in 2010).

3 Sheila Hicks, as quoted in Leslie Camhi, "A Career Woven From Life," *New York Times* (March 31, 2011).

4 Louise Bourgeois, "The Fabric of Construction," *Craft Horizons* 29 (March 1969): 33.

5 See in particular, Hans Robert Jauss, *Toward an Aesthetic of Reception*, trans. Timothy Bahti (Minneapolis: University of Minnesota Press, 1982).

6 Marsha Pels, "Louise Bourgeois: A Search for Gravity," *Art International* 23, no. 7 (October 1979): 47.

7 On the use of the term "decorative," particularly in this context, see Auther, *String, Felt, Thread*.

8 Louise Bourgeois, "The Fabric of Construction," 33.

9 See, among many other titles, Mildred Constantine and Jack Lenor Larsen, *Beyond Craft: the Art Fabric* (New York: Van Nostrand Reinhold, 1972); *Deliberate Entanglements* (Los Angeles: University of California Los Angeles Art Galleries, 1971); Irene Waller, *Thread! An Art Form* (London: Studio Vista, 1973); *Fiberworks* (Cleveland: The Cleveland Museum of Art, 1977); *Fibre Structures. An Exhibition of Contemporary Textiles* (Denver: The Denver Art Museum, 1972); *The Flexible Medium: Art Fabric from the Museum Collection* (Washington, DC: The Renwick Gallery of the National Museum of American Art, Smithsonian Institution, 1984).

10 In chapter 3, Auther, *String, Felt, Thread*.

11 Additional artists utilizing fiber in the 1990s include Do-Ho Suh (South Korea), Ghada Amer (Egypt), Charles LeDray (US), Anne Wilson (US), Sheila Pepe (US), Kimsooja (South Korea), Yinka Shonibare (Nigeria), Sheela Gowda (India), and Mark Newport (US), among others.

12 Louise Bourgeois, as quoted by Amy Newman, "Louise Bourgeois Builds a Book From the Fabric of Life," *The New York Times* (October 17, 2004). See also Newman, *Louise Bourgeois: Stitches in Time* (Dublin: Irish Museum of Modern Art, 2004).

13 Jerry Gorovoy, as quoted by Newman in "Louise Bourgeois Builds a Book."

14 Okwui Enwezor, "History Lessons," *Artforum* 46, no. 1 (September 2007): 382.

15 Nina Strizler-Levine, ed., *Sheila Hicks: Weaving as Metaphor*, (New York: Bard Graduate Center for Studies in Decorative Arts, Design & Culture, 2006).

16 The book was distributed widely throughout museum bookstores in the US.

17 On Boom's design and the award, see Alice Rawsthorn, "Reinventing the LOOK (EVEN SMELL) OF A BOOK," *New York Times*, March 18, 2007.

18 The exhibition was co-curated with Susan Faxon of the Addison Gallery of American Art, and ran through November 5, 2010 to February 11, 2011. For the press release, which emphasized Hicks's work as a bridge "between artist and artisan," see https://www.andover.edu/Museums/Addison/AboutUs/AddisonUpdates/Documents/PR_SheilaHicks.pdf.

19 Strizler-Levine, *Sheila Hicks: 50 Years* (New Haven: Yale University Press, 2010).

20 Camhi, "A Career."

21 Smith was awarded an MFA from Columbia University in 2004.

22 Fabienne Lasserre, email correspondence with the author, 2 December 2012.
23 Ibid. To continue, for Lasserre, Hicks represents a "strong commitment to art as a practice . . . a way of viewing the world rather than something to be looked at." In Hicks's own words: "What counts is your level of engagement, not your level of accomplishment," Sheila Hicks, as quoted in Leslie Camhi, "A Career."
24 On the subject, see the online project edited by Elena Filipovic, *The Artist as Curator* (London: Intellect, 2015).
25 Alison Gingeras, as quoted in Camhi, "A Career."
26 Lauren O'Neill-Butler, "Come Through," *Artforum.com*, September 26, 2010.
27 For a good analysis of how dealers benefit from silence and other forms of inaccessibility in the creation of status and power, see sociologist of art Sarah Thornton's *Seven Days in the Art World* (New York: W. W. Norton & Company, 2009). Sheila Hicks was equally resistant to answering these questions.
28 Obviously, Sikkema Jenkins & Co., like any other gallery, adds artists to their roster when they are confident they can sell their work. Currently, prices for contemporary art far exceed those for any other segment of the market, including studio craft, another market in which Hicks's work circulates. On the subject, see Don Thompson, *The $12 Million Stuffed Shark: The Curious Economics of Contemporary Art* (New York: Palgrave Macmillan, 2010).
29 ICA Boston's exhibition *Fiber Sculpture – 1960s to the Present*, curated by Jenelle Porter, was a particularly significant effort to bring to light artists working in fiber in the 1960s and 1970s who had been forgotten alongside the work of contemporary artists working with fiber. About her curatorial vision, Porter writes, "*Fiber* seeks to revise entrenched histories by assembling significant works by artists who have been essential to transforming the material definitions of fiber. . . . By turning to the works themselves to explore process and extrapolate meaning, this exhibition aligns with current critical trends toward disconnecting medium from discussions of art or craft, gendered limitations, and hierarchical summaries." Jenelle Porter, ed., *Fiber Sculpture – 1960s to the Present*, (Munich: Prestel, 2014), 14.
30 *Stitched Up*, Press Release, Sotheby's S|2 Presents, September 3–26, 2014. http://files. shareholder.com/downloads/BID/266423315x0x774799/D5F02A59–90A2–4FAA-851F-9CFB449FE7B4/774799.pdf. *Stitched Up* ran from September 3 through 26, 2014, and was organized by S|2, Sotheby's Contemporary art gallery, offering exhibitions and "bespoke private sales." The exhibition included both established and emerging artists working in fiber, including Alighiero Boetti (Italian), Rosemarie Trockel (German), Sergei Jensen (Danish), Ethan Cook (American), Alek O. (Argentinian) and Sterling Ruby (American).
31 Noelle Bodick, "Whitney Biennial Curator Michelle Grabner on Her Unruly 'Curriculum,'" *Artspace*, March 5, 2014.
32 An image of this work as installed at the Whitney Museum of American Art can be found at http://whitney.org/Exhibitions/2014Biennial/SheilaHicks.
33 Danielle Mysliwiec, "Interview with Sheila Hicks," *Brooklyn Rail: Critical Perspectives on Arts, Politics, and Culture*, April 2, 2014.
34 Ibid.

Bibliography

Auther, Elissa. *String, Felt, Thread and the Hierarchy of Art and Craft in American Art*. Minneapolis: University of Minnesota Press, 2010.
Bodick, Noel. "Whitney Biennial Curator Michelle Grabner on Her Unruly 'Curriculum,'" *Artspace* (March 5, 2014).
Bourgeois, Louise. "The Fabric of Construction," *Craft Horizons* 29 (March 1969): 31–35.
Camhi, Leslie. "A Career Woven from Life," *New York Times* (31 March, 2011).

Constantine, Mildred and Jack Lenor Larsen. *Deliberate Entanglements*. Los Angeles: University of California Los Angeles Art Galleries, 1971.

———. *Beyond Craft: The Art Fabric*. New York: Van Nostrand Reinhold, 1972.

Enwezor, Okwui. "History Lessons," *Artforum* 46, no. 1 (September 2007): 382–385.

Filipovic, Elena. *The Artist as Curator*. London: Intellect, 2015.

Jauss, Hans Robert. *Toward an Aesthetic of Reception*. Trans. Timothy Bahti. Minneapolis: University of Minnesota Press, 1982.

Jeffrey, Celina. *Louise Bourgeois: Stitches in Time*. Dublin: Irish Museum of Modern Art, 2004.

———. *The Artist as Curator*. London: Intellect, 2015.

Larsen, Jack Lenor. *Beyond Craft: The Art Fabric*. New York: Van Nostrand Reinhold, 1972.

———. *Deliberate Entanglements*. Los Angeles: University of California Los Angeles Art Galleries, 1971.

Mysliwiec, Danielle. "Interview with Sheila Hicks," *Brooklyn Rail: Critical Perspectives on Arts, Politics, and Culture* (April 2, 2014). http://www.brooklynrail.org/2014/04/art/sheila-hicks-wth-dainelle-mysliwiec

Newman, Amy. "Louise Bourgeois Builds a Book from the Fabric of Life," *The New York Times* (October 17, 2004).

———. *Louise Bourgeois: Stitches in Time*. Dublin: Irish Museum of Modern Art, 2004.

O'Neill-Butler, Lauren. "Come Through," *Artforum.com* (26 September, 2010).

Pels, Marsha. "Louise Bourgeois: A Search for Gravity," *Art International* 23, no. 7 (October 1979): 46–54.

Porter, Jenelle, ed. *Fiber Sculpture – 1960s to the Present*. Munich: Prestel, 2014.

Rawsthorn, Alice. "Reinventing the Look (Even Smell) of a Book," *New York Times* (March 18, 2007).

Strizler-Levine, Nina, ed. *Sheila Hicks: Weaving as Metaphor*. New York: Bard Graduate Center for Studies in Decorative Arts, Design & Culture, 2006.

———. *Sheila Hicks: 50 Years*. New Haven: Yale University Press, 2010.

Thompson, Don. *The $12 Million Stuffed Shark: The Curious Economics of Contemporary Art*. New York: Palgrave Macmillan, 2010.

Thornton, Sarah. *Seven Days in the Art World*. New York: W. W. Norton & Company, 2009.

Waller, Irene. *Fiberworks*. Cleveland: The Cleveland Museum of Art, 1977.

———. *Fibre Structures. An Exhibition of Contemporary Textiles*. Denver: The Denver Art Museum, 1972.

———. *The Flexible Medium: Art Fabric from the Museum Collection*. Washington, DC: The Renwick Gallery of the National Museum of American Art, Smithsonian Institution, 1984.

———. *Thread! An Art Form*. London: Studio Vista, 1973.

4

THE ELEPHANT IN THE CHURCH

Ai Weiwei, the media circus and the global canon

Wenny Teo

In the spring of 1819, a particularly surreal incident took place in the city of Venice, at a time when the once-powerful Venetian Republic had fallen under the control of the Austrian Hapsburg Empire. At the start of the carnival that year, a live Indian elephant was put on display near the famed Piazza San Marco as the exotic star of a travelling menagerie. To the horror of the adoring crowds, the creature abruptly broke from its shackles, killed its handler and went on a furious rampage through the narrow, labyrinthine streets. After evading its captors for several hours and proving remarkably impervious to gunfire, the frenzied animal barged into the nearby seventh-century Church of Sant'Antonin, where it was finally trapped. Permission from the Patriarch had to be granted before Austrian forces killed the elephant within the holy sanctuary by two blasts of a cannon.[1] Yet the beast was not so easily laid to rest.

The Indian elephant's tragic death in Venice inspired a number of politically charged poems that soon appeared in underground circles, posthumously transforming the creature into a powerful symbol of protest against the oppressive and censorious Austrian regime. The most incendiary of these was "*L'Elefante*" (1819), an obscene satire by Pietro Buratti, written in the Venetian dialect. While others had portrayed the animal as an innocent victim of state brutality or even as a martyr of the fallen republic, Buratti's elephant was instead the very embodiment of carnivalesque revolt – a libidinous, corporeal force of nature that violated the sanctity of church and state alike. The poet was swiftly arrested and sentenced to a month in prison for his subversive tract.

More than two centuries later, during the 2013 Venice Biennale, the lavishly restored church of Sant'Antonin was occupied by yet another incongruous presence, this time in the form of an imposing installation by a figure who looms large in today's hyper-networked global imaginary: the superstar artist, activist, social media celebrity and Chinese dissident Ai Weiwei. Six large iron boxes, weighing

nearly two and a half tons apiece, were solemnly positioned in front of the altar, in stark contrast to the baroque opulence of the ecclesiastical surrounds, Fig. 4.1. Despite their seeming opacity, the boxes were fitted with a number of narrow apertures that allowed visitors to peer into their enigmatic confines one at a time, only to be greeted with an unexpected series of dioramas that revealed the harrowing details of the artist's 81-day political detention in 2011. Each carefully framed vignette centered on a different facet of his dehumanizing ordeal, restaged by way of small-scale fiberglass models of the artist and his captors. We see Ai's uncannily life-like figurine walking into a windowless cell, handcuffed to a chair in front of

FIGURE 4.1 Ai Weiwei, *S.A.C.R.E.D.* Six-part work composed of (i) S upper, (ii) A ccusers, (iii) C leansing, (iv) R itual, (v) E ntropy, (vi) D oubt. Six dioramas in fiberglass and iron, 2011–2013. Installation view, Chiesa di Sant' Antonin, 2013. © Ai Weiwei Studio. Courtesy Lisson Gallery. Photograph by Ken Adlard.

his inquisitors, standing naked in the shower, sitting on the commode and eating his meals, all the while flanked by two impassive uniformed guards who even watch over him as he lies asleep on a narrow bed, his corpulent body laid out like a saint, Fig. 4.2. The work, titled *S.A.C.R.E.D.* (2011–2013), commemorated a pivotal event in the artist's storied biography that, for better or for worse, served to transform the iconoclastic *enfant terrible* of Chinese art into an international icon of freedom of expression who occupies pride of place in the hallowed ranks of the global contemporary art canon.

Ai first made international headlines in 2008, when he famously turned against the Chinese state by fiercely denouncing the Beijing Olympic Games as the nation's "false smile" to the global community, despite the fact that he himself had been one of the designers of its monument *par excellence*, the National "Bird's Nest" Stadium.[2] At a time when the eyes of the world were transfixed by the glowing spectacle of the Beijing Olympics – the apotheosis of China's near–decade-long efforts to rebrand itself as a benign 21st-century superpower – Ai stole the media spotlight by pointing out the state's continued disregard for human rights and civil liberties. Since then, the artist has led the charge in a series of virulent attacks against government corruption and censorship, harnessing the power of digital technologies to directly communicate his dissent and mobilize vast publics both within and beyond the "Great Firewall."[3] By 2011, amidst a restive geopolitical climate marked

FIGURE 4.2 Ai Weiwei, *Entropy – S.A.C.R.E.D.* Six-part work composed of (i) S upper, (ii) A ccusers, (iii) C leansing, (iv) R itual, (v) E ntropy, (vi) D oubt. Six dioramas in fiberglass and iron, 2011–2013. Installation view, Chiesa di Sant'Antonin, 2013. © Ai Weiwei Studio. Courtesy Lisson Gallery. Photograph by Ken Adlard.

by waves of mass uprisings throughout the world galvanized by networked communications, the state began to view the unruly artist as a distinct threat to China's national "harmony" that had to be stamped out, even at the expense of its more recent soft power initiatives.

Indeed, Ai's arrest and subsequent detention occurred at what was then the height of his artistic career. Just a year earlier, his consecration into the global art canon was ceremoniously confirmed when Ai became the first East Asian artist to be awarded the prestigious Unilever-sponsored commission at London's Tate Modern. In fact, his critically acclaimed, monumental installation *Sunflower Seeds* (2010) still occupied the vast cathedral-like space of the Turbine Hall when he was apprehended at the Beijing International Airport on April 3, 2011. News of the artist's disappearance provoked a media stampede and a storm of protests around the world – demonstrators took to the streets from New York to Hong Kong, whilst numerous petitions were circulated by human rights groups, European intellectuals and some of the art world's most prominent actors and agents. A protest was even staged upon *Sunflower Seeds* itself, whilst the words "Release Ai Weiwei" were boldly emblazoned upon the façade of the internationally renowned museum that enshrined it.

In the face of such mounting international pressure, the Chinese authorities eventually released the artist after 81 days but kept hold of his passport until July 2015 – effectively trapping the artist in China for four years. Far from silencing him, Ai's "captivity" has only served to bolster his much-mythologized public image, elevating him to the status of a global superstar and precipitating his canonization. Between 2011 and 2015, Ai has had a reported 100 solo exhibitions held in prominent museums throughout the world such as the Hirschhorn Museum, Washington, DC (2012), and the Royal Academy, London (2015), as well as in highly symbolic locations like the aforementioned Church of Sant'Antonin in Venice, Blenheim Palace in the UK (2014) and, most evocatively, the notorious prison island of Alcatraz (2014). His work has entered into the permanent collections of the Tate, MoMA and the Guggenheim, and his multivalent oeuvre – encompassing installations, sculptures, video, documentary, architecture, online and participatory practice – has been the subject of a growing body of scholarship not just in the field of visual culture but across the arts and social sciences. In what comes as a surprise to no one, the price of Ai's work in the ever-bullish art market has swelled to match his growing international stature. In February 2015, a bronze edition of *Circle of Animals/ Zodiac Heads* (2011) – an installation that has now been exhibited in no fewer than 21 different art venues across the world, including the Louvre – was sold for $4.4 million US to a private collector at a Philips auction, a record-breaking price for the artist that was quickly surpassed just a few months later.[4] What's more, whilst denied the freedom to travel, Ai has sublimated the trauma of his arrest, detention and entrapment into artworks like *S.A.C.R.E.D.* that so evocatively illustrate the compelling narrative of dissent, persecution and defiance constantly referenced in his countless interviews, news articles and opinion pieces. Not a day goes by that Ai hasn't unleashed a torrent of tweets, Instagram images, videos and

memes that often go viral to his legion of online followers. It is clear that the artist is a skillful ringmaster of the inexorable media circus that surrounds him, as well as one of its most captivating and quixotic stars.[5]

Today, it would appear as if Ai has not only been canonized through these various processes – museological, commercial, historiographical and mediatized – but deified to the extent that he has become one of the most powerful figures in the art world at large. Yet the art world's eagerness to embrace Ai Weiwei raises a number of crucial questions concerning the geopolitics of canonization that this chapter seeks to examine. What does the art world's veneration of Ai in the wake of his arrest and detention reveal about the Western-centric political, artistic and cultural biases that have traditionally determined which artists and works are granted visibility or relegated to obscurity? How has Ai sought to position himself in both global and local canons, and has his media-savvy, larger-than-life public persona now overpowered the social, political and critical import of his art as well as activism? Or does his mastery over the media and skillful manipulation of networked communications present a concrete threat to the traditional gatekeepers of the canon who have so long determined which artists and works gain visibility both nationally and internationally?

On one level, the fact that the "world's most famous living artist"[6] today is Chinese in the first place would seem to be a triumphant confirmation that the contemporary artistic canon has truly become "global,"[7] no longer the exclusionary and privileged citadel of the Western artistic tradition that it once was. While it would make for a far more compelling argument to suggest that Ai had first bulldozed his way into these sacred ranks against all odds, in reality, the path had long been cleared. Since the 1980s, the tides and pulls of a series of identity politics, galvanized by the exigencies of globalization, had ostensibly redrawn the temporal and geographical terrain of the art world, sweeping a previously marginalized contemporary art from "elsewhere" to the glittering shores of museums, galleries, auction houses and ever-proliferating biennales the world over. The abundance of scholarship, symposia and exhibitions on the validity of multi-sited and discrepant modernities, local canons, as well as nuanced theoretical investigations into the nature of "contemporaneity" all served to destabilize the Eurocentric foundations of the discipline. In the process, the canon has been attacked, expanded, revised, restructured and even dismissed to the extent that by the time Ai appeared in the international artistic arena in the early 2000s, the canon already appeared, as Hal Foster phrased it, "less a barricade to storm than a ruin to pick through."[8]

Yet despite these significant developments, the canonization of Ai Weiwei – far from being a definitive index of the art world's progressiveness, inclusiveness and openness to cultural and artistic difference – might be regarded as a regressive manoeuvre that serves to ultimately reinforce the primacy of Western artistic, political and ideological paradigms and interests above others, reflecting longstanding geopolitical anxieties and prejudices that have yet to be put to rest. This is most acutely seen in the tendency to "universalize" Ai's political stance in the wake of his arrest and detention, succinctly encapsulated in a statement released by the editors of *Art Review* when they declared the Chinese dissident artist the most influential

figure in the art world in their 2011 "Power 100" list: "[Ai's] work and his words have become catalysts for international political debates that affect every nation on the planet: freedom of expression, nationalism, economic power, the Internet, the rights of the human being."[9] In this, Ai is not merely portrayed as an artist whose "work and words" are seen to transcend cultural difference, but the values that he so fiercely champions – Western liberal notions of freedom of expression and human rights – are implicitly presented as equally applicable to all.

Indeed, *Art Review*'s impassioned response to Ai's arrest and detention reflected the zeitgeist of the art world in 2011 in the wake of the Arab Spring. As curator Okwui Enwezor drily remarked in a controversial article published in *Art Forum*, "it was as if a beehive had suddenly exploded and stung the passive moral lions of the field, waking them from their unreflective slumber."[10] This "awakening" was, however, not as bellicose as it seemed. In the same piece, Enwezor inveighed against the "meek petitions" circulated by prominent art-world players in support of larger-than-life figures of cultural difference and political dissent like Ai Weiwei, arguing that they strikingly "failed to engage the larger complexities of the geopolitics of art" and refused to "examine the complicity of the entire global system and its tacit acquiescence to the illiberalism of autocrats and despots."[11] As he further pointed out, it was no surprise that this outpouring of moral outrage was chiefly directed against countries and societies that "the Western art establishment feels should be better apprised of the avant-garde tradition of artistic autonomy and liberal notions of unfettered intellectual expression."[12] Enwezor was not the only one to call out the elephant in the room.

Weighing in on these debates, the expatriate Chinese curator Hou Hanru further proposed that the art world's effusive support for the dissident Chinese artist was indicative of a recurrent form of "political exoticism" and "cultural tokenism" that ultimately results in "a kind of simulacrum of democracy and human rights, produced by globalized colonial and capitalist modernity," regressively mirroring the spike in demand for contemporary Chinese art in the global artistic arena in the wake of the Tiananmen uprisings of 1989.[13] For the US-based Chinese scholar Tang Xiaobing, the art world's knee-jerk response to Ai's predicament rehashes the Enlightenment critique of Oriental despotism that was later revived by the ideological divides of the Cold War, predicated on the "classical liberal conception of society as resistance against state, of personal liberty in opposition to tyrannical power."[14] The appeal of such a narrative, as Tang put it in a nutshell, is that it "clarifies matters by rendering them black-and-white, identifies a larger-than-life hero as the object of our moral support, and thereby makes art from a different culture and society intelligible in terms of our own political concerns and interests."[15] Nowhere was this made more glaringly apparent than in a speech given by the media mogul Michael Bloomberg (who was then the mayor of New York City) inaugurating the grand opening of Ai's touring installation, *Circle of Animals/Zodiac Heads* (2010), shortly after his arrest.

By supporting Ai Weiwei, Bloomberg stirringly declared, "we stand in solidarity with the billions of people who do not have the most fundamental of all human rights, the most cherished of all American values, and the most valuable of all New

York City's riches: free expression [. . .] freedom is our competitive advantage."[16] Bloomberg's speech not only reflected contemporary anxieties over China's growing economic dominance but also served as a discomfiting reminder of the imbrications of artistic canonization, cultural imperialism and neoliberalism. In the 1950s and 1960s, as Eva Cockcroft has argued, the American abstract expressionists were championed by the CIA and the Museum of Modern Art with the financial backing of the Rockefellers, as a movement that epitomized the virtues of "freedom of expression" in an "open and free" society, in stark contrast to the total politicization of art under Stalin. In this, the freedom of American artists to pursue "art for art's sake" – the separation of art from politics – was ironically instrumentalized as a "weapon of the Cold War."[17] In the case of Ai Weiwei, however, it is clear that the stakes are other. Although he has been roundly admired for his politics and activism, which are seen to embody the "universal" desire for democracy and reflect the "spirit" of Western modernism, opinion remains fiercely divided as to the quality and originality of his art.

Ai's most ardent supporters frequently evoke the all-powerful trinity of Duchamp, Warhol and Beuys – figures that Arthur Danto once referred to as the "Founding Fathers of contemporary sensibility" – who have been variously "summoned from the shadows" as part of a wider reshuffling of the Western artistic canon in the post-war period in the wake of the wider geopolitical and theoretical shifts of the 1960s and 1970s.[18] In this view, Ai's art is inseparable from his politics, activism and indeed his public persona. But whereas before his arrest and detention in 2011, Ai was most often branded, quite blithely, as "China's Warhol" in the mainstream Western media due to his media-savvy personality and his early neo-pop aesthetic, the reference to the famously apolitical, machine-like art superstar no longer seemed appropriate in the light of Ai's newly fashioned public image in the eyes of the West as the fierce symbol of human rights and China's political struggles. Thus, for the *Guardian*'s art critic Jonathan Jones, "Ai Weiwei truly is Duchamp's heir." In his glowing review of Ai's exhibition at Blenheim Palace in 2014, Jones suggested that Duchamp "unleashed complete freedom in art," and Ai, "like Duchamp, sees art as a playing field with no rules."[19] In a similar vein, the internationally renowned curator Hans Ulrich Obrist referred to Ai's now-censored blog as "one of the greatest social sculptures of all time."[20] Obrist thus forged a critical link between Beuys's expanded notion of the artwork – the oft-quoted, utopian mantra that "everyone is an artist," capable of transforming the social organism itself into a work of art – and Ai's online activities. Of course, not everyone was so sold on Beuys's post-war resurrection at the time. Benjamin Buchloh took issue with what he perceived to be the art world's uncritical and ahistorical adulation of Beuys. "No other artist," Buchloh damningly wrote, "has tried and succeeded so systematically in aligning himself at a given time with esthetic and political currents, absorbing them into his myth and his work and thereby neutralizing and aestheticizing them."[21] No other artist, perhaps, until Ai Weiwei.

In recent years, there has been a significant backlash against the artist on similar grounds, led by those who insist that a separation must be made between Ai's art

and politics. While this may be a valid criticism, the means with which this separation has been conceived has often been reactionary, steeped in a language of aesthetic judgment that unapologetically rehearses the exclusionary rhetoric of high modernism. In his excoriating review of Ai's exhibition at the Hirschhorn museum, the art critic of the *New Republic*, Jed Perl, branded Ai Weiwei "a wonderful dissident" but a "terrible artist," in an article littered with examples of how Ai's formal strategies pale in comparison to that of their "original" Euro-American precursors. Perl accused Ai of failing to comprehend the very tradition that he has so brazenly purloined:

> [T]he crudity with which he connects creativity with action and action with art reflects a misunderstanding of the nature of modern art, and indeed of all art, that is as pervasive in democratic societies as it is in countries with authoritarian regimes [. . .] I would insist that art proceeds according to laws that politics can at times thwart or control but never fully contain or comprehend.[22]

If that didn't smack of a universalizing Greenbergian formalism, not to mention an anachronistic defense of the ideals of artistic autonomy, Perl continued, "the political causes that Ai embraces are noble [. . .] But when he takes his place inside the Hirschhorn Museum, with its Matisses and Brancusis and Mondrians, I cannot help but feel that he poses a threat to the universe that he dreams of inhabiting."[23] Perl, who after all coined the term "*laissez-faire* aesthetics," is also criticizing the art world's veneration of Ai as symptomatic of its unquestioning neoliberal reflex. But he contentiously chose to do so by reasserting the primacy and sanctity of the Western canon – or, more specifically, Modernism (with a capital "M") – as the inviolate standard of aesthetic quality that the Chinese artist couldn't possibly live up to or even fully comprehend. It was as if the discourses of post-modernity, post-structuralism and identity politics that had so radically destabilized Modernism's exclusionary principles of medium specificity, authenticity, authorship and originality since the 1960s had never occurred.

Perl's reaction is nothing new. After all, as the art historian Craig Clunas has pointed out, "putting the Other in its place has always been one of the acts that made the constitution of a history of art, particularly a singular story of art, possible."[24] Yet, even from a post-colonial perspective, Ai's art has also been found wanting. The UK–based Niru Ratnam, a former editor of *Third Text*, branded Ai the "ideal Asian artist for lazy Western curators" in an article published a few months before Ai's highly anticipated retrospective exhibition opened at London's the Royal Academy in September 2015.[25] Critical of the tendency to conflate Ai's politics and art, Ratnam's brief article reiterated the glaring fact that despite the significant inroads made on post-colonial, feminist and activist fronts since the 1970s, as Kavita Singh has lamented elsewhere, "the structure of art historical authority remains the same; i.e. the discourse of museums, masterpieces, and artistic genius is retained; only native examples are found to fit into it."[26] Ai Weiwei, Ratnam argued,

is the perfect fit, since when compared to other well-established Chinese artists of his illustrious generation, Ai's "work is the most attuned to western modern art movements . . . he uses the now rather obvious Duchampian strategy of treating everything as a readymade and Chinese cultural artefacts are often recontextualised in his work in this way."[27] In other words, Ai's work simply isn't authentically "Chinese" enough. Rather than consider Ai's appropriation of such avant-garde strategies as itself a political act that serves to challenge the presumed hegemony of Western art-historical narratives – a tactic that has been effectively employed by so many non-Western artists and intellectuals to decenter the authority of the Western canon since the 1980s – Ai is instead disempoweringly framed as yet another Chinese artist who is merely pandering, or rather "selling out" to the West. Ratnam calls out the fact that the art world's clamorous support for Ai has been "shot through with a certain level of cultural condescension" but concludes his article by saying that while Ai certainly doesn't deserve to be imprisoned for his art, "he probably doesn't deserve the whole of the Royal Academy" either. [28]

The general sentiment of these critiques is that Ai's politics are admirable, but his work doesn't quite measure up to the gold standard established by the West. Stripped of his politics and media celebrity, Ai's art is an awkward fit – a postmodernist pastiche of Dadaist iconoclasm, Warholian showmanship, Duchampian satire and Beuysian shamanism at best, better suited "to *Art in America* and *The New York Times* than to the pages of *October*," as Perl (2013) dismissively opined. Ironically, however, one of the most striking examples of Ai's consecration has been his inclusion in the expanded 2012 edition of the seminal art history textbook *Art Since 1900* (2004), a chronological survey of what the authors of the volume, the luminaries of the *October* group, consider the most significant artworks, artists, movements, styles and critical methodologies of the 20th century and the first decade of the 21st.[29] The entry on Ai, the penultimate in the volume, cites his 2010 Tate Modern installation as one such canonical event. Rather than dwell on the thorny issue of Ai's political saga as such, it begins with a nuanced discussion of how his celebrated works *Fairytale* (2007) and *Sunflower Seeds* (2010) pertain to contemporary discourses on the potentialities of the multitudes and emphasizes the formal, aesthetic and socially engaged properties of his artwork.

With this, Ai's art becomes part of the predominantly Euro-American genealogy that has come to determine how modern and contemporary art is made visible and legible. His work is seen to stand not only on the shoulders of Western canonical giants but alongside them on equal ground, reflecting the wider turn in art-historical discourses toward questions of art's political and social efficacy in an increasingly hyper-connected and mediatized world. Rather than view Ai simply as China's answer to Warhol or Duchamp, the entry on Ai further attempts to contextualize and situate his practice, suggesting that the artist's sophisticated understanding of the work of art as a "composition of different publics – particularly of a Chinese public encountering the West and a Western public encountering Chinese material culture [...] provides an apt introduction to contemporary art in China."[30] It then segues into a brief but cogent historical overview of Chinese "unofficial"

and experimental art since the 1978 open-door reforms – focusing on the tensions among economic, political and artistic liberalization in a period of remarkable transformation and looking at the various means through which the intellectual and artistic vanguard has "incrementally broadened the scope of artistic freedom as well as free speech in China."[31] Yet in this, it would appear that Ai has not only become one of the only Chinese artists to have entered the predominantly Euro-American narrative of modern and contemporary art, but, more problematically, his politics have also come to define how contemporary Chinese art is historicized, understood, framed and valued in the global artistic arena.

Of course, the idea that Ai Weiwei alone has shaped the West's understanding of contemporary Chinese art *tout court* – notwithstanding his undeniable pull over the global art world and mass media – would be oversimplifying the stakes. Indeed, the narrative of contemporary Chinese artistic development as presented in *Art Since 1900* was based on established Anglophone scholarship in the field by eminent art historians like Wu Hung, Gao Minglu, Lv Peng and Richard Krauss. Yet as Francesca Dal Lago has convincingly argued in her in-depth review of Wu Hung and Peggy Wang's edited series *Contemporary Chinese Art: Primary Documents* (2010) – an anthology of key critical texts published by the Museum of Modern Art in New York – this narrative of contemporary Chinese artistic development as inextricably bound to economic and political liberation not only chimes with Cold War teleology and ideology but also serves to validate the acquisition policies, artistic judgments and exhibitionary complexes of the West, whose museum curators have since the 1980s attempted to integrate art from "elsewhere" into their permanent collections.[32]

Thus, at the expense of more searching critical investigations into the heterogeneous dimensions of Chinese contemporary artistic practice, movements and styles, the works that ultimately achieve prominence in the global context, as Anna Bryzski among others observed, is an "art that speaks with a local dialect but plays by global rules defined not in China, but abroad through transnational art exhibitions, publications and markets."[33] The "global contemporary," far from being a carnivalesque Duchampian "playing field with no rules," is in this view conditioned by a distinct set of aesthetic procedures derived from Western modernist (and postmodernist) frameworks and ideologies. And as Ratnam would suggest, it has been Ai's familiarity with these rules and his mastery of them that has awarded him such a uniquely privileged position in the global contemporary canon.

Indeed, the artist has recently quipped that he considers himself "a global artist with Chinese characteristics" – making a witty reference to the reformist leader Deng Xiaoping's famous mantra "socialism with Chinese characteristics" that heralded the "open-door" economic reforms begun in 1978.[34] From the outset, Ai was one of the most "cosmopolitan" contemporary Chinese artists of his generation. The artist lived in the US from 1981 to 1993 and thus was not resident in China during the "heroic" phase of Chinese avant-garde practice in the 1980s nor the pro-democracy uprisings of 1989. Upon his return to Beijing, however, Ai quickly established himself as a key figure in the underground Chinese art scene. Arguably,

his most significant contributions to the development of contemporary Chinese art in this tumultuous period were his founding, together with the Dutch curator Hans Van Dijk and Frank Uytterhaegen, of the "China Art Archives and Warehouse," one of the first independent art spaces in Beijing, and his co-editorship of the seminal *Black, Grey* and *White Cover Books* in 1994, 1995 and 1997 respectively. This series of independently published anthologies was distributed in underground circles at a time when there were no viable public platforms for experimental Chinese artists to display and discuss their work.[35]

These books were always intended to be global in their scope, focusing, as the editors wrote, on "the current international discussions and debates, and their relation to the evolution of Chinese culture."[36] Thus, they presented the studio practices of contemporary Chinese artists – some of whom would go on to become prominent figures in the global art world – alongside Chinese translations of important texts on artists like Warhol, Duchamp and Koons. In this way the editors radically posited equivalence and established a critical dialogue between contemporary Chinese practices and the Western canon before Chinese art was included in the annals of "global" art history. Three thousand copies of each book were printed and shared across China's vast underground artists' network, stimulating contact, debate and exchange among its practitioners. In an early interview from 1995 included in the second volume, Ai already likened the role of the artist in society to that of "a computer virus,"[37] anticipating the significance of networked communications that would come to so profoundly define our present digital era.

Arguably, it has been Ai's unique ability to harness the power of social media that has allowed him to not only play by the "global" rules of the art world but also to subvert, challenge and even "transcend" the art world's blinkered purview. As a case in point, the very same week that the ponderous work in the Church of Sant'Antonin was unveiled to the elite art world audience at the 2013 Venice Biennale, the artist released a characteristically prankish music video on YouTube, made for the wider public. The video similarly recreated scenes from Ai's period of captivity, but as its title *Dumbass* (2013) made abundantly clear, there was nothing sacred about it. At one point, the burly artist – garishly made up and in drag – parades across his prison cell as if it were a catwalk as he trumpets the obscene lyrics of his song in the overlying audio track: "When you're ready to strike, stand on the frontlines like a dumbass, in a country that puts out like a hooker [. . .] Fuck forgiveness, tolerance be damned, to hell with manners, the low-life is invincible."[38] This was to be the first single of his upcoming heavy metal album, *The Divine Comedy*.

S.A.C.R.E.D. and *Dumbass* were a double act that knowingly played to different audiences. The former was a weighty "high-art" object with a potential commercial value that reinforced his status as an art martyr to the art-world elite who had flocked to Venice on their biannual pilgrimage to the world's most prestigious Biennale. *Dumbass*, on the other hand, was a distinctly low-brow gesture of defiance that could be endlessly circulated to the wider public at the click of a mouse. It offered Ai's populist appeal as a Rabelaisian force of nature, who uses every medium

and tool at his disposal to upend traditional hierarchies of power. By his own admission, the Internet has been Ai's most effective weapon of choice.

To his many supporters, Ai's engagement with digital technologies, networked communications and the online public sphere exemplifies a crucial shift in how art is valued, circulated and made meaningful today. David Joselit in his recent publication *After Art* (2014) argued that it is no longer the "aura" of a work of art with its concomitant modernist ideals of singularity, originality and authenticity that determines its value and impact but rather its "buzz." That is, its "saturation through mass circulation – the status of being everywhere at once rather than belonging to a single place."[39] Citing Ai as a key example of how art is now more than ever an international currency capable of crossing national, geographical and ideological systems of value, whose political efficacy now lies in "cultural diplomacy as opposed to the invention of avant-garde forms as new content,"[40] Joselit further proposed that the current shape of the global contemporary art world itself is now more akin to the rhizomatic, deterritorializing and interconnected patterning of the Internet, in effect rendering the hierarchical organization of canons and the implied authority of the traditional gatekeepers obsolete.

In this sense, we might regard Ai's social media activities as part of a wider struggle for what Rey Chow has termed "postcolonial visibilities" that has its roots in the political activism of the 1960s. To seize control of the media frame is to compete for "the right to own and manage the visual field, to fabricate the appropriate images and distribute the appropriate stories."[41] In recent years, new media modalities have afforded contemporary artists as well as audiences a heightened degree of agency in a "political economy of representation and performance" that presents a distinct challenge to the scopic regime. Whereas Western art museums once "served 'modernists' like a church in which believers gathered to declare their creed,"[42] Ai has recently stated that the Internet is his church.[43]

Given his huge online following and media celebrity, it is arguable that Western museums now need Ai Weiwei more than he needs them, particularly at a moment when many global institutions have faced significant cuts in public funding. In 2015, the Royal Academy has even appropriated Ai's online strategies and sought to capitalize on his popular appeal by launching its very first online crowd-funding campaign to raise £100,000 from the public on Kickstarter in order to bring one of Ai's monumental installations to London for what has been touted as the "most highly anticipated exhibition" of the year.

Of course, Ai's hyper-visibility in the global art world has been inversely proportionate to the display of his work in his native China. In recent years, particularly in the period in which he has been denied the freedom to travel, the artist has come under fire in the Chinese art world specifically for what is seen as his continuous attempts to arrogate to himself the authority to determine the shape and direction of contemporary Chinese art practice in the international artistic arena and in the eyes of the media. In other words, contrary to Joselit's optimistic pronouncement, Ai has been perceived as a rather poor "cultural diplomat." In 2013, the artist lashed out against an exhibition of contemporary Chinese art held in London's Hayward Galley,

titled the *Art of Change: New Directions from China* (2013). Ai's article published in the *Guardian* newspaper was provocatively titled "China's Art World Does Not Exist." Ai proposed that "in a society that restricts individual freedoms and violates human rights, anything that calls itself creative or independent is a pretence."[44] He also took issue with what he perceived to be the exhibition's lack of political and social consciousness, asking, "How can you have a show of 'contemporary Chinese art' that doesn't address a single one of the country's most pressing contemporary issues?" Unsurprisingly, such a belligerent stance that implies that all contemporary Chinese art must be politically and socially motivated to bear any sort of artistic relevance has provoked divisive reactions from Chinese artists, curators, critics and art historians.

This was especially pronounced in 2014, shortly after Ai's name was omitted from one of the press releases of the exhibition *Hans van Dijk: 5000 Names* at the privately owned Ullens Centre for Contemporary Art in Beijing. The exhibition featured the work of some 60 contemporary Chinese artists who had been close associates of the late Dutch curator, dealer and scholar who had played a major role in the development of contemporary Chinese art in the 1990s. On May 23, 2014, the opening day of the exhibition, three of Ai's works were abruptly removed from the display, a fact that drew considerable media attention. It was not, however, the authorities who stormed into the museum to remove Ai's work but rather Ai's own assistants, acting under his instructions. Images of this act were immediately posted on Ai's Instagram account along with a statement accusing the privately owned museum of self-censorship and capitulating to political pressure. By removing his name, Ai wrote in the accompanying statement, "the historical facts of contemporary art history have been altered [. . .] I withdrew the artworks that were part of the exhibit, to express my eternal remembrance of Hans and my disdain towards the bizarreness of Chinese contemporary art."[45] Beyond his condemnation of the Chinese art world's self-censorship, Ai's outburst also appeared to reflect a sense of frustration at being marginalized in the contemporary Chinese art canon in a national context.

Ai did not stop at removing his own work from the display but incited other participating artists to withdraw their work in protest as well. While some complied and several Chinese artists voiced their support for Ai's cause, others took to the Internet in protest. The artist Yan Xing was especially vocal, accusing the artist of shamelessly hogging the limelight and presenting himself as a "Chinese Hero of Democracy." "No other Chinese person today," Yan wrote, "can so completely focus the pity of the entire world on his person. But if China, or more precisely our Chinese artistic circles, were as open as the West, would he still be able to command so much attention? [. . .] No one dares to challenge him, and he is always unvaryingly right. Uncannily, these people have created a miniature version of the system their hero makes such a show of opposing."[46] Indeed, Ai's larger-than-life persona casts a long shadow, arguably occluding the heterogeneous practices of a younger generation of Chinese artists who are still fighting for artistic recognition and visibility on their own terms, both nationally and internationally.

Contrary to Joselit's notion of the power of art as "cultural diplomacy," Ai's global standing has arguably done more harm than good. As Ai himself once remarked,

several years before his more recent political troubles, "when you change things, the chances are that the changes will end up becoming the foundation [. . .] And so you will need to move on, or you will need to move up. And this will have to be your perpetual practice."[47] On July 22, 2015, Ai's passport was finally returned to him, just in time for him to oversee the installation of his landmark exhibition at the Royal Academy in London. Now granted the freedom to travel across the globe as freely as his work and his words, it remains to be seen if this extraordinary political animal will continue to break new ground or if his fame has become another form of entrapment.

Notes

1 See Margherita Turchetto, *Morte di un elefante a Venezia. Dalla curiosità allscienza* (Padova: Canova Edizioni, 2004).
2 Ai Weiwei, "Happiness can't be faked", *The Guardian*, August 18, 2008. http://www. theguardian.com/commentisfree/2008/aug/18/china.chinathemedia.
3 For a detailed study on the Chinese online public sphere, see Yang Guobin, *The Power of the Internet in China: Citizen Activism Online* (New York: Columbia University Press, 2010).
4 Guelda Voien, "Ai Weiwei Zodiac Sculptures Sell for Record $5.4M," *The Observer*, June 30, 2015, http://observer.com/2015/06/ai-weiwei-zodiac-sculpture-sells-for-record-5-4m-at-auction/.
5 See Giorgio Strafella and Daria Berg. "'Twitter Bodhisattva': Ai Weiwei's Media Politics." *Asian Studies Review* 39, no. 1 (January 2015): 138–57.
6 Ai is often referred to as such in the Western media. See Natalie Bushee, "Ai Weiwei at the Royal Academy: A Refugee Artist with Worldwide Status," *BBC Arts*, September 18, 2015, http://www.bbc.co.uk/programmes/articles/1zHn6zWHkrBtpPgvMJxRZwc/ai-weiwei-at-the-royal-academy-a-refugee-artist-with-worldwide-status.
7 Hans Belting, "Contemporary Art as Global Art. A Critical Estimate," in *Global Art World: Audiences, Markets, Museums*, Hans Belting and Andrea Buddensieg, eds. (Ostfildern-Ruit: Hatje Cantz, 2009), 38–74.
8 Hal Foster, "Art and Archive," in *Design and Crime: And Other Diatribes* (London: Verso, 2003), 66.
9 Mark Rappolt and David Terrien, "The Power 100" *Art Review* 55 (November, 2011): 108.
10 Okwui Enwezor, "Spring Rain: On Ai Weiwei and the Sharjah Biennal," *Artforum International* 49, no. 10 (Summer 2011): 75.
11 Ibid.
12 Ibid.
13 Hou Hanru, "Urgent Is to Take a Distance: A Letter from Hou Hanru to Hans Ulrich Obrist," *ARTiT* 20 (June 2011) accessed August 15, 2015, http://www.artit.asia/u/admin_ed_contri11/Iy1kMXmtgb7RS0vsduQ4/?lang=en.
14 Tang Xiaobing, *Visual Culture in Contemporary China* (Cambridge: Cambridge University Press, 2015), 212.
15 Ibid.
16 "On the opening of Ai Weiwei's Historic Outdoor Sculpture Exhibition," *Michael Bloomberg's website*, Accessed August 13, 2015, http://www.mikebloomberg.com/news/on-the-opening-of-ai-weiweis-historic-outdoor-sculpture-exhibition/.
17 Eva Cockcroft, "Abstract Expressionism, Weapon of the Cold War," in *Pollock and After: The Critical Debate*, Francis Frascina, ed. (London: Harper & Row, 1985), 125–33.
18 Arthur C. Danto, "Style and Salvation in the Art of Beuys," Forward to *Joseph Beuys: The Reader*, Claudia Mesch and Viola Maria Michely, eds. (Cambridge MA: MIT Press, 2007), xiii.

19 Jonathan Jones, "Ai Weiwei takes his Place Among the Greats Amid the Opulence of Blenheim", *The Guardian*, September 26, 2014, http://www.theguardian.com/artanddesign/2014/sep/26/ai-weiwei-among-greats-opulence-blenheim.

20 Hans Ulrich Obrist, interview with Mathieu Wellner, "Ai Weiwei," *Mono-Kultur*, no 22 (Autumn 2009), 5.

21 Benjamin Buchloh, "Beuys: The Twilight of the Idol," *Artforum International*, Vol 18, no. 5 (January 1980): 35–43, 36.

22 Jed Perl, "Noble and Ignoble – Ai Weiwei: Wonderful Dissident, Terrible Artist," *New Republic*, February 1, 2013, accessed (August 22, 2015), http://www.newrepublic.com/article/112218/ai-wei-wei-wonderful-dissident-terrible-artist.

23 Perl, "Noble and Ignoble"

24 Craig Clunas, "The Art of Global Comparisons," in *Writing the History of the Global*, Maxine Berg, ed. (Oxford: Oxford University Press, 2013), 166.

25 Niru Ratnam, "Ai Weiwei: The Perfect Asian Artist for Lazy Western Curators" *The Spectator*, August 22, 2015, accessed (August 22, 2015), http://www.spectator.co.uk/arts/heckler/9611342/ai-weiwei-the-perfect-asian-artist-for-lazy-western-curators/.

26 Kavita Singh, "Democratising Art History," in *South African Art History in an African Context*, Federico Freschi, ed. (Johannesburg: SAVAH, 2008), 5.

27 Ratnam, "Ai Weiwei."

28 Ibid.

29 The entry on Ai Weiwei was written by David Joselit, in Hal Foster, Rosalind Krauss, Yve-Alain Bois, Benjamin H. D. Buchloh, David Joselit, *Art Since 1900: Modernism, Antimodernism, Postmodernism*, 2nd ed., (New York: Thames and Hudson, 2012).

30 Foster et al., *Art since 1900*, 761.

31 Ibid., 760.

32 Francesca Dal Lago, "The 'Global' Contemporary Art Canon and the Case of China," *ARTMargins* 3, no 3 (October 2014): 77–97, 83.

33 Anna Brzyski, "By Whose Rules? Contemporary Art and the Geography of Art Historic Significance," *Artl@s Bulletin* 2, no. 1 (Spring 2013): 46–51, 47.

34 Ai Weiwei, quoted in Michael Podger, "Ai Weiwei – from Criminal to Art-world Superstar," *The Guardian*, September 12, 2015, accessed (September 12, 2015), http://www.theguardian.com/artanddesign/2015/sep/12/ai-weiwei-exhibition-royal-academy-from-criminal-to-art-world-superstar.

35 See Lee Ambrozy, "Introduction to 'A Conversation with Hsieh Tehching' from *The Black Cover Book*," *ARTMargins* 4, no. 2, (Summer 2015): 97–107.

36 Ai Weiwei and Xu Bing, editorial statement, *The Black Cover Book* (1994), quoted in Ambrozy, "Introduction," 98.

37 Ai Weiwei, "Ai Weiwei Dialogue with Zhuang Hui," trans. Lee Ambrozy in Wu Hung and Peggy Wang, *Contemporary Chinese Art: Primary Documents* (New York: The Museum of Modern Art, 2010), 266.

38 Ai Weiwei, "Dumbass – Heavy Metal Music Video," accessed (August 15, 2015). https://www.youtube.com/watch?v=lyQZ-oLshOQ

39 David Joselit, *After Art* (Princeton: Princeton University Press, 2013), 16.

40 Ibid., 6.

41 Rey Chow, "Postcolonial Visibilities," in *Entanglements, or Transmedial Thinking about Capture* (Durham: Duke University Press, 2012), 161.

42 Hans Belting, *Art History After Modernism* (Chicago: University of Chicago Press, 2003), 110.

43 Louise Osbourne, "Ai Weiwei Says Internet is like a Modern Church after Flood of Lego Offers," *The Guardian*, October 26, 2015, http://www.theguardian.com/artanddesign/2015/oct/26/ai-weiwei-internet-modern-church-lego-bricks

44 Ai Weiwei, "China's Art World Does Not Exist," *The Guardian*, September 10, 2012, http://www.theguardian.com/artanddesign/2012/sep/10/ai-weiwei-china-art-world

45 This statement accompanied the images of Ai's assistants removing his work, uploaded onto Ai's Instagram page, May 23, 2014, https://www.instagram.com/aiww/?hl=en

46 Yan Xing, "So Sorry," first posted in Chinese and English on Facebook on May 27, 2014, reposted on the Chinese website Art Ba Ba on (May 28, 2014), accessed (July 16, 2015), http://www.art-ba-ba.com/main/main.art?threadId=79609&forumId=8

47 Ai Weiwei, "Art and Its Markets: A Roundtable Discussion," *Artforum International* 46, no. 8 (April 2008): 303.

Bibliography

Ai, Weiwei. "Ai Weiwei Dialogue with Zhuang Hui," *Contemporary Chinese Art: Primary Documents*, trans. Lee Ambrozy in Wu Hung and Peggy Wang, 266. New York: The Museum of Modern Art, 2010.

———. "Art and Its Markets: A Roundtable Discussion," *Artforum International* 46, no. 8 (April 2008): 303.

———. "China's Art World Does Not Exist," *The Guardian*, September 10, 2012. http://www.theguardian.com/artanddesign/2012/sep/10/ai-weiwei-china-art-world

———. "Dumbass – Heavy Metal Music Video," accessed (August 15, 2015). https://www.youtube.com/watch?v=lyQZ-oLshOQ

———. "Happiness can't be faked", *The Guardian*, August 18, 2008. http://www.theguardian.com/commentisfree/2008/aug/18/china.chinathemedia.

Ai, Weiwei, Amy Cappellazzo, Thomas Crow, Donna De Salvo, Isabelle Graw, Dakis Joannou, Robert Pincus-Witten, James Meyer, and Tim Griffin. "Art and Its Markets: A Roundtable Discussion," *Artforum International* 46, no. 8 (April 2008): 292–303.

Ambrozy, Lee. "Introduction to 'A Conversation with Hsieh Tehching' from *The Black Cover Book*," *ARTMargins* 4, no. 2 (Summer 2015): 97–107.

Belting, Hans. *Art History After Modernism*. Chicago: University of Chicago Press, 2003.

———. "Contemporary Art as Global Art. A Critical Estimate," *Global Art World: Audiences, Markets, Museums*, Hans Belting and Andrea Buddensieg, eds, 38–74. Ostfildern-Ruit: Hatje Cantz, 2009.

Belting, Hans and Andrea Buddensieg. *Global Art World: Audiences, Markets, Museums*. Ostfildern-Ruit: Hatje Cantz, 2009.

Brzyski, Anna. "By Whose Rules? Contemporary Art and the Geography of Art Historic Significance," *Artl@s Bulletin* 2, no. 1 (Spring 2013): 46–51.

Bushee, Natalie. "Ai Weiwei at the Royal Academy: A Refugee Artist with Worldwide Status," *BBC Arts*, September 18, 2015. http://www.bbc.co.uk/programmes/articles/1zHn6zWHkrBtpPgvMJxRZwc/ai-weiwei-at-the-royal-academy-a-refugee-artist-with-worldwide-status

Buchloh, Benjamin. "Beuys: The Twilight of the Idol," *Artforum International*, Vol 18, no. 5 (January 1980): 35–43.

Chow, Rey. *Entanglements, or Transmedial Thinking about Capture*. Durham: Duke University Press, 2012.

Clunas, Craig. "The Art of Global Comparisons," *Writing the History of the Global*, Maxine Berg, ed., 165–176. Oxford: Oxford University Press, 2013.

Cockcroft, Eva. "Abstract Expressionism, Weapon of the Cold War," *Pollock and After: The Critical Debate*, Francis Frascina, ed., 125–133. London: Harper & Row, 1985.

Dal Lago, Francesca. "The 'Global' Contemporary Art Canon and the Case of China," *ARTMargins* 3, no. 3 (October 2014): 77–97.

Danto, Arthur C. "Style and Salvation in the Art of Beuys," forward, *Joseph Beuys: The Reader*, Claudia Mesch and Viola Maria Michely, eds., xiii–xvi. Cambridge MA: MIT Press, 2007.

Enwezor, Okwui. "Spring Rain: On Ai Weiwei and the Sharjah Biennal," *Artforum International* 49 no. 10 (Summer 2011): 75–76.

Foster, Hal, Rosalind Krauss, Yve-Alain Bois, Benjamin H.D. Buchloh, and David Joselit. *Art Since 1900: Modernism, Antimodernism, Postmodernism*. 2nd ed. New York: Thames and Hudson, 2012, 758–763.

Hanru, Hou, "Urgent Is to Take a Distance: A Letter from Hou Hanru to Hans Ulrich Obrist," *ARTiT* 20 (June 2011). http://www.artit.asia/u/admin_ed_contri11/Iy1kMX mtgb7RS0vsduQ4/?lang=en.

Jones, Jonathan. "Ai Weiwei Takes His Place Among the Greats Amid the Opulence of Blenheim", *The Guardian*, September 26, 2014. http://www.theguardian.com/artanddesign/2014/sep/26/ai-weiwei-among-greats-opulence-blenheim

Joselit, David. *After Art*. Princeton: Princeton University Press, 2013.

Obrist, Hans Ulrich. Interview with Mathieu Wellner, "Ai Weiwei," *Mono-Kultur*, no 22 (Autumn 2009): 5.

Osbourne, Louise. "Ai Weiwei Says Internet Is Like a Modern Church after Flood of Lego Offers," *The Guardian*, October 26, 2015. http://www.theguardian.com/artanddesign/2015/oct/26/ai-weiwei-internet-modern-church-lego-bricks.

Perl, Jed. "Noble and Ignoble – Ai Weiwei: Wonderful Dissident, Terrible Artist," *New Republic*, February 1, 2013, accessed (August 22, 2015). http://www.newrepublic.com/article/112218/ai-wei-wei-wonderful-dissident-terrible-artist

Podger, Michael. "Ai Weiwei – from Criminal to Art-World Superstar," *The Guardian*, September 12, 2015, accessed (September 12, 2015). http://www.theguardian.com/artanddesign/2015/sep/12/ai-weiwei-exhibition-royal-academy-from-criminal-to-art-world-superstar

Rappolt, Mark and David Terrien. "The Power 100," *Art Review* 55 (November 2011): 108.

Ratnam, Niru. "Ai Weiwei: The Perfect Asian Artist for Lazy Western Curators," *The Spectator*, August 22, 2015, accessed (August 22, 2015). http://www.spectator.co.uk/arts/heckler/9611342/ai-weiwei-the-perfect-asian-artist-for-lazy-western-curators/

Singh, Kavita. "Democratising Art History," *South African Art History in an African Context*, 23rd annual conference of the South African Visual Arts Historians (SAVAH), University of the Witwatersrand, Johannesburg, 12–15 September 2007. Federico Freschi, ed., 4–12. Johannesburg: SAVAH, 2008.

Strafella, Giorgio and Daria Berg. "'Twitter Bodhisattva': Ai Weiwei's Media Politics," *Asian Studies Review* 39 no. 1 (January 2015): 138–157.

Tang, Xiaobing. *Visual Culture in Contemporary China*. Cambridge: Cambridge University Press, 2015.

Turchetto, Margherita. *Morte di un elefante a Venezia. Dalla curiosità alla scienza*. Padova: Canova Edizioni, 2004.

Voien, Guelda. "Ai Weiwei Zodiac Sculptures Sell for Record $5.4M," *The Observer*, June 30, 2015. http://observer.com/2015/06/ai-weiwei-zodiac-sculpture-sells-for-record-5–4m-at-auction/

Yang, Guobin. *The Power of the Internet in China: Citizen Activism Online*. New York: Columbia University Press, 2010.

5

EL ANATSUI'S ABSTRACTIONS

Transformations, analogies and the new global

Elizabeth Harney

Five years ago, long-time *New York Times* art critic Holland Cotter wrote a small, alarming review titled "Under Threat: The Shock of the Old" that included the lament, "What happened to Africa? It disappeared . . . Do a quick scan of major exhibitions in American Museums in the past few years and Africa's barely there. . . . Wasn't the multicultural surge of yesteryear supposed to produce the opposite effect?"[1]

Cotter, donning an anthropologist's hat, is searching for what he calls the "old Africa," which occupied the temporal and spatial coordinates of "tribal" or "primitive" within museums, galleries, auction houses, and scholarship of our modern era.[2] Both regressive and provocative, his fears nonetheless identify a lingering unease within a larger art world that purports to embrace the cosmopolitanism of our "global contemporary" era but is, at the same time, deeply unsettled by the multiplicities and ambiguities inherent in such a premise. Regrettably, this jaunty piece oversimplifies the stakes, boiling them down to a war of maneuver between the a-historical "traditional" and the post-historical "contemporary."[3] This binary is of course derived from European modernist epistemologies that avoided or omitted the complicated histories of indigenous and multi-sited modernisms.

While preceding debates on the art-historical canon aimed to add to established Euro-American narratives or to identify and rectify exclusions by highlighting the mechanisms at work in the production of difference, current reflections seem determined to sweep aside the failures and inequities of modernity to recognize instead a condition of inter-connectedness, post-historicity, and post-ethnicity.[4] Contemporary "canon-talk" in established art centers posits new modes of "universalism," imagined as cosmopolitan globalism.[5] It pursues, anew, hopes for effective vanguardist and collective action and re-thinks the geo-temporal coordinates of the art world, enabling multiple ways of being in, of and out of time.[6] Paradoxically, its presentist bent rests upon an appetite for history and a fascination with processes of

remembering, forgetting and re-imagining. For instance, prominent thinkers such as Hans Belting, Okwui Enwezor and Terry Smith wrestle with defining a new condition of contemporaneity while concomitantly unearthing and re-configuring the global facets of a modernist archive and genealogy. In our proclaimed global contemporary moment, a nostalgic art market (and canon) seeks and rewards "analogies" to better-known versions of modernism. Measures of "difference" no longer rest on postmodern playful appropriation or ironic quotation but instead assume the form of modernist refraction. Terry Smith calls this phenomenon "re-modernism" but does not necessarily associate it with post-colonialism.[7] I argue elsewhere that it suggests a "retro-modernism" tied to colonial histories cut short and romanticized.[8]

In an effort to usher in new, more equitable and comparative art narratives, art historians, critics and curators have breached and re-configured the silos of marginalized fields of study – African, Asian, Oceanic or Indigenous – in order to develop practices of "global art history," "world art studies" or "multiple/global modernisms." But do these alternative or indigenous intellectual frameworks, made to disrupt the language of the center, represent just another form of "tokenism"? To what extent might they do more to change the field of art history?[9]

This chapter will address the discursive framing of El Anatsui's practice and "trouble" the smooth manner in which the canon of "global contemporary" art has incorporated his work. What does the art world "desire" from the work? And do its aesthetic logics demand new forms of art-historical practice? Sunanda Sanyal has recently argued that inclusion of African artists in the global canon is a "convenient multiculturalism, aimed at a kind of contrived egalitarianism."[10] A "politics of inclusion" infers that we have finally achieved parity in the art world. Yet inclusion assumes too readily that artists from outside the established centers of art have been able to "transcend" difference and broker the uneven effects of global capitalism. These presumptions risk diminishing or forgetting altogether the hard-fought political struggles of post-colonialism and sub-altern resistance.[11] Does Anatsui's inclusion then signal a significant shift in the manner in which histories of art can be imagined and narrated, or does it simply re-inscribe governing fictions of "otherness," "Africa" and "modernity" into art-world discourse?

Here is a contemporary artist, hailing from Ghana and based in Nigeria, who is seemingly conversant in local, regional and Western histories of practice and able to synthesize them to produce visually stunning and conceptually challenging works of art. To cite but one of countless pleasurable reactions to the work, a commentator at a recent Miami show noted enthusiastically, "He is trained in Western art and the abstract tradition, but he also takes some of the African tradition of using recycled objects and does it so brilliantly – so [he] combines African and modernist ideas to create something that gives you that sense of the sublime that we're always talking about when we're looking at big abstract art."[12] Perhaps more than any other artist from Africa, El Anatsui's rapid ascent to the upper echelons of the contemporary art market continues to fascinate critics, curators and collectors. Anatsui's renowned transformation of materials (heavy metal works appear as airy, transparent scrims

or iridescent watercolors), and his references to history's workings, both local and further afield, give his works wide-ranging appeal. And while he has been an innovative practicing artist for decades, showing locally and internationally since the 1970s, it is unquestionably the metal "cloth" series, debuting in the early part of this century, that catapulted him to art-world superstardom. These pieces – described variously as kinetic sculptures, assemblages, site-specific installations, tapestries or cloths – are made of nothing more than discarded metal caps and wrappings of countless locally sold and consumed liquor bottles. These common materials are "stitched" together with copper wire in economical fashion by a team of assistants, under the artist's creative guidance. Sometimes battered flat, other times crumpled or twisted, these transformed materials merge together to create infinitely variable, striated, circular and syncopated patterns of color and design. The resulting works are substantial, sharp and shiny.

Now displayed in some of the most prestigious locations in the art world, from Palais de Tokyo in Paris, the Kiasma Museum of Contemporary in Helsinki, the Centre Pompidou, Paris, the Metropolitan Museum of Art and Museum of Modern Art, New York, and the de Young Museum in San Francisco to name just a few, these resplendent works exude sophistication and magnetism, simultaneously reflecting and refracting their surroundings. They undulate and cascade down and across walls; they creep onto floors or envelop buildings; and they inhabit all these spaces with a charged energy that suggests buoyancy, delicacy and live monumentality, Fig. 5.1.

FIGURE 5.1 El Anatsui, *Five Decades* (installation view). The School, Kinderhook, New York, May 17–September 26, 2015. Courtesy of the artist and Jack Shainman Gallery, New York.

Contemporary art aficionados are drawn to them, in part, because they seem to have arrived before their blinkered eyes with little obvious pedigree.[13] Most commentators have been at a loss to explain how an unassuming sexagenarian based in a small university town in Nigeria could achieve a synthesis of form, material and process that so aptly captures the texture and tenor of our shared, contemporary moment. These works not only quench a thirst for novelty and a desire for difference, but they do so in a manner that is attuned to but not derivative of familiar Western forms.[14]

Extraordinary mixtures of the prosaic and the poetic, they evoke histories of modernist abstraction and offer access to plethora of West African visual practices. Though the details of African sources may be sketchy for a broader art public, they suggest just enough difference to appeal. For some, they reference the tortured tales of the Middle Passage and legacies of the colonial project. For others, they offer a nostalgic nod to the failed dreams of post-colonial development and pinpoint the acute unevenness of globalization (in re-used materials and hand-made process, evidence to many of the indigence of the developing world). His installations are read as comments upon neo-liberal economies of waste and twenty-first-century consumerism. In their making, they bear the marks of local consumption and collective, exhaustive human labor. (Anatsui employs a significant number of young men as apprentices in his university town of Nsukka. They work long hours twisting and stitching the metal caps.) His long-standing emphasis on re-generation and re-purposing of materials attracts those interested in the social relevance of environmentally sensitive art practices.[15] Above all, these impressively scaled works are remarkably beautiful and accessible.

The rise of an African maestro

The accolades this humble man has received in the past year alone are astonishing for any living artist, let alone one at work outside established centers of art-world power. In 2014, he took his place as an honorary academician at London's Royal Academy, and in 2015, he accepted the Golden Lion for Lifetime Achievement Award at the 56th Venice Biennale. In a now widely cited and critiqued feature in the Sunday *New York Times Magazine*, staff writer Alexi Worth describes the means through which Anatsui's work attracted art world attention:

> In the West . . . there is a divide between the earlier work, which can seem heavy-handed in its Africanness, and the new sculptures, which are more spectacular and, at the same time, subtler. An apparent fusion of Klimt and Christo, Seurat and Tuttle, Anatsui's wall hangings recall disparate Modernist sweet spots without quite settling into any familiar category.[16]

As far-fetched and neo-colonialist as some of these comparisons may seem, this critic has identified the moment when the politics of multiculturalism (one in which the works of minority artists in America and non-Western "others" were

managed through celebrations of difference alone) ceded to that of global cosmo-politanism, an updated form of universalism that values de-centered, multi-temporal modes of production and reception.

The embrace of global cosmopolitanism is strikingly evident in most of the museum texts that introduce Anatsui's bottle-cap pieces. For example, at the recent blockbuster travelling show titled *Gravity and Grace* (2012), organized by the Akron Museum of Art, a press release for its San Diego venue read,

> In his work, Anatsui strikes a rare combination of stunning beauty, fascinating communal process and deep metaphorical and poetic meaning. Just as the work is greater than the sum of its thousands of parts, its meaning transcends the particular cultural influences that contribute to the artist's psyche and embody something universal that strikes a chord in every one of us.[17]

The "inclusion" of Anatsui into the canon of contemporary global art occurred in spite of and in contradistinction to the efforts of ethnographic museums, many of which, in the late twentieth century, actively courted post-colonial artists whose works they hoped would exhume and then lay to rest the ghosts of imperial collecting histories. This widely practiced route to "contemporize the African galleries"[18] meant that many African artists found themselves "ethnologized," unable to break out of the newly re-branded ethnographic museums and their role as post-colonial interventionists or provocateurs.[19]

For the most part, El Anatsui fared much better than many of his contemporaries in this regard, in part because of the depth of his practice (and long career), in part due to fortuitous timing. His new genre corresponded with the proliferation of biennales and the rising discourse on nomadism, globalism and alternative modernities. His work has been collected and displayed by curators of African arts and those of contemporary art. In fact, it is common to find him represented in both the Africa-focused galleries and the contemporary art spaces of the same institution. While the ethnologists focus on perceived correspondences to local, African traditions of weaving or graphics, the contemporary curators place his pieces in the context of installation work, post-war assemblages, mixed-media works or abstract painting.

In the early 1990s, El Anatsui found support at the commercial galleries in New York (Skoto Gallery) and London (October Gallery) that focused primarily on the works of contemporary artists from outside the West. By the time he first exhibited at the Venice Biennale (1990) and in group shows in America, he had long been working across media, experimenting with process, materials and philosophical and political themes that both imagined and assumed diverse, local, layered and cosmo-politan audiences.[20] Whether working in wood, clay, paint or ink, he drew from a profound and abiding interest in indigenous methods of narrating and respecting histories. In works such as *Devotees* (1987) or *Well-Informed Ancestors* (1988), Anatsui made everyday "habitations of modernity" central to his iconography.[21] With plays of scale and color and attention to texture, line and patina, he channeled indigenous

graphic systems such as *nsibidi*, *uli* and *adinkra* to give voice to the masses, often in intimate, detailed fashion.

Even in that era, advocates pushed to exhibit his pieces outside the narrow confines that existed for the canon of African art. For instance, in 1996, Skoto Aghahowa, of Skoto Gallery in New York, paired Anatsui's lyrical, abstract wooden wall hangings with the conceptual works of Sol LeWitt, and in 1998, curators at the October Gallery positioned him at the forefront of an international transvangarde.[22]

Like the more familiar, recent bottle-cap pieces, Anatsui varied the arrangement of his wooden plank pieces within gallery spaces, encouraging an active viewer and curator, and promoting an open-ended and participatory aesthetic. Few would question that his adoption of the bottle caps in 1998 heralded a watershed moment, a flash of brilliance, perhaps, as some have even suggested, an invention of an entirely new genre – a rare feat indeed in the art world. This metal phase began with installations made from cassava graters, then tops of milk tins and finally bottle caps. But it was not until 2005 that wider audiences were able to view this new "genre," in the touring survey show Africa Remix, which opened in Düsseldorf and toured to London, Paris, Tokyo and Johannesburg and in his concurrent solo exhibition GAWU, which was organized by the Oriel Mostyn Gallery in Wales (in conjunction with October Gallery) and toured to several venues in the United States. By 2006, as his art-world fortunes widened, South African gallery David Krut Projects added him to its roster. In 2008, Jack Shainman Gallery in New York followed suit. While, in the past, duality within the art world had "ghettoized" his wood or ceramic works, now multiplicity serves as an easy means through which a wide array of institutions feature them. Most would cite the exhibition of his installations *Dusasa I* and *Dusasa II* in the Arsenale and *Fresh and Fading Memories* at the Palazzo Fortuny, as the moment of arrival. Both were part of the 52nd Venice Biennale (2007) curated by Robert Storr. Over the last decade, major art venues on both sides of the Atlantic have consistently featured his works – from the Highline Park in New York to the courtyard of the Royal Academy in London to the Guggenheim in Abu Dhabi to the Osaka Foundation in Japan. Anatsui is a global phenomenon.

Understood as revelation and revolution, Anatsui's turn to the bottle-cap pieces posed a unique challenge to the workings of a global art canon accustomed to tracing the arc of an artist's practice. The inclusion of his metaphorically and materially rich experimental works in wood and ceramic has not been a foregone conclusion. They were easily dismissed as anachronistic on the basis of medium and material (wood carving, ceramics, painting) or too "ethnic" because of their references to indigenous histories, textiles and scripts. By now, however, they have been re-coded as precursors to future greatness – the "period" that prepared him for the breakthrough moment.

Though many African art scholars, and the artist himself, have insisted that the "leap" must be understood in relation to a forty-year-plus career of a remarkably talented and consistent practice, the effort and energy needed to make these connections seemed initially too daunting or distracting for the average contemporary curator, who simply wanted to claim and celebrate the new. Even Robert Storr struggled to move beyond his fascination with the bottle-cap period but eventually urged others to consider the artist's larger oeuvre, noting, "when radical invention

comes about, more traditional mastery was already an accomplished reality, such that innovation is all the more authoritative and exhilarating."[23]

There remains debate as to whether he would have achieved status in the contemporary art canon without this "breakthrough." In her recent extensive monograph on the artist, curator Susan Vogel promptly confesses that while she is committed to tracing the long trajectory of his artistic development, it is the watershed moment – the revelatory transformation in his practice that gave birth to the metal works – that ultimately captures her imagination. She notes:

> The feat that interests me here is less the unprecedented success of an African artist at the highest levels of world art–impressive though that is–than a late-in-life-innovation producing an art of enormous conceptual and material complexity. How any artist makes the jump from one mode of expression to a more eloquent one is always a mystery, and Anatsui's swift, unexpected leap to international visibility from Nsukka, Nigeria, made his case seem more sudden and mysterious.[24]

Why, she wonders, did it take the bottle caps to get the larger world to recognize the brilliance of his work? Is it the material(ity), the process, the vision or just the right timing? Why, in the end, do these questions matter?[25] Because the struggle to answer any and all of them lies at the very heart of debates about the identity of the global contemporary and the workings of a "canon" after the "end of art history."[26]

Inter-media and metamorphosis: Anatsui's narratives of history

Anatsui's formal and conceptual brilliance is matched only by the cleverness of his interaction with a rapt art world. His interest in process and medium continues to shift but is consistently framed in a recognizable modernist language – as a quest toward greater enlightenment, better form and efficacy. For example, in a review of a major summer show in 2012, Holland Cotter asserted, "Mr. Anatsui himself compares his metal work to painting and sees the show as a record of his move from the equivalent of oils to watercolor, from opaqueness to transparency."[27] Indeed from the perspective of a hungry art world, his work seems to shape-shift on demand – assuaging the interests of a highly networked yet diverse world.

For instance, the artist's interests in nomadism, displacement and migration – central preoccupations of contemporary life – are long-standing and varied. He even has taken to describing his very large and complicated bottle-cap works as a "nomadic aesthetic," because they can be folded and cinched for packing and transport all over the world and because their very material existence speaks of long-established trade routes. Moreover, anyone lucky enough to walk alongside the figures of his epic installations made of reclaimed wood or weathered mortars, such as *Akua's Surviving Children* (1996) and *On Their Fateful Journey Nowhere* (1996), senses the profundity and essential humanity of these weathered materials and recognizes the predicaments of exilic experience, Fig. 5.2.[28]

FIGURE 5.2 El Anatsui, *On Their Fateful Journey Nowhere*, 1995. Installation, okpeye wood, height 36.2 in. (92 cm), width and depth variable. Collection of Setagaya Museum, Tokyo. Courtesy October Gallery, London. Photograph by Norihiro Ueno.

FIGURE 5.3 El Anatsui, *Ozone Layer*, 2010. Aluminum, copper wire, installation view, Alte Nationalgalerie, Berlin, 2010. Artwork © El Anatsui. Photograph by Chika Okeke-Agulu.

The inherent inter-medial nature of his works holds equal appeal, focused as it is on materials sourced from his local environment, dependent on resident labor and driven by a belief in metamorphosis, adaptation and viewer engagement.[29] Elsewhere I have called his ability to move among materials, forms and processes "inter-textual."

"In his hands, wood or metal resemble stamped cloth or strip-woven textiles, sculptures have a performative, kinetic presence, and clay pots become not containers but sculpted chambers of memory."[30] Anatsui referred to his 2010 *Ozone Layer and Yam Mounds*, an installation draped majestically across the facade of the Alte Nationalgalerie in Berlin, as a synesthetic "living sculpture," Fig. 5.3. In this instance, he took advantage of the windy site in the suspension of the piece. At times this enormous, glittering openwork cloth appeared to dance, sway or ripple gently and chime gracefully across the staid façade.

And in the last decade or so, Anatsui has increasingly reflected on his practice as one that oscillates between sculpture, assemblage and installation, performance and painting. In particular, the concentrated play between abstract form, fragment and color and the attention to scale, site specificity and materiality encourage comparisons with any number of art practices. His interest in abstraction and color elicits comparisons with the oeuvres of Frank Stella, Sam Gilliam, Alma Thomas and Mark Rothko; his engagement with found objects, fragments and workshop practices evoke Robert Raushenberg and Arman; and his interest in scale, site specificity and materiality bear analogies to the spectacular works of Henrique Oliviera or Felix Gonzalez-Torres.[31]

The poetry of old wood

The complex and capacious play of formal and conceptual elements in Anatsui's works, coupled with the "difference" derived from African resources, gives curators ample space to position them as arbiters of our zeitgeist. But the key to his "inclusion" in a burgeoning contemporary canon has to do with the current art world's retro-modern tastes, which value archival practices, savor analogies and reward cosmopolitanism. If just taken in the context of the bottle-cap pieces, it is easy to situate his work within the larger research-based practices of a number of contemporary artists who address what T.J. Demos has called the "haunting of the postcolony."[32] Unearthing the spectres of neo-liberalism and exorcising the ghosts of colonialism, the works of these artists focus, with ever-greater urgency, on exposing the willful amnesia of the art world and the continued inability or unwillingness of their own nations to address, critically, the remaining scars of the past. In Anatsui's hands, questions of the archive are addressed with great subtlety and grace, in which the most mundane object, the discarded bottle cap, the worn mortar or the tin can lid, is treated as a fragment worthy of investigation and ripe for translation.

His process consistently draws on the rich possibilities of bottom-up history and comments upon the mechanisms of time.[33] For instance, in his thoughts on what he called the "Sankofa syndrome," a conscious and selective process of "return and retrieve" that was prevalent in Ghana in his youthful years, Anatsui argues that the re-use and re-purposing of local materials and ideas is critical to creativity. "Express new ideas in old wood. Mix time-furrowed experience with buoyant smoothness; the concavity of old time with the convex posture of new time. New wood has

poetry locked in it. Old wood is poetry itself."[34] In the same publication, in an early interview with critic Olu Oguibe, Anatsui addresses European colonial denigration of indigenous methods of transmitting histories, honoring

> a continent that has been battered but still has its way of remembering or recording the experience not only through oral traditions but also through several surviving writing traditions. So that even if there were no history without writing, the truth remains that we had writing. Whichever way, we have a history.[35]

Indeed, the conceptual underpinning of his work is both deeply reflexive and dependent on the working and relating of histories, big and small. These do not weigh him down but rather endow the works with buoyancy, as if their very airing frees them. Okwui Enwezor recognized this trait in the artist's works, insisting, "Anatsui responds to every material he works with as if he has encountered it for the first time in the flux of history."[36]

African contemporary and modernist histories

Though the most widely cited exchange amongst scholars around the meaning and limits of the "contemporary" appeared in October (2009), the roundtable discussion a year later among scholars within *Nka: Journal of Contemporary African Art* (2010) proves more pertinent. Despite earlier challenges to the canon, modernist "primitivism" has continued to cast its pallor on the interpretive framings of modern and contemporary arts from the continent. For example, even when Robert Storr sought to center Anatsui's oeuvre within histories of the modern, he did so in ways that left the temporal contours of the revised story rather murky. In a recent catalogue essay, Storr avers, "It should be at last incontestable that modernism, like modernity, is, or has become – heterogeneously rather than homogeneously-global."[37] The "tense" of this acceptance into the canon serves to distance Anatsui and other African contemporary artists from their own multi-layered histories of modernist practice.

In the forum on contemporary African art, Peter Probst argued that "contemporary" was used as nothing more than a "purifying term" – one that ensured that the shifts between African (signifying local, tribal, non-Western, different) and global (cosmopolitan, urban, mainly installation or lens based) could be readily made within exhibitions. Weighing whether the label should be considered a threat or a blessing, he further argued,

> just like "fine art," the category "contemporary art" is a "purifier." Once art is categorized as "contemporary," the qualifier African tends to become obsolete. The process works for the artist, his or her work, and the curator. Being contemporary not only enables a work and its producer to move and circulate in the supranational sphere of the so-called global art world. It also authorizes

the curator, the gallery owner, and our colleagues in the – usually – Western contemporary camp to exhibit and discuss these works.[38]

Any quick read of a number of substantial exhibition and scholarly projects on "the contemporary" in the last decade quickly justifies Probst's distrust of the term as it is currently employed in the art world. In their introduction to *The Global Contemporary: Art Worlds After 1989*, Hans Belting and Andrea Buddensieg speak of a "new world map of art" in the era of globalization (post 1989):

> Today's contemporary art presents itself not only as new art but as a new kind of art, an art that is expanding all over the globe ... one element of its newness is that it is no longer synonymous with modern art. Rather it sees itself as contemporary: not only in a chronological sense, but also in a symbolic and even ideological sense. In many developing countries, art can only be contemporary because locally it has no modern history. Thus the twenty-first century is seeing the worldwide emergence of an art that lays claim to contemporaneity without limits and without history.[39]

In a similar fashion, in his treatise on the character of the contemporary art world for the TATE Triennial in 2009, curator Nicholas Bourriaud defines the heterochronical global era as "Altermodern" – one in which "the historical counters ... (can) be reset to zero." With this epistemological move, Bourriaud collapses the modern into the post-historical contemporary vanquishing history for contemporaneity. This juncture is where the discourse around El Anatsui's work sits. If we are to challenge remarkably misinformed claims like those above that fail to recognize or credit local modern histories, we need to continually address the still-prevalent asymmetries of power between Africa's artists and the canon makers of modernity and contemporaneity.[40] The challenge is no longer simply whether El Anatsui's work fits within global contemporary canons but rather how one re-inserts his story into the modernist and post-modernist histories that the contemporary art world desperately wishes to leave behind. He didn't just arrive. Despite the challenges of post-colonial scholarship, any work from "elsewhere" that looked like modernism or evidenced cosmopolitanism within European modernism was conveniently seen through the distorted lens of belatedness, mimicry or derivativeness.

Now the canon of contemporary art, operating on its archival impulses, needs a cosmopolitan modern. In other words, the fascination with the archive of "global" modernity services the needs of a contemporary art world still attempting to resolve and then move on from postmodernist challenges. What critics once dismissed as mimicry is now seen as a useful analogy or refraction of better-known precedents. Indeed, the overwhelming tenor of the reception around Anatsui's work evokes "same-but-different" comparisons. And while many well-meaning scholars do indeed support efforts to write a biography of modernity and visual modernisms on the African continent, a project of "filling in the archive" as it were,[41] we must, in Dipesh Chakrabarty's words, "engage and reengage our ideas about modernity

in a spirit of constant vigilance,"[42] as this project of revision is open for co-optation. Even amongst prominent Africanist scholars, the problem of the modern is far from resolved. For Okwui Enwezor, modernity and therefore modernism in Africa was strictly a "postcolonial" phenomenon, able to flourish only after the advent of political freedoms and in the aftermath of tradition – a space and time he terms "Aftermodernity." Notions of "tradition" and "indigenous authenticities" are to be discarded as figments of the colonial imagination or as misplaced forms of nativism. In his recent co-authored volume, *Contemporary African Art Since 1980*, modernism has become so problematic as to be ripe for dismissal. He notes, "One historical problem of modern African art is the way it can be said to inhabit two types of inauthenticity, first on account of its deviation from traditional art; second in its failure to be modern in relation to Western modern art;" "Contemporary African art" he continues, "shares none of the anxieties of modern African art."[43] And yet it is hard to deny that a large part of Anatsui's story rests in his engagements with local and regional heritage, the ambiguities of colonial modernity and the reconciliation of post-colonial nationhood with modernism. The artist's re-location to Nigeria in the 1970s to teach at the University of Nsukka brought him into some of the most innovative circles of African modernists, who were in the midst of reckoning their artistic heritage with the realities and exigencies of post-war life in the waning British Empire.

What the Western critics have failed to notice or acknowledge is that his works do not address just the "sweet spots" of Western modernity but also those of an already local-global modernity, in translation and mistranslation.[44] His engagements with abstraction, form, material and color are relevant to the work of key artists in the Aka, Uli and Natural Synthesis groups such as Obiora Udechukwu, Chike Aniakor, Uche Okeke and Tayo Adenaike, active at University of Nigeria at Nsukka.[45]

In his writings on what he termed "postcolonial modernism," Chika Okeke-Agulu has made great contributions to fleshing out these broader modernist practices to which Anatsui surely belongs.[46] Okeke-Agulu urges a truly comparative practice of art history – one that asks different questions, employs local terminologies, entertains other modes of analysis and, in the process, acknowledges multiple methods of history writing. But these comparative practices will remain ineffective and disingenuous if they do not address the continuing asymmetries in the art world rather than celebrate a shared condition of post-history. As one South Asian art historian asked, "Is it a formation of a new 'us' and 'them'-binary – between those of us who have invented a dominant art history and those who duplicate interpretive tools and are shackled in a derivative discourse as a perpetual tradition?"[47] At a time when critics proclaim a plurality of practices within a highly inter-connected field, the a-historicity and largely a-political nature of the "global contemporary" label begs greater attention to the mechanisms of canon formation, not least because these workings are imbricated in and naturalized by the exploitative networks of global capital. The work of a talented and insightful artist like El Anatsui provides remarkable opportunities to challenge the easy assumptions of universalism and inclusiveness supporting the global contemporary art world, insisting instead,

for those who heed his lessons, on complication, slow careful mediation and brico-lage and unresolved ambiguity.

Notes

1 Holland Cotter, "Under Threat: The Shock of the Old," *New York Times*, April 17, 2011: Art Review: 1.
2 A well-established literature exists on the "differencing" of Europe's others in the museum spaces of the imperialist era. While too copious to cite here, for particularly pertinent works, see Shelly Errington, *The Death of Authentic Primitive Art* (Berkeley: University of California Press, 1998); Sally Price, *Primitive Art in Civilized Places* (Chicago: University of Chicago Press, 1989); Saloni Mathur, *India By Design: Colonial History and Cultural Display* (University of California Press, 2007).
3 This lament echoes a now oft-cited challenge to the canon of African art that signaled a paradigm shift between generations in which an older one, largely trained in ethnogra-phy, questioned the methods and theories of a newer one, interested in thinking about African artists in a contemporary art arena. See Frederick Lamp, "Africa Centered," *African Arts* 32, no. 1 (Spring 1999); 1, 4–6, 8–10. See also responses in the same issue Suzanne Preston Blier, "Replies to Lamp's First Word: The GOGAG's Lament," *African Arts* 32, no. 1 (Spring 1999), 9 and Chika Okeke-Agulu, "Africanists and African Art History," *African Arts* 32, no. 1 (Spring 1999), 10; Carol Magee-Curtis, "A White Chick Sittin' Around Thinking and She Doesn't Like What She's Read," *African Arts* 32, no. 2 (Summer 1999): 9–10, 85–87; Steven Nelson, "The Holy Book of Africanist Art History: Chapter 20," *African Arts* 32 no. 3 (Autumn 1999): 9, 85. Suzanne Preston Blier, "Replies to Lamps First Word: The GOGAG's Lament," 9; Chika Okeke-Agulu, "Africanists and African Art History," 10; Carol Magee-Curtis, A White Chick Sittin' Around Thinking And She Doesn't LIke What she's Read," 85; Steven Nelson, "The Holy Book of Afri-canist Art History: Chapter 20, 86–87.
4 Belting, "Contemporary Art as Global Art. A Critical Estimate," *Global Art World: Audi-ences, Markets, Museums*, Belting and Andrea Buddensieg, eds. (Ostfildern-Ruit, 2009), 41–44.
5 This rhetoric of globalism is tempered by critiques of its inherent Euro-centrism, par-ticularly by scholars operating in centers now implicated in a global field. See Partha Mitter, "Intervention. Decentering Modernism: Art History and Avant-Garde Art from the Periphery," *Art Bulletin* 90, no. 4 (December 2008): 543–544; or contributions to James Elkins volume, *Is Art History Global: The Art Seminar* (New York: Routledge, 2006).
6 Terry Smith, *What Is Contemporary Art?* (Chicago: Chicago University Press, 2009). Smith and others consider the contingent and political nature of our measures of time. In our contemporary condition, they posit, we imagine being in the present, of the moment and equally positioned beyond (or out) of now-discredited modernist markers of historical time.
7 Smith identifies a "current" in Euro-American contemporary art practice as "remodernist," which he explains as "a continuation of styles in the history of art, particularly Modernist ones." He differentiates these tendencies from the "transnational transitionality" evident in formerly colonized regions of the modern world. Smith, "Worlds Pictured in Contempo-rary Art: Planes and Connectivities" in *Humanities Research* XIX, no. 2 (2013): 26.
8 Harney, *Retro-Modern Africa: Art After the Contemporary*, in progress.
9 Parul Dave Mukherji, "Whither Art History in a Globalizing World," in *Art Bulletin* 96, no. 2 (June 2014): 153; see also Belting, "From World Art to Global Art: View on a New Panorama," *The Global Contemporary and the Rise of New Art Worlds*, Belting, Andrea Buddensieg, and Peter Weibel, eds. (Karlsruhe, Germany: ZKM Press Center for Art and Media, 2013), 178–85.
10 Sunanda K. Sanyal, "Critiquing the Critique: El Anatsui and the Politics of Inclusion," *World Art* 4, no. 1 (2014): 89–108, 94.

11 For a comparable argument on these issues, see Sanyal, "Critiquing the Critique."

12 As quoted by George Fishman, "El Anatsui's Miami Beach Exhibition at Bass merges Colonial Past with Contemporary Art," *Miami Herald* (Visual Arts) (June 6, 2014).

13 Early readings of these works associated them with strip-woven cloths from Ewe and Akan traditions in Ghana. Initially, through interviews and title choices, Anatsui seemed to encourage these interpretations. However, he soon began to encourage more capacious readings of the works, with references to abstraction, syncopation and assemblage.

14 The capacity for the art world to graft Anatsui's bottle-cap works onto a whole array of Western precedents is astonishing, a practice in which writers evoke everything from Byzantine to Baroque to pointillism or Paco Rabanne. See, for example, David Ebony, "African Baroque: The Sculpture of El Anatsui," *Art in America* (April 29, 2013); or Raphael Rubinstein, "Full Metal Fabrics," *Art in America* 94, no. 5 (2006): 58–62.

15 There is now an extensive bibliography on his work, much of it written in the art trade journals, but also increasingly within scholarly venues.

16 Alexi Worth, "El Anatsui," Museum of Contemporary Art, San Diego, "Gravity and Grace: Monumental Works by El Anatsui, March–June 28" http://www.mcasd.org/exhibitions/gravity-and-grace-monumental-works-el-anatsui

17 https://akronartmuseum.org/newsroom/details.php?unid=2960

18 Chris Spring, as quoted by Chika Okeke-Agulu, "Nka: Roundtable III: Contemporary African Art and the Museum," *Nka: Journal of Contemporary African Art* 31 (Fall 2012): 68.

19 See Polly Savage, "Playing to the Gallery: Masks, Masquerades and Museums," *African Arts* 41, no. 4 (Winter 2008): 74–81. Elizabeth Harney, "The Perils of Intervention," *Retro-Modern Africa: Art after the Contemporary*, forthcoming.

20 Grace Stanislaus, *Contemporary African Artists: Changing Traditions* (New York: Studio Museum Harlem, 1991).

21 Dipesh Chakrabarty, *Habitations of Modernity: Essays in the Wake of Subaltern Studies* (Chicago: University of Chicago Press, 2002).

22 Coining the phrase "transvangarde" in 1979, the October Gallery referred to "a transcultural avant-garde composed of cutting edge artists from all cultures around the planet. The transvangarde denotes a true vanguard of artists who, escaping from the boundary definitions of any single culture operate between and even beyond culture." http://www.october.gallery.ukgateway.net/transvan.htm. Years later the Akron Museum of Art would make the same choice, pairing his bottle-cap works with those in its collection by Sol LeWitt and Helen Frankenthaler.

23 Robert Storr, "Ambition," *Parkett* 90 (2012): 48.

24 Susan Mullin Vogel, *El Anatsui-Art and Life* (Munich, London, New York: Prestel, 2012), 10.

25 Sanyal, "Critiquing the Critique"; Vogel, *El Anatsui: Art and Life*; Okeke-Agulu, "Response to 'Questionnaire on The Contemporary,'" *October* 130 (2009): 44–45; Okeke-Agulu, "Mark-Making and El Anatsui's Reinvention of Sculpture" *El Anatsui: When I Last Wrote to You about Africa*, Lisa Binder, ed., (New York: Museum for African Art, 2010), 33–50; Okeke-Agulu, "Globalization, Art History, and the Specter of Difference," *Contemporary Art: 1989 to the Present*, Alexander Dubadze and Susan Hudson, eds. (Hoboken, NJ: Wiley-Blackwell, 2012), 447–56; Okwui Enwezor, "El Anatsui, Response to 'Questionnaire on The Contemporary,'" *October* 130 (2009): 33–39.

26 Belting, *Art History After Modernism*. Trans. Caroline Saltzewedel, Mitch Cohen, and Kenneth J. Northcott (Chicago: University of Chicago Press, 2003).

27 Cotter, "A Million Pieces of Home," *New York Times*, February 8, 2013.

28 Emma Ejiogu, "Art-in – Life: El Anatsui's World of Migration," in *Lagos Life*, November 10–16, 1988.

29 Binder, "El Anatsui: Transformations," *African Arts* 41, no. 2 (Summer 2008): 24.

30 Harney, "Excess and Economy: Thoughts on the Recent Works of El Anatsui," in *El Anatsui: Zebra Crossing*. Catalogue for an exhibition held at Jack Shainman Gallery, New York, 10 February–13 March 2008.

31 Harney, "A Nomad's Revolutionary Beauty," *Nka: Journal of Contemporary African Art* 28 (Spring 2011): 115–29.

32 T.J. Demos, *Return to the Postcolony: Specters of Colonialism in Contemporary Art* (Berlin: Sternberg Press, 2013).

33 John Picton addressed Anatsui's interest in history and his ability to teach others early on in "'Patches of History' Patching up my Art History: Reflections on the Sculpture of El Anatsui," *El Anatsui: A Sculpted History of Africa* (London: Saffron Books, 1998), 17–25.

34 Anatsui, "Sankofa," 42.

35 Ibid., 83–84.

36 Enwezor, "A Ceaseless Search for Form," *Parkett* 90 (2012): 36.

37 Storr, "The Shifting Shapes of Things to Come," *When I Last Wrote*, Binder, ed., 60.

38 Peter Probst, "Nka: Roundtable on Contemporary African Art and Scholarship," *Nka: Journal of Contemporary African Art* (Spring 2010): 83.

39 Belting and Buddensieg, *The Global Contemporary: Art Worlds After 1989* (Karlsruhe: ZKM, 2011), 7.

40 Questions of hetero-temporality of modernity are taken up now by many writers. I have cited the arguments of merely a few of the most prolific thinkers: Smith, Enwezor, Bourriaud, Belting; and in regards to Africa, Okeke-Agulu, Harney, Sanyal, Colin Richards, Prita Meier.

41 Enwezor, et al., *The Short Century: Independence and Liberation Movements in Africa: 1945–1994* (New York: Prestel, 2001).

42 Chakrabarty, *Habitations of Modernity*, xx.

43 Enwezor, *African Art Since 1980* (chapter 2). He re-iterated these claims in a different context, "Modernity and Post-colonial Ambivalence," *Altermodern: Tate Triennial*, Bourriaud, ed. (London: Tate Publishing, 2009), 25–40.

44 Parts of this chapter were first advanced as a short thought piece in Harney, "Keeping Afloat: El Anatsui, Global Africa and the Contemporary," *ArtsouthAfrica* 12, no. 2 (December 2013).

45 Simon Ottenberg, *New Traditions from Nigeria: Seven Artists of the Nsukka Group* (Washington, DC: Smithsonian Institution, 1997); Ottenberg, ed., *The Nsukka Artists and Nigerian Contemporary Art* (Seattle: University of Washington Press, 2002).

46 Okeke-Agulu, *Post-Colonial Modernism: Art and Decolonization in 20th Century Nigeria* (Durham: Duke University Press, 2015).

47 Mukherji, "Whither Art History," 153.

Bibliography

Anatsui, El. "Sankofa: Go Back an' Pick: Three Studio Notes and A Conversation," *Third Text: Third World Perspectives on Contemporary Art and Culture. Africa Special Issue* (Summer 1993).

———. *El Anatsui: A Sculpted History of Africa*. London: Saffron Books, 1998.

Belting, Hans. *Art History After Modernism*. Translated by Caroline Saltzewedel, Mitch Cohen, and Kenneth J. Northcott. Chicago: University of Chicago Press, 2003.

———. "Contemporary Art as Global Art. A Critical Estimate," *Global Art World: Audiences, Markets, and Museums*, Hans Belting and Andrea Buddensieg, eds., 41–44. Ostfildern-Ruit: Hatje Cantz, 2009.

———. "From World Art to Global Art: View on a New Panorama," *The Global Contemporary and the Rise of New Art Worlds*, Hans Belting, Andrea Buddensieg, and Peter Weibel, eds., 178–185. Karlsruhe, Germany: ZKM Press Center for Art and Media, 2013.

Belting, Hans and Andrea Buddensieg. *The Global Contemporary: Art Worlds After 1989*. Karlsruhe: ZKM, 2011.

Binder, Lisa. "El Anatsui: Transformations," *African Arts* 41, no. 2 (Summer 2008): 24–37.

Bourriaud, Nicholas. "Altermodern," *Altermodern: Tate Triennial*, Bourriard, ed. London: Tate Gallery, 2009.

Chakrabarty, Dipesh. *Habitations of Modernity: Essays in the Wake of Subaltern Studies.* Chicago: University of Chicago Press, 2002.

———. "Under Threat: The Shock of the Old," *New York Times* (April 17, 2011: Art in Review).

Cotter, Holland. "A Million Pieces of Home," *New York Times* (February 8, 2013).

Demos, T.J. *Return to the Postcolony: Specters of Colonialism in Contemporary Art.* Berlin: Sternberg Press, 2013.

Ebony, David. "African Baroque: The Sculpture of El Anatsui," *Art in America* (April 29, 2013).

Ejiogu, Emma. "Art-in-Life: El Anatsui's World of Migration," *Lagos Life* (November 10–16, 1988).

Elkins, James. *Is Art History Global: The Art Seminar.* New York: Routledge, 2006.

Enwezor, Okwui. ed. *The Short Century: Independence and Liberation Movements in Africa: 1945–1994.* New York: Prestel, 2001.

———. "El Anatsui, Response to 'Questionnaire on the Contemporary,'" *October* 130 (2009): 33–39.

———. "Modernity and Post-colonial Ambivalence," *Altermodern: Tate Triennial*, Bourriaud, ed., 25–40. London: Tate Publishing, 2009.

———. "A Ceaseless Search for Form," *Parkett* 90 (2012): 33–38.

Errington, Shelly. *The Death of Authentic Primitive Art.* Berkeley: University of California Press, 1998.

Fishman, George. "El Anatsui's Miami Beach Exhibition at Bass Merges Colonial Past with Contemporary Art," *Miami Herald (Visual Arts)* (June 6, 2014).

Harney, Elizabeth. "Excess and Economy: Thoughts on the Recent Works of El Anatsui," *El Anatsui: Zebra Crossing.* Catalogue for an exhibition held at Jack Shainman Gallery, New York, 10 February–13 March 2008.

———. "A Nomad's Revolutionary Beauty," *Nka: Journal of Contemporary African Art* 28 (Spring 2011): 115–129.

———. "Keeping Afloat: El Anatsui, Global Africa and the Contemporary," "*ArtsouthAfrica* 12, no. 2 (December 2013).

———. "The Perils of Intervention," in Elizabeth Harney, *Retro-Modern Africa: Art after the Contemporary*, forthcoming.

Houghton, Gerard. *El Anatsui: A Sculpted History of Africa.* London: October Gallery, 1998, 27–55.

Lamp, Frederick. "Africa Centered," *African Arts* 32, no. 1 (Spring 1999): 1, 4–6, 8–10.

Mathur, Saloni. *India by Design: Colonial History and Cultural Display.* Berkeley, Los Angeles and London: University of California Press, 2007.

Mitter, Partha. "Intervention. Decentering Modernism: Art History and Avant-Garde Art from the Periphery," *Art Bulletin* 90, no. 4 (December 2008): 543–544

Mukherji, Parul Dave. "Whither Art History in a Globalizing World," *Art Bulletin* 96, no. 2 (June 2014): 151–155.

Okeke-Agulu, Chika. ed. "Response to 'Questionnaire on the Contemporary,'" *October* 130 (2009): 44–45.

———. "Globalization, Art History, and the Specter of Difference," *Contemporary Art: 1989 to the Present*, Alexander Dumbadze and Suzanne Hudson, eds., 447–456. Hoboken, NJ: Wiley-Blackwell, 2012.

———. "Nka: Roundtable III: Contemporary African Art and the Museum," *Nka: Journal of Contemporary African Art* 31 (Fall 2012): 46–111.

———. "Mark-Making and El Anatsui's Reinvention of Sculpture," *El Anatsui: When I Last Wrote to You about Africa*, Lisa Binder, ed., 33–50. New York: Museum for African Art, 2010

———. *Post-Colonial Modernism: Art and Decolonization in 20th Century Nigeria*. Durham: Duke University Press, 2015.

Ottenberg, Simon. ed. *New Traditions from Nigeria: Seven Artists of the Nsukka Group*. Washington, DC: Smithsonian Institution, 1997.

———. *The Nsukka Artists and Nigerian Contemporary Art*. Seattle: University of Washington Press, 2002.

Picton, John. "'Patches of History' Patching up my Art History: Reflections on the Sculpture of El Anatsui," *El Anatsui: A Sculpted History of Africa*, edited by John Picton with Gerard Houghton and Elisabeth Laloushek, 17–25. London: Saffron Books, 1998.

Pollack, Barbara. "The Newest Avant-Garde," *Art News* 100, no. 4 (2001): 124–129.

Price, Sally. *Primitive Art in Civilized Places*. Chicago: University of Chicago Press, 1989.

Probst, Peter. "Nka: Roundtable on Contemporary African Art and Scholarship," *Nka: Journal of Contemporary African Art* (Spring 2010): 83.

Rubinstein, Raphael. "Full Metal Fabrics," *Art in America* 94, 5 (2006): 58–62.

Sanyal, Sunanda K. "Critiquing the Critique: El Anatsui and the Politics of Inclusion," *World Art* 4, no. 1 (2014): 89–108.

Savage, Polly. "Playing to the Gallery: Masks, Masquerades and Museums," *African Arts* 41, no. 4 (Winter 2008): 74–81.

Smith, Terry. *What Is Contemporary Art?* Chicago: Chicago University Press, 2000.

———. "Worlds Pictured in Contemporary Art: Planes and Connectivities" *Humanities Research* XIX, no. 2 (2013): 26.

Stanislaus, Grace. *Contemporary African Artists: Changing Traditions*. New York: Studio Museum Harlem, 1991.

Storr, Robert. "The Shifting Shapes of Things to Come," *When I Last Wrote to You About Africa*, Lisa Binder, ed., 51–62. New York: Museum for African Art, 2010.

———. "Ambition," *Parkett* 90 (2012): 46–61.

The TATE Triennial: Altermodern (London, UK: Tate Publishing, 2009). Vogel, Susan Mullin. *El Anatsui-Art and Life*. Munich: Prestel, 2012.

Worth, Alexi. "El Anatsui," *New York Times (Style)*, (February 19, 2009).

PART II

Mediums/media

Part II: Mediums/media

We typically think of artists and artworks rather than artistic mediums entering the canon, but mediums, too, are at times subject to exclusion or inclusion as a whole. Think, for example, of Charles Baudelaire, the poet known for his embrace of modernity, who in 1859, when photography was still a young medium, vigorously rejected any possibility that photography could become a medium for the making of art. Similarly, color lithography, used first for color reproduction of artworks (derogatively named "chromos"), was initially rejected by print collectors as a legitimate medium for art making, and works made in this medium were barred from exhibition in the Paris Salon (of the Society of French Artists) until 1899.[1]

The essays in this section focus on case studies of mediums used for art making in the twentieth and twenty-first centuries. Rosalind Krauss, who deplores what she defines as the loss of medium specificity, argues that artists will have "to reinvent or rearticulate" the medium they have embraced.[2] This insight applies to all the cases discussed in this section, yet the analysis in this part of the volume – of video art, performance art, street art and new-media art – is not about medium specificity but rather shifts attention to a broader framework, demonstrating the ways in which, in all these cases, the art field initially resisted but later canonized art made in a new medium.

William Kaizen's "The Apotheosis of Video Art" traces the evolution of video art from the 1960s, when artists first appropriated television, to video's ascension to "the most prominent fine-art medium to be canonized in the art world during the latter half of the twentieth century." In "Performance Art: Part of the Canon?" Jennie Klein traces the beginnings of performance art in the 1970s, when artists worked outside the mainstream, to today's institutionalization of performance art, which is now regularly exhibited in major museums (as in the case of Marina

Abramović's 2010 piece *The Artist Is Present* performed at MoMA). Must the contemporary practice of performance stay outside the institution of the museum to avoid being coopted? Klein considers this question by analyzing the complex status of performance art, a medium that has already fully entered the art history canon and the museum. Yet even so, as Klein writes, some performance art remains close to its roots in anti-object political activism, now transposed into international festivals, outside of mainstream art institutions.

Paula J. Birnbaum's "Street Art: Critique, Commodification, Canonization" examines the entry of street art into the global art canon and market and asks whether commodification and canonization have become synonymous. Analyzing the works of two leading street artists – the British Banksy and the American Swoon – Birnbaum focuses on processes of canonization and demonstrates how their work fosters a critical dialogue that depends on inhabiting both the street and the canon. In "New Media Art and Canonization," art historians Sarah Cook and Karin de Wild lead a discussion among curator Mark Daniels, art historian Charlotte Frost, Museum Director Axel Lapp, and new-media artist Addie Wagenknecht. Topics include the difficulties involved in curating and collecting media art and in its preservation and historicization and the issues that new-media artists face in the course of transforming an experimental art process into a commodity capable of being exhibited, collected, and ultimately canonized.

Notes

1 Ruth E. Iskin, *The Poster: Art, Advertising, Design, and Collecting, 1860s–1900s* (Hanover: Dartmouth Press, UPNE, 2014), Ch. 3.
2 Rosalind Krauss, *A Voyage on the North Sea,: Art in the Age of the Post-Medium Condition* (London: Thames & Hudson, 1999), 56.

6

THE APOTHEOSIS OF VIDEO ART

William Kaizen

Today, an art gallery or art museum without video art is unthinkable. At documenta, the Venice Biennale and countless other global art fairs, video art has become one of the primary forms of contemporary art. Video art arose from experiments that started as early as the 1960s to become the most prominent fine-art medium to be canonized in the art world during the latter half of the twentieth century. Given its religious origins in relation to the sanctification of saints, canonization is generally equated with the institutional embrace of individuals as dogmatic icons. In the art world, works of art, movements, even mediums are similarly canonized through the consolidation of networks of institutional recognition and support. The emergence and eventual canonization of video art happened in two main stages. The first occurred during the 1960s and early 1970s, when visual artists began using television as a medium. This was the time when the name "video art" was coined, marking a major step toward canonization. But it took until the 2001 Venice Biennale for video art's apotheosis to be complete. Its ubiquity there prompted a number of critics to declare that the very idea of a contemporary art gallery had been transformed by video art from a white cube into a black box.

Before the 1970s, the idea that techniques and technologies derived from television would become a major part of the visual arts would have struck critics and artists alike as absurd. The visual arts were persistently associated with painting and sculpture, while television was dismissed as a vast wasteland. In 1957, Meyer Schapiro referred to the mass media as "the arts of communication" and contrasted it with visual art.[1] Schapiro likened the experience of the beholder before an abstract expressionist work to a secularized religious experience. The painting becomes an occasion for "communion and contemplation" between the artist and viewer, with the artwork serving as intermediary.[2] Maintaining painting as a traditional art medium, he concludes that abstract expressionism offers a kind of salvation from industrial society.

Over the course of the 1960s, television began directly encroaching on the visual arts in the U.S. Large numbers of artists began turning away from the humanist communion of traditional fine art mediums, parodying handicraft or abandoning it altogether as they dove into the mass media and mass mediums. The reasons are complex and include the increased accessibility of semi-professional and consumer media technologies such as portable videotape systems as well as the optimistic vision of technological progress promoted by the Kennedy administration.[3] One consequence of these intertwined developments was a shift in the role played by the artist from atavistic craftsman to avant-garde technophile. In 1966 Andy Warhol, who ironized these identities by continuously moving between them, said of this shift, "I suppose it's hard for intellectuals to think of [my work] as Art. I'm a mass communicator."[4] In a 1969 article on video art, John Margolies agrees, putting this more broadly: "The concept of the artist's role is undergoing a transformation; the artist is emerging as a communicator."[5] Both statements signal a shift in which visual artists had become wide-ranging practitioners of many forms of communication, particularly those associated with the mass media.

Marshall McLuhan helped pave an intellectual path for the acceptance of television as a medium worthy of significant consideration inside and outside the art world, as well as of the notion of the artist as mass communicator.[6] McLuhan famously opposed those who claimed that television induced passivity, arguing that television was engendering a new society heralded by an increased sense of communitarian engagement. Like many earlier commentators, he singled out immediacy as one of the key aspects of television because of its ability to bring live events to the public in a way that felt less mediated than previous mediums. He links immediacy to tactility, writing that the low resolution of the television image drives greater audience participation as viewers work to fill in the gaps both visually and because of the continually changing types of information it conveys. McLuhan urged visual artists to adopt electronic mediums like television. In a 1966 article in *Art News*, he reimagined the visual artist as a mass communicator working for the benefit of the public good by creating "anti-environments" in which the "psychic and social consequences" of the mass media on society would become perceptible.[7] He writes that television is particularly ripe for engagement in artistic anti-environments because in everyday life, it "remains quite invisible, while foisting an entirely new set of sensory modalities on the population."[8] The task he set before young artists was allowing their work to act as an "early warning system, making explicit the cultural assumptions" that television hides.[9]

By the time McLuhan wrote these words, artists had already begun stepping forward to fit this bill. In 1963, Tom Wesselman, Wolf Vostell, Nam June Paik and Gerd Stern all made important works incorporating television sets. Over the next several years, television sets and televisual images began appearing with increasing frequency in a multi-media art scene directly engaged with McLuhan. Stern became a personal interlocutor of McLuhan's at art-world events. Paik appeared with McLuhan on an NBC television program. McLuhan's ideas were ever present in reviews of multi-media art events, and the reverse was true as well: in his book *The Medium*

Is the Message, McLuhan illustrated his thoughts regarding media environments with an image of Andy Warhol's nightclub act, the "Exploding Plastic Inevitable."[10] Of these artists, only Paik would make television a career-long preoccupation. Paik's notion of "participation television," which he used as the title of several works, also stands as a suitable description of the goal of many of the artists who turned to television during this time, including Allan Kaprow, Andy Warhol, Stan VanDerBeek, Gerd Stern and USCO (the group Stern co-founded), as well as later collectives such as the People's Video Theater, the Raindance Corporation, and the Videofreex. These artists envisioned a world in which everyone would be a media maker. They developed alternative networks of production, distribution and consumption aimed at transforming the medium from a one-way to a two-or-more-way street by giving the people increased voice in both their own mass mediation and the wider televisual coverage of events. Paik's own work grew from modified television sets on which simple viewer interactions caused abstract images to appear onscreen to a fully fledged analog video synthesizer that he hoped would be widely distributed so that anyone could make their own televisual mashups and share them with others.

Circa 1970, in conjunction with the rise of the video collectives, a younger generation of artists began further experimentation with television in the context of abstract psychedelia and postminimalism. Artists such as Eric Siegel, Stephen Beck and Thomas Tadlock developed their own video synthesizers that generated acidly colored image fields designed to trigger ecstatic electronic communion. Forgoing communion in favor of an often alienating neo-Brechtian critique, the work of postminimalists such as Bruce Nauman, Dan Graham, Vito Acconci, Lynda Benglis and Joan Jonas helped explicate the ideologies that underlay the purportedly transparent immediacy of commercial programming and closed-circuit surveillance. Such a bounty of activity prompted Gregory Battcock to write in an essay titled "Explorations in Video" from 1973:

> The quantity of video material presented in galleries, museums, artists' lofts and university workshops during the past year or so is truly amazing. It is no exaggeration to say that today video is the fastest growing field for artistic exploration. Quite literally, everybody is interested in it and practically everybody is working within some aspect of video. In addition, galleries, museums and foundations seem eager to support virtually any experimental activity in video that comes their way.[11]

While commentators have frequently noted that much of this work flourished because affordable, portable videotape equipment (aka "the portapak") had recently become available, there were many other factors supporting the explosive rise of video art. Battcock only hints at the institutional support surrounding video art, which was truly remarkable.

The year 1974 marks the first significant moment in the canonization of video art. The year began with a key event held at the Museum of Modern Art in New York in January. "Open Circuits: An International Conference on the Future of

Television" lasted three days and featured speakers from around the world. Nam June Paik debuted his proto-music video *Global Groove*, which featured performers from around the world transformed in a wash of video synthesis. While the conference triggered heated debate, all the participants seemed to agree, as per the words of Paul Stitelman, "that video has arrived as an art. The very presence of the 'Open Circuits' symposium at an institution as staid as the Museum of Modern Art indicates as much."[12] By 1974, the national and international institutions supporting video art included cable and public television stations giving artists access to funding and equipment; the journal *Radical Software* dedicated wholly to supporting the video art scene; courses on video art in colleges and universities; non-profit spaces where artists could produce and screen their video work; major museum exhibitions; art fairs featuring video art; and government and private foundation funding for video art. While 1974 marks a moment when television in the form of video art was generally accepted into the pantheon of the fine arts, it also marks the beginning of a long gestational phase in which video art would remain a lesser god among greater deities. Well into the 1990s, video art played a parenthetical role in relation to the thriving world of performance art, neo-expressionism and the return to painting, the success of sculpture in the wake of the reception of the readymade and the even more meteoric rise of photography as a generally accepted, non-ghettoized fine art medium.

Capturing sentiments that built on McLuhan, which echoed across the work of later critics, Battcock writes that the primary goal of early video art was the attempt to define its medium-specific properties. As it began frequently appearing in print, the term "video art" was becoming the accepted name for the use of techniques and technologies related to television, and this consolidation occasioned much critical reflection on what might distinguish this new medium from others inside and outside the art world.[13] One difficulty that Battcock points out is the similarity between television and film, as visual artists have adopted them when turning to the moving image. Battcock's own attempt to distinguish between the two hinges on video art's scale. He claims that, because of its connection to television, video art's small scale distinguishes it from film. Unlike film, he says, what makes television and its use in video art unique is its identity as a form of "portable, disposable communication."[14] The portability of the equipment used to make much video art (enshrined in the very nickname "portapak"), as well as the set-sized monitors on which video art was then almost solely screened, distinguish it from the immersive nature of film, particularly when considered as a theatrical, cinematic experience. But Battcock's analysis failed the test of time, at least in the short term. Immersion in a pseudo-cinematic black box and not the more casual experience of everyday television viewing would play the crucial role in video art's ultimate canonization.

★★★

So what happened? It took a long time, but by the mid-1990s, the early explorations in video Battcock describes eventually settled into institutionally manageable conventions. The latter is a less discussed requirement for canonization hiding

beneath the promotion of someone or something to iconic status. Through the early 1990s, video art suffered from related exhibition and funding difficulties. The open reels which early video art relied upon were able to withstand limited public screenings but were unreliable, to say the least, in extended exhibition settings. Video art was plagued with technical difficulties, which scared off both private and institutional collectors. The only museums in the U.S. to build serious collections of video art starting in the 1970s were the Museum of Modern Art, the Whitney Museum of American Art and the Long Beach Museum of Art. Through the 1970s and early 1980s, much video art was made directly or indirectly with government funding, through state grants like those offered by New York State Council on the Arts or through the support of public television, but these dried up by the early 1980s due to budget cuts. Attempts were made by Electronic Arts Intermix, Castelli-Sonnabend Videotapes and Films, art/tapes/22 and a few others to distribute and sell artist's video during this time, but video art had marginal commercial value when compared to mediums such as painting, sculpture or even photography. Although there was hope that the widespread use of videocassettes would lead to a mass market in artists' video, this never came to be; the avant-garde proved resistant to mass audiences. While museums started to collect video art in the early 1970s, for a long time it remained in the institutional basement. This was literally true, for example, at the Museum of Modern Art, where video art was only regularly exhibited in a subterranean gallery, but it was more broadly true because video art was considered less aesthetically and economically valuable than work made in other mediums. While Bill Horrigan refers to the 1980s as "the golden years of video [art]" and cites an admirable number of works made during this time, he also admits that back when the National Endowment for the Arts was one of the few reliable funding sources, it barely supported video art and that video art lacked a robust gallery system because it was unprofitable.[15]

Video art only returned to widespread museum exhibition and particular gallery exhibitions with the emergence of more reliable technology in the form of laserdiscs and DVDs. A disruptive technology, discs hit the art world in the early 1990s, heralding a second explosion of video art. Although prone to scratching, disc-based media are considerably more durable than those based on magnetic tape. In the early days, their life span was unknown, but the migration of digital information offered greater hope for the longevity of artworks than the lower-fidelity transfers of analog tape. As with the commercial success of avant-garde photography, discs could be reliably editioned in extremely limited quantities, thereby draining the "mass" out of their medium to create value through artificial scarcity. Barbara Gladstone pioneered this technique relative to video art by selling limited-edition laserdiscs of Matthew Barney's work, which he turned into collectible icons by decorating them and placing them in sculpted vitrines. Another key feature of disc-based video is that it can reliably be set to automatically play in a loop. This technique was well suited to the art gallery, given its long-standing relationship to atemporal mediums. Short pieces of several minutes' duration could approximate the amount of time typical gallery-goers spend in front of a painting or sculpture without trying their patience.

The last bit of technology that led to video art's second flowering during the late 1990s was the availability of affordable, reliable digital video projectors. Artists had been using video projectors since the mid-1960s, but they were expensive, unwieldy and hard to acquire. Multi-channel works using monitor banks were equally expensive and difficult to store and maintain. With their decreased cost and increased reliability, digital video projectors solved the exhibition-related problem of either having large numbers of people crowding around a tiny video monitor or using costly projectors or monitor banks. When shown as a projection, video art could finally compete with mural-sized paintings and gallery-filling sculptural installations. By the end of the 1990s, the conventions of the black box were born. This led to a viral spread of video art in the form of quasi-narrative, disc-based loops of relatively short duration, sometimes alone but often in combination, screened in a darkened room and filling an entire wall if not multiple walls. Starting in the mid-1990s, video art was suddenly everywhere. Bill Viola and Gary Hill were early adopters of digital video technology and reaped the rewards as their work, along with Paik's, became canonical in the annals of video art. This was especially true of Viola, who represented the U.S. at the Venice Biennale in 1995 and had a retrospective that travelled around the U.S. and Europe in 1997.

The Metropolitan Museum of Art was one of the last major museums to hold off acquiring video art. In 2001, with great fanfare, it finally purchased a work of video art for its permanent collection: Viola's *Quintet of Remembrance* (2000), from his series "The Passions." Even before Viola's piece went on display, *Forbes Magazine*'s online site published a "Connoisseurs Guide [to] Collecting Video Art." Along with the Met's recent purchase, the author heralded the work of Shirin Neshat (another Gladstone artist), whose video work was fetching "up to $40,000 at auction!" Recalling Battcock, the author writes that despite nagging problems with conservation and the potential obsolescence of the equipment, "video art is now one of the fastest-growing categories in contemporary art." She notes, "large installations by the grand old men of video art like Viola easily run into six figures."[16] Instead of bringing art treasures into the homes of the public via television, television transformed into video art had finally become a cultural treasure worthy of being put on permanent display in an art museum or, if one were wealthy enough, in one's own private art collection.

★★★

While the 2001 Venice Biennale marks the completion of the canonization of video art, for many people the rise of the black-box gallery was something to bemoan not celebrate. When a diverse group of critics reviewed the Biennale in *Artforum* under the collective title "Groans of Venice," they reached the same conclusion: video art dominated the exhibition occasionally for better but mostly for worse. Daniel Soutif and Robert Storr both describe the transformation of the gallery from white cube to black box, which was the first time this comment was set in print. For Soutif, the exhibition marks not so much the apotheosis of video art but "the sinister apotheosis of the remote control."[17] He recounts how exhaustingly traipsing

from darkened room to darkened room filled with one video after another recalled indiscriminate, late-night channel surfing. With greater spleen and more rigorous theorization, Benjamin Buchloh says much the same:

> This year's Venice Biennale was in many ways a showdown between new electronic technologies (in particular digital-video projections) and the media of painting and sculpture, with the latter on the defensive, if not in manifest retreat, from their traditional stronghold in this most venerable of biennials. Spectators frequently found themselves standing in line to enter claustrophobic spaces, halfway [sic] between movie house, darkened living room and Skinner box ... Exhibition value – the condition of the secularized modernist work as fully emancipated from cult value and myth – has been replaced by spectacle value, a condition in which media control in everyday life is mimetically internalized and aggressively extended into those visual practices that had previously been defined as either exempt from, or oppositional, to mass-cultural regimes.[18]

Soutif and Buchloh irrefutably identify a problem that began with the predominance of the black-box gallery and has continued unabated since. Traditional art galleries were designed for perambulation and the perusal of atemporal objects. Traditional theatrical experiences were designed for the seated viewing of performances that unfold over time. The black-box gallery strikes an uneasy compromise between the two that remains difficult to reconcile. This is especially true when works of video art are shown in large quantities, with inadequate and uncomfortable seating, as is typical at large exhibitions such as the Venice Biennale. And this problem has only grown worse in ensuing years with the "documentary turn," which has led to video artworks of increased length and narrative complexity.[19]

But beyond gripes related to video art's typical installation, it's worth unpacking a number of issues that Buchloh raises because they shed further light on the medium at the moment of its canonization and since. When Buchloh writes that exhibition value has been supplanted by spectacle value, he's judiciously mixing ideas borrowed from Walter Benjamin and Guy Debord. From Benjamin, he takes the notion that art has passed through a paradigm shift in its transition from a pre-modern, auratic regime predicated on mythic, cult value to a modern regime in which art emancipated itself from religious trapping under the rubric of art for art's sake and gained an exhibition value that gave it the power to act as a means of social critique. The power of this critique was derived from the art gallery as an autonomous space from which to launch explorations of the grounds of visual art itself and the wider culture of visual representation under the auspices of modernity. Buchloh adds another paradigm shift to Benjamin's account using Debord by marking art's recent transition from exhibition value to spectacle value. For Debord, the rise of the electronic mass media and its effect on subjectivity, which he refers to as "the spectacle," has caused art to collapse back into a state in which it can no longer stand apart from other forms of visual culture but is co-opted, becoming merely another visual amusement afloat a vast entertainment soup. Recognizing that there

is no returning to the critical force once found in exhibition value, Buchloh argues, like Debord, that pockets of resistance can still be created by tactically using the spectacle's own techniques and technologies against itself.

Buchloh is especially tough on Viola's work at the Biennale. Viola exhibited *The Quintet of the Unseen* (2000), also from "The Passions." It shows five actors responding in ultra-slow motion to an off-screen event who move so slowly that at first they look like a photograph. The figures are shown in a frieze, from the chest up, in rivetingly vivid color against a black background, their faces contorted in extreme states of emotion. Viola drew on specific Renaissance paintings as the source material for this series. *The Quintet of the Unseen* was roundly criticized by Buchloh and others for misunderstanding the medium of video art in a misguided bid to fuse television and neo-classical painting. In Buchloh's terms, Viola has ceded art's power to oppose the spectacle because he seems to be nostalgically calling for a return to art's pre-modern aura through a seductive celebration of high-quality televisual imagery. By attempting to re-aurify television in the name of video art, Viola undermines the power of both the original paintings upon which his works were based and the kind of self-reflexive critique still possible in video art when it challenges rather than embraces the apparatus of mass mediation.

One tactic that Buchloh identifies for resisting spectacle value is the non-nostalgic use of outmoded technologies, which he finds in Pierre Huyghe's installation in the French pavilion. Rather than leapfrog back to pre-modern technology, Huyghe mined the history of high technology for moments of obsolescence by making reference to modernist high rises, the 1969 moon landing, early video games and an anime character whose company has shelved her, effectively putting her brand out of business. In turning to these themes, Buchloh argues that Huyghe "mobilizes an allegorical counterforce" against the spectacle by bringing its recent past back to life in order to challenge the ideology of progress that informs so much technophilia. As Buchloh describes it, the events that Huyghe recalls were moments when technological progress seemed to promise new forms of emancipation while serving to mask the further integration of mechanisms of control into everyday life.

Buchloh doesn't address the ways in which the issue of tactility also ran through Huyghe's installation in conjunction with his use of the outmoded. By addressing the tactile, Huyghe challenged one of the biggest problems with black-box video art: that its makers all too often refuse to consider the conditions of reception of their work. Works such as *The Quintet of the Unseen* plunge their viewers into darkness in a bid to make the viewers' bodies and the gallery space disappear, as if the experience of viewing were purely optical and could be divorced from somatic or social experience. Recognizing the impossibility of this, Huyghe highlights the ways in which bodies, images and technologies come into contact in the midst of electronic spectacle. Although he showed works of video art, he relied less on the black box than was evident in other parts of the Biennale. Only two of his pieces were projected videos, and only one (*Les Grands Ensembles*, 2001) was situated in a dark room. One of the other two rooms contained *Prototype de Luminaire* (2001), a massive, tree-like lighting fixture which sprouted from a UFO–shaped modernist

couch. The lights grew from the couch, spreading across the ceiling of the room and pulsing from dim to bright in an organic pattern that lent the room a warm, ever-changing glow. The same room also contained a projection of *One Million Kingdoms* (2001), the video of the obsolete anime character. Viewers could sit on the couch in comfort, either facing away or toward the video as they saw fit, watching it or using it as yet another light source. As viewers' bodies directly touched the couch, the light from above visibly played across all parts of the viewing space as its subtly changing luminosity charged the air with presence. In *Atari Light* (1999), a grid-ded, drop-ceiling lighting fixture also dominated the room, doing double duty as a massive game of Pong. Huyghe transformed the lights into patterns that mimicked the original game's pixelated ball and rackets, which viewers could "swing" using a paddle controller. In a gallery-spanning update of Paik's participation TV, the audi-ence directly affected both the abstract space of the game and the ambience of the room through manual manipulation, the whole of the room becoming one big cybernetic circuit.

Walter Benjamin raised the issue of tactility in relation to the moving image long before Marshall McLuhan. As Tobias Wilke convincingly argues, Benjamin, like McLuhan later on, saw the avant-garde artist as a critical force working to make visible the sensory modalities that modernity was imposing on subjectivity.[20] Writing in the 1930s, Benjamin singled out film as the key medium that could act as a training ground for new sensory experiences by allowing the audience to feel the shock of modernity in a controlled way. Playing on the double meaning in German of the word *taktisch*, Benjamin described the radical use of montage in film editing as both a re-envisioning of the "tactile" space of visual design described by Alois Riegl and as a "tactical" means of grappling with distraction as the newly dominant condition of everyday life. For Benjamin, distraction was one of the most salient features of modernity, as the contemplation that characterized communion in older art forms had given way to the viewer as an absent-minded examiner.[21] In Benjamin's account, the tactility of a medium like film generates distraction in viewers in as much as it prevents absorption in favor of an experience of abrupt movement from one juxtaposed thing to another, like in a Dada or surrealist col-lage. McLuhan seems to contradict Benjamin when he argues that the tactility of television leads not to distraction but to absorptive participation, but whereas McLuhan opposed participation with passivity, for Benjamin distraction itself is an active condition. Benjamin believes that absent-minded viewing has a critical potential beyond adapting the masses to modernity. He suggests that despite an inability to focus, there remains critical potential in the restless distraction of a mind that refuses absorption. From the perspective of the present, one can imagine that while such a mind might fall prey to a state of benumbed passivity, it also has the capacity to quickly travel across disparate information, making connections, linking diverse ideas, and connecting with the radically other.

When Huyghe turned to the tactile at the Biennale, he was less interested in the power of distraction than in building an installation that broke with the typical black box by orchestrating an interplay among viewers, the architectural space of

the gallery and various mediating apparatuses. Huyghe used tactility as a means of communal connection rather than critical distraction. The tactility he evoked – by offering seating and giving viewers a chance to play a game – were gestures of hospitality toward those who may otherwise have been overwhelmed by the excess of mediation found in other parts of the Biennale. And yet, behind these seemingly friendly gestures lurked an exacerbation of the mediated control that critics claimed the Biennale as a whole was imposing on viewers with its predominance of black boxes. For the duration of the exhibition, Huyghe ironically renamed the French Pavilion "Le Chateau de Turing" and nicknamed the computer that controlled its systems HAL after the mad computer in *2001: A Space Odyssey*. HAL sequenced the pavilion's video projections and lights, ran the game of Pong and even controlled the doors between the rooms, leading viewers en masse in a timed sequence from one room to the next in a proscribed promenade.

In 2008, thirty years after *Open Circuits*, video art left the basement of the Museum of Modern Art in spectacular fashion. Pipilotti Rist's *Pour Your Body Out (7354 Cubic Meters)* filled the museum's titanic new atrium with more aplomb than any other artist to date. Rist staged a less ironic exploration of tactility in relation to black-box video art than Huyghe by focusing more intently on the stakes of distraction in relation to contemporary media culture. Twenty-five-foot-high, candy-colored video projections enveloped the atrium, whose size is referenced in the work's subtitle. The videos' projectors and speakers were housed in enormous nipples protuberating from the walls. In the center of the space sat a giant circular couch on an even bigger carpet where tired museum visitors sprawled body to body. Without calling for a return to a mythic past, Rist harnessed Ovidian themes in order to playfully inject a wild and non-reductive feminism into the heart of modern art's greatest bastion. Towering images of a nude woman capered above the audience. Beyond her tremendous scale, she was all the more imposing because Rist shot her from a worm's eye view with a fish-eye lens. She ate flowers and dug for earthworms. She got down on all fours, snuffling across a verdant field with animalistic fervor, her image fading into that of a boar. Floating in an amniotic sea that turned the color of menses, she disappeared into a field of red, seeming to return to the womb, perhaps her own as if she were turned inside out. The images were often reflected and mirrored, causing recognizable imagery to fold into abstract patterns like those of the ecstatic images found in earlier forms of synthesized video. Bodies became foliage became animal became colored patterns of light, around and around with viscous plasticity. Through these transmogrifications, Rist was lobbying for the inclusion of women in the art world's canon using video projection to colonize one of the most spectacular museum lobbies in the world. In a move that a perceptive viewer might very well find shocking, she offered a seductively abject spectacle of unbounded femininity that effectively countered the kinds of female objectification and cult of feminine beauty that artists like Vanessa Beecroft were continuing to uphold and that remained inescapable in the world of the mass media.

Yet many people in the atrium were immune to the power of Rist's video. They lounged lost in conversation with a friend, watched through the lens of their

camera while taking a picture or video, or watched something else on their phone altogether. As often as not, the deeply affective images filling the room were being ignored or consumed in various states of distraction. In fact, it was quite impossible, given the hustle and bustle of the atrium, to consume *Pour Your Body Out* with anything close to the contemplative absorption of modernist exhibition value. Although used as an exhibition space, the museum's atrium is a space for passage. Rist countered this with the couch and the carpet, turning a passway into a paragon of contemporary media consumption. She created a space even more hospitable than Huyghe had, and the public was happy to take advantage of the comforts offered. Here's where Battcock ultimately got things right in his discussion of television, video art and portability. At the moment of video art's apotheosis via the black box, television was being remediated as yet another form of online information to be accessed via computer and increasingly via cell phones in devices that were far more portable than the smallest sets available in the 1970s. Just as "video" was becoming a word used to describe online moving images, Rist managed to capture the new forms of distraction that were quickly becoming the norm, even in the formerly contemplative precincts of the museum. She put the audience on display as a distracted collective engaged in communion with multiple screens, mostly of their own possession.

As its title indicates, *Pour Your Body Out* acknowledged the ways in which contemporary viewers pour themselves not only into works of art or physical institutions such as a museum but also into the many electronic devices that were in evidence, from the audio guides and iPods to cell phones, cameras and camcorders. While the woman frolicking above their heads was playing at becoming nature, so many of the viewers below inhabited bodies that were lost in the second nature of technology to such an extent that they couldn't absorb the screened images above them without the interposition of their own personal screens if they could absorb them at all. While some members of the audience were making connections between Rist's work and bits of relevant information using their personal electronic devices, others were undoubtedly off in their own world, shut down rather than opening themselves up to communion with Rist's vision of radical otherness. At just the moment that video art had finally ascended to the most storied halls of the art world, video was slipping through its fingers. If the black box was problematic from its inception, after 2008, it would begin to feel archaic. Yet once conventions are enshrined by canonization, they become difficult to change. Almost a decade after *Pour Your Body Out*, the black box still dominates the art world's understanding of how video art should be shown, and it remains to be seen how artists and museums will move beyond it and into the devices we cling to even more tightly today.

Notes

1 Meyer Schapiro, "The Liberating Quality of the Avant-Garde," *Art News* 56, no. 4 (1957): 40.
2 Ibid., 41.

3 Other reasons include the Oedipal rejection by young artists of the previous generation's claim to fame, the belated reception of the readymade during the late 1950s, the rising predominance of the electronics industry, and the wider tide of post-war consumer goods, including television, buoyed by the country's rising fortunes.

4 John Heilpern, "The Fantasy World of Warhol," *Observer* (1966): 11.

5 John Margolies, "TV – the Next Medium," *Art in America*, September–October 1969: 50.

6 Marshall McLuhan, *Understanding Media: Lectures and Interviews* (Cambridge: MIT Press, 2003), 34.

7 McLuhan, "Art as Anti-Environment," *The Art World: A Seventy-Five-Year Treasury of Artnews*, Barbaralee Diamondstein, ed. (New York: Rizzoli International Publications, Inc., 1966), 358.

8 Ibid.

9 Ibid.

10 McLuhan and Quentin Fiore, *The Medium Is the Massage: An Inventory of Effects* (New York: Touchstone, 1967).

11 Gregory Battcock, "Explorations in Video," *Art and Artists* (February 1973): 22.

12 Douglas Davis and Allison Simmons, *The New Television: A Public/Private Art*, (Cambridge: MIT Press, 1977), 102.

13 This culminated with the publication of a book compiled by several of the editors of *Radical Software*: Ira Schneider and Beryl Korot, eds., *Video Art: An Anthology* (New York: Harcourt, Brace, Jonvonovich, 1976).

14 Battcock, "Explorations in Video," 22.

15 Bill Horrigan, "A Backwards Glance: Video in the 1980s," *This Will Have Been: Art, Love and Politics in the 1980s*, Helen Molesworth, ed. (New Haven: Yale University Press, 2012), 401.

16 Anna Rohleder, "Connoisseur's Guide: Collecting Video Art," http://www.forbes.com/2001/10/31/1031conn.html; accessed 6/7/15.

17 Daniel Soutif, "Pick to Click," *Artforum International* (September 2001): 160.

18 Benjamin Buchloh, "Control, by Design," *Artforum International* (September 2001): 163.

19 Mark Nash, "Reality in the Age of Aesthetics," *Frieze*, April 2008, http://www.frieze.com/issue/article/reality_in_the_age_of_aesthetics.

20 Tobias Wilke, "Tacti(ca)lity Reclaimed: Benjamin's Medium, the Avant-Garde and the Politics of the Senses," *Grey Room*, no. 39 (2010): 39–55.

21 Walter Benjamin, "The Public Is an Examiner, but an Absent-minded One," *Illuminations: Essays and Reflections*, Hanna Arendt, ed. (New York: Schoken Books, 1968), 241.

Bibliography

Battcock, Gregory. "Explorations in Video," *Art and Artists* (February 1973): 22–27.

Benjamin, Walter. *Illuminations: Essays and Reflections*, ed. Hanna Arendt. New York: Schoken Books, 1968.

Buchloh, Benjamin. "Control, by Design," *Artforum International* (September 2001): 163.

Davis, Douglas and Allison Simmons. *The New Television: A Public/Private Art*. Cambridge: MIT Press, 1977.

Heilpern, John. "The Fantasy World of Warhol," *Observer* (June 12, 1966): 8–12.

Horrigan, Bill. "A Backwards Glance: Video in the 1980s," *This Will Have Been: Art, Love and Politics in the 1980s*, 400–411. Helen Molesworth, ed. New Haven: Yale University Press, 2012.

Margolies, John. "TV – the Next Medium," *Art in America* (September–October 1969): 48–55.

McLuhan, Marshall. "Art as Anti-Environment," *The Art World: A Seventy-Five-Year Treasury of Artnews*, 358–359. Barbaralee Diamondstein, ed. New York: Rizzoli International Publications, Inc., 1966.

————. *Understanding Media: Lectures and Interviews.* Cambridge: MIT Press, 2003.

McLuhan and Quentin Fiore, *The Medium Is the Massage: An Inventory of Effects.* New York: Touchstone, 1967.

Nash, Mark. "Reality in the Age of Aesthetics," *Frieze* (April 2008).

Rohleder, Anna. "Connoisseur's Guide: Collecting Video Art," http://www.forbes.com/2001/10/31/1031conn.html.

Schapiro, Meyer. "The Liberating Quality of the Avant-Garde," *Art News* 56, no. 4 (1957): 36–42.

Schneider, Ira and Beryl Korot, eds. *Video Art: An Anthology.* New York: Harcourt, Brace, Jonvonovich, 1976.

Soutif, Daniel. "Pick to Click," *Artforum International* (September 2001): 160.

Wilke, Tobias. "Tacti(ca)lity Reclaimed: Benjamin's Medium, the Avant-Garde and the Politics of the Senses," *Grey Room*, no. 39 (2010): 39–55.

7

PERFORMANCE ART

Part of the canon?

Jennie Klein

The brief history of performance art

In order to understand how performance art has both defined and challenged the "canon," it is necessary to first explicate what it means to call something "performance art" as well as what it means for performance to challenge the canon, since performance art has always drawn upon a variety of sources, particularly dance and theater. Roselee Goldberg, who authored the first introductory text on the history of performance art in 1979, defined performance as "a way of bringing to life the many formal and conceptual ideas on which the making of art is based."[1] Goldberg began performance art history with the theatrical experiments of the Futurists and Dadaists and included experimental theater and dance, manifestos, puppetry, cabaret, painting, and, in the two most recent editions, a chapter on the media generation: video and film performances.[2] For Goldberg, performance art challenged the canons of fine art, dance, and theater by mixing the disciplines and introducing elements that were extrinsic to these art forms. She was not interested in the use of performance for social activism, although the 1988 edition did include coverage of feminist artists such as Carolee Schneemann, Laurie Anderson, and Karen Finlay. Notably absent, however, are discussions of artists and collectives who have used performance to challenge social injustice. For example, the 2001 edition included Vanessa Beecroft but not the activist performance artist Suzanne Lacy. Goldberg's pioneering history has been expanded upon by several important exhibitions and surveys, including Henry Sayre's *The Object of Performance* (1989), Paul Schimmel's *Out of Actions* (1998), and Amelia Jones's and Tracey Warr's *The Artist's Body* (2000).[3] These three texts acknowledge the activist, anti-establishment roots of performance art and situated it within the context of avant-garde studio art, the anti-institutional politics of the 1960s and 1970s, the waves of civil disobedience that coursed through Western Europe and the U.S. during those years, and the aesthetic language of

conceptualism, with its anti-object emphasis on ideas and processes. Important to all three texts is the emphasis on the intersection among performance, politics, and identity politics, particularly in terms of feminism, race, and ethnicity.

The performance art covered in these texts is that which was developed in the United States, Western Europe, and Japan in the late 1950s and early 1960s in response to the desire to extend modernist painting to its logical conclusion by emphasizing the actions of the painter and "environment" of the artist and the painting rather than the finished artwork. Artists, dancers, and musicians such as John Cage, Merce Cunningham, Robert Rauschenberg, and Allan Kaprow sought to challenge the distinction between art and life through the incorporation of chance, ambient sounds, improvised actions, untrained bodies, and non-traditional venues. In Japan, the Gutai Art Association, founded by Yoshihari Jirō in 1954, experimented with a combination of performance, interactive environments, painting, and Japanese calligraphy.[4] The international group Fluxus, founded in 1960 by George Maciunus, devised performances that were influenced by musical compositions but drew from real life and corporeal experience. Fluxus performances were never attached to one "author" and could be "performed" by anyone, much like a musical score. By the 1970s, artists who had been trained as painters, sculptors, dancers, and actors such as Chris Burden, Yvonne Rainer, Anna Halprin, Joseph Beuys, Yoko Ono, Tom Marioni, Vito Acconci, Stuart Brisley, John Latham, Gustav Metzger, Dick Higgins, Wolf Vostell, Linda Montano, Hannah Wilke, Carolee Schneemann, Bruce Nauman, Barbara T. Smith, Marina Abramović, Ulay, and Paul McCarthy were all working primarily in performance. Significantly, a number of these artists were women who turned to performance art because of its accessibility in an art world that was still largely male dominated in the 1970s.[5]

Performance and the art-historical canon

Performance, unlike other media such as textiles or collage, was from the beginning sited within the modernist trajectory of post-abstract art and was practiced primarily by artists trained in studio arts. Nevertheless, it was some time before performance art was recognized alongside the more traditional media of painting, sculpture, and drawing/printmaking. By the mid- to late 1970s, alternative art spaces such as Franklin Furnace in New York, Los Angeles Institute of Contemporary Art (L.A.I.C.A.) and Los Angeles Contemporary Exhibitions (LACE), Tom Marioni's Museum of Conceptual Art (MOCA) in San Francisco, and the Demarco Gallery in Scotland had been established as platforms for performance art. The first generation of performance artists such as Cage and Kaprow in the U.S., Joseph Beuys in West Germany, and Barbara Steveni, John Latham, and Stuart Brisley in the UK had teaching positions in universities and art schools. By the mid-1970s, art students were earning MFAs for performance art. Burden's MFA thesis show for UC Irvine was the notorious *Five Day Locker* (April 26, 1971–April 30, 1971), which consisted of him spending five days in Locker #5 with a five-gallon container of water in

the locker above and an empty five-gallon container below.[6] Several alternative DIY (do-it-yourself) self-funded publications devoted exclusively or largely to performance art, including the San Francisco-based *Avalanche* (1970–1976), the Los Angeles-based *High Performance* (1978–1997), and the UK–based *Performance Magazine* (1979–1992), were established in the late 1970s.[7] Performance art even found its way into a few exhibitions in contemporary art museums. For example, Burden's *Doomed*, where he lay behind a pane of glass until offered aid, was performed at the Museum of Contemporary Art (MCA) in Chicago in 1975 as part of the *Bodyworks* exhibition curated by Ira Licht.[8] In the 1970s, performance was still very much a DIY art form with poor documentation, self-published catalogs, and very little recognition from the mainstream art world. Goldberg's history, published in 1979, was the first history to situate performance art within the trajectory of avant-garde art movements. It was not until the early 1990s that performance art was included in newer editions of modern and contemporary art history surveys such as H.H.Arnason's *History of Modern Art* (1968) or Jonathan Fineberg's *Art Since 1940* (1995).[9]

Although it was not immediately recognized or incorporated into major museum shows or art history survey texts, performance art aligned itself with the avant garde, a point that was emphasized by Goldberg from the beginning. Historically, the avant garde, as represented by the Dadaists and Surrealists, had rebelled against bourgeois culture through actions as well as artwork. Renato Poggioli has suggested that avant-garde movements are quite frequently formed to "agitate *against* something or someone. The something may be the academy, tradition; the someone may be a master whose teaching and example, whose prestige and authority, are considered wrong or harmful. More often than not, the someone is that collective individual called the public."[10] A product of its time, performance art appeared as artists tried to grapple with an increasingly unstable social climate. Sayre has drawn a connection between performance art and postmodernism (which he aligns with early 20th-century avant-garde art that was political, theatrical, performative, and not much concerned with painting). Sayre notes that much of the early performance art was intensely political in nature, emerging in Northern California in conjunction with the Be-Ins and the People's Park demonstrations in Berkeley; in Southern California in conjunction with the Feminist Art Programs at Fresno State, Cal Arts, and the Woman's Building, and in New York in the form of the Art Worker's Coalition, an artist's organization that took on the Museum of Modern Art in 1969. "For the avant-garde," Sayre writes, "the art establishment and the larger establishment were demonstrably one and the same, and both were to be opposed for the most urgent political reasons."[11] Sayre's point is worth noting. In the 1970s and continuing through today, performance art derives its meaning from challenging the establishment, whether it be the art establishment or society in general. In the minds of the artists working in performance, the art-historical canon that their work challenged was more or less interchangeable with conservative and repressive social viewpoints.

From the onset, performance art was constructed as a radical, rebellious, and anti-establishment art form that challenged hegemonic ideologies in the art world

and the "real" world. While situated by artists and writers within the canon of late modernist/postmodernist art, performance art nevertheless remained a gadfly in the art world, chipping away at art-world elitism. Performance art both underscored and undermined the modernist trajectory of the development of art, representing both the logical conclusion of the drive toward increasingly abstract art and the dissolution of the modernist fiction of disembodied immanence and transcendence through the introduction of the artist's body.

I propose to trace performance's transformation from a deliberately marginalized and politically activist art form to an international sector that includes producers, venues, institutions, and publications. Through a mapping of the institutional trajectory, I hope to demonstrate that performance art was initially supported by alternative art institutions that reinforced rather than undermined performance's status as an art outside of the canon. I will go on to show that performance art continues to be supported by alternative institutions in spite of its recent appearance at high-end art events such as art fairs, biennales, and museum exhibitions. I will argue that performance art is most effective when it operates from the margins and demonstrate how performance has changed in response to its incorporation into the institution, although some artists continue to use it to challenge social injustice.

The 1970s: the Los Angeles Woman's Building

Performance art in the 1970s was closely aligned with the counterculture and civil rights movements. A number of alternative gallery spaces designed to feature

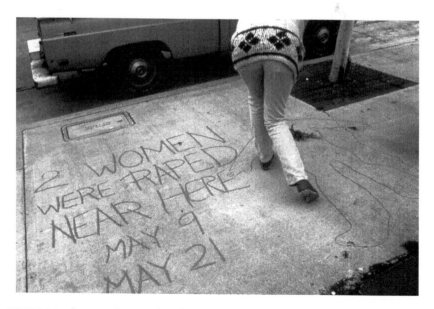

FIGURE 7.1 Suzanne Lacy and Leslie Labowitz, *Three Weeks In May*. Public Performance. Los Angeles, 1977. Courtesy of Suzanne Lacy.

performance were established, including F Space Gallery in Santa Ana, California, founded by Burden and his fellow graduate students at UC Irvine. By far the most innovative and radical institution was the Los Angeles Woman's Building and the feminist art school housed within, the Feminist Studio Workshop (FSW) founded by Judy Chicago, Arlene Raven, and Sheila Levrant de Bretteville in 1973.

The FSW was a further development of the initial Feminist Art Program founded by Chicago at Fresno State and then co-directed with artist Miriam Schapiro at Cal Arts. Frustrated by the administrative restrictions imposed upon them by CalArts, Chicago, Raven, and Levrant de Bretteville conceived of an independent women's art school. They leased a building in downtown Los Angeles, which allowed them to rent space to several feminist organizations, including the Womanspace art gallery, an exhibition and performance space that had opened a year and a half earlier on Venice Boulevard in Culver City and was the first exhibition and performance space in California dedicated to women's art. Suzanne Lacy, at that time a recently minted MFA who had studied with Chicago, Levrant de Bretteville, and Kaprow at CalArts, joined the FSW faculty along with several others a year after its opening.[12] A pioneer in feminist performance and activist art, Lacy united her feminist education with Kaprow's performance structures in her work. She found the ideal collaborator in Leslie Labowitz, who had studied in Germany with Beuys, who was a founding member of Fluxus, a committed pacifist and environmentalist (who ran an unsuccessful campaign for parliament as a Green Party candidate in 1980). Lacy collaborated with Labowitz on *Three Weeks in May* (1977), a performance that took place in a mall in downtown Los Angeles. The performance included a large map of Los Angeles onto which Lacy stamped RAPE each time a rape was reported. There were also demonstrations, talks, and workshops and an evening of performances titled *She Who Would Fly*. Lacy's students would subsequently develop their own performance activist collectives such as the Waitresses, founded by Jerri Allyn and Anne Gauldin in 1977, and the Feminist Art Workers (FAW), founded by Nancy Angelo, Vanalyne Green, Laurel Klick, and Cheri Gaulke in 1976. The work of both collectives was characterized by public performances that were often educational while being very humorous or whimsical (the Waitresses marched in a parade, and the FAWs made non-obscene phone calls to single women) while calling attention to the unequal treatment of women in society.[13]

The performance art produced in conjunction with the FSW and Woman's Building was passionate, sometimes raw, quickly executed, and far removed from the art history canon.[14] In spite of the fact that it was produced in conjunction with an art program and directed by an instructor with an MFA, it wasn't immediately recognized as "art." Incredibly, feminist critics writing in the 1980s and 1990s dismissed it as being too simplistic and claimed that it fell into the trap of presenting an essentialist and universal construction of women that reinforced the patriarchal status quo.[15] In my 2009 article on feminist spirituality, I argued that part of the problem was the postmodern turn in the late 1980s, which coincided with the

entry of feminism into the academy. Feminist critics unjustly repudiated or ignored this work, and thus it was doubly excluded from both the art history canon and the emerging feminist canon.[16] Publications such as Norma Broude's and Mary Garrard's 1994 *The Power of Feminist Art* and exhibitions such as *Sexual Politics*, curated by Amelia Jones in 1996, paved the way for this work to eventually be included in histories of contemporary art.[17]

The 1980s: alternative spaces

In the 1980s, performance art moved closer to becoming mainstream entertainment. The definition of performance art expanded to include theatrical monologues, vaudeville, walkabouts, illusionistic spectacles, and dazzling combinations of technology and live performance. The simple "actions" and Happenings were replaced by much slicker presentations that combined experimental music, dance, and actions and sometimes included a cast rather than the artist as sole creator/suffering body. Artists such as Robert Wilson, Laurie Anderson, Anne Magnusson, Paul Zaloom, and Richard Foreman and collectives such as the Blue Men, the Kipper Kids, Hesitate and Demonstrate, and Gilbert and George, along with choreographers such as Pina Bausch, Lucinda Childs, and Martha Clarke, developed entertaining spectacles that were edgy enough to retain the veneer of performance art in spite of the fact that they had little in common with the deliberately unrehearsed and rough-edged work of the 1970s. The 1980s also saw the rise of monologists including Eric Bogosian, Spalding Grey, Anna Deveare Smith, Tim Miller, Holly Hughes, Karen Finley, and Whoopi Goldberg. A number of significant spaces dedicated solely or primarily to performance were founded in that decade, including Sushi in San Diego; Highways in Santa Monica, California; FADO in Toronto; Mobius in Boston; Franklin Furnace and PS1 in NYC; the Green Room in Manchester, England; the Arnolfini in Bristol; and Whitechapel Gallery in London. Several significant performance festivals were launched in the U.S. and UK such as the National Review of Live Art in the UK and the Cleveland Performance Art Festival in the U.S. By the end of the decade, just about every city in the developed world could boast at least one or two alternative, artist-run, often state-funded spaces that were devoted entirely to performance or had a robust performance program. Most contemporary art museums and centers included performance programming. In short, performance art was becoming a sector, defined by Dominic Johnson as a useful label for a context, a frame that permits even very disparate work to cohere into a recognizable category.[18] The sector of performance art, which from the beginning was international in scope, was (and continues to be) supported by a network of venues, festivals, development agencies, related programming, external funding, and a network of academics, academic organizations, conferences, and publications. While much of this work in the 1980s remained challenging, the shift from austere, body-based, avant-garde work to entertaining spectacle paved the way for the inclusion of performance art in major museums and art events by the turn of the millennium.

The 1990s: the Culture Wars and the Live
Art Development Agency/LADA

By the end of the 1980s, several artists such as Laurie Anderson or the Talking Heads who had had their start in performance had made the jump to mainstream entertainment. Performance still remained the province of those who considered themselves to be marginal to mainstream cultural institutions. Collectives such as Pomo Afro Homos (1990–1995), who made work about African-American queer identities and the AIDS crisis, and the Border Arts Workshop/Taller de Arte Fronterizo (established in 1985), used performance to challenge racist, homophobic, and classist policies in the U.S. BAW/TAF (Border Arts Workshop/Taller de Arte Fronterizo), which included Guillermo Gómez-Peña as a member, performed many of their pieces on the San Diego/Tijuana border to highlight the inequities that would result from NAFTA. In the U.S., as the 1980s segued into the 1990s, the AIDS crisis intensified, the pro-life movement intensified its war on the reproductive rights of women, and Ronald Regan's neoconservative and neoliberal agendas began to be felt in the decreased funding for social services, public facilities, and alternative arts organizations. In 1990, the NEA (National Endowment for the Arts) rescinded four previously approved grants after Congress passed a decency clause. The NEA Four – Tim Miller, Holly Hughes, Karen Finley, and John Fleck – were all performance artists whose work included nudity and often frank discussions of non-normative sexuality and/or AIDS. The Culture Wars mobilized the quiescent leftist community and the art world, resulting in increased visibility for the NEA four and a major retrospective for BAW/TAF at the San Diego Museum of Contemporary Art in 1993. Unfortunately, the Culture Wars had a deleterious effect on the nascent performance art sector, as arts funding decreased and artists who were not as famous as the NEA Four found it more difficult to obtain venues for their work. For example, artist Marilyn Arsem, a professor at the SFA in Boston and one of the founding members of Mobius Performance Space, recalled that she was forced to go outside of the U.S. in order to continue performing.[19]

The situation in the UK, even under Margaret Thatcher, was very different. The efforts of the Artist Placement Group (APG), founded in 1965 by Barbara Steveni in order to integrate artists into local industries, set the stage for the establishment of a number of developmental organizations in the UK, all of which promoted and encouraged live art and artists. Artsadmin and New Work Network, two organizations based in London at Toynbee Studios and funded with Arts Council monies, provided advisory services, grants, and networking opportunities for live-art artists. In 1999, Lois Keidan, along with Catherine Ugwu, founded the Live Art Development Agency (LADA) based in London. For more than 10 years, LADA has provided resources, professional development, and funding for projects and initiatives. Keidan and her current co-director C.J. Mitchell coordinate Live Art UK, the national network of live art promoters.[20] The term "live art," at least as it is used on the LADA web site, includes such a wide range of performance actions that it is

difficult to pin down exactly what live art is other than loosely related to perfor-mance art and firmly committed to cutting-edge, innovative practices. Nevertheless, LADA implies that live art is still marginalized and anti-establishment, even while doing its best to promote it as the most important art form in the UK.[21] Under the umbrella of LADA, Keidan has cannily used the self-help language of neoliberalism in order to garner support for experimental live art. An international organization whose influence extends way beyond the English Channel, LADA actively supports experimental performance art in a number of geographic regions, including China and Slovenia. By prodding the British government to use Arts Council funds to support performance art (and thereby demonstrate its progressive, developed world politics), LADA/Keidan has provided an example that other countries can emulate, particularly those countries that desire to be part of the global capitalist economy of the 21st century. Support for the arts, especially performance art, which has tra-ditionally been associated with rebellion against established societal values, signifies tolerance and acceptance to the rest of the world. Artists working in performance often have to undertake delicate negotiations in order to continue to make artwork with integrity while receiving monetary support.

The 2000s: PSi, *The Artist Is Present,* and delegated performance

LADA was established at about the same time as PSi (Performance Studies Interna-tional), a professional association founded in 1997 in order to facilitate communi-cation among artists, writers, critics, and facilitators interested in performance. PSi hosts an annual conference, which has taken place primarily in the UK and the U.S., but also in Zagreb, Copenhagen, Singapore, and Melbourne. The importance of LADA and PSi for performance art, particularly in a social environment that can be hostile to experimental art, cannot be understated. The two organizations have been responsible for disseminating information about artists working outside of the UK, Europe, and North America, promoting these artists, and facilitating exchanges with artists from countries such as Slovenia, China, Chile, Singapore, the Philippines, and Russia. They also facilitated the rise of international performance festivals, which served the dual purpose of creating a community of artists and making the work of these artists available outside of their home countries. By 2000, performance had become a major international sector at around the same time that art fairs were replacing gallery shows, biennales were multiplying, and the importance of the cura-tor had almost surpassed that of the artist. Organizations such as LADA and PSi thus facilitated the incorporation of performance artists into these events, particularly performance by artists who hailed from countries outside of the UK/Europe/North America nexus.

The increasing visibility of performance art via supportive organizations, public-ity, festivals, and publications made performance art a more desirable commodity for art museums, which needed to reinvent themselves as dynamic, cutting-edge institutions rather than merely as archives of art objects. By 2000, performance art

had been incorporated into the museum in the form of exhibitions of performance documentation – videos, photographs, ephemera, and text – alongside performance programming over several evenings. After 2000, performance began showing up in museums, art fairs, and biennales as actual bodies performing during the regular scheduled hours of the institution. This shift would seem to imply that performance had become completely co-opted by the institution, and far from existing outside of the canon of art history, it was actually central to the structure of an emerging revised canon. The emphasis on individualism and increased individual responsibility (without any monetary support for those individuals) that is a hallmark of the neoliberalist doctrine resonates well with the idea of the individuality of the artist, who has always functioned as a free agent in the capitalist art market. More so than any other medium, performance, which is premised upon the actual performing body of the artist, encourages the perception of "individualism" that is so central to neoliberal policies.

Thus for her 2010 MoMA retrospective *The Artist Is Present*, Marina Abramović actually "performed" for the duration of the exhibition, sitting motionless at a table while visitors queued for the privilege of sitting opposite the artist. Lara Shalson has shown how well durational performance addresses the needs of the museum, which is open for many hours each day. "Extended duration is, paradoxically, that which enables the work to be recognized according to the ideal of 'timelessness' (one of the most traditional values attributed to great art) to be seen as *not* subject to time."[22] Abramović's presence in the museum ensured that the mythos of the artist, so closely aligned with the ideology of the avant garde, not only remained intact but reached a new apotheosis.

The Artist Is Present included a number of performances that were re-enactments of performance pieces that Abramović had done either by herself or with her then partner Ulay during the 1970s and early 1980s and which by now have become canonical. Retrospectives, blockbuster exhibitions, gala openings, and commercial art fairs need something a bit more interesting than grainy video and bad photographs. The desire to have the experience of liveness rather than mere documentation has resulted in performances that are delegated at these events. A delegated performance, as its name implies, is one in which the artist hires other people to perform in her or his stead. Delegated performances differ from theatre because the performers tend to be non-professionals and "perform" their own socio-economic category, whether that is gender, race, class, ethnicity, profession, or disability. Unlike documentation, body art, even when not using the body of the actual artist, continues to suggest authenticity through the presence of non-professional performers who have an indexical link to the real. However, while body art of the 1960s and 1970s was produced cheaply, delegated performance is a luxury game. The rebellious traces of performance's origins, along with the promise of ephemerality and transgression, are enough to create anticipation and hype for performance events staged in conjunction with art fairs, biennales, and major museum events.[23] In this situation, performance art is all but stripped of its initial power to shock the middle class and defy societal conventions, even as certain forms of performance art, most

notably endurance, become a symbol for the timelessness and universality of the art within the museum.

The 2010s: festivals, activism, and global performance

Over the past four decades, performance art has thrived precisely because it is able to maintain its oppositional status. The incorporation of formerly challenging endurance performance into a museum setting, along with the use of delegated performance for luxury art events – such as Abramović devised for the 2011 LA MOCA Gala performance, which involved guests seated at tables and confronting the head of a performer – would imply that performance art has become a parody of itself. However, it is a mistake to look merely at MoMA's exhibition schedule or the Venice Biennale to gauge the position of performance art and artists today. Rather, it is necessary to look at alternative institutions, artists' collectives, and festivals in order to understand the scope of contemporary performance art, which in many ways can be said to have returned to its roots of anti-object, political activism, albeit in an international context. One of the most important contemporary contexts for performance is the festival, which permits people to gather and see a lot of performance art in a very short time. Probably the most prominent performance art festival is the bi-annual event *Performa*, which premiered in 2005. Organized by Goldberg, *Performa* was responsible for bringing Abramović back into the public eye when she performed *Seven Easy Pieces* at the Guggenheim as part of the festival in 2005. *Performa*, however, is the exception rather than the rule for performance festivals, most of which are platforms for a combination of younger and more established artists, many of whom make work that recalls the simplicity of performance done in the 1970s. The most recent incarnation of *Rapid Pulse*, a Chicago-based festival that premiered in 2012 sponsored by Defibrillator Performance Gallery, included a number of durational performances by an international roster of artists that included Marilyn Arsem, Martine Viale, Mary Coble, and Jelili Atiku.[24] The ninth incarnation of Future of the Imagination (FOI) in Singapore, which started under the artistic direction of Lee Wen and is presently directed by Jason Lim, took endurance art as its theme. Most of these international festivals "share" artists: Lim performed at Rapid Pulse in 2014, and Arsem performed at FOI later that year, Fig.7.2. Festivals such as Rapid Pulse and FOI are run on shoestring budgets (FOI does receive Arts Council monies, although this is a fairly recent development) and often struggle to cover the expenses and fees of the artists. These festivals are organized with students and aspiring artists in mind. Rapid Pulse, for example, includes a workshop and several panels on various aspects of performance every year, while FOI hosts a workshop and panel discussion in conjunction with the festival.[25] These international festivals of performance art serve to reinforce a community of artists, scholars, and students who are more interested in the exchange of ideas than merely the advancement of their careers. As Nick Anderson, co-director of Glasgow Buzzcut Festival (along with Rosana Cade) suggested, much of the "business" of these festivals takes place between and after these festivals, during

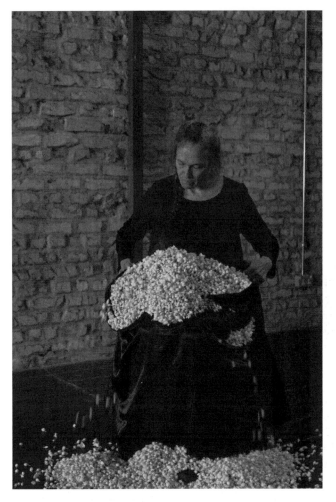

FIGURE 7.2 Marilyn Arsem, *Marking Time IV*. Future of the Imagination Performance Festival (FOI 9), Singapore, 2014. Curated by Jason Lim. Courtesy of the artist. Photograph by Nel Lim.

which a widely dispersed community is able to meet up and exchange ideas and notes. The festivals, and their aftermaths, are intimate and inexpensive affairs that harken back to the anti-object/anti-consumption ethos of early performance art.[26] The festivals also pay homage to the activist legacy of performance art, featuring artists and collectives whose work represents an intervention into the social fabric of contemporary culture. FOI included a performance by Wantan Wuma, whose work has often engaged with his indigenous identity as a member of the Atayal tribe in Taiwan. Ayana Evans's (Fig. 7.3) public guerrilla performances have often forced white, middle-class art audiences into an uncomfortable proximity with urban, African-American identity such as was performed at Rapid Pulse 15. In

FIGURE 7.3 Ayana Evans, *Stay With Me*, Rapid Pulse Performance Festival, Chicago, June 15, 2015. Courtesy of the artist. Photograph by Tonya Michelle.

Stay With Me, performed at Rapid Pulse 15 in Chicago, Evans, wearing high heels, dangling earrings, and a formal dress, performed a dance marathon of jumping jacks and high kicks in a storefront window in Chicago, causing cars and pedestrians to stop in astonishment when confronted by such an out-of-place spectacle.

Conclusion

Can artists who work in performance continue to operate from the margins, or do success and visibility ensure that the medium of performance art will be appropriated into the art-historical canon, included in art history textbooks, and made the subject of museum exhibitions? Amy Bryzgel, writing about Eastern European performance, has argued that artists in the East were working from a completely different set of goals and interests than those in the West, noting that they "utilized performance art to reclaim both public space and the body from the control of the state, and engage with issues that they could not address in paintings, and which, in addition, would be considered taboo in official contexts."[27] In 2012, the feminist activism of the WB would appear again in the guise of the Moscow-based Pussy

Riot (PR), whose work challenged entrenched sexism, lack of equality, and political injustice. A Russian art collective/riot grrrl band founded in 2011, PR staged provocative guerilla performances in public that were then shared as YouTube videos. They became an international cause célèbre after a one-minute performance at the Cathedral of Christ the Savior in Moscow in 2012. The grrrlz attempted to perform an anti-Putin song to the public (a few worshippers) but were quickly stopped. A subsequent video of the performance that was uploaded on the Internet went viral. While PR's antics were perceived as hate speech in Russia, they were hailed as heroines and martyrs in the west, especially after three of their members were tried and sentenced to prison.[28]

The gap between the performance art of the Woman's Building/FSW and Pussy Riot, whose members are currently receiving a great deal of media attention, demonstrates how performance art has become a global art form that can now reach an international audience thanks to social media. This gap also demonstrates how quickly performance art's rebelliousness is taken up and commodified by institutions and organizations that benefit from the appearance of resistance. As art historian Thomas Crow, writing about the 19th-century avant garde, first argued in 1983, "while it is true that the apparatus of spectacular consumption makes genuine human striving – even the resistance it meets – into reified commodities, this is no simple procedure: exploitation by the culture industry serves at the same time to stimulate and complicate those strivings in such a way that they continually outrun and surpass its programming."[29] Beginning in the 1980s and continuing through today, performance art and artists have been increasingly appropriated by the culture industry. So far, at least some performance artists have managed to resist this appropriation by embracing, supporting, participating in, and running institutions such as LADA and PSi and festivals such as Rapid Pulse and FOI. Whether they can continue to do so remains to be seen.

Notes

1 Roselee Goldberg, *Performance Art: From Futurism to Present*, rev. ed. (New York: Harry N. Abrams, 1988), 7. Matthew Barney's *Drawing Restraint 7*, 1993 is on the cover of the 2001 edition.

2 Goldberg, *Performance Art: From Futurism to Present*, rev. ed. (New York: Thames and Hudson, 2001).

3 Henry M. Sayre, *The Object of Performance: The American Avant-Garde since 1970*, (Chicago: University of Chicago Press, 1989); Paul Schimmel, ed., *Out of Actions: Between Performance and the Object 1949–1979* (Los Angeles: The Museum of Contemporary Art, 1998); Tracey Warr and Amelia Jones, *The Artist's Body: Themes and Motives* (London: Phaidon, 2000). This is by no means a comprehensive list of books that established a canon and history of performance art. However, they are representative of consensus regarding performance history.

4 Ming Tiampo and Alexandra Munroe, "Gutai: Splendid Playground," *Guggenheim Museum*, 2013, http://www.guggenheim.org/new-york/exhibitions/past/exhibit/4495.

5 Amelia Jones, "Survey," *The Artist's Body*, 30–31.

6 Emily Anne Kuriyama. "Everything You Need to Know About Chris Burden's Art Through His Greatest Works," *Complex Style*, October 2, 2013, http://www.complex.com/style/2013/10/chris-burden-art-new-museum/.

7 *Performance Magazine* did eventually receive Art Council monies.

8 Ira Licht, *Bodyworks* (Chicago: Museum of Contemporary Art, 1975).

9 Arnason's *History of Modern Art* was first published in 1968 by H.N. Abrams. It is currently in its seventh edition. Fineberg's *Art Since 1940* was first published in 1995 by Pearson. Currently in its third edition, it includes Bruce Nauman and Anne Hamilton on the cover. The 1995 edition included Joseph Beuys as well.

10 Renato Poggioli, *The Theory of the Avant-garde* (Boston, MA: Harvard University Press, 1968), 52.

11 Sayre, *The Object of Performance,* 14.

12 Those who joined the core faculty in 1974, along with Lacy, were art historian Ruth Iskin, writer Deena Metzger, and graphic artist Helen Roth.

13 Cheri Gaulke, "Acting Like a Woman: Performance Art of the Woman's Building," *The Citizen Artist: An Anthology from High Performance Magazine 1978–1998,* Linda Frye Burnham and Steven Durland, eds. (Gardiner, NY: Critical Press, 1998), 18–21.

14 Burnham, "Performance Art in Southern California: An Overview," *Performance Anthology: Source Book of California Performance Art,* Carl E. Loeffler and Darlene Tong, eds. (San Francisco: Last Gasp Press and Contemporary Arts Press, 1989), 390–438.

15 Judith Barry and Sandy Flitterman-Lewis, "Textual Strategies: The Politics of Art-Making," *Visibly Female: Feminism and Art Today,* Hilary Robinson, ed. (London: Camden Press, 1987); and Thalia Gouma-Peterson and Patricia Mathews, "The Feminist Critique of Art History," *Art Bulletin* 69, no. 3 (September 1987): 326–357.

16 Jennie Klein, "Goddess: Feminist Art and Spirituality in the 1970s," *Feminist Studies* 35, no. 3 (Fall 2009): 577.

17 Norma Broude and Mary Garrard, eds., *The Power of Feminist Art* (New York: Harry N. Abrams, 1994); and Amelia Jones, *Sexual Politics* (Berkeley and Los Angeles: UC Press and the Armand Hammer Museum, 1996).

18 Dominic Johnson, "Introduction: The What, When, and Where of Live Art," *Contemporary Theatre Review* 22, no. 1 (2012): 7.

19 Marilyn Arsem, "Interview with Author," (September 8, 2014), unpublished.

20 For more information on Live Art sector organizations in the UK, see Klein, "Developing Live Art," *Histories and Practices of Live Art,* Deirdre Heddon and Jennie Klein, eds. (London: Palgrave MacMillan, 2012), 12–36. Also see LADA's web site: http://www.thisisliveart.co.uk/

21 LADA, "What Is Live Art?" http://www.thisisliveart.co.uk/about/what-is-live-art/.

22 Lara Shalson, "On Duration and Multiplicity," *Performance Research: A Journal of Performing Arts* 17, no. 5 (2012): 99.

23 Claire Bishop, "Delegating Performance: Outsourcing Authenticity," *October* 140 (Spring 2012): 102.

24 www.rapidpulse.org.

25 www.foi.sg.

26 Nick Anderson, "Statement," *Inquiry and Restraint,* Rapid Pulse 15, curated by Giana Gambino, June 6, 2015.

27 Amy Bryzgel, *Performing the East: Performance Art in Russia, Latvia and Poland since 1980,* (London: I.B. Tauris, 2013), 24.

28 Elena Gapova, "Becoming Visible in the Digital Age," *Feminist Media Studies* 15, no. 1 (2015): 19.

29 Thomas Crow, "Modernism and Mass Culture in the Visual Arts," *Pollock and After: The Critical Debate,* Francis Frascina, ed. (New York: Harper and Row Publishers, 1985), 256.

Bibliography

Anderson, Nick. "Statement," *Inquiry and Restraint,* Rapid Pulse 15, curated by Giana Gambino (June 6, 2015).

Arnason, H. Harvard. *History of Modern Art: Painting, Sculpture, Architecture, Photography.* New York: H.N. Abrams, 1968.

Arsem, Marilyn. "Interview," (September 8, 2014). Unpublished.

Barry, Judith and Sandy Flitterman-Lewis. "Textual Strategies: The Politics of Art- Making," *Visibly Female: Feminism and Art Today*, Hilary Robinson, ed., London: Camden Press, 1987, 66–72.

Bishop, Claire. "Delegated Performance: Outsourcing Authenticity," *October* 140 (Spring 2012): 91–112.

Broude, Norma and Mary Garrard, eds. *The Power of Feminist Art*. New York: Harry N. Abrams, 1994.

Bryzgel, Amy. *Performing the East: Performance Art in Russia, Latvia and Poland since 1980*. London: I.B. Tauris, 2013.

Burnham. "Performance Art in Southern California: An Overview," *Performance Anthology: Source Book of California Performance Art*, Carl E. Loeffler and Darlene Tong, eds., 390–438. San Francisco: Last Gasp Press and Contemporary Arts Press, 1989.

Carlson, Marvin. *Performance: A Critical Introduction*. London and New York: Routledge, 1996.

Crow, Thomas. "Modernism and Mass Culture in the Visual Arts," *Pollock and After: The Critical Debate*, Francis Frascina, ed., 256. New York: Harper and Row Publishers, 1985.

Fineberg, Jonathan David. *Art since 1940: Strategies of Being*. New York, NY: H.N. Abrams, 1995

Frye Burnham, Linda. " Performance Art in Southern California: An Overview," *Performance Anthology: Source Book of California Performance Art*, Carl E. Loeffler and Darlene Tong, eds., San Francisco: Last Gasp Press and Contemporary Arts Press, 1989, 413–416.

Gapova, Elena. "Becoming Visible in the Digital Age," *Feminist Media Studies* 15, no. 1 (2015): 19.

Gaulke, Cheri. "Acting Like a Woman: Performance Art of the Women's Building," *The Citizen Artist: An Anthology from High Performance Magazine 1978–1998*, Linda Frye Burnham and Stephen Durland, eds., Gardiner, NY: Critical Press, 1998, 16–19.

Goldberg, Roselee. *Performance Art: From Futurism to Present*. Rev. ed. New York: Harry N. Abrams, 1988.

———. *Performance Art: From Futurism to Present*, rev. ed. New York: Thames and Hudson, 2001.

Gouma-Peterson, Thalia and Patricia Mathews. "The Feminist Critique of Art History," *Art Bulletin* 69, no. 3 (September 1987): 326–357.

Johnson, Dominic. "Introduction: The What, When, and Where of Live Art," *Contemporary Theatre Review* 22, no. 1 (2012): 4–16.

Jones, Amelia. *Sexual Politics*. Berkeley and Los Angeles: University of California Press and the Armand Hammer Museum, 1996.

———. "Survey," *The Artist's Body*, 2012: 30–31.

Klein, Jennie. "Goddess: Feminist Art and Spirituality in the 1970s," *Feminist Studies* 35, no. 3 (Fall 2009): 575–603.

———. "Developing Live Art," *Histories and Practices of Live Art*, Deirdre Heddon and Jennie Klein, eds., London: Palgrave MacMillan, 2012, 12–36.

Kuryima, Emily Anne. "Everything You Need to Know about Chris Burden's Art Through His Greatest Works," *Complex Style* (October 2, 2013).

LADA. "What Is Live Art?" *This Is Live Art* (August 19, 2015). http://www.thisisliveart.co.uk/about/what-is-live-art/

Licht, Ira. *Bodyworks*. Chicago: Museum of Contemporary Art, 1975.

Poggioli, Renato. *The Theory of the Avant-Garde*. Boston: Harvard University Press, 1968.

Sayre, Henry. *The Object of Performance: The American Avant-Garde since 1970*. Chicago: University of Chicago Press, 1989.

Schimmel, Paul, ed. *Out of Actions: Between Performance and the Object 1949–1979*, Los Angeles: The Museum of Contemporary Art, 1998.

Shalson, Lara. "On Duration and Multiplicity," *Performance Research: A Journal of Performing Arts* 17, no. 5 (2012): 98–106.

Tiampo, Ming and Alexandra Munroe. "Gutai: Splendid Playground," *Guggenheim Museum of Art*, 2013. www.guggenheim.org.

Warr, Tracey and Amelia Jones. *The Artist's Body: Themes and Motives*. London: Phaidon, 2000.

8

STREET ART

Critique, commodification, canonization

Paula J. Birnbaum

By what processes has street art entered the global art market and canon? And has the commodification of this art form become synonymous with its canonization?[1] I address these questions first by analyzing the critical reception of several recent street art exhibitions in prominent museums and then by considering two case studies of leading street artists today whose careers took off in the 1990s: the British Banksy (born c. 1974), and Swoon (born 1978), one of the most famous American practitioners. By examining their distinct methods of interaction with the street and diverse branches of the art world, I analyze two quite different ways in which street artists engage with issues of critique, commodification and canonization.

While many refer to a "street art movement,"[2] I prefer to avoid this term, as it implies a group of artists working together with shared goals, which is often not the case. Such a claim of a unified street art movement may foster the notion of canonization, yet it does not accurately capture the diversity of this hybrid art form and its ambivalent relationship to the global market and canon. Moreover, there are inherent difficulties in defining or categorizing street art as a unified medium, given the wide range of practices and forms of appropriation, from the pasting of photographs and mass-produced imagery as social critique to stenciling and tagging politically charged commentary in spray paint. But beyond these uses of media by street artists, an important factor is the mass media's documentation and global dissemination of these images, as Martin Irvine notes in his definition of street art, c. 2010:

> hybrid art in global visual culture, a post-postmodern genre being defined more by real-time practice than by any sense of unified theory, movement or message . . . a form at once local and global, post-photographic, post-Internet and post-medium, intentionally ephemeral but now documented almost

obsessively with digital photography for the Web, constantly appropriating and remixing imagery, styles and techniques from all possible sources.[3]

For Irvine, street art engages with remix and hybridization to occupy a fluid space in global visual culture that begs questions about the relationship between everyday urban experience and the legacy of postmodernism in the institutional art world. For many artists, Irvine argues, the old distinctions between high and low, inside and outside no longer exist, leading me to question how the critical message of their work translates differently when moving from street to canon.

The work of political theorist Chantal Mouffe in her 2013 book *Agonistics* helps to situate the relationship between cultural producers and the culture industry in a way that is useful for understanding the process by which artists shift their practice from street to studio, Internet, gallery and museum. Mouffe argues that "the very idea of critical public spaces has lost its meaning" due to "the blurring of the lines between art and advertising."[4] She claims that the distinction between public and private is no longer relevant, since "every critical gesture is quickly recuperated and neutralized by the forces of corporate capitalism."[5] According to Mouffe's political philosophy of agonistics, democracy is about constant struggle, debate and pluralism. I argue that street artists have an opportunity to engage with what she describes as multiple "discursive surfaces and public spaces" to foster such critical dialogue. For most artists working in the domain of illegal graffiti and street art today, some combination of public commissions and commercial work is vital to making a living. By connecting their activism in the street and the studio with their engagement with museums, the art world and advertising, they are negotiating what Mouffe would call an "agonistic" process of co-optation that makes street art such a hybrid medium.

From street to commodity to canon

Street art's paradoxical relationship to the canon and culture industry may be understood further by exploring the tension between artistic critique and curatorial authority. The art canon functions as a limited body of artists, movements and art forms deemed to be of both aesthetic and economic value.[6] The canon is established through a dynamic relationship among art institutions, such as museums and galleries, and individual agents, including curators, scholars, critics, collectors, dealers and those working in related fields.[7] For street art to be canonized, it must first be approved by this complex network of institutions and agents and then positioned within a theoretical framework of an existing or emerging art-historical canon. Curatorial authority is related to the practice of canonization, as institutions and agents together control the process of making an artist, medium or exhibition visible. This dynamic has led to the production of a growing body of literature on street art featuring a now-familiar roster of artists, acquisition of their works for the permanent collections of major museums, the decision to feature their works in blockbuster exhibitions and the purchase of such works for large sums in elite

galleries and at auction. The curatorial process also influences which artists are left out of these narratives, and much has been written on this aspect of exclusion and canonization in the history of art.[8]

A brief exploration of the critical reception of American graffiti in the 1980s art world offers an important precursor to the reception of global street art in the 2000s. It was not until graffiti became associated with hip-hop culture in New York in the early 1970s that it came to be considered "art."[9] Keith Haring and Jean-Michel Basquiat were the first to enter the American art canon when they transitioned from illegal work on the gritty downtown walls of lower Manhattan to the white walls of Midtown blue-chip galleries in the early 1980s. While critics associated with the avant-garde canon were skeptical of the emerging neo-expressionist aesthetic, the rapid commercialization of graffiti imagery held mass appeal.[10] In response, Hal Foster wrote in a 1981 essay on graffiti in *Art in America*,

> graffiti is largely mediated . . . Not only are these 'empty' signs filled with media content, but a few are invested with art (economic) value, anonymous tags become celebrity signatures . . . graffiti art is concerned less to contest the lines between museum and margin, high and low, than to find a place within them.[11]

If Foster and other critics writing about urban art in the 1980s felt that the canon and art market were mutually exclusive in the case of graffiti because of its direct engagement with advertising, I am arguing that today one cannot be part of the canon without having a strong art market presence. Mouffe's more recent theory of agonism allows for a more nuanced understanding of both the historical and contemporary relationship among street art, the academy and the market. Academics and critics must reconcile this global practice that is, on the one hand, powerfully associated with political dissent and, on the other, with capitalism, the art world and canonicity. The question of an artist's or art form's success on the market versus in the canon of contemporary art is a complicated one that is historically specific.[12] Let us now consider how museums have negotiated this paradoxical relationship between canon and art as an autonomous commodity in the case of street art.

International museums today are faced with a variety of challenges, both conceptual and physical, in curating exhibitions devoted exclusively to street art. A number of prominent institutions, including the Tate Modern (2008), the Grand Palais in Paris (2009), the National Gallery of Australia (2011) and the Tel Aviv Museum of Art (2011), have taken different curatorial and educational approaches.[13] Some of these exhibitions included walking tours, performances and gallery wall space on which visitors were invited to tag or apply stickers. For all of these exhibitions, both curators and artists grappled with a variety of challenges in capturing the feel of their work on the street inside the white walls of the museum.

One of the most ambitious of these street art exhibition initiatives was the controversial *Art in the Streets* exhibition, which ran from April 17–August 8, 2011, at the Geffen Contemporary at the Museum of Contemporary Art (MoCA) in Los

Angeles, Fig. 8.1.[14] The exhibition was co-curated by Jeffrey Deitch, then museum director and head curator (and former gallerist representing major street artists), along with Roger Gastman and Aaron Rose, both independent curators and long-time promoters of graffiti art. Billed as "the very first major U.S. museum exhibition of graffiti and street art" tracing the development of this art form from the 1970s to the present, the exhibit occupied 4,000 square meters, drew record attendance and attracted significant media attention.[15] Many artists were commissioned to recreate works once made on the street inside the gallery space as well as on the museum's exterior walls, such as Risk and Rime's tribute to Blade, the legendary graffiti icon active in New York in the 1970s and 1980s. Because of the ephemeral nature of the work, the museum galleries also featured photographs of major graffiti and street art initiatives. The exhibition emphasized the role of New York and Los Angeles in the evolution of street art, with sections dedicated to the latter's Cholo, or Mexican-American, gang graffiti and Dogtown skateboard culture contributing new perspectives on this history. The curators also briefly addressed global trends in street art from Paris (André, JR) to São Paulo (Os Gêmeos) to Tokyo (Hiroshi Fujiwara, NIGO, Stash, Jun Takahashi). However, the exhibition and accompanying catalogue largely promoted an American perspective on origins, influence and legacy. Given the location of the exhibition and expertise of the curatorial team, this emphasis is not surprising; however, the project would have benefited from a more developed analysis of geographical precedents, from Mexican murals and Brazilian *pixação* to Italian Arte Povera, and the role of cultural exchange in the global dissemination of graffiti and street art.[16]

The many controversies that arose surrounding the *Art in the Streets* exhibition demonstrate how the canonization of street art has not been fully accepted by the institutional art world or by the practitioners themselves. Some critics pointed to the broad scope and lack of conceptual framework or critical examination of

FIGURE 8.1 Installation view of *Art in the Streets*, April 17–August 8, 2011 at The Geffen Contemporary at MOCA. Courtesy of The Museum of Contemporary Art, Los Angeles. Photograph by Brian Forrest.

the social, economic or political issues connecting the works.[17] Others focused on methods of display and exhibition design; while it can be challenging to avoid creating a spectacle, many were dismissive of the carnival-like atmosphere of *Art in the Streets* (that included a skate ramp and artists' recreation of an urban street, complete with overturned trucks, a refrigerator and blaring hip-hop music playing from overhead speakers).[18] Another concern arose that the exhibition would contribute to a renewed spread of illegal graffiti in Los Angeles, a fear some linked to the Brooklyn Museum's cancelation of the New York leg of *Art in the Streets*.[19] The controversy that best epitomizes the contradictory relationship of street art and the canon involved the censoring of the artist Blu's commissioned mural depicting a panorama of coffins draped in dollar bills. Museum officials were ordered to white-wash the painting, which criticized governmental sponsorship of war, stating that it was "inappropriate" in light of its location beside a veterans' hospital and monument to Japanese-American soldiers who died in World War II. This action alienated many within the graffiti and street art community, and the museum missed an important opportunity to promote a dialogue about its own role as an institutional agent in such a paradox. While *Art in the Streets* offered new strategies for display and visitor engagement, the conflicted reception of this exhibition reflects street art's paradoxical relationship to the canon and culture industry in light of the tension between curatorial authority and artistic critique. By moving on to two case studies examining how Banksy and Swoon negotiate their own ambivalent relationships to the global market and canon, I will analyze two quite different ways in which street artists engage with issues of critique, commodification and canonization.

Banksy: "Don't bite the hand that feeds you"

The British artist Banksy perhaps best embodies the tension between the commodification and canonization of street art. His identity remains a mystery, and he has built his reputation through this branded "anonymity," which may be a necessity because of the illegality of his street work but may also suggest his critical commentary on the co-optation of the art canon. He works illegally in urban areas around the globe, sometimes with a team. Strategically selecting prominent public spaces, he incorporates stencils, stickers and photocopies applied with wheat paste, accompanied by slogans that challenge the dominant structures of authority. His best-known actions include depicting England's Elizabeth II as a chimpanzee during her Golden Jubilee celebration in London (2002), releasing an inflatable Guantanamo Bay prisoner at Disneyland (2006), painting idyllic landscape images on the West Bank separation barrier in Bethlehem (2005 and 2007), along with more recent interventions in Gaza (2015). To date, Banksy regularly sells his work for well over half a million dollars at auction, making him by far the most financially successful of the street artists.

For many there is an irreconcilable tension in the relationship between Banksy's activism and self-promotion for financial gain. Is he a political artist? A capitalist? Both? Banksy's 2010 Academy Award–nominated film, *Exit through the Gift Shop*,

poses these very questions about the value of authenticity and the role of "the superstar in a subculture built in shunning the mainstream."[20] Asked by *New York Times* critic Melena Ryzik "whether a film that takes shots at the commercialization of street art would devalue his own work, Banksy responded, 'It seemed fitting that a film questioning the art world was paid for with proceeds directly from the art world. Maybe it should have been called *Don't Bite the Hand That Feeds You.*'"[21] Such irony is typical of Banksy's work.

In addition to his iconic stencils on the street, Banksy is known for his interventions in museums to point out the politics and elitism of the art world and the canon it displays. During a well-documented visit to New York City in 2005, Banksy smuggled his own works featuring anti-war, anti-capitalist, and anti–art world statements into four of the city's most prominent museums in one day (the Metropolitan, the Museum of Modern Art, the Brooklyn Museum and the Museum of Natural History). He hung his works beside those in the permanent collections, in some cases to be discovered only days later. And during what he referred to as his 2012 "artist residency" in New York, Banksy claimed to have set up a stall along Central Park to "sell 100% authentic Banksy" works for $60, with very few customers willing to buy the work. With the help of the Internet and media, these widely publicized actions succeed in taking Warhol's pop art strategies one step further by making a broad public audience contemplate the inter-dependent nature of the art world's intertwined mechanisms of canonization and commodification.

In one of his most prominent museum interventions, the 2009 exhibition *Banksy Versus Bristol Museum*, the artist fostered a public dialogue on what it means to subvert the authority of the museum and art canon through his own blockbuster exhibition. This time Banksy targeted the Bristol City Museum (thought to be his hometown institution) and planned a "top-secret" exhibition, with only a few museum officials apparently aware of the plan. The exhibit attracted an average of 4,000 visitors per day, and critic Eva Branscome described how Banksy turned the museum into "a shrine of popular culture and commentary on the art market."[22] The exhibition offered a "full-scale infiltration and remix of the museum and its collections" and included sculptures of a Metropolitan Police riot squad officer on a bucking carousel horse, a copy of Michelangelo's *David* strapped with a suicide bomb and a marble rendition of Paris Hilton overloaded with shopping bags.[23] Some in the art world responded with cynicism to such a large-scale exhibition of a "sanctioned outlaw" graffiti artist inside a traditional museum. Was it merely an attempt to boost attendance, or might it be interpreted as a willingness to promote critical dialogue on the mechanics of canonization?

The simultaneous commodification and canonization of street art has led to covering some of Banksy's street works with Plexiglas to keep other graffiti artists from painting over works deemed valuable. An increasing trend has been cutting Banksy's works off of the walls of public buildings as a means to preserve them and make a profit. In response, Banksy states on his website that he does not

support any unauthorized sale of his work. For many years he was represented by art dealer Steve Lazarides, but in 2009 Banksy set up his own organization called Pest Control to maintain control of the authentication and promotion of his work. The irony of the transfer of Banksy's work from the street to art market and/or museum becomes apparent with *Haight Street Rat*, an image of a rat wearing a Che Guevara beret holding a large red magic marker (originally connected to a line of text stating "This is where I draw the line"), spray-painted by the artist on the side of a building in San Francisco in 2010, Fig. 8.2. When a local resident, Brian Greif, learned that the building owner was going to paint over the work, he persuaded the owner to let him take down the eight redwood siding planks on which the rat was painted. He then raised $10,000 to offset the cost of restoration, in which the planks were mounted on aluminum backing. Banksy's *Haight Street Rat* was then included in a controversial 2012 exhibit, *Banksy Out of Context*, at an art fair held in conjunction with Art Basel Miami Beach and more recently was displayed in a non-profit gallery in San Francisco, Fig. 8.3. While Greif promised never to sell it and has tried to donate the work to numerous museums, without a letter of authentication from Pest Control, the institutions have refused to accept the work. In other cases, individuals have succeeded in cutting Banksy's works off buildings in order to preserve them and profit from it. The example of Banksy demonstrates how the very idea of the "anonymous" street artist trying to avoid appropriation and co-optation in fact cannot escape commodification.

FIGURE 8.2 Banksy, San Francisco, 2010. Courtesy of Gallery 835M, San Francisco. Photograph by Brian Greif.

FIGURE 8.3 Banksy, Gallery 836M, San Francisco, January 20, 2015. Courtesy of Gallery 835M, San Francisco and Chantal Buard, Amplifier Strategies.

Swoon: street art as activism

The American artist Caledonia Curry, who works under the name of Swoon, uses different strategies to comment on contemporary culture through a career that began in the street and now involves a wide variety of venues.[24] She aims to provoke public engagement with social and humanitarian issues such as urbanism, sustainability and human rights. Swoon made her reputation in New York City,

where she began creating life-size wheat-paste prints and paper cutouts of figures inspired by German expressionist woodblock prints and Indonesian shadow puppets in the late 1990s. Swoon's early work depicts realistically rendered people to evoke the disenfranchised, urban poor in New York – immigrants, workers and homeless people. She pastes her pieces illegally in uninhabited public places such as abandoned buildings, fire escapes, bridges and water towers. Her signature materials and methods – pierced paper and intaglio print, on newspaper and recycled newsprint – make such works vulnerable to human interaction as well as to the elements and are hence intentionally temporal. Swoon's work has been understood as giving agency to those who are marginalized by focusing upon everyday experiences.[25] On the other hand, her work has also been critiqued for "reifying" her subjects, "turning the actual pain, joy, alienation and celebration experienced by the subjects into an opportunity for an aesthetic experience, in effect anesthetizing both the subject of the works and the viewing subject."[26] Moreover, because she participates in the art market and creates permanent representations of the urban poor for museums and collectors, some question whether her work outdoors functions more as advertising for her museum and commercial practice than as pure social commentary.[27]

Swoon began selling her work to collectors in the early 2000s through then leading street art dealer Jeffrey Deitch, who featured her work in a solo exhibition at Deitch Projects in 2005. That same year, she was invited to contribute an installation of her work in the *Greater New York* exhibition in PS1 followed by the 2006 Whitney Biennial, and the Museum of Modern Art in New York acquired it. Today her work fetches prices in the tens of thousands of dollars at auction and is regularly exhibited in and acquired by a variety of museums.[28] Swoon is represented on the West Coast by New Image Art Gallery, a West Hollywood gallery launched in 1994 by art dealer Marsea Goldberg to launch or help mobilize the careers of many important urban artists including Shepard Fairey, Ed Templeton, Faile and Retna.[29] Swoon also sells multi-edition prints of her work on her own website as a means to fund her projects and, like Banksy, refuses corporate sponsorship. Swoon's ability to move fluidly within what Mouffe calls multiple "discursive surfaces and public spaces" while retaining her activist focus has helped establish her reputation as a studio/street artist who has entered the canon in a different way from many of her colleagues.

Swoon's recent engagement with museums reflects her desire to promote social activism while pushing the physical limits of an institutional setting. Her 2011–2012 installation, *Anthropocene Extinction*, commissioned for the seventy-fifth anniversary of the Institute of Contemporary Art in Boston (curated by ICA curator Pedro Alonzo), featured a forty-foot-high mural that spanned the entire length of the lobby, highlighted by an immense portrait of a ninety-year-old Aboriginal woman, surrounded by delicate, organic forms,[30] Fig. 8.4. Art critic Christine Temen noted how this "incongruous," nomadic figure introduced the installation's theme of "industrialized society destroying ancient lifestyles and the environment."[31] The mural was connected by a delicate paper chain to a 400-pound, mixed-media sculpture suspended beside the ICA's glass elevator. As a whole, Swoon's installation commanded the space of the busy museum lobby, the ultimate site of both canon and commerce (ticket counters, café entrance and gift shop) and encouraged visitors to contemplate the theme of environmental justice.[32]

FIGURE 8.4 Installation view of *Swoon: Anthropocene Extinction*, Institute of Contemporary Art, Boston, Sandra and Gerald Fineberg Art Wall, September 3, 2011–December 30, 2012. © Charles Mayer. Courtesy of Institute of Contemporary Art, Boston.

In 2014, the Brooklyn Museum of Art commissioned a similarly large-scale, site-specific installation of Swoon's work in its rotunda gallery for the exhibition *Swoon: Submerged Motherlands* (curated by the museum's curator Sharon Matt Atkins). Both museums have a history of supporting the work of street artists in an institutional setting: Alonzo at the Boston ICA curated prior solo exhibitions of the work of Shepard Fairey (2009) and Os Gêmeos (2012) that broke attendance records. The Brooklyn Museum (although it had cancelled *Art in the Streets*, scheduled for 2012) previously staged a group exhibition titled *Graffiti* in 2006, along with solo exhibitions of the work of Jean-Michel Basquiat (2005), Keith Haring (2012), and Faile (2015, also curated by Atkins). The Swoon exhibition was the first time that the Brooklyn Museum featured a solo exhibition of the work of a living street artist, let alone a woman who made her career in Brooklyn. It was also the first time that the work of a living artist was installed on a scale that used the full height of the rotunda, requiring consultation with architects and engineers.[33]

Critics viewed Swoon's exhibit at the Brooklyn Museum as a culmination of five years of work engaged with themes of climate change, sustainability and poverty.[34] Inspired by Hurricane Sandy that devastated the Atlantic coast in 2012, the exhibition included a monumental sculptural tree and a fleet of boats and rafts built from scrap wood and other discarded junk. Swoon in fact traveled upon these handmade armadas on the Mississippi, the Hudson River, the Adriatic Sea and the canals of Venice to crash the 2009 Biennale (the *Swimming Cities of Serenissima* project).

When asked how these projects relate to her work in the street, Swoon explained that the connection "between the work is in the impulse to create art that interacts with the world in ways that do not depend upon a protected institutional setting."[35] According to Sarah Suzuki, a curator at the Museum of Modern Art, "When you look at the work of a lot of her peers, hers stands apart.... Swoon's work isn't based in cynicism or a critique of commercial culture. There's an emotional core there."[36] The critical success of Swoon's ICA and Brooklyn Museum exhibitions shows how an artist who is valued for her activist work outdoors can also engage with the art museum as a site where critique, canonization and commodification can coexist.

We might briefly compare how Swoon and Banksy work differently as activists around the question of the globalization of street art – in terms of their commitment to work in different locations – as well as how they relate to local issues in their global work. Both artists use their commercial success to draw attention to a variety of social and environmental issues on a national and global scale. Swoon embeds herself in the communities in which she works and makes long-term commitments to address local concerns in collaboration with community-based artists' collectives and residents. For example, in 2012 she launched the Konbit Shelter Project in Cormiers, Haiti, a sustainable building project assisting Haitians who lost their homes in the devastating 2010 earthquake. The project has since evolved into her continuing commitment to supporting this Haitian community in collaboration with a variety of local and international organizations. In 2015, Swoon created her own non-profit organization – the Heliotrope Foundation – that enables her to fund such projects and infuse her practice with social activism. Another current project includes her development, in collaboration with local artists and residents, of a community activism center in the Lower Ninth Ward in New Orleans, a historic area near the levee that received the most damage from Hurricane Katrina and was previously occupied primarily by an African American population. Swoon also partially supports these projects through the sale of her work in self-organized auctions and pop-up exhibitions in galleries and alternative spaces and other venues.

In contrast, Banksy's shorter-term, self-financed actions focus on bringing global media attention to social issues, from *Santa's Ghetto* (2007), in which he organized a group of leading international street artists that included Swoon to join him in making work on the separation barrier in Bethlehem in protest of the Israeli Occupation, to the more recent Dismaland (2015), a dystopian theme park in the English seaside town of Weston-super-Mare, Somerset, in which he invited fifty-eight artists, including Damien Hirst and Jenny Holzer, to collaborate in a parody of corporate capitalism, politics and the art world. In both of these examples, Banksy imported leading international artists to create a short-term tourist destination and media event in order to bring global attention to the issues at hand. Banksy's strategies result in widespread visibility and financial gain for local communities, but unlike Swoon, he does not engage their active participation. In the case of his work in the West Bank, not all community members appreciated the presence of imported, internationally famous street artists wishing to aestheticize and beautify a structure meant to segregate without consulting them. For example, as Banksy

reports, an older Palestinian man passing by Banksy's work on the separation wall said, "You paint the Wall, you make it look beautiful. . . . We don't want it to be beautiful, we hate this Wall, go home."[37] Nonetheless, Banksy's projects in both Bethlehem and Weston-super-Mare resulted in increased tourism that benefited both communities.

In the case of Dismaland, Banksy claims that the park was stripped for parts to provide shelter for the thousands of refugees living in the Calais "Jungle," the migrant camp in northern France, a site where he also has contributed his ironic street art,[38] Fig. 8.5. In December of 2015, Banksy visited the camp and created an image of the late Steve Jobs, the founder of Apple, with a black bag thrown over one shoulder and an early version of the Apple computer in his hand. The work made a pointed reference to Jobs's background as the son of a Syrian migrant who came to the United States after World War II. Soon after it was created, entrepreneurial migrants began charging visitors €5 to see the work, and local authorities covered it with protective glass. While Banksy's intention by posting the image on his website was likely to address negative attitudes toward migrants, the work was defaced by vandals, who smashed the protective glass and added two graffiti tags over the image: one states "LONDON CALLING" (using the image of Jobs to form the letter "I"), while the other says "because it's worthless." Perhaps such an act of vandalism was intended to protest the work's status as an art-world commodity. Or the vandals may have felt that Banksy's work "misses a crucial point about the refugee crisis" that "millions of ordinary human beings are suffering. They may not change the world, but they're no less deserving for it."[39] In contrast to Banksy's focus on bringing global attention to humanitarian issues through such media actions,

FIGURE 8.5 Banksy, *Calais, France*, December 2015. Courtesy Philippe Huguen/AFP/ Getty Images. Photograph by Philippe Huguen.

Swoon's international work in Haiti offers direct support, action, job training and connectivity to communities in need. In short, both Banksy and Swoon offer very different examples of artists' own response to globalization that demonstrate how the lines among art, activism and capitalism have become blurred with the globalization of street art.

Conclusion: from co-optation to social activism

This chapter has investigated the different approaches to the relationship between the art canon and market in the cases of Banksy and Swoon. Banksy, with his self-consciously ironic and critical commentary and actions, consistently mocks the very notion of the cultural gatekeeper in his role as anonymous yet branded street artist. Swoon, on the other hand, strives to unite gatekeeper, artist and community alike in creative projects with a shared vision and deep social impact. In light of Chantal Mouffe's theory of agonistics, these two case studies show how street art is embroiled in a rich and varied landscape that can productively navigate between critique and canon, activism and capitalism. The simultaneous canonization and co-optation of street art by popular culture and the art world economy has created a significant point of tension for the discipline, as well as for those contemporary artists whose work negotiates the frictions among the street, gallery, museum and corporation. It should be noted, however, that although street art has been widely absorbed into mass culture and art-world institutions, some street art purists have resisted engagement with capitalism.[40]

Finally, we might speculate about how Swoon's and Banksy's legacies in the canon will be described twenty years from now: Will Swoon be understood as naïve or as savvy in her ability to shift within multiple art worlds, marketplaces and global sites of activism? And because Banksy is so commercialized, will he be criticized as having "sold out" as in fact he already is by many? In his case, we might think back to the Warholian understanding of public identity and engagement with art-world structures and consumer culture and ask to what extent his self-conscious delight in commodification offers a powerful critical position that has been celebrated as canonical. I would conclude by stating that in the case of both artists, once their work has been translated from the street to a museum setting and has become a precious art-world commodity, there is a process of inevitable neutralization through which the sense of urgency and social critique is defused. Nonetheless, to return to Mouffe's agonistic approach – given their fluid movement between discursive sites that are both unsanctioned and codified – these artists foster a critical dialogue that to a large extent depends on their inhabiting both the street and the canon.

Notes

1 Thanks to Kim Anno, Irene Cheng, Ruth E. Iskin, Tirza True Latimer, Jordana Moore Saggese and Jennifer L. Shaw for their feedback on this chapter at various stages, as well as to Amber Spicer for assistance with research. The literature on street art takes up a

range of critical positions, with some focusing on legal issues and global citizenship, as in Alison Young's *Street Art, Public City: Law, Crime and the Urban Imagination* (London: Routledge, 2014), and others addressing the tension between underground and mainstream, as in Carlo McCormick, Marc Schiller, and Sara Schiller's, *Trespass: A History of Uncommissioned Urban Art* (Köln: Taschen, 2010). A partial list of other noteworthy books includes: Rafael Schacter, *The World Atlas of Street Art and Graffiti* (New Haven: Yale University Press, 2014); Roger Gastman and Caleb Neelon, *The History of American Graffiti* (New York, NY: Harper-Collins, 2011); Jay Edlin, *Graffiti 365* (New York: Abrams, 2011); Cedar Lewisohn, *Street Art: The Graffiti Revolution*, 1st ed. (New York, NY: Abrams, Tate Publishing, 2008); Patrick Nguyen and Stuart Mackenzie, eds., *Beyond the Street: The 100 Most Important Players in Urban Art* (Berlin: Die Getalten Verlag, 2010). While this anthology was not yet available at the time this chapter was written, see also Peter Bengtsen, "Stealing from the Public: The value of street art taken from the street," (Chapter 32) and Maia Morgan Wells, "Graffiti, Street Art and the Evolution of the Art Market," (Chapter 35) in Jeffrey Ian Ross, ed., *Routledge Handbook of Graffiti and Street Art* (London: Routledge, 2016), 416–428 and 464–474.

2 For example, see Anna Waclawek, "From Graffiti to the Street Art Movement: Negotiating Art Worlds, Urban Spaces and Visual Culture, c. 1970–2008," PhD thesis, Concordia University, 2008.

3 Martin Irvine, "The Work on the Street: Street Art and Visual Culture," in *The Handbook of Visual Culture*, Barry Sandywell and Ian Heywood, eds. (London: Berg, 2012), 235–278.

4 Chantal Mouffe, *Agonistics: Thinking the World Politically* (London: Verso, 2013), 85.

5 Ibid.

6 Pierre Bourdieu, *The Field of Cultural Production* (New York: Columbia University Press, 1993).

7 For more on canonization and contemporary art practice, see Malin Hedlin Hayden, *Video Art Historicized: Traditions and Negotiations* (Aldershot: Ashgate, 2015), Anna Brzyski, ed., *Partisan Canons* (Durham: Duke University Press, 2007); Paul Crowther, *Defining Art, Creating the Canon* (London: Oxford University Press, 2007); James Elkins, *Master Narratives and their Discontents* (London: Routledge, 2005).

8 Griselda Pollock, *Differencing the Canon: Feminist Desire and the Writing of Art's Histories* (London: Routledge, 1999).

9 Alison Pearlman, *Unpackaging Art of the 1980s* (Chicago: University of Chicago Press, 2003), 69–104. On the history and reception of early graffiti art exhibitions, including the Times Square Show (June 1980) and Patti Astor's Fun Gallery in the East Village (1981–85), see Charlie Ahearn, Patti Astor, Fab 5 Freddy, Lee Quinones, with Jeffrey Deitch and Carlo McCormick, "The Birth of the Wild Style," in *Art in the Streets*, Deitch, Roger Gastman and Aaron Rose, eds. (Los Angeles: Museum of Contemporary Art, 2011), 43–61; Natalie Hegert, "Radiant Children: The Construction of Graffiti Art in New York City," *Rhizomes* 25 (2013): http://www.rhizomes.net.

10 See Jordana Moore Saggese, "Jean-Michel Basquiat and the American Canon" in this volume, and Saggese, *Reading Basquiat: Exploring Ambivalence in American Art* (Berkeley: University of California Press, 2014), for a discussion of how art critics associated with the *October* journal were skeptical of the emerging Neo-expressionist aesthetic.

11 Hal Foster, "Between Modernism and the Media," *Recodings: Art, Spectacle, Cultural Politics* (New York: The New Press, 1998), 51–2.

12 Terry Smith, "Coda: Canons and Contemporaneity," in *Partisan Canons*, Brzyski, ed., 309–26.

13 Lewisohn, *Street Art*; Jaklyn Babbington, *Space Invaders: Australian Street Art / Stencils / Posters / Paste-ups / Zines / Stickers* (Sydney: National Gallery of Australia, 2011); *Street Art in Israel*, ed., Tali Lanir (Tel Aviv: Tel Aviv Museum of Art, 2011).

14 Deitch, Gastman and Rose, eds., *Art in the Streets*. A.H. Simmons, review of *Art in the Streets*, eds., Deitch, Gastman and Rose, *CHOICE: Current Reviews for Academic Libraries* 49, no. 10 (June 2012): 1855–6, http://www.ala.org/acrl/choice/home.

15 Sharon Mizota, "Art Review: 'Art in the Streets' at the Geffen Contemporary at MOCA," *Los Angeles Times*, April 15, 2011, http://latimesblogs.latimes.com; Roni Feinstein, review of *Art in the Streets*, eds., Deitch, Gastman and Rose. *caa.reviews* (January 11, 2012): Jed Perl, "A Los Angeles Museum Commits Suicide," *New Republic*, July 23, 2012, http://newrepublic.com.

16 For a global survey, see Schacter, *The World Atlas of Street Art and Graffiti*.

17 See Carolina Miranda, "Art in the Streets," *ARTnews* (June 1, 2011); Jacob Kimvall, "Art in the Streets," *Konsthistorisk Tidskrift/Journal of Art History* 80, no. 4 (2011): 254.

18 Mizota, "Art Review: 'Art in the Streets.'" In response, some argue that untraditional objects and methods of display can prompt viewers to forgo the art world's privileging of the "white cube" in lieu of experiencing the noises, smells and stimulation of the city as part of the work. See Andreas Gartus and Helmut Ledar, "The White Cube of the Museum Versus the Gray Cube of the Street: The Role of Context in Aesthetic Evaluations," *Psychology of Aesthetics, Creativity and the Arts* 8, no. 3 (2014): 311–320.

19 Heather MacDonald, "Crime in the Museums – America's First Major Graffiti Show Celebrates Urban Sabotage," *City Journal*, April 17, 2011. http://www.city-journal.org; Anny Shaw, "Walls come tumbling down," *The Art Newspaper*, no. 226 (July/August 2011), 35.

20 Melena Ryzik, "Riddle? Yes. Enigma? Sure. Documentary?" *New York Times*, April 13, 2010.

21 Ibid.

22 Eva Branscome, "The True Counterfeits of Banksy: Radical Walls of Complicity and Subversion," *Architectural Digest* 81, no. 5 (September 2011): 114–21.

23 Helen Weaver, "Banksy: Bristol City Museum and Art Gallery," *Art in America*, September 18, 2009, http://www.artinamericamagazine.com/reviews/banksy/.

24 *Swoon* (New York: Abrams, 2010).

25 Carlo McCormick, "Swoon, Noted in Passing," in Swoon, 23–24.

26 James Cockcroft, "Street Art and the Splasher: Assimilation and Resistance," Master's Thesis, Stonybrook University, 2008, 16.

27 Ibid., 17.

28 See figures from Artnet's annual "Urban Art Auction," March 3–10, 2015, http://www.artnetmarketing.com/urban-art-2015.html.

29 Swoon's work was also featured in a recent collaborative exhibition titled "Witch-Wife" with artist Monica Canilao at Chandran Gallery in San Francisco (February 19–April 1, 2016).

30 Exhibition webpage for "Anthropocene Extinction; A Site Specific Installation by Swoon," Institute of Contemporary Art, https://www.icaboston.org/exhibitions/anthropocene-extinction-site-specific-installation-swoon.

31 Christine Temen, "Swoon," *Sculpture*, November 1, 2012, 72.

32 Ibid.

33 Melena Ryzik, "Life of Wonderment: Swoon Blurs the Line Between Art and Activism," *New York Times*, August 6, 2014, http://www.nytimes.com.

34 Kurt McVey, "Swoon's Motherload," *Interview Magazine*, May 4, 2015, http://www.interviewmagazine.com.

35 "Interviews: Swoon – the Swimming Cities of Serenissima," *Arrested Motion*, March 30, 2009. http://arrestedmotion.com.

36 Ryzik, "Life of Wonderment."

37 Banksy, *Wall and Piece* (London: Random House UK, 2005), 20.

38 See Banksy's webpage for Dismaland: http://dismaland.co.uk.

39 Issy Lapowky, "Banksy's Steve Jobs Mural Misses the Point about Refugees," *Wired*, December 11, 2015, http://www.wired.com/2015/12/banksys-steve-jobs-mural-misses-the- point-about-refugees/.

40 CDH, "Notes on the Commodification of Street Art," *Art Monthly Australia*, 263 (September 2013): 43, http://www.artmonthly.org.au.

Bibliography

Ahearn, Charlie, Patti Astor, Fab 5 Freddy, Lee Quinones, with Jeffrey Deitch and Carlo McCormick, "The Birth of the Wild Style," *Art in the Streets*, Roger Gastman Deitch and Aaron Rose, eds., 43–61 Los Angeles: Museum of Contemporary Art, 2011.

Babbington, Jaklyn. *Space Invaders: Australian Street Art/Stencils/Posters/Paste-ups/Zines/Stickers*. Sydney: National Gallery of Australia, 2011.

Banksy. *Wall and Piece*. London: Random House UK, 2005.

Bengtsen, Peter. "Stealing from the Public: The Value of Street art Taken from the Street," *Routledge Handbook of Graffiti and Street Art*, Jeffrey Ian Ross, ed., 416–428. London: Routledge, 2016.

Bourdieu, Pierre. *The Field of Cultural Production: Essays on Art and Literature*. New York: Columbia University Press, 1993.

Branscome, Eva. "The True Counterfeits of Banksy: Radical Walls of Complicity and Subversion," *Architectural Digest* 81, no. 5 (September 2011): 114–121.

Brzyski, Anna. *Partisan Canons*. Durham: Duke University Press, 2007.

CDH. "Notes on the Commodification of Street Art," *Art Monthly Australia* (June 2013).

Cockcroft, James. "Street Art and the Splasher: Assimilation and Resistance," Master's Thesis, Stonybrook University, May 2008.

Crowther, Paul. *Defining Art, Creating the Canon*. London: Oxford University Press, 2007.

Deitch, Jeffrey, Roger Gastman and Aaron Rose, eds. *Art in the Streets*. Los Angeles: Museum of Contemporary Art, 2011.

Edlin, Jay. *Graffiti 365*. New York: Abrams, 2011.

Elkins, James. *Master Narratives and Their Discontents*. London: Routledge, 2005.

Feinstein, Roni. Review of *Art in the Streets*, eds., Deitch, Roger Gastman and Aaron Rose. *caa.reviews* (January 11, 2012).

Foster, Hal. *Recodings: Art, Spectacle, Cultural Politics*. New York: New Press, 1998.

Gartus, Andreas and Helmut Ledar. "The White Cube of the Museum Versus the Gray Cube of the Street: The Role of Context in Aesthetic Evaluations," *Psychology of Aesthetics, Creativity and the Arts* 8, no. 3 (2014): 311–320.

Gastman, Roger and Caleb Neelon. *The History of American Graffiti*. New York: HarperCollins, 2011.

Hayden, Malin Hedlin. *Video Art Historicized: Traditions and Negotiations*. Aldershot: Ashgate, 2015.

Hegert, Natalie. "Radiant Children: The Construction of Graffiti Art in New York City," *Rhizomes* 25 (2013). http://www.rhizomes.net.

Irvine, Martin. "The Work on the Street: Street Art and Visual Culture," *The Handbook of Visual Culture*, Barry Sandywell and Ian Heywood, eds., 235–278. London: Berg, 2012.

Kimvall, Jacob. "Art in the Streets," *Konsthistorisk Tidskrift/Journal of Art History* 80, no. 4 (2011): 254.

Lanir, Tal, ed. *Street Art in Israel*. Tel Aviv: Tel Aviv Museum of Art, 2011.

Lewisohn, Cedar. *Street Art: The Graffiti Revolution*, 1st ed. New York: Abrams, Tate Publishing, 2008.

Lapowky, Issy. "Banksy's Steve Jobs Mural Misses the Point about Refugees," *Wired*, December 11, 2015. http://www.wired.com/2015/12/banksys-steve-jobs-mural-misses-the-point-about-refugees/

MacDonald, Heather. "Crime in the Museums – America's First Major Graffiti Show Celebrates Urban Sabotage," *City Journal*, April 17, 2011. http://www.city-journal.org

McCormick, Carlo, Marc Schiller and Sara Schiller. *Trespass: A History of Uncommissioned Urban Art*. Köln: Taschen, 2010.

McVey, Kurt. "Swoon's Motherload," *Interview Magazine*, May 4, 2015. http://www.inter viewmagazine.com

Miranda, Carolina. "Art in the Streets," *ARTnews* (June 1, 2011).

Mizota, Sharon. "Art Review: 'Art in the Streets' at the Geffen Contemporary at MOCA," *Los Angeles Times*, April 15, 2011. http://latimesblogs.latimes.com

Mouffe, Chantal. *Agonistics: Thinking the World Politically*. London: Verso, 2013.

Nguyen, Patrick and Stuart Mackenzie, eds. *Beyond the Street: The 100 Most Important Players in Urban Art*. Berlin: Die Getalten Verlag, 2010.

Pearlman, Alison. *Unpackaging Art of the 1980s*. Chicago: University of Chicago Press, 2003.

Perl, Jed. "A Los Angeles Museum Commits Suicide," *New Republic*, July 23, 2012. http://newrepublic.com.

Pollock, Griselda. *Differencing the Canon: Feminist Desire and the Writing of Art's Histories*. London: Routledge, 1999.

Rinder, Lawrence and Dena Beard, eds. *Barry McGee*. Berkeley: University of California, Berkeley Art Museum & Pacific Film Archive, 2012.

Ryzik, Melena. "Riddle? Yes. Enigma? Sure. Documentary?" *New York Times*, April 13, 2010.

———. "Life of Wonderment: Swoon Blurs the Line Between Art and Activism," *New York Times*, August 6, 2014. http://www.nytimes.com

Saggese, Jordana Moore. *Reading Basquiat: Exploring Ambivalence in American Art*. Berkeley: University of California Press, 2014.

Schacter, Rafael. *The World Atlas of Street Art and Graffiti*. New Haven: Yale University Press, 2014.

Simmons, A.H. Review of *Art in the Streets*, eds., Deitch, Roger Gastman and Aaron Rose. *CHOICE: Current Reviews for Academic Libraries* 49, no. 10 (June 2012): 1855–1856. http://www.ala.org/acrl/choice/home.

Smith, Terry. "Coda: Canons and Contemporaneity," *Partisan Canons*, Brzyski, ed., 309–326.

Swoon, with introduction by Jeffrey Deitch. *Swoon*. New York: Abrams, 2010.

Temen, Christine. "Swoon," *Sculpture* (November 1, 2012): 72. http://www.sculpture.org.

Waclawek, Anna. "From Graffiti to the Street Art Movement: Negotiating Art Worlds, Urban Spaces and Visual Culture, c. 1970–2008," PhD thesis, Concordia University, 2008.

Weaver, Helen. "Banksy: Bristol City Museum and Art Gallery," *Art in America* (September 18, 2009). http://www.artinamericamagazine.com/reviews/banksy/.

Wells, Maia Morgan. "Graffiti, Street Art and the Evolution of the Art Market," *Routledge Handbook of Graffiti and Street Art*, Jeffrey Ian Ross, ed., 464–474. London: Routledge, 2016.

Young, Alison. *Street Art, Public City: Law, Crime and the Urban Imagination*. London: Routledge, 2014.

9

NEW MEDIA ART AND CANONIZATION

A round-robin conversation

Sarah Cook with Karin de Wild

The participants

Sarah Cook, Dundee Fellow at Duncan of Jordanstone College of Art and Design at the University of Dundee; co-author, with Beryl Graham, of *Rethinking Curating, Art after New Media* (MIT); editor of *Information* (Whitechapel Gallery, MIT)

Mark Daniels, Director of New Media Scotland, Chair of the Alt-w Fund and Honorary Fellow of the University of Edinburgh. Former International Coordinator of the Liverpool Biennial

Charlotte Frost, Assistant Professor in School of Creative Media at the City University of Hong Kong; author of *Art Criticism Online: A History* (Gylphi); founder/director of *PhD2publish.com* and *ArtsFuture.org*

Axel Lapp, director of MEWO Kunsthalle, Strigel- and Antoniter-Museum, Memmingen; co-founder of *The Green Box Publishing* and of *International Curators' Forum*

Addie Wagenknecht, artist represented by bitforms gallery, New York. Recent exhibitions include *Electronic Superhighway (2016–1966)* (Whitechapel Gallery) and *Shellshock* (bitforms gallery)

Karin de Wild, PhD candidate at Duncan of Jordanstone College of Art and Design at the University of Dundee; part of the curatorial team of NEoN festival and co-curator of the conference *Digital Horizons, Virtual Selves*, RCMC, Leiden

Introduction

In keeping with the fluid, dynamic and endlessly over-written history of new media art, this conversation was not a roundtable but a round-robin series of interviews, undertaken during one 24-hour period, via Skype, in which each conversation was

immediately (live-) transcribed (online) and then read by the following interviewee prior to their interview.[1]

The three invited guests represent what could be considered three poles of the field under consideration: Axel Lapp, a museum director (with a PhD in art history, who is also a curator and has extensive experience as an art critic); Mark Daniels, a curator (who is also a producer, a director of a media arts agency and art funding scheme, and a commissioner of creative technology); and Addie Wagenknecht, an artist (who is represented by a commercial gallery). All three straddle the so-called "divide" between the contemporary art world and the many different new media art worlds. The conversations transcribed here circled around some key commonalities, such as representation at the Venice Biennale, the difficulties of curating and collecting media art, and whose responsibility is the preservation and historicization of media art. Although this is far too large and unwieldy a topic to summarize, we nevertheless asked art historian Charlotte Frost to reflect on some of the key points raised.

Round 1: Axel Lapp

Sarah Cook: In some notes you emailed to us before this conversation you wrote, "When I am looking around museums and galleries, I see paintings and photographs, video works, installations, sculptures and very occasionally a performance. I hardly see digital art! The only one piece I recall seeing in Venice this year was an adaptation of an older work by Hans Haacke, a visitor survey, that was filled in via a touch screen with the statistics being updated on the spot, though the digital element will only remain live during the show and afterwards the data will be available as spread sheets like the earlier pre-digital versions. To become part of the 'canon,' works have to be publicized and they have to be seen. They have to be part of important biennials and of big museum shows. The market that regulates these shows, however, is extremely conservative. The market will decide the fate of digital art, whether it will become part of the canon or whether it will forever be a specialist field." That's a bit depressing isn't it, coming from someone who is a trained art historian, and a museum director?

Axel Lapp: There is always a problem with canonization because, what does it mean, what is it? The canon is something that in the end the market generates. Things go in and out of fashion and then somehow the most expensive things end up as part of the canon, not necessarily the most interesting ones. There will always be interesting new media "stuff," and monographs and other publications will keep a record, but whether it goes into the overall canon is a totally different matter. For that it has to go into the shows, not the digital art shows or the net art shows, [but] the big biennials and overview exhibitions. That isn't happening enough at the moment. And as long as the market

does not support it, I don't see [that] it will be, because for a piece to go into the Venice Biennial, someone has to pay for it!

Sarah Cook: The biennial has supported media art, so it is a case that there is already a canon but we are not aware of it, or it is not as obvious?

Axel Lapp: It is not obvious. It is still not prominent enough. Is there a history of the biennial supporting media art?

Sarah Cook: Yes. Francesca Franco's PhD dissertation studied this, beginning with Nam June Paik's work being included in the German pavilion with Hans Haacke.[2]

Axel Lapp: There might be examples [of new media art at Venice], but were they part of the big shows, in what Harald Szeemann showed or what Okwui Enwezor is showing now? Of course, there is occasionally a piece in the national pavilions or in the peripherals, but the landmarks are generated in the international exhibition – in the biennale pavilion. There, it will be one or two pieces of new media art out of 300? In the national pavilions there is so much stuff going on, and more and more venues. There is no way everyone is going to see it all. The general audience will not even get near those places. It doesn't enter the canon just because it was in Venice.

Sarah Cook: More philosophically, how long does it take things to enter the canon – is it about proliferation or visibility? Are the works there, but not as visible, because they are not as multiple – seen across many venues repeatedly?

Axel Lapp: That is a difficult question. When does a contemporary work of art become part of the canon – the stuff that everyone recognizes – if it is not just the work that turns up at auctions, of young artists at 25 selling work for 500,000 dollars – then isn't the canon going to be only the people who are in their fifties? I don't know. What is the difference between hype and a canon?

Sarah Cook: Christian Marclay's work *The Clock* could be an example we could discuss, in that it is very visible and was bought by many museums.[3]

Axel Lapp: Yes that is in there.

Sarah Cook: But then, by it being in the canon does it then excuse the canon from looking at other works – other database, algorithmic, cut up, generated, cinema etc. new media artworks? That one work stands in for a whole area of practice?

Axel Lapp: It does.

Sarah Cook: Because it is the best, or just the most seen, or because it is by the best-known artist?

Axel Lapp: It is the most seen. It is easy to grasp what it is about. You don't have to spend too much time with it in order to understand what it is. That is also a problem [for new media art], if you have to interact with the piece for 30 minutes to see how it works, that takes a lot of

effort, and not many people are prepared to take that. It's about easy recognition. That's how paintings get into the canon, because they are easily graspable, you only need to have one image, you can spread that image and everyone knows it.

Sarah Cook: Is this then a particular problem with new media – that there is a lack of a recognizable style? Every work has so many different versions or different images of it, and many have crowd-sourced documentation. Is that a problem with new media art entering the canon?

Axel Lapp: Yes. It is the same with all sorts of time-based art. Because you can't experience it in the form of a static image, it all depends whether there is a narrative. Have enough people experienced it so that one image is enough? For instance, a James Turrell piece – a photo will not do it justice, but a lot of people have had the experience of the work, they know what it felt like, so just an image will do.

Sarah Cook: As a curator and museum director trained in art history, where do you see your role, or how do the things you do as a curator (or even as a writer) affect the canonization process when you come across new art?

Axel Lapp: By showing new art I am part of that. I am using that position. When it comes to young artists, I am giving them their first performance space in the gallery, their first institutional show that is distinctly different from a gallery project space, or artist-run space. Then again, quite often, I don't have the budget! I have only 50K for a year to do 12 shows. When I find a young interesting painter, I can hang their work on the walls and have no additional costs. It helps me save pockets of more money to spend on something that is more expensive that needs to be produced. I'm doing something next year with Nick Crowe and Ian Rawlinson, but also next year I have a show where works [all that remains of the work of a deceased artist] have to be printed from glass plates, and they are in the National Museum of Photography in Rotterdam; imagine how much they charge for hand printing! There is also the problem where the work gets really complicated [technologically] – we opened a show on Friday, on Tuesday I met someone who was in the gallery over the weekend, and the piece wasn't working! It was a simple installation running from an Xbox, but the [invigilators] couldn't get it to work. That is always a bother. If you don't have qualified staff, it is a problem for them to work with that kind of material no matter how many lists of instructions you write or how detailed they are.

Museums are not made for change. Works of art that are not finite in their structure or appearance, that depend on data input or interaction, are notoriously difficult to maintain. Everything that cannot just be plugged in and operated with a single switch poses a problem in the running of an exhibition, and such works also suffer from the ever-shorter life cycles of the technology employed. Dwindling budgets add to this problem.

Most museums do not have an acquisition budget anymore. They rely on donations from benefactors and gifts from collectors. Unless these build collections of digital art and these permeate into the museums, I do not see digital art breaking out from their niche institutions for new media art.

Sarah Cook: Do we run the risk of sounding regressive: "Never mind all the hard work we've done to get new media into the canon ..."

Axel Lapp: No! It might just be that it is disillusionment with the market. "Canonization" is the wrong term for it. There is interesting stuff happening, fantastic work out there. But "the canon" is something different. It is like MoMA. Their display of the permanent collection, until about 10 years ago, it still had one definitive view of art history in the 20th century, a working canon of art. But then it became expanded. Suddenly women became part of the story! Canons can be expanded but the mechanisms are really difficult.

Sarah Cook: At CRUMB we say that new media art changes how you think about curating ... ergo it should also change art history and canonization – new media art challenges these existing structures [by not being static, singly authored, unique, etc.].[4]

Axel Lapp: It is the case, but you also have to accept that the obvious space for media work might not be the museum. It is like land art, or performance. They exist somewhere else, and they are very valuable and fantastic, and then someone has the great idea to take a photo and hang that in the gallery and call that a land art piece or add a few cobblestones and a description. This means they conceptualize the idea, when the work really exists in another realm. Maybe a shift like that has to happen with new media art to enter the canon, to make it easily graspable.

Round 2: Mark Daniels

Sarah Cook: As a curator and producer of new media art, do you think these artworks have longevity and will become a part of the art-historical canon?

Mark Daniels: As a chair of Alt-w Fund I am always conscious of which of these works are going to be "sticky" – or actually going to have a long life. Which works do curators want to include in other exhibitions? Alt-w has commissioned more than 120 pieces of work, it is important that works of these artists will continue to be seen. (The Alt-w Fund is for practitioners based in Scotland to make and develop new artworks, devices and creative applications that challenge the notions of what new media creativity can be.) For example Thomson & Craighead's *A Short Film About War* has a good history with

respect to further showings.[5] I long for that level of recognition for more pieces of work, but it takes time.

New Media Scotland also has a work in the collection of the National Museum of Scotland; I stress the "national museum" rather than "art museum." The work *Cybraphon* (by the artist group called FOUND) was accessioned in 2013.[6] The key thing is that this piece requires specialist conservation. National Galleries of Scotland cannot support that, but the National Museum can. I don't want it to be lost to art history, because it cannot be placed within an art gallery. It is interesting that Gestalten actually have a page on FOUND and information about *Cybraphon* was published in the book *Touch of Code: Interactive Experiences and Installations* in April 2011.[7] Sadly FOUND no longer operates as FOUND anymore. Because we worked with them occasionally to commission works, it was always good to see in which new directions their work was going. Their artwork *End of Forgetting* was shown as part of the *Material Rites* group exhibition.[8] That level of presence for new media practice is important. The Alt-w alumni show we curated [within the Society of Scottish Artists Annual Exhibition at the Royal Scottish Academy Galleries] in December 2014 was important and remarkable in terms of its impact.[9] The key challenge is getting work into the National Galleries of Scotland. I know there is a genuine interest there, but I'd like to actually see it happening. *Beauty by Design*

FIGURE 9.1 Thomson & Craighead, *A Short Film About War*, 2009/2010. Two-channel video, 9 minutes and 37 seconds. Photograph © Ruth Clark.

(curated with New Media Scotland at the National Portrait Gallery) wasn't a new media show, but it opened a door.

The great thing about the Alt-w exhibitions is that we can pick and choose from alumni and bring them greater attention. Not all of it is great; there are over 60 web-based works, which were commissioned at the beginning, which don't really get the time of day now. Many of them don't exist anymore. How does one, or should one, exhibit web-based pieces of work? Or should you let the visitor simply look at it at home?

Sarah Cook: How about the critical writing and the reviews of these exhibitions – do you think we should have a different kind of writing about this work?

Mark Daniels: As New Media Scotland, we don't often get stuff written up in national press or arts press. We operate outside that bubble. I'm conscious of that and I try to position the work to such a capacity that the fine art press *wants* to write about it. As such, I have a strong ambition to curate the Scottish pavilion for Venice.

Sarah Cook: In the previous conversation, Axel Lapp commented that it does not really matter what happens within the individual and national pavilions in Venice – you have to get the work within the main curated biennale pavilion. There are only two, maybe three new media works of art in there.

Mark Daniels: I am not downhearted by that. We can take matters into our own hands in terms of national pavilions, but who is to say how we get work into the biennial pavilion? We've just undertaken a new commission for the town of Paisley, commissioned in and for Scotland.[10] This will be by boredomresearch, who will create a new piece of work, which has the capacity to have impact – to be "sticky."[11] I would like to see more artists based in Scotland propose and deliver projects of that caliber.

I still believe in the "Superflat" world of Takeshi Murakami – the Japanese ability to understand art from high and low cultures with the same level of consideration.[12] I would love to see that happening more in Europe as well. We were introducing the term "device art" to artists in Scotland, who had no idea about how they were supposed to pigeonhole their work, or if they had to pigeonhole their work. Back in 2011 we curated the exhibition *Left To My Own Devices* to bring device art over from Japan and show it alongside the best works from Scotland along the same time. That was a positive show of eight artists. People were spending up to two hours with the work, and repeat visits were high. There was an appetite for that type of work and presentation. In terms of art history, I would like to see more of that appetite. That's what I will always strive to do.

FIGURE 9.2 FOUND, *Cybraphon*, 2009. Found objects, including musical instruments, light bulbs, old-fashioned radio speakers, a cigar box, a whisky bottle, a galvanometer, Meccano parts, a Tibetan ringing bowl and gramophone horns. National Museums Scotland, Edinburgh, United Kingdom. Photograph © Tommy Perman.

As you and I have discussed, in Scotland there are very few thematic exhibitions; usually they are all single-artist exhibitions. I come from a background of thematic exhibitions and I miss that opportunity. I want to do more of that now, so I can address the imbalance here.

Audiences like this type of work, but they're not being given it at the National Galleries, since it is not being collected there. There are plenty of beautiful works, but they don't know how to look after them. It's not impossible, but collecting new media art requires more work than a painting, and by including these artworks our aesthetic landscape will become more democratic. My next job, in my development role at New Media Scotland, is to show national galleries that they have a big gap in their collections. The lack of specific expertise within galleries is a major stumbling block. It has been very interesting recently to hear boredomresearch talk about who collects their work and where their work is.

Within the town of Paisley we now have to decide how often boredomresearch's generative work should be presented and where. Plus how do we capture what it is doing at any given moment in time? This will be addressed through this project. If it is to be housed in the museum, art gallery, or within the town, then great, but it could be somewhere else too, in a custom paisley-patterned pocket!

Round 3: Addie Wagenknecht

Sarah Cook:　　　　Axel Lapp mentioned that part of the problem is in the artwork's visibility and easy "graspability." Is this a reason why painting fits more easily into the canon?

Addie Wagenknecht:　Typical for new media is what you could define as "multifaceted." For example some weeks ago I was in conversation with the team of Paddle8 [organizer of online auctions] and one of their challenges during the auction "Paddles ON!" was how to show a gif on a static page.[13] You'll have to show a multifaceted use instead of a single image. What is interesting is that a lot of Internet-based artworks can circulate independently from the artist. There is an advantage in terms of the production of those pieces, since their circulation is not directly tied to the person. So the artist can have the possibility to shape the relationship between a piece and themselves.

Karin de Wild:　　　Does digital art need an alternative economic model?

Addie Wagenknecht:　This is a question a lot of people are looking at right now. Kevin McCoy is developing *Monegraph*, which is basically a

way to create an alternative certificate of authentication for an artwork through using Bitcoin block chain technologies and digital currencies.[14] They are using the same sort of models and algorithms to verify an original "digital piece." The JPEG can be eternally replicated – that questions which is the original when they are all identical copies? For digitally based works there is this question on how to create value, how to commodify it or create market conformity. What I have seen in the market is that art traditionally has been defined as a sort of lasting asset and something that is eternally archival. In case of digital work this relies on the maintaining of the system or integrity of the code. MoMA has started to define this within the context of the canon. They have recently acquired some videogames into their collections. They start looking at the archive-ability. Instead of maintaining a static relic, new questions arise like: How do you maintain code? Or how do you maintain an Atari game that only runs on this system that was developed in the seventies and now is completely obsolete?

Karin de Wild: Do you care, as an artist, to be in a canon?

Addie Wagenknecht: Until I started working with galleries I did not think about questions like, how to archive my work or how to preserve or document it. I was more interested in producing the work and in the experimentation. The value was in the process and not so much in the end result. When I started to work with reputable galleries, they wanted to see my installation instructions, they wanted to see how many editions I had and who had them. I had not thought about my work as a commodity yet. It took me two years to rethink how I could create these documents, how I could ship and install easily, all these things that I think create a successful piece of work now.

Karin de Wild: Instead of a single authorship, some of your works are open source. Do we need to rethink authorship?

Addie Wagenknecht: I had to adapt my practice, because prior to working with galleries, it was based on the notion of being documented in a way that it could be repeatable. Or I could put it online with a license so that a lot of people could modify or copy it. Now that I am working with a gallery I started thinking about how I can create a brand. The work sells when it is identified with me as a person. The art is this product that circulates dependent on my identity and signature, and I have to give it my certificate of authenticity. At the same time I am still open sourcing certain aspects of the work. Not all of them, but I document my performance pieces and put these videos online so people can replicate them. If I code a hardware-based work, I put that

FIGURE 9.3 Addie Wagenknecht, *XXXX.XXX*, 2014. Five custom-printed circuit boards, Ethernet patch cables, 80/20 aluminum, installation: 76 × 190 × 13 in (193 × 482.5 × 33 cm). Photograph © bitforms gallery, New York.

information onto my GitHub so people can download the schematics or the code, and they could replicate these pieces theoretically or appropriate them. [GitHub is a website that uses "Git" to develop software within groups. A Git is a repository of files with monitored access. Every change made to the source can be tracked, along with who made the change and why they made it.] So far this has not been an issue for my galleries or for collectors, because they are in particular interested in the ownership of the "original" idea.

Karin de Wild: So it is possible to sell the open-source works?

Addie Wagenknecht: Yes. In 2014 I created a Wifi sniffer, which could tell what was going on in the networks and visualizes that into the circuit boards. It stretches between the poles of "market commodity" and "the resistance to the market." You have to find the balance between the resistance and the conformity to do something that seems true to you as an artist. There are a lot of examples of how artists treat market conditions. When you take a look at clichés like Warhol or Duchamp, you never see the complete picture. They represent a subjective selection of cases that is a reflex of the market. It is not necessarily a strategy that should be imitated, but it can be interesting in terms of a formula. It relates to a history of artists that were in a sense cultural producers and in the meanwhile trying to encapsulate contemporary culture.

In the last few years I have been developing the Deep Lab, which includes feminists, hackers and researchers. We are working in this apex of data aggregation and immediate surveillance. We are at a point where data is valued as dollars. It can be measured: each Tumblr or Facebook user is worth hundreds of dollars. I am working on this, but I see it even more within the practices of younger artists. They are re-blogging, re-appropriating and dissolving their identity within the work. So it becomes a community of practice instead of a singular identity.

Sarah Cook: Feminist practices and hacking is at the start of new media art history. There seems to be a circular (or recursive) nature within the art market and the canon: it keeps rebuilding itself.

Addie Wagenknecht: For me it is frustrating – especially as a female artist – to realize that you are working in an economy and an art world that is antiquated towards femininity. I had a solo exhibition in New York and people asked me, thinking that I was the gallery assistant: "Where is the artist? I would love to meet him." I had two or three established gallery directors saying to me that my work was masculine: "Definitely male art." Well what is female art then? I started asking curators: "What is a female work and how do you define those works?" This is just a tension along the lines of how to rebuild this system over and over again.

Karin de Wild: How do you think, as an artist, that we could broaden the perspective on the canon? How can we include multiple perspectives within art history?

Addie Wagenknecht: We are in a community and world of the Internet. People are becoming citizens of the Internet more than they are of actual places with physical borders. It's not that one is right or wrong, but there are multiple iterations of the same path. Wikipedia is a brilliant example of how something can be defined in multiple ways. When you take a look at those edits, you can see different perspectives, and they are all the truth in some way. They include citations and other aspects that make them "factual." Ultimately the definitions are all correct. The history of digital art is evolving all the time. This relates to this notion that we are "socially" in a new reality, which relates to the culture of Wikipedia and Torrents among others. Creating a communal narrative, instead of one, is much more powerful in the end. With more authors you can create a more balanced idea of the truth.

Karin de Wild: In an ideal vision of the future, would you like to change the strong gatekeepers within the art world (biennales, certain exhibitions and fairs, etc.)?

Addie Wagenknecht:	I have not actually thought about that yet. Also I go to these places as a reference point to see what is going on. The Venice biennale for example is like a preview of a menu. You already know by then who is going to be in auctions, who will be exhibited at the MoMA next year and who will have the solo within the Whitney Museum. It is both frustrating and consistent.
Karin de Wild:	Do we need to have more media artworks in the biennale?
Addie Wagenknecht:	Yes, I think so, to some extent. It has been frustrating to see how difficult it is to have works in there that are not "paintings." People like Michael Manning and Petra Cortright (artists who are so-called "Post Internet"), institutions collect their works, they are included in the contemporary sales, but it is still the traditional canvas, not the screen consistently. The works of mine that sell well are works produced on canvas and paper without electronic components. There is a familiarity there, where I think we have to educate the curators within the museums and the collectors on how to adapt, collect and embrace these new forms of expression.

Charlotte Frost's response

This is a rich and fascinating discussion that perfectly describes – and indeed demonstrates – the ways the art market, museum, and even artistic medium impact an artwork's canonization. We see here too how curators and artists can remain mindful of how they might develop strategies for shoring up the legacy of an artwork. Lapp balances his exhibition program in order to develop new talent; Daniels considers the accessibility of art as integral to its longevity; Wagenknecht varies the form of her work to cater to different institutional tastes. An additional strategy, tried and tested by the conceptual art community, is to expand and develop upon that which can be rendered "eternally archival": the conversation. Over recent years I have been working on a history of online art discussion communities. My aim has been threefold: to tell the story of these communities, to investigate their impact on the practice of art criticism, and (as these archives provide valuable documentation on new media art but are often incomplete and difficult to navigate) to provide a more secure route back into these collapsing worlds. For example, I use a stable media (like a print book) to provide an interface to existing online materials alongside arguably more appropriate formats (like live online discussions themselves) to demonstrate and reflect upon the lived experience of new media art contextualization. It is apt then that Cook and de Wild invited me to consider their digital discussion relay, which, as you read it now, is part of a book but retains an essence of the fluid nature of the post-Internet art-historical archive. Perhaps most importantly, however, by conducting these kinds of conversations and preserving them for further

consideration, we create the very documents future generations will come to rely upon in revising the canon. To those art historians reading this now (on a giant electronic book-harp that sings the page metadata into a parallel thinking-goblet), I would add: remember, good art doesn't fit, and, well, that's kind of the point!

Notes

1 New media art history is endlessly over-written in part because it does not have an agreed methodology or markers. It is also literally over-written in the way that it is collectively authored online – see, for example, the revisions to the Wikipedia pages for new media art and digital art and how those pages differ from the page for contemporary art.

2 Francesca Franco, "Ars Ex Machina – The Missing History of New Media Art at the Venice Biennale, 1966–1986." PhD diss., University of London, 2012.

3 Christian Marclay's *The Clock* (Single-channel video with sound, 2010) was acquired by the Museum of Modern Art, New York, Tate, London, Centre Pompidou, Paris, and the Israel Museum, Jerusalem, among others.

4 The online resource for curators of new media art, CRUMB, was founded in 2000 by Sarah Cook and Beryl Graham. See www.crumbweb.org.

5 For more information on Thomson & Craighead's work *A Short Film About War* (two-channel video installation, 2009), see www.thomson-craighead.net.

6 *Cybraphon*, by the artist group FOUND, consists of a series of robotic instruments housed in a large display case, which behaves like a real band. Image conscious and emotional, the band's performance is affected by online community opinion as it searches the web for reviews and comments about itself 24 hours a day. (Found objects, including musical instruments, light bulbs, old-fashioned radio speakers, a cigar box, a whisky bottle, a galvanometer, Meccano parts, a Tibetan ringing bowl and gramophone horns, 2009)

7 Robert Klanten, Sven Ehmann, and Lukas Feireiss, eds., *A Touch of Code: Interactive Installations and Experiences* (Berlin: Die Gestalten Verlag, 2011).

8 *End of Forgetting* (2010) by the artist group FOUND is a sculpture that remembers every sound it hears, which can be accessed by turning its wheel. Over time, its memories become confused, and every few minutes it plays a brief snippet of the latest audio uploaded by anyone onto the Internet at that moment. The group exhibition *Material Rites* was curated by Sandy Wood and shown at the Royal British Society of Sculptors in London (2011 January 12– 2011, February 11).

9 The *Society of Scottish Artists Annual exhibition* had more than 12,000 visitors in two weeks and four-star reviews.

10 For more information about the Alt-w commission for the town of Paisley, see www.mediascot.org.

11 boredomresearch is British artists Vicky Isley and Paul Smith. For more information about their work, see www.boredomresearch.net.

12 When Mark Daniels worked with the Liverpool Biennial, he wrote about the work of Takeshi Murakami and spent time in Japan researching art and culture. For more information on Murakami's work with the Biennial, see http://www.biennial.com/2004/exhibition/artists/takashi-murakami

13 From June 21 until July 3, 2015, Phillips and Tumblr presented "Paddles ON!" (London). This auction and online exhibition, curated by Lindsay Howard, brought together artists who used digital technologies, among others. It was the second digital art auction at Philips.

14 In 2014, Kevin McCoy co-founded monegraph.com, a platform that uses the technology underlying Bitcoin to provide a mechanism for validating, owning, and trading digital media assets. The project was presented at the New Museum as part of Rhizome's "Seven on Seven" conference and at "TechCrunch Disrupt" in New York.

Bibliography

Cook, Sarah, ed. *Thomson & Craighead: Flat Earth*. Memmingen: MEWO Kunsthalle and Dundee Contemporary Arts, 2013.

Franco, Francesca. "Ars Ex Machina – The Missing History of New Media Art at the Venice Biennale, 1966–1986." PhD diss., University of London, 2012.

Graham, Beryl and Sarah Cook. *Rethinking Curating: Art After New Media*. Cambridge: MIT Press, 2010.

Klanten, Robert, Sven Ehmann, and Lukas Feireiss, eds. *A Touch of Code: Interactive Installations and Experiences*. Berlin: Die Gestalten Verlag, 2011.

PART III

Exhibitions, museums, markets

Part 3: Exhibitions, museums, markets

Articles and roundtables in this section address issues related to the role of art institutions and markets in canonization at a time in which, as Andrea Fraser states, "Museum and market have grown into an all-encompassing apparatus of cultural reification."[1] In "On the Canon of Exhibition History," Felix Vogel examines the current formation of a canon of art exhibitions and the history of exhibitions, reflecting on the relationship between the exhibition canon and the older established canon of art movements; the role of canonizing exhibitions in historicizing the contemporary; the position of the curator; the use of influence and genealogy; and the role of emulation and imitation as strategies for constituting a canon of recent exhibitions.

In "Canonizing Hitler's 'Degenerate Art' in Three American Exhibitions, 1939–1942," Jennifer McComas examines a particular case study in the American canonization of the German Expressionist art movement. She analyzes how several exhibitions in American museums coupled with a close relationship with the market succeeded in canonizing German Expressionism soon after the infamous 1937 *Degenerate Art* exhibition in Germany, which took extreme steps to denigrate this art movement as part of Nazi propaganda, while the regime confiscated and looted artworks. In "Museum Relations," Martha Buskirk analyzes a range of political work by artists, from the late 1960s Art Workers Coalition's demonstrations against MoMA and the 1966 *Peace Tower* in West Hollywood, by Mark di Suvero and other artists protesting the Vietnam War, to such recent work as artists' protests in New York and Venice against the Guggenheim Museum's treatment of migrant labor in the construction of a massive Frank Gehry edifice on Saadiyat Island in Abu Dhabi. Recent works that Buskirk discusses include Tania Bruguera's storefront operation in Corona, Queens, and Christoph Büchel's London community center at a leading

art gallery. She analyzes political art against the backdrop of ongoing debates about the interplay of ethics and aesthetics within a contemporary art discourse on the social turn in art and relational aesthetics. She demonstrates that during a period in which critical consensus regarding the significance of anti-aesthetic and anti-insti tutional gestures has helped their incorporation into canonical museum narratives, there are still ongoing areas of tension and exclusion within an increasingly global network of museums and biennale-type exhibitions.

Ronit Milano, in "The Commodification of the Contemporary Artist and High-Profile Solo Exhibition: The Case of Takashi Murakami," argues that in the twenty-first century, not only art and artist but also major art exhibitions are commodified.

Using the example of Murakami, she demonstrates how his exhibitions function as commodified symbolic capital and are "bought" by some governments as well as private and public institutions to promote political, cultural and economic interests.

The volume ends with two roundtable discussions by art professionals. In "Troubling Canons: Curating and Exhibiting Women's and Feminist Art," Helena Reckitt leads a conversation among artists Pauline Boudry and Renate Lorenz and art historians and curators Angela Dimitrakaki, Kerryn Greenberg, Koyo Kouoh, Camille Morineau, and Mirjam Westen. The discussion assesses a range of issues related to the canonization of women artists through exhibitions and scholarship; the position of women in mainstream canons; the need for specialized feminist canons; and the productive if problematic functions of canons. In the second roundtable, "The Contemporary Art Canon and the Market," art critic and art historian Jonathan T.D. Neal leads a conversation with art critic Ben Davis, curator Alma Ruiz, art historian and curator Chika Okeke-Agulu, and sociologists of the art field Sarah Thornton and Olav Velthuis. Together they address issues such as whether the power to canonize has shifted to the art market; the impact of "emerging markets," their relationship to established marketplaces, and the role of the rise of "new" markets in canons of contemporary art; whether contemporary art canons exist at all – or there are only "dominant trends" in artistic production, institutional discourse and market dynamics; and whether the term "contemporary international art" still coincides primarily with contemporary Western art.

Note

1 Andrea Fraser, "From the Critique of Institutions to an Institution of Critique," *Artforum* 44, no. 1 (September 2005), 278–83, at 278.

10

ON THE CANON OF EXHIBITION HISTORY

Felix Vogel

Exhibitions were undoubtedly always part of art-historical writing, yet it is only recently that one can speak of their evolving into a new branch of scholarship in its own right. Like any other newly established field of study, the history of exhibitions had to establish a canon of its objects. This chapter examines the construction of the canon(s) of exhibitions: How did the history of exhibitions become a topic worthy of interest? What values went into forming its configuration of studies? What is it that continues to keep them in place?[1] And what is the resonance of exhibition histories to curatorial practice?

A curious peculiarity about the canon of exhibitions is the fact that what is being canonized is itself an instrument in the process of canonization. Since the eighteenth century, exhibitions have been the medium through which art became public and the major tool with which artists' careers were launched and maintained through inclusion or exclusion. Exhibitions have also been the prime tool for proclaiming trends, building movements and creating affiliations – in short, exhibitions establish the canon. In turn, the canon seems to be an inexhaustible source for the production of blockbuster exhibitions, a practice that reproduces and consolidates the claim of canonicity.

Whereas earlier on, the canon of artists was mainly built through steady museum collections, this task slowly shifted (though not entirely) to temporary specialized exhibitions. More and more, large museums define themselves primarily through their temporary exhibition program rather than through their permanent collection. This is part of a general emphasis on contemporary art and the competition for attention, but it is also due to smaller museum budgets along with increasing art-market prices. Part of this development is a new approach to handling collections: collections are increasingly periodically re-hung, the history they narrate is re-evaluated, and new displays are created from them. This certainly has to do with a revision of the canon in the sense of, for instance, post-colonial and feminist

critiques, yet it also reflects an interest in "the archive" and is an economic way to claim audiences' attention. In addition, it is connected to the rise of the exhibition, if we understand such displays of collections as a temporalization of a formerly permanent, static and immobile collection. Put differently, we witness a convergence between collection and exhibition.

To answer the question about the practices and agents that establish the canon and insist on its validity, it is important to first consider the assumption that there is a multiplicity of exhibition canons. Canons both are bound to disciplinary traditions and establish a discipline. The fact that the history of exhibitions came to the fore only recently is connected to establishing the profession of the curator – that is, the formation of a new discipline – and subsequently to developing a discourse on curating.[2] Although curatorial discourse will be the main object of investigation in this chapter, I do not mean to imply that it alone constitutes the history of exhibitions.

The canon of exhibitions in art history reproduces a prior canon of art movements

The treatment of exhibitions in art history differs from their treatment in the emerging field of curatorial studies. In art history, the study of exhibitions continues the much older branch of the study of museums. The latter dates back to the late nineteenth century with books dedicated to collections and curiosity cabinets.[3] This field of study has been re-evaluated in the formation of so-called "new art history" beginning around 1970, which stimulated a new type of studies on the ideological role of museums, collections and displays.[4] We should note that the exhibition as such appears only on the margins of these studies. Nonetheless, it is a logical step. That is, paired with art history's growing interest in contemporary art, the tradition of art history would merge into a specialized study of exhibitions and curators.

The discipline of art history usually studies exhibitions that are relevant to the narrative of the development of art but not for the development of the form of the exhibition. An example is Bruce Altshuler's two volumes, *Exhibitions That Made Art History*, which is undoubtedly a standard work in the field and implicitly makes canonical claims.[5] If one compares the list of twenty-four exhibitions in the first volume and twenty-five in the second with art-historical surveys such as *Art Since 1900*,[6] one finds the very same chronology with all-too-familiar corner stones of a Western-centric teleological history.[7] On the one hand, the creation of a sequence of exhibitions refers to a linear and progressive development; on the other, it isolates and highlights singular exhibitions and therefore extends the classical (and mostly outdated) art history narrative of a history of "masterworks" – from artworks to art exhibitions.

This tendency appears also in seminal publications such as the series *Afterall Exhibition Histories*[8] and *The Artist as Curator*.[9] There are further parallels between the publications of Altshuler and Foster and colleagues, not only in the selection

of artists and movements (often through the same events: *The First International Dada Fair*, *When Attitudes Become Form* etc.), but also in the structure of history that underlies them. Like in *Art Since 1900*, the model in *Exhibitions That Made Art History* is a linear history of progress. Focusing on exhibitions that show art which is already part of the canonical narrative of art history, such art-historical studies of exhibitions are based on an already-established canon of artworks and artists and on fixed categories. Such art-historical studies of exhibitions reproduce this canon by affirming its validity for an emerging field, positioning it as a continuous offshoot to art history. What is worthy for the study of art in art history – and thus establishes the canon – becomes also worthy for the canon of exhibitions in art history. This is not to say that the discussed exhibitions are of no importance for the development of the exhibition form but rather that they are discussed in ways that depend on concept formations, accumulations of value and processes of canonization negotiated elsewhere. Instead of revisioning the canon through the studies of exhibitions and trying to establish a counter-narrative of modern art through exhibitions, art-historical studies of exhibitions become part of a canon that already exists and that it subsequently reinforces. To sum up, the canon of exhibitions in art history mirrors the discipline's canon of movements, themes, artists and artworks.

In curatorial discourse, the canon of exhibitions establishes primarily the curator's position

The number of books and PhD dissertations dedicated to the history of exhibitions in art history is ever increasing, yet the largest chunk of publications on the topic originates from curatorial studies.[10] Some writing in this field has even gone so far as to claim that "the art history of the second half of the twentieth century is no longer a history of artworks, but a history of exhibitions."[11] It goes without saying that the curatorial discipline has a very different (and much younger) tradition and customs than art history and that its involvement in the history of exhibitions is motivated by different interests. Here the concern with the history of exhibitions is developed from the perspective of curators as agents within the field. Curators have a double role in producing the object, namely the exhibitions: one is the practice of curating; the other is writing about it (whether their own or someone else's). This practice-led interest in exhibition history might explain three points that all have an impact on the formation of a canon of exhibitions: the concentration on persons, the primary focus on exhibitions that occurred from the 1960s onward and the rhetoric of innovation.

First, it is not a surprising observation that the curatorial discourse is primarily organized around the curator – a figure who, quite often, adopts the features and power of the artist. This is the case in diverse types of publications – monographic ones on pioneering curators, collections of interviews (Hans-Ulrich Obrist's *A Brief History of Curating*),[12] anthologies (*Curating Subjects*)[13] and *Ten Fundamental Questions of Curating*)[14] or a journal (*The Exhibitionist*). In all these publications, it is almost exclusively curators that appear in positions of authorship, leading to

a situation in which the curator speaks about and for the object that he/she has produced and where the curator is established as author.[15] Even when curators do not speak about their own exhibitions, they nevertheless speak from a position that is not that of a supposedly objective outsider. Rather, the curator becomes the chief protagonist of a discourse about exhibitions, and within its historiography, he/she is both subject and object. This effects the canon of exhibitions on two levels: on a first level, in terms of the content of the canon, the relevance of an exhibition is bound to the position of the curator, thus the almost exclusive focus on (thematic) group exhibitions, which is the prime genre in which the "genius" of a curator emerges. The concentration on the curator might also explain why in curatorial discourse, all canonized exhibitions are positive examples, whereas in art history, discredited exhibitions like *Degenerate Art* (1937) are also part of the canon. On a second level, the fact that the curatorial discourse mainly focuses on the curator has the effect that the writings of curators establish an understanding of authorship that equip the curator with authority to decide about the canon. That is to say that the formation of the canon is not established through a claimed "external" power, such as in art history, but by the authors of the objects (namely exhibitions) themselves. In some cases, it is even argued that such writings about exhibitions and establishing a canon of exhibitions "reflect [. . .] curatorial methodology itself."[16]

A second observation in regard to curatorial discourse is that it focuses almost exclusively on exhibitions from the 1960s onward. This limitation shows that the concept of the exhibition in curatorial discourse is not only tied to the (autonomous) curator, who supposedly emerged in this time period, but it also narrows down the criteria for exhibitions worthy of becoming part of the canon to those that are understood as "a creative act in its own right."[17] This argument establishes an erroneous dichotomy between *curating* as a creative act that only emerges at a specific time and *exhibition making* as the mere administration of art. An example is Jens Hoffmann's book *Show Time*, which claims to present "50 key exhibitions of contemporary art from the late 1980s to today – shows that truly changed the course of the discipline and contributed to a more complex understanding of what exhibition making means."[18] Hofmann uses "exhibition making" in this introduction synonymously with "curating." The book is structured thematically, including eight chapters, such as "Beyond the White Cube," "Artists as Curators as Artists" or "Biennial Years." It gives a very brief introduction to each exhibition and includes a fact sheet stating the title, curator(s), dates, location(s), publication(s) and artists. The texts in *Show Time* are distinguished by the same aspects that characterize all publications of the curatorial discourse: positivism, a colloquial tone, an impressionistic and descriptive language, and the absence of criticism and scholarship. Hoffmann gives three reasons for setting the time frame for his selection: "the end of the Cold War and the beginning of the globalization of the art world [sic],"[19] the establishment of curatorial study programs and the first publications of curatorial essays. All three arguments are significant, insofar as they attest to the self-understanding of the field. They also tell us about the reasons for determining the time frame of the canon: the end of the Cold War

marks not only a geopolitical break but a caesura in the development of exhibitions with new opportunities (*Magiciens de la Terre* is mentioned in this context and is framed as a precedence for subsequent shows); the introduction of curatorial studies marks the institutionalization of the profession (and frees curating from the former dependence on art history) and necessitates a canon of exhibitions;[20] the publications on curating bear witness to the autonomous production of discourse on the exhibition.

Connected with this is the rhetoric of innovation. While the claim of innovation in the sense of advancement in the frame of a linear development is an argument that is part of any canon formation, it is worthy to briefly look at the use of this criterion in curatorial discourse. In an attached conversation to *Show Time* among some high-profile curators, Hans-Ulrich Obrist expresses the relation between innovation and history in the simple formula: "We only remember exhibitions that invent new rules of the game."[21] But if one looks more closely at the shows presented in *Show Time* (or similar publications), it is conspicuous that almost all exhibitions happened in high-ranking museums or as part of well-established (and well-funded) recurrent art events such as *documenta*, *Manifesta* or the biennials of Berlin, Lyon and São Paulo (which is not to say that exhibitions in such institutions cannot be innovative). In contrast, exhibitions in less established art venues and in commercial galleries are overlooked, although some of them did play a vital role in challenging the meaning of exhibitions (for example, the exhibitions curated by Tricia Collins and Richard Milazzo since the mid-1980s in commercial galleries and artist-run initiatives like *Friesenwall 120* in Cologne between 1990 and 1994, to mention only two striking examples). Furthermore, all the exhibitions that are discussed testify to a rather classical conception of art and the worship of the single object or artistic idea. In short, they are only risk taking and innovative within very limited boundaries, that is, the boundaries that hold the power relations in place. Thus the canon of exhibitions authored by curators reproduces existing knowledge and hierarchies while functioning to affirm its own position of exhibitions and their curators.

Curatorial discourse bases its canon of exhibitions on the ideas of influence and genealogy

According to Harold Bloom, poets are in a constant battle with other poets, specifically with their precursors. Bloom understands the contact of poets with texts of the past not as simple influence and argues instead that such legacies have to be destroyed by the poet in order to create a new vision. For Bloom, the canon is understood by the author's rejections, as something that is expelled because of his/her "anxiety of influence."[22] Although such an attempt at exclusion of a canonical precursor tries to repress influence, it is still present as an undercurrent in a work. Such an argument can easily be transferred from Bloom's example of poetry to art, especially to the art of the avant garde. It is actually one of the key features of any avant-garde movement, in as much as the avant garde defines itself through

anti-normativity and anti-canonicity. This argument, however, seems not to hold true for exhibition making and the curatorial discourse.

Although the rhetoric of the afore-mentioned texts is often infused by the vocabulary of the avant garde, it would be misleading to speak of an "anxiety of influence" among curators; quite to the contrary – as the many volumes of interviews with pioneering curators demonstrate. It is no coincidence that the form of the interview is the favored genre, since it is understood as a seemingly unmediated form of speech and thus is underlying the alleged authenticity of the statements of the curator. The goal of Obrist's *A Brief History of Curating* is to look into the formation of a practice that is seen (or constructed) as the origin of curating today. The objective is to establish a genealogy. Thus, in the afterword to the book, Daniel Birnbaum describes the interviewed curators as Obrist's "grandparents."[23] The curatorial discourse of exhibition history hence constructs a tradition that determines the practice of its authors, while the latter, in turn, determines historical precedents and the objects that constitute a history of exhibitions that comprise the canon. Exhibition history here means, as a first step, the establishment of a claimed tradition, and the second step is to inscribe oneself within that tradition.[24] In Bloom's terms, one could describe such a strategy as the opposite of an "anxiety of influence."

Books that focus on a more recent time frame operate on the same principle. In *Show Time*, Hoffmann even explains the selection of exhibitions with very personal motives: "I did not include any of my own curated exhibitions, but I did want to discuss those that I experienced personally and that have since proved relevant to the development of my practice, as well as to those of many others."[25] Subjectivity is always a part of an argument, but most often one attempts to reduce it to a minimum, whereas Hoffmann self-confidently establishes it as a leading criterion. This certainly indicates a key moment of the formation of the curatorial canon and points to the production of value, but it also demonstrates how the self-understanding of a curator is shaped by consciously selected influences. In establishing a canon of relevant curators, significant practices and exemplary exhibitions, such anthologies can be understood as attempts to determine one's own identity – both the identity of the particular speaker and the identity of the whole discipline of curating. The formation of a canon, however, is not only a tool for (self-) legitimation of a curator or a discipline (i.e., influence as a way to legitimate the present through the past). Rather, it further establishes standards and obligations for the future (i.e., the creation of a set of prerequisites that will influence the future).[26] This seems to be particularly relevant in relation to the education of curators.

The use of influence and genealogy in the formation of a canon has a very different motivation in the discourse of art history than in curatorial discourse. In art history, influence – although being now largely understood as an outdated category – is used to explain linkages among artists in order to draw a picture of the progression of the history of art as a genealogical model. It is a more or less reasonable strategy to establish an order of contingent facts from an outside perspective. In curatorial discourse, however, influence is used to manifest and naturalize affiliations from within the field.

The historicization and canonization of exhibitions is part of historicizing the contemporary

The process of canonization is structured by the overlapping of two different modes of temporality: synchrony and diachrony. The former delineates epochs or periods by means of a synecdoche: exhibitions are marked with a time signature and represent a specific time. Diachrony comes into play through the intersection of different time models (linear, cyclical, recursive etc.): it is the means to establish historical causality, through before/after conjunctions of exhibitions. Synchrony and diachrony are also reflected in the characteristic of a canonized work as being both time specific and time transcending. Even a canon of the contemporary operates through both temporal principles, although there might be a slight emphasis on synchrony in order to delineate a time span in the first place. To ask about the formation of the canon of the contemporary is a way of inquiring into the historicization of the contemporary.

During the last decade, inquiries into the question about the contemporary have seemed to constitute a genre in their own right.[27] We cannot consider this complex discussion in depth here, but it is worthwhile to recapitulate some of its aspects, because they shed light on our problem. Juliane Rebentisch argues that "in order to determine the historical place of the contemporary, one has to establish a relation between the present and the past in a way that the present gains a direction, the direction of a historical development."[28] However, the contemporary has to be understood as something other than a category of periodization (such as "Renaissance"). Instead "the present is increasingly characterized by a coming together of different but equally 'present' temporalities or 'times,' a temporal unity in disjunction, or a *disjunctive unity in present times.*"[29] In order to present such a disjunction as something coherent, the contemporary has to be a highly speculative enterprise; it is an "operative fiction" that "*regulates the division* between the past and the present within the present."[30]

The history of exhibitions is connected to these arguments in three different ways. First, the exhibition occupies a special place in the discourse of contemporary art. The exhibition is not only the site in which most of contemporary art becomes visible, it is also a site that itself is reflected in contemporary artworks. Besides site-specific works or installations, which are defined by an explicit awareness of their modes of exhibiting, even traditional media like painting frequently consider their exhibition context or are understood as extensions into space. The reflection on the conditions of both traditional media such as painting and newer media such as site-specific installations of "being exhibited" constitutes an imperative part of the concept of work in contemporary art. If conditions of exhibiting take part in the formation of a work concept, this fact is naturally reflected in writing about contemporary art, and such writing subsequently valorizes the exhibition as such. The construction of a concept of contemporary art and the construction of a concept of the contemporary exhibition and their ever-specific canons are interlocked then, informing each other and following the very same patterns. It is on the level of the

discussion of a work concept of contemporary art (which necessitates a historicization of contemporary art) that the historicization of exhibitions becomes relevant in order to define the object of contemporary art.

Second, it is the exhibition form – to be more precise, the "globalization and transnationalization of the biennale as an exhibition form"[31] – that is responsible for the fiction of the contemporary, which is always a "geopolitical fiction."[32] This adds a spatial dimension to the problem of historicizing contemporary art and thus also to the question of the canon, because it puts the position from which one is thinking into perspective. Biennials and other large-scale international exhibitions gained importance after 1989 because they were understood as the privileged place in which a global term of contemporary art is negotiated. This furthermore complicates the periodization of contemporary art and especially the synchronization of spatially different developments. A central aspect of biennials is their claim of the authority of such synchronizations, in other words their claim of the normative power to define contemporary art. That is why such exhibitions (*Magiciens de la Terre*, various editions of *documenta* and certain biennials) are frequently mentioned in the discourse on global art and on the history of exhibitions and thus become part of the canon.

Third, exhibitions that are part of the canon of curatorial discourse are those that almost exclusively show contemporary art. It appears as if only contemporary art exhibitions are significant and as if there have not been any innovative approaches in exhibiting "historical" art, thus giving the impression that there have been no ground-breaking and influential exhibitions in that field.[33] Some exceptions do exist, particularity certain large-scale exhibitions that included historical works (although rarely from before 1900), but these exhibitions mostly have a claim to their significance in the canon because of their supposed contemporaneity. Exceptions are primarily exhibitions that are curated by artists. One such example is Joseph Kosuth's *The Brooklyn Museum Collection: The Play of the Unmentionable* (1990), which presented artworks that had been censored at some earlier point. A particularly well-known example is Fred Wilson's *Mining the Museum: An Installation* (1992–93), in which the artist produced an exhibition at the Maryland Historical Society in Baltimore, which created shocking juxtapositions of objects by selecting objects that had been confined to storage and excluded from public view and from exemplifying the history of America, such as a slave's shackles. Wilson brought attention to the exclusion by juxtaposing the shackles with the kind of domestic colonial polished silver objects that are usually placed in vitrines in such museums. By these curatorial means, Wilson brought to light the repressed history of African Americans and Native Americans in American institutions. What justifies both examples as worthy to become part of the canon is their specific curatorial approach to historical objects. Hence, the canon of exhibitions is also a canon of practices and methods but one in which practices are related to established roles and hierarchies in the art field. To put it more bluntly: what Wilson did in *Mining the Museum* was only possible because the museum extended to him certain rights in his capacity as artist, not as curator. Moreover, although historical objects were

exhibited, they became part of a contemporary work of art. Eventually, different notions of authorship for different art-historical epochs come to the fore: while curating contemporary art is framed by an emphasis on the curator's role as author, notions of authorship – at least in the sense of artistic authorship – in exhibitions of historical objects, if they are not part of an artistic intervention, seem less important, even to such an extent that their claim might jeopardize an exhibition's scholarly reputation.

Emulation and imitation are key strategies for constituting the canon of recent exhibitions

Exhibitions are not merely part of the process of historicizing and canonizing contemporary art, but rather some of them play the role of a kind of historiography of exhibitions. As in contemporary art,

> claims to contemporaneity are frequently now made not merely via, but *as* claims to cultural memory. [. . .] As a result, the historical present is being artistically defined [. . .] in a primarily backward-looking manner, as a time of memory, of recovery, in the very act of articulating its distance or separation from the past that is being remembered.[34]

The diversity of exhibitions that qualify for such a definition includes a variety of shows and different approaches to the past: *Stations of the Modern: The Most Significant Art Exhibitions in 20th Century Germany* (1988) partially reconstructs twenty German exhibitions between 1910 and 1969 in the style of period rooms; *Pictures* (2001) was a re-hanging of a legendary eponymous exhibition with the addition of both later works by the original participants and new works by contemporary artists; *When Attitudes Become Form: Bern 1969/Venice 2013* (2013) was the attempt to entirely re-create and transfer Szeemann's exhibition from the Kunsthalle Bern in 1969 to a Venetian palace in 2013; *Other Primary Structures* (2014) performed a revision of the seminal minimal art exhibition *Primary Structures* (1966) at the very same institution, the Jewish Museum in New York, by exchanging the original Western artworks with those from different parts of the world that could have equally been part of the show in 1966. In relation to our question of the canon, it is first of all striking that the historical exhibitions of all the shows mentioned were already part of the canon before they were recreated. One could even argue that it was their canonical status as exhibitions that made them desirable for such curatorial undertakings. But we can see such a "claim to cultural memory" and an affirmation of the canon not only in such explicit re-creations, re-constructions or re-enactments of historical shows but also in exhibitions that only refer to historical predecessors through, for example, formal borrowings: For instance, *documenta 12* (2007) referred in its spatial design to the first *documenta* held in 1955. Even if a critique of the exhibition is formulated, as in the case of *Other Primary Structures*, a critique of the Western-centric selection of artists of the 1966 show, which is also

a critique of the canon – such a critique does not include the exhibition and its concept as such; it merely filled it with a different content.

What unifies all these examples and furthermore explains the investment of curators in the writing of the history of exhibitions (in the form of both texts and exhibitions) are the underlying strategies of emulation and imitation. Emulation and imitation are more than just the explicit or implicit link to a tradition. They are, furthermore, and in contrast to the idea of influence, actively and deliberately employed. Both are part of the rhetorical tradition since antiquity, and both played a fundamental role in relation to the canon. In Horace, imitation (*imitatio veterum*) means the orientation of poets to exemplary earlier texts, that is, the imitation of canonical authors and, contrary to the concept of *mimesis*, not the imitation of nature. The concept of emulation (*aemulatio*) describes a somewhat refined version of imitation, in that it establishes a relation to earlier works as a form of competition, combining likeness and distinction and an outdoing by the same means. It may be questionable to apply directly concepts from antique rhetoric to the field of contemporary curating; nonetheless, one can see clearly that these examples follow the principles of imitation and emulation in that they return to an already agreed upon set of exhibitions to which they offer a response, even if that is a mere copy or an emulation "in spirit." Emulation and imitation are thus the operational modes by means of which such exhibitions are produced and historical genealogies established.

One could certainly argue that at least since so-called appropriation art, if not since Marcel Duchamp, artistic practice is less defined by originality than by a re-evaluation of already existing (art) objects. One can indeed make such parallels to curatorial practices today. But while such artistic practices always involved a critical reconsideration of the object in question – for instance, by examining its medial conditions – such a criticality is completely absent in most of the aforementioned exhibitions. In the worst cases, these shows stand for mere worship and fetishization.

In analyzing *When Attitudes Become Form: Bern 1969/Venice 2013*, art historian Beatrice von Bismarck argues that such repetitions of exhibitions have to be understood as an "act of third order showing."[35] She referred to the fact that objects in an exhibition always show something but also themselves, and exhibitions too are understood as entities that show something but also themselves. For Bismarck, the quality of this particular exhibition was the fact that it "shows itself and the conditions that constituted the re-staged exhibition."[36] I would like to refine her argument and argue that the constituting conditions are only shown to a certain degree and that such a claim cannot be made for every exhibition of this genre. It is clear that the spatial relations of the works to each other, modes of display and even marginal details like labels can tell us a lot about a specific historical situation and shed light on past curatorial practices, evaluations of artists and the imagination of a public. But the mere repetition – that is, the imitation – of an exhibition does not tell us much about the political conditions, art-historical lineages, curatorial precedence and the reception of the exhibition by the then-public, nor about the exhibition's role in the formation of a canon. The curators attempted to make all this visible in the Venice show, yet, ultimately, it had to be done through the catalogue

and a documentary annex to the exhibition, which presented materials such as letters, newspaper clippings and photographs. Such projects – and this again draws a parallel to contemporary art practices – fail when the repetitions of exhibitions focus merely on the representation of past exhibitions and ignore the constructive dimension of any such representation. The supposed radicalism or criticality of a historical exhibition is, in most cases of such re-created exhibition, only available as a representation, whereas the initial show performed such a criticality.

If we generalize this argument, it could be applied to the question of the canon as a whole. Any form of canonization petrifies its object, yet this offers at least two contrary options. On the one hand, exhibitions entering the canon offer some sort of binding exemplar, which, for curatorial practice, could mean the narrowing of possibilities and establishing an obligation for the future. But on the other hand, it could also offer new opportunities for a re-evaluation of seminal projects and for taking certain ideas further for critically actualizing ideas. It is this double sense that we have to keep in mind when thinking about the canon of exhibitions.

Notes

1 These questions are articulated in Keith Moxey, "Motivating Art History?" *Art Bulletin* 77, no. 3 (September 1995): 392.
2 "Exhibition history" is not a discipline on its own, even though the Central Saint Martins College in London offers a postgraduate MA course in "exhibition studies." Although it is pointless to insist on strict boundaries between disciplines, such a heuristic division will help this analysis in identifying diverging canons. Yet such a division is actively constructed. Jens Hoffmann, for example, argues that "curating has come to be regarded as a professional practice in its own right rather than a sub-discipline of art history." Jens Hoffmann, *Show Time: The 50 Most Influential Exhibitions of Contemporary Art* (London: Thames & Hudson, 2014), 11.
3 An early example is Julius von Schlosser, *Die Kunst und Wunderkammern der Spätrenaissance: Ein Beitrag zur Geschichte des Sammelwesens* (Leipzig: Klinkhardt & Biermann, 1908).
4 Exemplary is Carol Duncan and Alan Wallach, "The Universal Survey Museum," *Art History* 3, no. 4 (December 1980): 448–69.
5 Bruce Altshuler, *Salon to Biennial: Exhibitions that Made Art History*, 1 (London: Phaidon, 2008): 1863–1959; *Biennials and Beyond: Exhibitions That Made Art History*, 2 (London: Phaidon, 2013): 1962–2002.
6 Hal Foster, Rosalind Krauss, Yve-Alain Bois, Benjamin H. D. Buchloh and David Joselit, ed., *Art Since 1900: Modernism, Antimodernism, Postmodernism* (London: Thames & Hudson, 2012).
7 Altshuler includes in the first volume only a single exhibition from outside the Western art discourse: *The First Gutai Art Exhibition*, 1955, which also appears in *Art Since 1900*; in the second volume, Altshuler includes three exhibitions (*Second Havana Biennial*, 1986; *China/Avant-Garde*, 1989; *24th São Paulo Biennial*, 1998). Including such exhibitions has a naturalizing effect.
8 Christian Rattemeyer, *Exhibiting the New Art: "Op Losse Schroeven" and "When Attitudes Become Form" 1969* (Cologne: König, 2010); Rachel Weiss, *Making Art Global 1: "The Third Havana Biennial" 1989* (Cologne: König, 2011); Cornelia Butler, *From Conceptualism to Feminism: Lucy Lippard's "Numbers" Shows 1969–74* (Cologne: König, 2012); Lucy Steeds, *Making Art Global 2: "Magiciens de la Terre" 1989* (Cologne: König, 2013); Joshua Decter, *Exhibition as Social Intervention: "Culture in Action" 1993* (Cologne: König, 2014); Lisette Lagnado, *Cultural Anthropophagy: "The 24th Bienal de Sao Paulo" 1998* (Cologne: König, 2015).

9 The series is published by the art magazine *Mousse* and investigates the role that artists have played as curators and has been edited by Elena Filopovic since 2013.

10 For a more detailed analysis of the following arguments on the "curatorial discourse," see Felix Vogel, "Notes on Exhibition History in Curatorial Discourse," *Oncurating* 21 (2014): 46–57.

11 Florance Derieux, ed., *Harald Szeemann: Individual Methodology* (Zürich: JRP Ringier, 2007): 8.

12 Hans-Ulrich Obrist, ed., *A Brief History of Curating* (Zürich: JRP Ringier, 2011).

13 Paul O'Neill, ed., *Curating Subjects* (London: Open Editions, 2007).

14 Jens Hoffmann, ed., *Ten Fundamental Questions of Curating* (Milan: Mousse, 2013).

15 See Felix Vogel, "Autorschaft als Legitimation. Der Kurator als Autor und die Inszenierung von Autorschaft, 'The Exhibitionist,'" in *Subjektform Autor? Autorschaftsinszenierungen als Praktiken der Subjektivierung*, Sabine Kyora, ed. (Bielefeld: Transcript, 2014), 157–77.

16 Hoffmann, *Show Time*, 16.

17 Ibid., 14.

18 Ibid., 11.

19 Ibid., 14.

20 See Simon Sheikh, "On the Standard of Standards, or, Curating and Canonization," *Manifesta Journal* 11 (2010/2012): 13–18.

21 Hoffmann, *Show Time*, 242.

22 Harold Bloom, *The Anxiety of Influence: A Theory of Poetry* (New York: Oxford Univ. Pr., 1973).

23 Daniel Birnbaum, "The Archaeology of Things to Come," *A Brief History of Curating*, Hans-Ulrich Obrist, ed. (Zürich: JRP Ringier, 2011), 293.

24 On the level of curatorial practice, "influence" should not merely be understood as a form of appreciation. Rather, there are many examples of curators who take a corrective or dialectical position to predecessors. For example, *Magiciens de la Terre* was such a critical reaction to *Primitivism* (MoMA New York, 1984). This, however, does not change the importance of influence. I thank Denise Ryner for this point.

25 Hoffman, *Show Time*, 15.

26 See Sheikh, "Standard of Standards," 15.

27 To name only the most prominent examples: Hal Foster, "Questionnaire on 'The Contemporary,'" *October* 130 (Fall 2009): 3–124; Julieta Aranda et al., ed., *What is Contemporary Art?* (Berlin: Sternberg Press, 2010); Peter Osborne, *Anywhere or Not at All: Philosophy of Contemporary Art* (London: Verso, 2013).

28 Juliane Rebentisch, *Theorien der Gegenwartskunst* (Hamburg: Junius, 2014), 13.

29 Osborne, *Anywhere or Not at All*, 17.

30 Ibid., 23–24.

31 Ibid., 21.

32 Ibid., 25.

33 To mention only three disparate examples: *Norsk Middelalderkunst* at the Henie Onstad Kunstsenter in Oslo in 1972 presented a very different view on medieval art, not least through Sverre Fehn's progressive exhibition design (see on this exhibition: Natalie Hope O'Donnell, "A Thousand Years of New Art: Henie Onstad Kunstsenter in the 1970s," *Musealisierung mittelalterlicher Kunst: Anlässe, Ansätze, Ansprüche*, Wolfgang Brückle, Pierre Alain Mariaux, Daniela Mondini, ed. (Berlin: Deutscher Kunstverlag 2015), 235–49. O'Donnell, *Richard Wilson: The Landscape of Reaction* (London: Tate Gallery, 1982), suggested a revisionist reading of landscape painting and grounded Wilson's art in the political context of *Interwoven Globe: The Worldwide Textile Trade, 1500–1800* (Metropolitan Museum of Art in New York, 2013–2014) spotlighted an often-overlooked medium and explored the truly global dimension of textiles in early modern times.

34 Osborne, *Anywhere or Not at All*, 190.

35 Beatrice von Bismarck, "Der Teufel trägt Geschichtlichkeit oder Im Look der Provoka-
tion," *Kunstgeschichtlichkeit: Historizität und Anachronie in der Gegenwartskunst*, Eva Kern-
bauer, ed. (Paderborn: Fink, 2015), 233–48, at 236.
36 Ibid., 236.

Bibliography

Altshuler, Bruce. *Salon to Biennial: Exhibitions that Made Art History, vol. 1: 1863–1959*. Lon-
don: Phaidon, 2008.
———. *Biennials and Beyond: Exhibitions That Made Art History, vol. 2: 1962–2002*. London:
Phaidon, 2013.
Aranda, Julia, Brian Kuon Wood, and Anton Vidokle, ed. *What Is Contemporary Art?* Berlin:
Sternberg Press, 2010.
Birnbaum, Daniel. "The Archaeology of Things to Come," *A Brief History of Curating*, Hans-
Ulrich Obrist, ed., 293. Zürich: JRP Ringier, 2011.
Bismarck, Beatrice von. "Der Teufel trägt Geschichtlichkeit oder Im Look der Provokation,"
Kunstgeschichtlichkeit: Historizität und Anachronie in der Gegenwartskunst, Eva Kernbauer, ed.,
233–248. Paderborn: Fink, 2015.
Bloom, Harold. *The Anxiety of Influence: A Theory of Poetry*. Oxford: Oxford University Press,
1973.
Britain, Georgian Peck, Amelia and Amy Elizabeth Bogansky.
Butler, Cornelia. *From Conceptualism to Feminism: Lucy Lippard's 'Numbers' Shows 1969–74*.
Cologne: König, 2012.
Decter, Joshua. *Exhibition as Social Intervention: 'Culture in Action' 1993*. Cologne: König, 2014.
Derieux, Florance, ed. *Harald Szeemann: Individual Methodology*. Zürich: JRP Ringier, 2007.
Duncan, Carol and Alan Wallach. "The Universal Survey Museum," *Art History* 3, no. 4
(December 1980): 448–469.
Foster, Hal, Rosalind Krauss, Yve-Alain Bois, Benjamin H.D. Buchloh and David Joselit, eds.
Art Since 1900: Modernism, Antimodernism, Postmodernism. London: Thames & Hudson,
2012.
Foster, Hal, ed. "Questionnaire on 'The Contemporary'" *October* 130 (Fall 2009): 3–124.
Hoffmann, Jens, ed. *Ten Fundamental Questions of Curating*. Milan: Mousse, 2013.
———. *Show Time: The 50 Most Influential Exhibitions of Contemporary Art*. London: Thames &
Hudson, 2014.
Lagnado, Lisette. *Cultural Anthropophagy: 'The 24th Bienal de Sao Paulo' 1998*. Cologne:
König, 2015.
Moxey, Keith. "Motivating Art History?" *Art Bulletin* 77, no. 3 (September 1995): 392–401.
O'Donnell, Natalie Hope. "A Thousand Years of New Art: Henie Onstad Kunstsenter in the
1970s," *Musealisierung mittelalterlicher Kunst: Anlässe, Ansätze, Ansprüche*, Wolfgang Brückle,
Pierre Alain Mariaux, Daniela Mondini, eds., 235–49. Berlin: Deutscher Kunstverlag,
2015.
———. *Richard Wilson: The Landscape of Reaction*. London: Tate Gallery, 1982.
O'Neill, Paul, ed. *Curating Subjects*. London: Open Editions, 2007.
Obrist, Hans-Ulrich, ed. *A Brief History of Curating*. Zürich: JRP Ringier, 2011.
Osborne, Peter. *Anywhere or Not at All: Philosophy of Contemporary Art*. London: Verso, 2013.
Rattemeyer, Christian. *Exhibiting the New Art: 'Op Losse Schroeven' and 'When Attitudes Become
Form' 1969*. Cologne: König, 2010.
Rebentisch, Juliane. *Theorien der Gegenwartskunst*. Hamburg: Junius, 2014.

Schlosser, Julius von. *Die Kunst- und Wunderkammern der Spätrenaissance: Ein Beitrag zur Geschichte des Sammelwesens*. Leipzig: Klinkhardt & Biermann, 1908.

Sheikh, Simon. "On the Standard of Standards, or, Curating and Canonization," *Manifesta Journal* 11 (2010/2012): 13–18.

Steeds, Lucy. *Making Art Global 2: 'Magiciens de la Terre'* 1989. Cologne: König, 2013.

Vogel, Felix. "Autorschaft als Legitimation. Der Kurator als Autor und die Inszenierung von Autorschaft, 'The Exhibitionist,'" *Subjektform Autor? Autorschaftsinszenierungen als Praktiken der Subjektivierung*, Sabine Kyora, ed., 155–177. Bielefeld: Transcript, 2014.

———. "Notes on Exhibition History in Curatorial Discourse," *Oncurating* 21 (2014): 46–57.

Weiss, Rachel. *Making Art Global 1: 'The Third Havana Biennial' 1989*. Cologne: König, 2011.

11

CANONIZING HITLER'S "DEGENERATE ART" IN THREE AMERICAN EXHIBITIONS, 1939–1942

Jennifer McComas

In 1957, the Museum of Modern Art in New York (MoMA) mounted *German Art of the Twentieth Century*. With 178 works by forty-two artists, it was the largest exhibition of modern German art held to date at an American institution. Billed as the "most comprehensive survey [of German art] ever presented in this country,"[1] the exhibition was, however, weighted heavily toward expressionism (a shifting artistic category but defined by this time as works produced by members of the pre–World War I artists' groups *Brücke* and *Blaue Reiter* as well as stylistically related works created during and after the war). Comprising almost half the checklist of the MoMA show,[2] expressionism had clearly attained a foothold in the canon that other modes of German modernism such as Neue Sachlichkeit and Dada had yet to achieve. Indeed, the publication in the same year of several scholarly books on German expressionism – the first in English – offered clear proof of expressionism's now-canonical status in the United States.[3]

The prestige and popularity that expressionism enjoyed in the U.S. in 1957 would have been unthinkable only twenty years earlier and represented, as art historian Herschel Chipp put it, "one of the most thoroughgoing changes of taste" in the realm of modern art.[4] Yet expressionism's postwar canonization was not the result of a change of taste alone. In fact, it was motivated almost entirely by its denunciation as "degenerate art" in the Third Reich, a propaganda tactic that ironically brought worldwide attention to modern German art in the late 1930s. Scholars have noted the conjunction between the 1937 *Degenerate Art* exhibition and the growing esteem for expressionism in the U.S., reflected in part by an upsurge in exhibitions.[5] However, they have devoted little attention to the manner in which expressionism was displayed or to the nuances of the exhibitions' checklists. Yet the curatorial and interpretive strategies shaping these exhibitions determined how expressionism was disseminated to the American public during an era marked by hostility with Germany. Importantly, too, they reflected the close relationship

between museums and the market at a time when many expressionist works from museum collections were newly available through the auspices of German émigré art dealers. This chapter aims to deepen our understanding of how museum and gallery exhibitions – in constituting the interpretation and status of the art and mediating among the market, potential collectors, and the general public – were fundamental drivers in the American canonization of German expressionism in the World War II era and beyond. Playing a critical role in this canonization were works from German public art museums that were branded "degenerate" and confiscated by the Nazi authorities. The "degenerate art" campaign differed from the well-known looting of private Jewish collections in that it targeted state-owned works that were exploited not only as a source of income but also for propaganda, most notably in the *Degenerate Art* exhibition of 1937. When these works began entering the United States, their former museum status proved as critical to the process of canonization as their defamation by the Nazis.

On July 19, 1937, the *Degenerate Art* exhibition opened in Munich. Intended to defame modernist art, the exhibition featured more than 600 paintings, prints, and sculptures from the collections of Germany's public art museums. Nearly all the works on view could be described as expressionist, and all had been acquired by German museums during the Weimar era (1918–1933). Although the official status of expressionism had been a matter of debate in the early years of the Third Reich, its promotion in the 1920s by an elite group of museum officials and art dealers (many of whom were Jewish) ultimately contributed to its denunciation during the Nazi era. The *Degenerate Art* exhibition was part of a larger anti-modernist, anti-Weimar, and anti-Semitic cultural campaign that began with the firing of "non-Aryan" and modernist-oriented museum directors and art professors in 1933 and culminated in the purge of approximately 21,000 expressionist and other modernist works from museums in 1937 and 1938. Many of these objects were subsequently destroyed or sold abroad, frequently to a growing circle of American collectors. Whereas Americans had generally expressed either indifference or hostility toward expressionism before 1937, the *Degenerate Art* exhibition and associated museum purge ensured it a place in American discussions about Nazism and sparked a reappraisal of German modern art. The display of expressionism in the U.S. with reference to the Nazis' "degenerate art" campaign was a critical factor contributing to its eventual canonization.

Three exhibitions deserve particular attention for their role in shaping the American reception of expressionism during World War II: *Contemporary German Art* at Boston's Institute of Modern Art in 1939, *Landmarks in Modern German Art* at the Buchholz Gallery in New York in 1940, and *Free German Art* at MoMA in 1942. All three were modeled on *Twentieth Century German Art*, an exhibition held in the summer of 1938 at the New Burlington Galleries in London before touring the United States in condensed form the following summer. The London exhibition, displaying 269 works by artists branded "degenerate" by the Nazi regime, was conceived as a protest against the *Degenerate Art* exhibition. It focused primarily on expressionism but also included a selection of works in impressionist and more traditional styles.

By contrast, the subsequent American exhibitions were almost exclusively concerned with the Nazis' primary target: expressionism. Examining these exhibitions as a group reveals their unified response to the "degenerate art" campaign. The close cooperation between museum curators and art dealers was critical to the success of these exhibitions, which reinforced each other's political and aesthetic messages through the repetition of carefully crafted strategies and rhetoric. In particular, the works' provenance was used as a tool to condemn the Nazis and convince a new audience of expressionism's desirability. All three exhibitions displayed works that had been purged from German museums, including some that had been installed in the *Degenerate Art* exhibition. However, by drawing associations between "degenerate art" and the canonical artists of Germany's past – particularly by making visual comparisons to sixteenth-century painters such as Holbein and Dürer – the exhibitions undermined the Nazi rhetoric of degeneracy. Likewise, by highlighting the prestigious museum provenances of the works displayed, the exhibitions drew attention to the high cultural status that expressionism had already attained in Weimar Germany, alerting collectors and museum visitors alike to its merits. Finally, the exhibitions appealed to moral sensibilities by presenting expressionism as "exiled art," a tactic that connected its display and acquisition to the larger conflict over immigration in late 1930s America.[6] Ultimately, Hitler's "degenerate art" became a marker in America for cultural and political freedom. Yet it must also be acknowledged – especially given the moralistic tone of these exhibitions – that they themselves occupied an ethically questionable space. For the exhibitions' impressive checklists depended on the "degenerate art" purge and the subsequent financial transactions with the Nazi authorities that enabled the works to leave Germany in the first place.

Building a market for expressionism in the United States

Prior to the 1930s, German expressionism had few advocates in the United States. Disinterest in – and even disapproval of – German art stemmed from the anti-German propaganda of World War I as well as a general preference for French art among major American collectors such as Albert Barnes and the Cone sisters. In the 1920s, expressionism's primary supporters in America, for example the art dealer J.B. Neumann and the collector Erich Cohn, tended to be German (often German Jewish) émigrés. The only American museum actively collecting expressionism in the 1920s was the Detroit Institute of Arts – under the direction of a German émigré, the art historian Wilhelm R. Valentiner. Expanded institutional interest dates to the early 1930s, when the Germanic Museum at Harvard acquired its first examples of modern German art and MoMA mounted America's first major museum exhibition on the subject, *German Painting and Sculpture*, in 1931. A surprisingly large number of American lenders – fourteen – are noted in MoMA's catalogue, yet these were primarily German Jewish émigrés or collectors with close ties to the few museums that supported German modernism.[7] It was only when several prominent German art dealers opened New York galleries in the late 1930s that Americans began to take serious notice of modern German art.

The émigré art dealer Curt Valentin arguably played the most important role in carving out a niche in the American market for German expressionism. Beginning in March 1937, he mounted exhibitions in his New York gallery featuring significant expressionists including Ernst Ludwig Kirchner, Max Beckmann, Lyonel Feininger, and Paul Klee. He also transacted sales of these artists' works to museums and collectors throughout the country. In order to build this market, Valentin needed access to a large quantity of high-quality expressionist art. Thanks to the "degenerate art" purge of 1937–1938, the German museums emerged as the most important source of his gallery stock. Valentin made no attempt to hide the provenance of the objects he sold; in fact, he publicized it as confirmation of the works' high cultural and artistic value. Only recently has the question of *how* Valentin managed to import so many "degenerate" paintings and sculptures been addressed.[8] It is now known that most of his expressionist stock had been acquired directly from the Nazi state; in fact, he arrived in the United States in possession of an export license from the Reich Chamber of Fine Arts.[9] Valentin also acquired five works at the auction held in June 1939 on behalf of the German government at the Galerie Fischer in Lucerne,[10] but the key to his success – and, arguably, the key to expressionism's ultimate canonization in the U.S. – was his connection to Karl Buchholz, one of four German art dealers authorized by the Third Reich to sell "degenerate art" (i.e., former museum holdings) to foreign clients.[11] Valentin's gallery in New York was, in fact, a branch of the Berlin-based Buchholz Gallery. There, he received shipments of "degenerate art" that Karl Buchholz had acquired for low sums.[12] What makes Valentin's ethically tenuous position more complex, however, is that in addition to profiting from the museum purge, he likely believed he was protecting these works from harm in Germany. Moreover, he displayed his stock of "degenerate art" in exhibitions that condemned Nazi anti-modernism. By organizing and contributing to exhibitions that criticized Nazi cultural policy and ideology, Valentin may have been hoping to deflect attention from his questionable connections with his German suppliers. In addition, he also exploited the sensationalism of the "degenerate art" phenomenon to bolster sales of expressionism to Americans. And apparently the Reich authorities were willing, to some extent, to look the other way regarding Valentin's activities. Although Karl Buchholz received an official reprimand when it became clear that expressionist art he had acquired from the German government was being used in anti-Nazi exhibitions abroad, Germany did not halt the transatlantic trade in confiscated museum objects.[13]

Although we now look askance at Valentin's relationship with the Nazi-controlled art market, in the late 1930s, hardly anyone remarked upon the financial transactions with the Nazis that facilitated the creation of an American market for expressionism. A rare exception was an editorial in the communist newspaper *The Daily Worker* that condemned MoMA's 1939 acquisition of five works of "degenerate art" from Valentin, stating that "the purchases do not reflect much credit on the Museum, for the works were bought from the Nazi government and only the Nazis will benefit from this transaction."[14] More typical was the tone of a *New York*

Times article written after Valentin's death in 1954. Here, he was lauded as a hero who had been "active as an 'undercover man' in rescuing many of the great works of 'degenerate' art in German museums . . . and helped to get them safely abroad."[15] Indeed, MoMA's 1939 "degenerate art" acquisition from Valentin received far more praise than criticism in the press, reflecting the prevailing view that the acquisition of works purged from German museums was an anti-fascist and even morally imperative act. Although the absence of a real critique of the "degenerate art" market in the U.S. allowed galleries and museums to deflect difficult questions, it also enabled them to focus the public's attention on the political and aesthetic messages conveyed in their exhibitions, encouraging a reassessment of the negative opinions that many Americans had previously held about modern German art.

Contemporary German Art, 1939

Contemporary German Art opened at the Institute of Modern Art in Boston on November 1, 1939, exactly two months after Germany's invasion of Poland. Founded in 1936 as a regional affiliate of MoMA, the Institute proved to be a strong advocate for expressionist directions in modern art. However, Curt Valentin, who lent twenty-five of the seventy-four works on the *Contemporary German Art* checklist, also exerted a strong influence on the exhibition's expressionist orientation and its emphasis on artists of an earlier generation. None of the artists had been born in the twentieth century, and most had established their reputations by 1914. Styles that developed during the Weimar Republic, including abstraction and Neue Sachlichkeit, were poorly represented. Whereas Neue Sachlichkeit artists such as George Grosz and Otto Dix were best known for their trenchant, and frequently grotesque, critiques of contemporary German society, they were represented in *Contemporary German Art* only with works featuring traditional subjects such as portraits, landscapes, and still lifes. These choices suggest an attempt to make German art more appealing to a conservative American audience that, according to a post-war assessment by émigré art historian H.W. Janson, generally "agree[d] with the politics of the Reichskulturkammer," the ministry that oversaw arts and culture in the Third Reich.[16] The focus of this polemical exhibition was squarely on the pre-war expressionists whose work had been canonized by Weimar-era museums only to find themselves branded "degenerate" in 1937.

The catalogue's introductory essay by the Institute's director James S. Plaut was unequivocal in its condemnation of Nazi cultural policies. He began with a quotation from the 1931 MoMA catalogue for *German Painting and Sculpture*, which had praised the Weimar museums' patronage of contemporary German art: "Some fifty German Museums are a most positive factor both in supporting artists and in educating the public to an understanding of their work."[17] "Now, eight years later," Plaut continued, "most of these same artists are denied public showing in Germany, and the German museums are disposing of their works."[18] The German museum provenances for twenty objects were printed in the catalogue. By highlighting the

prestigious provenances of specific works in the exhibition, Plaut cast the expressionists as modernist "old masters." Presenting expressionism in this way simultaneously emphasized the barbarity of the museum purge and the desirability of the defamed works for new collectors.

More subtly, the publication of the works' provenance also referenced and undermined the Nazis' own use of provenance in the *Degenerate Art* exhibition. In Munich, the works on view had been labeled with an abbreviated provenance consisting of the name of the museum from which they had been confiscated and their acquisition prices. This strategy was intended to persuade spectators that the Weimar bureaucracy had misused public funds to promote the careers of "degenerate" artists. Once the decision was reached in 1938 to sell off "degenerate art," the Reich Propaganda Ministry – perhaps foreseeing that the works' provenance might fuel anti-Nazi sentiment abroad – apparently ordered that marks identifying the former museum collections be removed from the objects.[19] Yet as this verso of an Emil Nolde painting (with inscriptions and stamps clearly identifying it as the former property of the Städtisches Museum in Halle) shows, these orders were disregarded in at least some cases (see Fig. 11.1). And as the wartime exhibitions confirm, American curators and art historians knew very well – with or without extant labels – that the expressionist objects appearing on the U.S. art market originated in German museums.

FIGURE 11.1 Verso (detail), Emil Nolde, *Nudes and Eunuch* (*Keeper of the Harem*), 1912. Oil on canvas, 34.4 × 28.3 in. (87.3 × 72.1 cm). Jane and Roger Wolcott Memorial, Gift of Thomas T. Solley, Indiana University Art Museum 76.70. Courtesy Indiana University Art Museum. Photograph by Kevin Montague.

Landmarks in Modern German Art, 1940

Given Curt Valentin's involvement with the 1939 Boston exhibition, it is not surprising that similar interpretive strategies characterized the show held at his New York gallery in April 1940. His approach in *Landmarks in Modern German Art* was to place modern German art within a historical framework by highlighting the works' recent provenances as well as positioning them within the larger history of German art. The exhibition, whose title promised a presentation of masterpieces, featured twenty-six works, twenty-three of which had been in the collections of eleven German museums until 1937. Curt Valentin had purchased three of the sculptures at the controversial Lucerne auction the previous summer.[20] He had acquired most of the remaining works via Karl Buchholz, and they were available for purchase through the New York gallery. Several major works in the show, including Max Beckmann's paintings *Descent from the Cross* and *Christ and the Woman Taken in Adultery*, both dated 1917, had been prominently featured in the *Degenerate Art* exhibition, Fig. 11.2 and Fig. 11.3. From 1919 to 1937, these

FIGURE 11.2 Installation view, *Landmarks in Modern German Art*, Buchholz Gallery, 1940. Right to left, on view: Max Beckmann, *Christ and the Adulteress*, 1917; Max Beckmann, *Deposition from the Cross*, 1917; Franz Marc, *Deer and Goat*, 1913; Ernst Barlach, *Reading Monks*, 1932. Courtesy of the Perry Townsend Rathbone papers, 1929–1985. Photograph by Adolph Studley. Archives of American Art, Smithsonian Institution, Washington, DC.

FIGURE 11.3 "Entartete Kunst" (Degenerate Art) Exhibition in the gallery of the Munich Hofgarten, opened on July 19, 1937. Left to right, on view: Max Beckmann, *Deposition from the Cross*; *Christ and the Adulteress*; Emil Nolde, *Christ and the Sinner*; *The Three Magi*; and Thalheimer, *Temptation of Saint Anthony*. Zentralarchiv, Staatliche Museen zu Berlin. Courtesy bpk, Berlin/Art Resource, NY.

two paintings had hung, respectively, on the walls of the Städelsches Kunstinstitut in Frankfurt am Main and the Kunsthalle in Mannheim. In addition to citing this prestigious provenance in the catalogue, Valentin called on a museum curator, Perry Rathbone, to argue for their artistic significance, sensing that a scholar's words would lend art-historical credence to the exhibition. Indeed, as a protégé of Wilhelm Valentiner at the Detroit Institute of Arts, Rathbone was well qualified to make this argument. Rathbone himself invoked the authority of the Weimar-era museum directors who had previously selected these same works for their collections, writing in the catalogue:

> The exhibition represents the collective critical judgment of a museum personnel which was remarkable for its foresight and independence in the prompt recognition of the importance of contemporary German art, and was in a position to secure the best and most significant works . . . of the movement.[21]

The fact that American collectors were now in the position to acquire these "best and most significant works" would not have been lost on the exhibition's visitors.

Although the gallery's press release announced that the exhibition encompassed the "significant developments" in modern German art,[22] *Landmarks in Modern*

German Art was even more stylistically homogenous than *Contemporary German Art*. For example, while the Boston exhibition had included four abstract paintings by Wassily Kandinsky, abstraction was entirely absent from Valentin's exhibition. Instead, he emphasized figurative expressionist works by artists who had freely acknowledged their debt to German late-medieval and Renaissance art. References to fifteenth- and sixteenth-century German and Netherlandish art are indeed common in modern German art. Before World War I, the *Brücke* group positioned itself as heir to artists such as Martin Schongauer and Lucas Cranach the Elder, and their works are often characterized by compositional devices that evoke medieval art, including figural distortion, exaggerated perspective, and spatial compression. Likewise, in the 1920s, Neue Sachlichkeit painters embraced the hyperrealist style and glazing technique employed by northern Renaissance artists such as Hans Holbein the Younger.[23] The Beckmann paintings in Valentin's exhibition reflect the artist's study of medieval art during World War I. Both feature the *horror vacui* and elongated figures common in late Gothic art. *Descent from the Cross*'s composition even appears to be lifted directly from a late-fifteenth-century painting by Michael Wolgemut.[24] Likewise, the three wood sculptures in the exhibition – *Revenge* (1922) and *Reading Monks* (1932) by Ernst Barlach and *Joseph and Mary* (1927) by Gerhard Marcks – recall the style, subject, and technique of medieval German woodcarving.

Valentin's decision to emphasize the "Germanic" qualities of expressionism in the midst of World War II – a time when many galleries and museums were reluctant to display German art at all, and if they did, interpreted it as a "universal" style[25] – was, surprisingly, a brilliant strategy. Valentin's aesthetic selectivity gave the exhibition a visual coherence that earned it an enthusiastic review from critic Elizabeth McCausland. Convinced of expressionism's significance, she wrote, "it is almost like a new experience to see the masterpieces assembled by Curt Valentin; they again prove the valid power of modern German art."[26] And critically, Valentin's association of expressionism with canonical German art of the past implied that the bland classicizing style favored in the Third Reich was the real aberration. In formulating this strategy, Valentin may have taken his cue from the New Burlington Galleries' exhibition catalogue, in which British art historian Herbert Read argued that "the most characteristic type of modern German art demands and has received a special name, Expressionism; and . . . this type of art is in essential conformity with the historical tradition of German art – the art of Cranach, Altdorfer, and Grünewald."[27] Similar rejections of the "degenerate" ideology on the grounds that expressionism was an "authentic" German style, while Nazi-approved art was feeble and reactionary, had also been made by American commentators. For example, consider this discussion of the "degenerate art" campaign in *The New Republic*: "the stigmatized work is healthy . . . and in the best tradition of the German past while the officially sanctioned art . . . is . . . rankly 'degenerate.'"[28] Arguments like this aligned the formal qualities of expressionism with anti-fascism, concluding that opposition to Nazism could literally be read into a work of art (and conveniently ignoring the fact that certain expressionists, notably Emil Nolde, sympathized with the Nazi cause). Considering the prevalence of this rhetoric during the war,

it could be argued that expressionism was ultimately canonized as much for what it was *not* (i.e., Nazi-sanctioned classical realism) and for what it was associated with (medieval and Renaissance German art) as for its own aesthetic merits and innovations.

Free German Art, 1942

In June 1942, six months after the U.S. entered World War II, MoMA, the country's leading institutional authority on modern art, finally joined the ranks of museums and galleries that had organized anti-Nazi exhibitions that highlighted "degenerate art." *Free German Art* was produced under the auspices of the museum's Armed Services Program, a wartime initiative through which MoMA presented a series of unabashedly pro-war exhibitions that endorsed ideals of freedom and patriotism. *Free German Art* was paired with *Road to Victory*, a propagandistic exhibition that utilized photomurals to celebrate an idealized vision of American culture and instill confidence in American military prowess. *Free German Art* should thus be understood within this political context not only as a condemnation of Nazism but also as a commentary on American ideals. A modest exhibition, *Free German Art* included just eighteen works, all of which MoMA had acquired between 1939 and 1941. Like Curt Valentin's 1940 show, *Free German Art* was heavily slanted towards figurative expressionism, perhaps unsurprising considering that at least thirteen of the works had been recently purchased from Valentin.[29] Just four artists – all mainstays of the emerging market in German art in America – were represented: Max Beckmann, Emil Nolde, Käthe Kollwitz, and Ernst Barlach. The exhibition lacked a catalogue in which to print the works' provenance. The importance attached to provenance is nevertheless confirmed by an internal memorandum stating that the exhibition "showed works of art which had been exiled from the German museums" even though this was true for just eight of the works.[30]

As suggested by the exhibition's title, the show's message was that democracy alone enabled the arts to thrive. The wall labels directed viewers to perceive the artists not only as Hitler's victims but as exemplars of free artistic expression who would rather risk the wrath of the regime than conform to Hitler's dictatorial artistic precepts. One label explained that the expressionists had "felt at liberty to change the forms and colors of nature, to exaggerate and distort them in any way that his feeling or intuition commanded."[31] This text implicitly contrasted expressionist innovation and sophistication with the easily legible, propagandistic works favored by the Third Reich and called to mind Hitler's condemnation of artists who painted non-naturalistically. Despite this politicization of expressionism, however, the labels made no comment on the wide range of the dates of the works, even though some pre-dated World War I and others had been created as recently as the mid-1930s. Although the exhibition might have explored why so many modern German artists referenced the art of the past to comment on the present, *Free German Art* instead followed Valentin's lead by simply emphasizing the formal affinity of expressionism with historical antecedents to bestow the legitimation of masters

from the German art canon. MoMA's press release thus described the anguish and violence depicted in some of the works as a characteristic of German art throughout the centuries:

> Barlach's heroic *Head* with closed eyes and Kathe [sic] Kollwitz's lithographs of Death attacking impoverished women and children belong to the great tradition of religious and human pathos, which leads back to Duerer [sic] and Gruenewald [sic] to the crucifixes, the Dances of Death, and the violent martyrdoms of German medieval art.[32]

Although failing to examine how contemporary German artists responded to Nazism, *Free German Art* did situate "degenerate art" within the current American discourse on exile and immigration. By extension, the exhibition appealed to cherished notions of American identity, particularly the idea that America was a haven for the oppressed, to garner wider acceptance for expressionism. A contentious dialogue over immigration had gripped the nation since the early 1930s, when the rise of Nazism resulted in an increase in visa applications to the U.S. Despite calls to overturn, or at least expand, the strict immigration quotas set in 1924, the general population appeared reluctant to allow more immigration.[33] While the scarcity of employment during the Great Depression was partly to blame, anti-Semitism also influenced anti-immigrant attitudes, especially since most refugees seeking asylum from Nazi Germany were Jewish. MoMA itself acquiesced to American anti-Semitism by blaming Hitler's "philistine" taste for the "degenerate art" campaign, thereby denying its anti-Jewish basis.[34] On the other hand, the museum's presentation of expressionism through the lens of exile could be seen as a gesture of solidarity with German Jewish émigrés, a group known for its patronage of expressionism. In any event, the "degenerate art" appearing on the U.S. market was frequently described as "exiled art," implying that Americans had a moral duty to accept and safeguard Hitler's outcasts. Gallery exhibitions organized around this time, such as *Artists in Exile*, held at the Pierre Matisse Gallery in March 1942, capitalized on New York City's new status as a refuge for artists fleeing the war in Europe. Tellingly, in his review of *Free German Art*, Edward Alden Jewell likened the "degenerate" works on view to political exiles, stating, "we may indeed take pride in the acknowledgement that these German artists and their work 'are welcome here.'"[35] Yet the most prominent work in the exhibition, Max Beckmann's *Departure*, was by an artist who had recently been denied a U.S. visa, Fig. 11.4.

Curt Valentin, who had become Beckmann's American agent, acquired *Departure* from the artist in 1938. The work became well known to the American public when he lent it to MoMA's high-profile 1939 exhibition *Art in Our Time* and to a Beckmann show organized by the Arts Club of Chicago in January 1942. Painted between 1932 and 1935, *Departure* was the first of Beckmann's nine triptychs, a format he used for allegorical scenes that defy easy interpretation. *Departure's* side panels contain violent images of bound figures being subjected to torture. These offer a stark contrast to the tranquil central image of figures standing in

FIGURE 11.4 Max Beckmann, *Departure*, 1932–35. Oil on canvas, 3 panels. Side panels 84.76 × 39.2 in. (215.3 × 99.7 cm); center panel 84.76 × 45.35 in. (215.3 × 115.2 cm). Given anonymously (by exchange), The Museum of Modern Art, New York. Courtesy of the Museum of Modern Art. Digital image © The Museum of Modern Art/Licensed by SCALA/Art Resource, NY. © 2016 Artists Rights Society (ARS), New York/VG Bild-Kunst, Bonn.

a boat on a calm blue sea. Although the meaning of this imagery is ambiguous, there was little doubt among American audiences that *Departure* was Beckmann's personal response to the cultural suppression in Nazi Germany and to his own exile. For example, when *Departure* was first displayed at the Buchholz Gallery in 1938, critic Elizabeth McCausland interpreted the central scene as an allegory of flight from the anti-modernist ideology of "a regime which ignorantly condemns all modern art."[36] The reading of *Departure* as a commentary on exile may have been bolstered by MoMA's consistent misdating of the triptych to 1937, an error that enabled the museum to identify the work with the commencement of Beckmann's self-imposed exile in Amsterdam and with his denunciation in the *Degenerate Art* exhibition.[37] *Departure*'s inclusion in *Free German Art* suggests that MoMA's director, Alfred Barr, who worked tirelessly on behalf of exiled German artists and scholars, consciously sought to align "degenerate art" with the discourse on exile and immigration. Indeed, the exhibition bore the same title as a 1938 exhibition organized by German exiles in Paris. By presenting "degenerate art" as a political exile and by contrasting its formal qualities with those of Nazi-approved art, *Free German Art* equated expressionism and its practitioners with anti-fascism while simultaneously arguing that artistic excellence depended upon political freedom.

Conclusion

In 1942, Alfred Barr made a claim for expressionism's place in the canon when he stated that the "pre-Nazi German school [was] second in Europe only to that of Paris."[38] Yet the canonization of German expressionism in the English-speaking world was far from assured until the *Degenerate Art* campaign had fixed international attention on modern German art in the late 1930s, transforming it into a symbol of anti-Nazism and flooding the market with works formerly housed in German museums. Today, interest in expressionism continues unabated. German expressionist works command high prices at auction, inspire blockbuster exhibitions, and are the subject of an ever-growing body of scholarly literature. Moreover, increased scrutiny of Nazi-era provenance and calls for restitution of art looted by the Nazis from Jewish collections (some of which were known for their modernist holdings) have, in fact, sharpened contemporary interest in expressionism during the past two decades. And as new archival and online resources for provenance research appear, it is easier than ever to trace the journeys of expressionist works from Germany to American collections. It is thus a timely moment to examine the mechanisms of the American canonization of German expressionism.

While the Nazis' defamation and purge of modern art stimulated American interest in expressionism, its canonization resulted more specifically from the large-scale importation of "degenerate art" from German museums into the U.S. and the strategic display of these works. As sites where politics, aesthetics, and market forces converged, American exhibitions of "degenerate art" were critical to the process of canonization. Exhibitions in commercial venues, such as the Buchholz Gallery, emphasized prestige and salability, while museum exhibitions offered more ideological condemnations of the "degenerate art" campaign. Yet, reflecting the close collaboration between dealers and museums, they all employed similar curatorial strategies to raise the profile of "degenerate art." In particular, the museum provenance of "degenerate art" played an important role in each exhibition. Curators used provenance as a tool to enhance expressionism's prestige, align it with historical German art, and present it as an "exiled" art. With checklists of museum masterpieces, the exhibitions examined here capitalized on the "degenerate art" purge to ensure expressionism a place in the American market, on museum walls, and in academic discourse. Thanks to these exhibitions and their influence, expressionism attained a starring role in the Western art-historical narrative a mere twenty years after the infamous *Degenerate Art* exhibition.

Notes

1 Press release, October 2, 1957, Press Release Archives, Museum of Modern Art Archives, New York (hereafter: MoMA Archives).

2 Andrew C. Ritchie, ed., *German Art of the Twentieth Century*, exh. cat. (New York: Museum of Modern Art, 1957).

3 These included: Peter Selz, *German Expressionist Painting* (Berkeley and Los Angeles: University of California Press, 1957); Charles Kuhn, *German Expressionism and Abstract Art:*

The Harvard Collection (Cambridge, MA: Harvard University Press, 1957); and Bernard Myers, *German Expressionists: A Generation in Revolt* (New York: Praeger, 1957).

4 Herschel Chipp, "Review," *Art Bulletin* 41, no. 1 (March 1959): 119.

5 See, for example, Cécile Whiting, "Regenerate Art: The Reception of German Expressionism in the United States, 1900–1945," *Art Criticism* 9, no. 1 (1994): 72–92; Vivian Endicott Barnett, "Reception and Institutional Support of Modern German Art in the United States, 1933–1945," *Exiles and Émigrés: The Flight of European Artists from Hitler,* Stephanie Barron, ed., exh. cat. (Los Angeles: Los Angeles County Museum of Art, 1997), 273–284; and Pamela Kort, "The Myths of Expressionism in America," *New Worlds: German and Austrian Art, 1890–1940,* Renée Price, ed., exh. cat. (New York: Neue Galerie, 2001), 260–293.

6 This conflict is summarized in a pro-refugee article by Kurt R. Grossmann, "Refugee: Burden or Asset?" *Nation* (December 26, 1942): 708–10.

7 Alfred H. Barr, Jr., *German Painting and Sculpture,* exh. cat. (New York: Museum of Modern Art, 1931).

8 Jonathan Petropoulos, "From Lucerne to Washington, DC: 'Degenerate Art' and the Question of Restitution," *Degenerate Art: The Attack on Modern Art in Nazi Germany, 1937,* Olaf Peters, ed., exh. cat. (New York: Neue Galerie, 2014), 282–301; and Anja Tiedemann, *Die 'entartete' Moderne und ihr amerikanischer Markt: Karl Buchholz und Curt Valentin als Händler verfemter Kunst* (Berlin: Akademie, 2013).

9 Memorandum from the Reichskammer der bildenden Künste to Curt Valentin, September 22, 1936. Jane Wade Papers, Archives of American Art, Smithsonian Institution, Washington, DC (hereafter: AAA) (microfilm reel 2322).

10 Tiedemann, *Die 'entartete' Moderne,* 223.

11 For more on the sale of "degenerate art," see Andreas Hünecke, "On the Trail of the Missing Masterpieces: Modern Art from German Galleries," *"Degenerate Art:" The Fate of the Avant-Garde in Nazi Germany,* Stephanie Barron, ed., exh. cat. (Los Angeles: Los Angeles County Museum of Art, 1991), 121–33.

12 For prices, see the 1942 inventory of confiscated art produced by the Reichsministerium für Volksaufklärung und Propaganda: http://www.vam.ac.uk/content/articles/e/entartete-kunst/. Tracing the provenances of the works that passed through the hands of Buchholz and Valentin has been facilitated by the *Beschlagnahmeinventar "Entartete Kunst," "Degenerate Art" Research Center,* Freie Universität Berlin: http://geschkult.fuberlin.de/en/e/db_entart_kunst/datenback/index.html. Tracing works looted from private collectors, on the other hand, generally requires much more detective work.

13 Christine Fischer-Defoy and Kaspar Nürnberg, eds., *Gute Geschäfte: Kunsthandel in Berlin 1933–1945,* exh. cat. (Berlin: Aktives Museum Faschismus und Widerstand in Berlin, 2011), 32–34.

14 "The Modern Museum and Exiled Art," *Daily Worker,* August 16, 1939.

15 Aline B. Saarinen, "A Fitting Memorial: Exhibition Pays Homage to Curt Valentin," *New York Times,* October 10, 1954.

16 H. W. Janson, "Benton and Wood, Champions of Regionalism," *Magazine of Art* 39, no. 5 (May 1946): 184.

17 Barr, *German Painting and Sculpture,* 7–8, quoted in James S. Plaut and Mary C. Udall, *Contemporary German Art,* exh. cat. (Boston: Institute of Modern Art, 1939), 5.

18 Plaut and Udall, *Contemporary German Art,* 5.

19 Uwe Fleckner, "Marketing the Defamed: On the Contradictory Uses of Provenance in the Third Reich," *Provenance: An Alternative History of Art,* Gail Feigenbaum and Inge Reist, eds. (Los Angeles: Getty Research Institute, 2012), 144–45.

20 Tiedemann, *Die 'entartete' Moderne,* 228.

21 Perry Rathbone, *Landmarks in Modern German Art,* exh. cat. (New York: Buchholz Gallery, 1940).

22 Press release, Curt Valentin papers, I.[62], MoMA Archives.

23 For a discussion of this technique, see Bruce F. Miller, "Otto Dix and His Oil-Tempera Technique," *Bulletin of the Cleveland Museum of Art* 74, no. 8 (October 1987): 332–55.

24 A reproduction of Wolgemut's painting *Descent from the Cross* was included in Curt Glaser's survey of German painting, *Zwei Jahrhunderte deutscher Malerei* (Munich: F. Brudmann, 1916).

25 In 1943, the City Art Museum of St. Louis rejected and exhibition of Lovis Corinth's work on the grounds that it looked too "Teutonic." Letter from Charles Nagel to Otto Kallir, April 27, 1943, exhibition file for "Lovis Corinth," 1943, Galerie St. Etienne Archives, New York. *Expressionism: An Exhibition of Modern Painting from Many Countries*, Modern Art Society, Cincinnati, Spring 1941, presented expressionism as a universal style.

26 Elizabeth McCausland, "Exhibitions in New York," *Parnassus* 12, no. 4 (April 1940): 37.

27 Herbert Read, *Twentieth Century German Art*, exh. cat. (London: New Burlington Galleries, 1938): 7.

28 Paul Rosenfeld, "'Degenerate Art,'" *New Republic*, June 22, 1938: 183.

29 For the provenances of the works (except those by Kollwitz), see http://www.moma.org/collection/provenance.

30 Memorandum, "Propaganda for Freedom," ca. 1942, Alfred H. Barr, Jr., Papers, Departmental Records, 1941–42, owned by MoMA, microfilmed by AAA (AAA microfilm reel 2199).

31 Wall label, Museum Collection Files, Department of Painting and Sculpture, MoMA.

32 *Free German Art Acquisitions Shown by Museum of Modern Art*, press release, Press Release Archives, MoMA.

33 Fleckner, "The Fortune Survey: XX," *Fortune Magazine*, April 1939: 102. 83% of respondents to a survey about immigration wanted quotas to remain the same.

34 *Exiled Art Purchased by Museum of Modern Art*, press release, August 7, 1939, Press Release Archives, MoMA.

35 Edward Alden Jewell, "'Free Art:' Works Nazis Reject Shown at Museum," *New York Times*, June 28, 1942.

36 Elizabeth McCausland, "Gallery Notes," *Parnassus* 10, no. 2 (February 1938): 29.

37 For example, the 1937 date is given in the catalogue *Art in Our Time* by Alfred H. Barr (New York: Museum of Modern Art, 1939).

38 *Free German Art* press release, MoMA.

Bibliography

Barnett, Vivian Endicott. "Reception and Institutional Support of Modern German Art in the United States, 1933–1945," *Exiles and Émigrés: The Flight of European Artists from Hitler*, Stephanie Barron, ed., 273–284. Exh. cat. Los Angeles: Los Angeles County Museum of Art, 1997.

Barr, Alfred H., Jr. *Art in Our Time*. Exh. cat. New York: Museum of Modern Art, 1939.

Barr, Alfred H., Jr. *German Painting and Sculpture*. Exh. cat. New York: Museum of Modern Art, 1931.

Chipp, Herschel. "Review," *Art Bulletin* 41, no. 1 (March 1959): 119–124.

———. *Expressionism: An Exhibition of Modern Painting from Many Countries*. Exh. cat. Cincinnati: Modern Art Society, 1941.

Fischer-Defoy, Christine and Kaspar Nürnberg, eds. *Gute Geschäfte: Kunsthandel in Berlin, 1933–1945*. Exh. cat. Berlin: Aktives Museum Faschismus und Widerstand in Berlin, 2011.

Fleckner, Uwe. "The Fortune Survey: XX," *Fortune Magazine* (April 1939): 84–85, 102–108.

———. "Marketing the Defamed: On the Contradictory Uses of Provenance in the Third Reich," *Provenance: An Alternative History of Art*, Gail Feigenbaum and Inge Reist, eds., 137–153. Los Angeles: Getty Research Institute, 2012.

Glaser, Curt. *Zwei Jahrhunderte deutscher Malerei*. Munich: F. Brudmann, 1916.

Grossmann, Kurt R. "Refugee: Burden or Asset?" *Nation* (December 26, 1942): 708–10.

Hünecke, Andreas. "On the Trail of the Missing Masterpieces: Modern Art from German Galleries," *"Degenerate Art:" The Fate of the Avant-Garde in Nazi Germany*, Stephanie Barron, ed., 121–133. Exh. cat. Los Angeles: Los Angeles County Museum of Art, 1991.

Janson, H.W. "Benton and Wood, Champions of Regionalism," *Magazine of Art* 39, no. 5 (May 1946): 184–186, 198–200.

Jewell, Edward Alden. "'Free Art:' Works Nazis Reject Shown at Museum," *New York Times*, June 28, 1942.

Kort, Pamela. "The Myths of Expressionism in America," *New Worlds: German and Austrian Art, 1890–1940*, Renée Price, ed., 260–293. Exh. cat. New York: Neue Galerie, 2001.

Kuhn, Charles. *German Expressionism and Abstract Art: The Harvard Collection*. Cambridge, MA: Harvard University Press, 1957.

McCausland, Elizabeth. "Gallery Notes," *Parnassus* 10, no. 2 (February 1938): 27–29.

———. "Exhibitions in New York," *Parnassus* 12, no. 4 (April 1940): 34–46.

Miller, Bruce F. "Otto Dix and His Oil-Tempera Technique," *Bulletin of the Cleveland Museum of Art* 74, no. 8 (October 1987): 332–355.

Myers, Bernard. *German Expressionists: A Generation in Revolt*. New York: Praeger, 1957.

Peters, Olaf, ed., Exh. cat. New York: Neue Galerie, 2014, 282–301.

Petropoulos, Jonathan. "From Lucerne to Washington, DC: 'Degenerate Art' and the Question of Restitution," *Degenerate Art: The Attack on Modern Art in Nazi Germany, 1937*. Olaf Peters, ed., 282–301. Exh. cat., New York; Neue Galerie, 2014.

Plaut, James S. and Mary C. Udall. *Contemporary German Art*. Exh. cat. Boston: Institute of Modern Art, 1939.

Rathbone, Perry. *Landmarks in Modern German Art*. Exh. cat. New York: Buchholz Gallery, 1940.

Read, Herbert. *Twentieth Century German Art*. Exh. cat. London: New Burlington Galleries, 1938.

Ritchie, Andrew C., ed., *German Art of the Twentieth Century*. Exh. cat. New York: Museum of Modern Art, 1957.

Rosenfeld, Paul. "'Degenerate Art,'" *New Republic* (June 22, 1938): 183–184.

Saarinen, Aline B. "A Fitting Memorial: Exhibition Pays Homage to Curt Valentin," *New York Times*, October 10, 1954.

Selz, Peter. *German Expressionist Painting*. Berkeley and Los Angeles: University of California Press, 1957.

Tiedemann, Anja. *Die "entartete" Moderne und ihr amerikanischer Markt: Karl Buchholz und Curt Valentin als Händler verfemter Kunst*. Berlin: Akademie, 2013.

Whiting, Cécile. "Regenerate Art: The Reception of German Expressionism in the United States, 1900–1945," *Art Criticism* 9, no. 1 (1994): 72–92.

12

MUSEUM RELATIONS

Martha Buskirk

The history of tensions between artists and the institutional spaces in which art is displayed is long and colorful. Notable instances include protests and counter-exhibitions mounted in response to the salon in nineteenth-century France and the rhetorical extremes of the Futurists, linking museum to mausoleum and calling for its immolation. Over the past fifty years, however, there has been an exponential rise in the complexity of this dance of attraction and confrontation, as the canonization of historic avant-garde movements has been followed by the absorption of strategies associated with institutional critique. Museums play a crucial role in the decentralized process of conferring value on modern and contemporary art, even as programming is linked not only to gallery offerings but also, in less obvious ways, to projects undertaken as part of a conscious effort to work outside museum traditions. As critical consensus regarding the significance of anti-aesthetic as well as anti-institutional gestures has helped precipitate their incorporation into canonical museum narratives, it is important to pay attention to what is lost through this approbation.

Situation-specific work that invites participation has been articulated as a counterpoint to museum traditions focused on individual authorship and purportedly autonomous objects. Yet art that emphasizes social exchange turns out to mesh nicely with the networked interactivity that has become a locus for building consensus about artistic importance. The embrace of extended definitions of artistic practice (including artists promoted under the banner of relational aesthetics) by institutions eager to showcase contemporary work indicates the need to examine art's role in the context of event-driven programming generated by a mobile and closely interwoven community of curators and artists, many of whom enjoy a form of celebrity status.

Even as the contemporary art world has become more inclusive in certain respects, there are ongoing areas of tension and exclusion within an increasingly

global network of museums and biennial-type exhibitions. Challenges posed by activist interventions are particularly acute, given that political and aesthetic efficacy are sometimes viewed as operating at cross purposes. It is important to consider not only the process whereby certain artists and works are valorized but also how boundaries between art and non-art are drawn. Museums have also presented a symbolic allure for non-sanctioned demonstrations from the 1960s to the present – including a recent series of protests focused on the Guggenheim that have demanded improved labor conditions at Abu Dhabi's cultural hub on Saadiyat Island.

One point of reference in the U.S. context is the Art Workers Coalition (AWC), which formed in the immediate aftermath of Takis's symbolic removal of one of his works (owned by the museum) from the Museum of Modern Art's 1969 exhibition *The Machine as Seen at the End of the Mechanical Age*. AWC critiques of museum exclusions in terms of diversity and problems of access remain sadly relevant. Even though AWC agitation was framed in "us versus them" terms, dividing lines were hardly fixed, and there were tensions between calls to dismantle the existing art world versus artists who simply wanted in. Although MoMA was the main focus for AWC protests, staff members were ready to collaborate on the production of a well-known protest poster that superimposed the text "Q: And babies? A: And babies." on top of a gruesome Ron Haeberle photograph of the My Lai massacre until museum participation was vetoed by the board president. Hans Haacke was intimately involved in AWC activism (helping write the initial list of demands), yet he was nonetheless invited by Kynaston McShine to participate in MoMA's 1970 *Information* exhibition, where his *MoMA-Poll* implicitly linked a question about the war in Vietnam to the role of the Rockefeller family in MoMA's founding and ongoing leadership. And Lucy Lippard has indicated how the AWC could turn on a dime, from vociferous criticism to support, when funding cuts were threatened.[1] It is also important to note that, even though Haacke incorporated his activism into his art, many other AWC participants did not do so in obvious ways – leading Lippard to describe it as neutral with respect to types of art making, "involved in ethics rather than aesthetics."[2]

A few years before AWC's founding, the Los Angeles–based Artists' Protest Committee decided to make a dramatic anti-war statement. Enlisting the services of Mark di Suvero as well as hundreds of artists who contributed individual works in a uniform 2 × 2-ft. size, they erected the 1966 *Artists' Tower of Protest*, also known as the *Peace Tower*, in West Hollywood, (Fig. 12.1). Although the original plan was to hang the works from the tower itself, they wound up installed on the interior of the fence surrounding the steel structure. Evidence of effectiveness as well as vulnerability can be seen in the constant threat of vandalism during its three-month run (necessitating a cadre of volunteers to guard it on a nightly basis). It did succeed in attracting extensive regional television and newspaper coverage but little in the way of national attention during a pre-Internet era, when local responses did not have today's potential reach. It was not until five years later that it was reproduced on the November–December 1971 cover of *Art in America* – made freshly relevant, Julia Bryan-Wilson suggests, by AWC agitation.[3]

FIGURE 12.1 Charles Brittin, photograph of Mark di Suvero, *Artists' Tower of Protest*, 1966. Charles Brittin Archive, The Getty Research Institute, Los Angeles (2005.M.11). Courtesy of and © J. Paul Getty Trust.

Rirkrit Tiravanija learned about the *Peace Tower* while participating in *Utopia Station* at the 2003 Venice Biennale, and in response to discussions with the Public Art Fund, he suggested a remake in Central Park to coincide with the 2004 Republican Convention in New York. That unrealized plan led to an invitation to create the work for the 2006 Whitney Biennial, whereupon Tiravanija proposed the revival to di Suvero. Tiravanija and di Suvero again solicited panels – from the

original participants as well as younger artists – and this time the contributions were hung from the structure itself, which rose up in the protected moat in front of the Whitney's Marcel Breuer building. But this new version, both protected and sequestered within the boundaries of the museum, never became a nexus for larger protest activity. The same was true of a third version, created as part of the *Pacific Standard Time* exhibition organized by the Getty in 2011–12, where it provided the occasion for remembering the first but little of the same vitality, even though it was only a few blocks away from the original site.[4]

The social turn

It is interesting to consider these examples of earlier political activism against the backdrop of ongoing debates about the interplay of ethics and aesthetics within what Grant Kester describes as the social turn. There is a superficial similarity to Nicholas Bourriaud's conception of relational aesthetics, theorized as a shift of attention away from the artist's production decisions to the total set of social relations or exchanges engendered by the work's reception. Whereas Bourriaud's examples often focus on exchange as an end in itself, however, Kester's emphasis on issues of social justice and collaboration favors projects by artists and collectives in which facilitating dialogue within and among communities (which generally takes place outside a museum or gallery setting) includes the potential for tangible social change.

Questions about how to assess such work were central to a rather polemical 2006 *Artforum* article in which Claire Bishop singled out a number of artists, along with Kester himself, for privileging the social over aesthetic rigor.[5] Elaborating her critique of this "ethical turn" in *Artificial Hells*, Bishop found insufficient evaluation with respect to social projects undertaken outside the art realm, arguing that "the point of comparison and reference for participatory projects always returns to contemporary art, despite the fact that they are perceived to be worthwhile precisely because they are non-artistic."[6] For Kester, however, a crucial difference between artists' projects and those mounted by non-governmental organizations (NGOs) or other agencies has to do with their open-ended, generative nature – not necessarily working toward specific goals, even if the best-case scenario is still the potential for concrete outcomes. Kester was quick to counter the 2006 piece by criticizing Bishop's distinctions between aesthetics and ethics, arguing for the need to recognize "a continuum of collaborative and 'relational' practices" that would include "biennial-circuit stalwarts" as well as less visible groups.[7] Yet it is important to ask how much of a challenge community-based work associated with charismatic leadership poses to an art-world order framed in relationship to individual authorship.[8] Bishop, by contrast is unabashed in her desire to hold on to authorial privilege, arguing that Kester's "righteous aversion to authorship can only lead to the end of provocative art and thinking."[9] For all her insistence on the need to evaluate art according to aesthetic criteria rather than ethical goals, however, Bishop can be vague about exactly what standards of judgment should be brought to bear in the face of contemporary art's myriad forms.

Another crucial area of disagreement between Bishop and Kester concerns aggression or shock in certain avant-garde prototypes (citing dada in particular among historic examples). Where Kester argues against tactics that would create a separation between artist and audience, Bishop privileges disruption or discomfort. This was the central point in her equally combative 2004 critique of Bourriaud. Citing Ernesto Laclau and Chantal Mouffe, she stressed the importance of antagonism in democratic debate, which she contrasted to a less confrontational framing of social interaction under the guise of relational aesthetics. Accusing such Bourriaud stalwarts as Tiravanija and Liam Gillick of merely creating "amenities within the museum," Bishop posed Santiago Sierra and Thomas Hirschhorn as alternatives based on their confrontational stance toward exhibition visitors.[10]

One of the striking aspects of this three-point comparison (Bourriaud, Bishop, Kester) is that all are discussing art no longer conceived as an autonomous physical object, reflecting a critique of traditional institutional strategies, and involving a transformed relationship between artist and audience. But perhaps for this reason the contrasts are that much more starkly posed. Because he privileges dialogue and exchange taking place outside museums, however, Kester often leaves open the question of how such work can be conveyed to an audience that is not present. By contrast, the examples that Bishop uses to contest Bourriaud operate within established exhibition contexts, raising a different set of questions regarding the degree to which institutional dynamics can be interrupted by art that is officially on offer. In response not only to Sierra but to the multitude of biennial-based works that purport to disrupt the viewing experience, Kester has suggested that the response to the work could potentially include "pleasure or even self-affirmation" for viewers who can take comfort in their identity as "tolerant, enlightened, willing to accept risk and challenge."[11] Whereas early articulations of institutional critique presumed sometimes staked-out sharp dichotomies, these divergent readings all struggle to articulate complex and shifting relations between artistic production and the art world establishment in the wake of institutional critique's widespread absorption.

The potential for both complexity and contradiction becomes apparent when one delves further into the opening examples. Irving Petlin recounts how calls for coordinated political action prior to the *Peace Tower* were met with surprising responses, including enthusiasm from Craig Kauffman, an artist they saw as apolitical, and rejection by Ed Kienholz.[12] He also describes meetings and organizational activities leading up to the initial *Peace Tower* – which did indeed begin, per Kester's model, with open-ended dialogue. The hostility and threats of vandalism evoke the antagonism Bishop describes as central to a vital democracy (although Bryan-Wilson has indicated the danger that, rather than educating or persuading, it could simply reinforce beliefs people already held about the war).[13] And Tiravanija's initiation of the 2006 remake moves into prime relational aesthetics territory.

Different readings of Tiravanija's work are central to Bishop's critique of Bourriaud, particularly the meals he began to serve in galleries starting in 1992, with Bishop pointing out how the audience for these social situations (extoled by Bourriaud as micro-utopias) tends to focus on a fairly narrow band of art-world insiders.

Bishop draws attention to the paradox that "intensifying convivial relations for a small group of people" is likely to produce "greater exclusivity vis-à-vis the general public"[14] – an issue that becomes particularly apparent with respect to differences between opening-night intensity versus the need to sustain a situation over the duration of an exhibition. That contrast was certainly the case for *Utopia Station*, curated by Tiravanija in collaboration with Molly Nesbit and Hans-Ulrich Obrist for the 2003 Venice Biennale, where the inaugural festivities included a program of seminars, meetings, and performances, while later visitors mainly encountered the armature for potential encounters. Indeed, it seems that Bishop and Kester would be in agreement about wanting more than Tiravanija serves up.

The Whitney version of the *Peace Tower* appeared in the midst of another unpopular war. But the larger context was one of somewhat muted protests, which helps account for the range of individual contributions – some referencing the conflict in Iraq but others more ambiguous or playfully ironic. Reviewing the Biennial for *Frieze*, Peter Eleey found that "the tower made clear how easily the relational form can be employed as a stand-in for engagement, allowing its practitioners to dodge the real thing while [they] make political overtures" (a critique that would apply to the curators as much as to the artists), and he also took a jab at the idea of "artists ducking behind other artists' work, but still taking authorial credit under the guise of collaborative homage."[15]

Creative protest

But several other detours are important here. One is di Suvero himself, who has been politically active as an individual even if his work, other than the 1966 tower, has generally not reflected that in obvious ways. Soon after the original *Peace Tower*, he stopped exhibiting in the U.S. for the duration of the Vietnam war, and he was arrested not only during those protests but also while demonstrating outside the 2004 Republican convention, where he publicly denounced George W. Bush as a liar. Di Suvero assumed that his political activism was the reason he was not invited to speak during the dedication of a downtown New York site known as Liberty Plaza Park (and later renamed Zuccotti Park after the chairman of the company that owned the site) when his sculpture *Joie de Vivre* was installed in 2006.[16]

Yes, that Zuccotti Park – which was made famous when it was taken over by Occupy Wall Street (OWS) as a protest encampment for approximately two months in fall 2011. The participants might have been motivated to embrace the sculpture had they known of di Suvero's own activism, but there would also have been reasons for suspicion, given that the work landed in the park due to the largess of collector and art patron Agnes Gund. As it was, however, the initial response was incomprehension, with the sculpture labeled "weird red thing" on a map published in the first edition of the *Occupied Wall Street Journal*.[17] A lack of regard was also suggested by graffiti and taped-up signage that appeared on the work.

There are obvious tensions between readings of the work and the political sympathies of the artist himself. According to Yates McKee, di Suvero's work "exemplifies

a tradition of highly conservative modernist public sculpture designed primarily as a decorative aesthetic amenity for nominally public, or often 'private-public' spaces such as Zuccotti Park."[18] Despite di Suvero's personal activism, the work fits what Miwon Kwon has described as the "art-in-public-places" mode of public art, where the relationship to the site is basically incidental, in contrast to later "new genre" public art advocated by Suzanne Lacy, foregrounding social issues, activism, and collaboration.[19] Perhaps that was its suitability, however, given the description of the park quoted by Rosalyn Deutsch as meant for "passive uses."[20] But when protesters who were aware of di Suvero's political engagement attempted to make contact, the calls to his studio were unanswered, which McKee connected to the "inconvenient fact" that his wife, Kate Levin, was Mayor Michael Bloomberg's Commissioner of Cultural Affairs.[21]

From early on, there were larger questions about the role of art in the context of a movement centered on creative protest. The precedent of the Situationist International (SI) is salient both for the connections to May 1968 and for calls by the SI to abandon art production. The Situationist strategy of *détournement* clearly relates to OWS attempts to turn slogans and images of the dominant social and cultural order against itself. Yet, as McKee points out, OWS was hardly averse to harnessing media pageantry to its own ends – putting it at odds in that respect with Guy Debord's famous critique of the society of the spectacle.[22]

One of the more problematic Occupy actions was the October 22 invasion of Artists Space, when a splinter group established an encampment, or squat, in the non-profit and generally left-leaning space for twenty-eight hours, until they were evicted by security guards.[23] There was also a rather sad coda when the Occupy encampments of fall 2011 were revived (or perhaps more accurately restaged) the following spring and summer under the auspices of *documenta 13* in Kassel and the Berlin Biennial. According to documenta curator Carolyn Christov-Bakargiev, the encampment was connected to the spirit of Joseph Beuys (relating the creative forms of protest to his dictum "everyone is an artist"). Yet this version would have to be described as a symbolic demonstration of participatory engagement, acting out political intervention in response to an institutional invitation. At Kassel, they also performed their own eviction – which took them another step closer to posing as an Occupy reenactment society.

If the critical evaluation published in the inaugural issue of *Field* (a journal founded and edited by Kester) is any indication, Kester would not privilege Occupy in this instance either. Sebastian Loewe found that, instead of actually protesting, "they wanted to promote and advertise the protest," and he described the two collaborations with international art exhibitions as "watershed events that mark the decline of the movement."[24] In Berlin, critiques were particularly harsh, with the symbolic encampment described as a "human zoo" – although many of the hostile responses also encompassed the entire exhibition, curated by artist Artur Żmijewski and art historian Joanna Warsza, with the goal, according to Żmijewski, of presenting "art that actually works, makes its mark on reality, and opens a space where politics can be performed."[25] Christy Lange, writing for *Frieze*, observed a "staging

of conflict under controlled circumstances, drained of spontaneity or urgency," and she drew a contrast to the protest documentation included in *Pacific Standard Time* (which happened to be on display concurrently at Berlin's Martin-Gropius-Bau) for its evidence of a focused political agenda.[26]

Also writing for the inaugural issue of *Field*, Gregory Sholette addressed both the increasing embrace of engaged practices by mainstream institutions and various possibilities behind this interest, including relational aesthetics, a turn by artists toward ephemeral actions in response to shrinking studio space availability, and the need by museums facing funding cuts to popularize their programming. Arguing that we are well beyond understanding the dynamic as "a simple matter of good intentions being coopted by evil institutions," he posits that the "co-dependence of periphery and center, along with the widespread reliance on social networks, and the near-global hegemony of capitalist markets makes fantasies of compartmentalizing social practice from the mainstream as dubious as any blanket vilification of the art world."[27] Indeed, to the extent that social practice entails movement from site to site by artists (in contrast to the traditional shipping of an object), this is consistent with the structure of a larger creative economy understood to be an engine of economic development rather than its critical subversion. Helena Reckitt gives a telling description of the artist as "flexible worker who travels constantly, networks endlessly, is always contactable, and develops temporary projects with different people under short-term contracts."[28] While interesting things can be accomplished from within such a model, it is not (contrary to some of Bourriaud's more enthusiastic pronouncements) particularly transformative in and of itself.

Museum interventions

There is another thread to this history, however, and that is the strategy of using museums as sites for high-profile, unauthorized demonstrations. For their now infamous November 1969 *Blood Bath*, members of the Guerrilla Art Action Group, or GAAG (an AWC splinter faction) entered MoMA with sacks of beef blood concealed in their clothing and proceeded to stage a bloody confrontation, along with distributing a communiqué calling for the immediate resignation of all Rockefellers from the museum board. This was followed by a January 1970 demonstration in which copies of the My Lai poster that the AWC produced on its own following the failure of the planned collaboration with MoMA were held up in front of *Guernica* – a painting that remained on display despite AWC appeals to Picasso to have it removed until the conclusion of the Vietnam War.[29] A January 2012 rally at MoMA by Occupy Museums was in certain regards a continuation of the AWC agenda, drawing attention to Sotheby's extended lockout of their unionized art handlers while also addressing ongoing problems with gender and racial diversity in the museum's exhibitions along with audience access. The event took place on the museum's weekly free night, and this waiver of the standard $25 fee reflects a concession to AWC demands for fully free admission – though protesters were not impressed by its transformation into a sponsorship opportunity ("Target Free Friday" at the time of the demonstration).[30]

Here again lines do not remain sharp, however, since MoMA has complemented its strong holdings of historic avant-garde work with interest in more recent activism. The 2012 rally took place in the presence of an exhibition of Sanja Iveković's work featuring her *Lady Rosa of Luxembourg* – a large-scale counter-monument that aroused public furor when it was installed as temporary public art in Luxembourg in 2001, based on its reworking of a well-known war memorial, conjoined with references to the martyrdom of Marxist activist Rosa Luxemburg, in the midst of a banking capital.[31] Sholette also discusses the irony of MoMA becoming the repository of the PAD/D (Political Art Documentation and Distribution) archive.[32]

In Haacke's case, early AWC involvement coincided with a shift already underway from natural to social systems, including a significant number of works responding to the history, politics, and economics of art institutions. And some institutions seem dedicated to giving him new material to work with: Haacke returned in 2014 to the motif of promotional banners, hanging off of the Metropolitan Museum of Art since the Thomas Hoving era, to zero in on a recent sponsorship deal – the Met's sale of naming rights for its entry plaza to conservative activist David H. Koch. In *The Business Behind Art Knows the Art of the Koch Brothers*, Haacke responded with three photographs, two showing Koch's name in large brass lettering on the fountains in front of the museum and a center image photoshopped with a mock banner, "The Business Behind Art Knows the Art of Good Business – Your Company and The Metropolitan Museum of Art," taken from the title of a pamphlet the museum once produced to pursue corporate sponsors (Fig. 12.2).

FIGURE 12.2 Hans Haacke, *The Business Behind Art Knows the Art of the Koch Brothers*, 2014. 3 color inkjet photos, overall triptych framed: 37 × 99 1/2 × 1 3/8 in. (94 × 252 × 3.5 cm); photo-collaged hundred-dollar bills each: 8 × 16 1/2 in.; overall installation dimensions variable. © Hans Haacke/Artists Rights Society (ARS), New York/VG Bild-Kunst, Bonn. Courtesy the artist and Paula Cooper Gallery, New York. Photograph by Steven Probert.

Cascading below were oversized versions of $100 bills adorned with water-based landscape imagery. Nor was Haacke's the only creative rejoinder to this controversial largess: members of an activist group called The Illuminator were arrested and their equipment confiscated for projecting statements on the museum exterior during celebrations to inaugurate the plaza ("The Met: Brought to you by the Tea Party" and "Koch = Climate Chaos," in honor of Koch's support for right-wing and climate change–denial groups). A charge of unlawful posting of advertisements was eventually dropped, and the activists subsequently filed their own lawsuit alleging false arrest and First Amendment violations based on the impounding of their projection equipment.[33]

The biggest focal point, however, has been the Guggenheim, site of multiple protests in both New York and Venice. The center of contention has been migrant labor conditions on Saadiyat Island in Abu Dhabi, where the Guggenheim, Louvre, and New York University are in the process of building museum and campus branches. A March 2011 petition, addressed to Guggenheim director Richard Armstrong and signed by an impressive list of contemporary artists, curators, and theorists, called on the Guggenheim to protect the rights of workers employed in construction of a massive Frank Gehry edifice.[34] Subsequent interventions mounted by G.U.L.F. (Global Ultra Luxury Faction, an offshoot of Gulf Labor) within the Guggenheim rotunda in New York have taken place against the backdrop of a series of avant-garde exhibitions, including Italian Futurism (notwithstanding their early calls for museum destruction), the Zero Group, and On Kawara, Fig. 12.3. A demonstration on the landing outside the Peggy Guggenheim Collection in Venice was timed to coincide with the opening of the biennale. Yet Gulf Labor was also an official biennale participant, using the invitation to Okwui Enwezor's *All the World's Futures* exhibit as a platform to publicize their latest report about labor conditions on Saadiyat Island.[35]

In the wake of this activism, members of Gulf Labor were denied entry into the United Arab Emirates – first theorist Andrew Ross in March 2015 and then artists Ashok Sukumaran and Walid Raad in May 2015 – notwithstanding the fact that Raad and Sukumaran were invited speakers at an annual Sharjah Art Foundation event that coincided with the 12th Sharjah Biennial. A substantial list of art-world luminaries, including the MoMA and Tate directors and the International Committee for Museums and Collections of Modern Art, have joined in calling for the travel ban to be lifted, as have many of the artists with work exhibited in the 2015 biennial.[36] Yet limits on freedom of expression under an absolute monarchy were already evident four years earlier, when curator Jack Persekian, former Sharjah Foundation director and widely credited with raising the biennial's profile, was fired abruptly in response to controversy about an installation by Algerian artist Mustapha Benfodil at the 2011 biennial.[37] Raad, as it happens, participated in that year's biennial, where he showed a portion of an ongoing work begun in 2007, *Scratching on Things I Could Disavow: A History of Art in the Arab World*, through which he has been exploring the emergence of new art and education institutions across the Arab world, including Abu Dhabi, Beirut, Cairo, Doha, Istanbul, Ramallah, and Sharjah.[38]

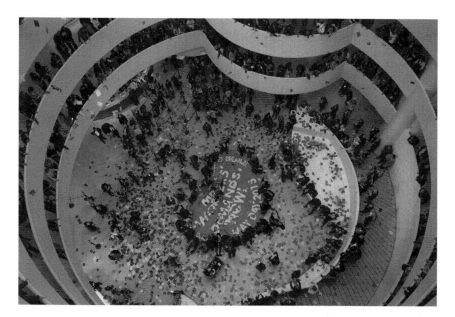

FIGURE 12.3 G.U.L.F. (Global Ultra Luxury Faction) protest at the Guggenheim, New York, May 1, 2015: "Meet Workers' Demands Now! Living Wage · Debt Jubilee · Right to Organize · May Day 2015." Photograph by Benjamin Sutton for *Hyperallergic*. Courtesy Benjamin Sutton.

But Raad is fully aware of the web of tensions and affiliations associated with the institutional embrace of critical practices – releasing a noteworthy enumeration of his non-outsider status in an open letter about the UAE denial of entry.[39]

Global art futures

The contemporary art world presents an interesting parallel world order in which, despite the absence of any central organizing body, there is a surprising degree of consistency in the global currency of contemporary art. Even as different organizing bodies attempt to craft niche identities, regional specificities are validated by appearing together with artists and being organized by curators who are already recognized names on the international circuit. Equally important is the issue of motivation, with the cosmopolitan sophistication associated with contemporary art serving a multitude of subtle ends in relation to internal as well as external audiences. There are potentially interesting opportunities opened up by the global mobility of art but also major perils for institutions and individuals working in the context of authoritarian regimes (including China's clampdown on Ai Weiwei, clearly tempered only by his international renown).[40] And artists have continued to use their analyses of tensions to formulate works that reveal these underlying issues.

Tania Bruguera took advantage of the relative absence of censorship associated with the 2009 Havana Biennial to stage her *Tatlin Whisper #6*, in which she

invited members of the audience to the microphone, promising each one minute of free speech. The biennial's organizing committee quickly repudiated the event for hijacking the biennial to "strike a blow at the Cuban Revolution," even as Bishop quotes Yoani Sánchez's claim that the piece would not have been complete without the official condemnation.[41] Bishop lauded the "conjunction of political action and illegality" underpinning the action, but Coco Fusco suggests that Bishop was too credulous regarding the politics of the situation, emphasizing that it took place during the opening festivities, before an invited audience, and positing that the relative absence of censorship while the international contingent was present represented a conscious strategy to shape Cuba's image.[42] But Bruguera managed to find the limits of that fragile balance of motivations when, in the immediate aftermath of the December 2014 announcement of plans to normalize relations between Cuba and the U.S., she proposed a new version of *Tatlin Whisper #6* to take place in the Plaza of the Revolution and travelled to Havana for that purpose. Bruguera was detained to prevent the performance from taking place, and prior to her release, her passport was confiscated.[43] The resulting legal limbo meant that Bruguera was still in Cuba during the May opening of the 2015 Havana Biennial, diverting news attention both with the evidence of her ongoing confinement and by staging a durational performance in her home based on a 100-hour reading of Hannah Arendt's *The Origins of Totalitarianism* – which she pursued despite loud roadwork that suddenly erupted right outside her building, and after which she was again detained.[44]

In the years immediately prior to this harrowing return to Cuba, Bruguera used her identity as an artist to pursue a long-term project under a category she designates *Arte Útil*, engaged directly with immigration issues. With support from the Queens Museum as well as Creative Time and others, Bruguera established Immigrant Movement International (IMI) in a storefront space in Corona, Queens, with the goal of offering a range of educational and community services during 2010–15 and potentially beyond (Fig. 12.4). Bruguera also promoted what could be described as an open-source approach, encouraging others to take up the IMI model and establishing a framework in which participants would assume leadership roles. Conceiving of it as an art project opened up potential access to funding in that realm, even as she also made a conscious decision to move outside gallery or museum confines. Talking about this work in terms of an "aesthetic of ethics," she spoke to an interviewer about the need to "start talking about ethical beauty when someone does social or political art."[45]

One is forced to wonder what percentage of the IMI five-year budget was required to produce a very different community-based project, Christoph Büchel's *Piccadilly Community Centre*, which transformed Hauser & Wirth's posh London gallery building into a seemingly humble neighborhood meeting place for the duration of eleven weeks in 2011. In a prodigal display of conspicuous non-extravagance, the building was made over, top to bottom, with shabbily realistic versions of the inelegant spaces one might expect to find in such a location, and outreach assured that its classes and activities were heavily used by area residents who seemed unconcerned with its art status. Citing Georges Bataille's ruminations on expenditure,

FIGURE 12.4 Tania Bruguera, *Immigrant Movement International*. Conception Year: 2006; Implementation Years: 2010–2015; Medium: Appropriation of Political Strategies, Useful Art; Duration: Long-Term Project; Materials: Immigration policies and laws, Immigrant Population, Elected Officials, Politicians, Community Organizations, Public Pressure, Media; Location: Corona, Queens, New York, United States. Courtesy Tania Bruguera.

Reckitt describes this as a "deeply critical artwork" for the issues it raised about public support for communal resources, even as she compared Hauser & Wirth to "the triumphant chiefs of potlatch," based on their production of this lavish and possibly unsalable project.[46] Four years later, Büchel used a version of the same strategy at the Venice Biennale, where, under the auspices of the Iceland Art Center, he installed the trappings of a mosque within a deconsecrated church. It was a work of art but also a functioning space for prayer in a city lacking a mosque despite a long history of Islamic influence. Only two weeks after it opened, however, city officials in Venice closed the space down, citing security risks and overcrowding. The underlying issue seems to have been its double identity – an art project and a place that people were using for religious worship.[47] With these strange inversions of the readymade, Büchel does indeed manage to reveal something about both the art world and the needs of the users who have taken the installations at their face value, but the rarified budget support making them possible also places them at the opposite end of the spectrum from projects generally grouped under the category of social practice.

There is a superficial resemblance between Bruguera's storefront operation in Corona, Queens, and Büchel's London community center, in that both were employed by people attracted to their services rather than their status as art, but the differences are far more telling. Büchel's was more about the gesture and frisson, a large-budget project by a well-known artist at a gallery so top echelon that it could afford a potentially unmarketable gesture as part of its investment in both artistic

and gallery brand – and the audience role could certainly be described in terms of Bourriaud's "society of extras."[48] Bruguera's project was first and foremost about improving conditions for the immigrants who took advantage of its services, and based on reports by the artist and others, it succeeded with its localized goals. But there is still the question of larger impact, and Bishop found a "lack of accountability" when activists and organizers raised questions about pressing for actual policy change.[49] Moreover, this potential limitation is rooted in its origins as an art project: Bruguera has recounted how her initial impulse to found a political party came up against restrictions on direct political involvement by her non-profit funding sources (and hence the pivot to the more generalized "movement").[50]

Early on, the AWC called upon museums to set up branch operations. But they were envisioning outposts that would serve low-income neighborhoods in the same city, not branded franchise operations spread out across the globe. A remarkable increase in the number of museums focused on modern and contemporary art is only one aspect of a vast expansion in art production and consumption during the last half century, including galleries, biennial-type exhibitions, and art fairs, along with an expanded pipeline of MFA programs and other art training. The nature of art has changed as well, with conceptual, site-specific, and performance-based work once posited as anti-establishment now widely promoted by exhibiting institutions and firmly entrenched as part of the contemporary canon. The impact, but perhaps also limitations, of the practices of institutional critique that arose during this same period are evident in a greater inclusiveness that is nonetheless still far from all embracing and in the smooth incorporation of work that reveals aspects of institutional protocol into the narratives that museums tell about themselves. In addition, the establishment of a global contemporary art network populated by highly mobile art professionals and aficionados, combined with expanded interest in ephemeral or performance-based work, has helped produce an increasing stratification of experience: those attending opening festivities or fundraising galas are likely to have a very different encounter, including access to event-based work, than those who visit during regular hours of operation, with relational work all too often supporting rather than disrupting institutional business as usual.[51]

"Every time we speak of the 'institution' as other than 'us,' we disavow our role in the creation and perpetuation of its conditions," insists Andrea Fraser, in the context of discussing the necessarily embedded nature of any practice taking place within the broad frame of art.[52] Clearly the "us versus them" dichotomy between artists and museums posed in AWC rhetoric overstated the case even then. And in the half century since, the network of social and economic ties linking producers to consumers, curators to sponsoring entities, and ultimately ethics to aesthetics, has become exponentially more complex. The various forms of collaborative, community-based action discussed by Kester, Sholette, and others proffer an important corrective to a market-driven star system. But there is still the issue of what purpose is served by their designation as art. Presenting such projects within an exhibition framework runs the risk of transforming participants into performers, even as operating at a distance poses the

challenge of how or whether the experience will be communicated to a larger audience. This web of contradiction that emanates from the canonization of earlier avant-garde movements as well as recent forms of institutional critique, however, is also one of the reasons activism in and around institutions of art retains a significant potency: the symbolic and publicity value is high precisely because of the often contradictory intersection of money, prestige, and claims about cultural significance associated with art patronage. In addition to the worthy goal of advocating progressive change within institutions, it is possible to employ an analysis of these dynamics to mount a form of institutional hijacking, using the frame of art to broadcast to a wider world.

Notes

1 Lucy Lippard, "Biting the Hand: Artists and Museums in New York since 1969," Julie Ault, ed., *Alternative Art, New York, 1965–1985* (Minneapolis: University of Minnesota Press; New York: Drawing Center, 2002), 87. Members of the AWC wrote a formal letter to Mayor John Lindsay opposing budget cuts for museums a week after the AWC open hearing, April 10, 1969.
2 Lippard, "The Art Workers' Coalition: Not a History," *Studio International*, 180, no. 927 (November 1970): 174.
3 Julia Bryan-Wilson, *Art Workers: Radical Practice in the Vietnam War Era* (Berkeley: University of California Press, 2009), 7.
4 See, for example, Jon Wiener, "When Art and Politics Collided in L.A.," *Los Angeles Times*, January 25, 2012, http://articles.latimes.com/2012/jan/25/opinion/la-oe-wiener-tower-of-protest-20120125.
5 Bishop, "The Social Turn: Collaboration and Its Discontents," *Artforum* 44, no. 6 (2006): 178–83.
6 Bishop, *Artificial Hells: Participatory Art and the Politics of Spectatorship* (London: Verso Books, 2012), 19.
7 Grant Kester, "Another Turn" (Letter to the Editor), *Artforum* 44, no. 9 (2006): 22.
8 In the U.S. context, Theater Gates's Rebuild Foundation in Chicago or Rick Lowe's Project Row House in Houston are prominent examples – even as other artists have used market success to fund community projects conceived as separate from their practice, including Mark Bradford's efforts in Los Angeles, for instance, or various charitable foundations set up via artists' bequests.
9 Bishop, "Another Turn" (Letter to the Editor), *Artforum* 44, no. 9 (2006): 22.
10 Bishop, "Antagonism and Relational Aesthetics," *October* 110 (Fall 2004): 51–79, see particularly 52–53 & 65–67.
11 Kester, *The One and the Many: Contemporary Collaborative Art in a Global Context* (Durham: Duke University Press, 2011), 83.
12 Irving Petlin, in Petlin, Mark Di Suvero, Rirkrit Tiravanija, and Jeffrey Kastner, "Peace Tower," *Artforum* 44, no. 7 (2006): 252–57.
13 Bryan-Wilson, *Art Workers*, 8.
14 Bishop, *Artificial Hells*, 209.
15 Peter Eleey, "2006 Whitney Biennial," *Frieze* no. 100 (June–August 2006): 256–57, http://www.frieze.com/issue/review/2006_whitney_biennial/.
16 Travis Diehl, "Universal Steel: Mark di Suvero, Occupy Wall Street, and the Artists' Tower of Protest," *East of Borneo*, March 12, 2014, http://www.eastofborneo.org/articles/universal-steel-mark-di-suvero-occupy-wall-street-and-the-artists-tower-of-protest; and Jerry Tallmer, "The Man behind Life's Joy," *Downtown Express* 19, no. 3 (June 2–8, 2006), http://www.downtownexpress.com/de_160/themanbehind.html.

17 Hrag Vartanian, "#OccupyWallStreet Journal Map Calls Mark di Suvero's 'Joie de Vivre' Weird," *Hyperallergic*, October 6, 2011, http://hyperallergic.com/37434/occupywallstreet-map-mark-di-suervo/.

18 Yates McKee, "The Weird Red Thing: #OccupyWallStreet, Site-Specificity, and di Suvero's Joie de Vivre," *Broken English – a Performa Project*, Julieta Aranda and Carlos Motta, eds. (newsprint publication produced in association with *Performa* 11, November 2011), 6, 43, and available online, http://11.performa-arts.org/images/uploads/pdf/BROKEN_ENGLISH.pdf.

19 Miwon Kwon, *One Place after Another: Site-specific Art and Locational Identity* (Cambridge: MIT Press, 2002), 60.

20 Statement by Brookfield Office Properties, owner of the park at the time of OWS, quoted by Rosalyn Deutsche, "Occupy Response," *October* 142 (Fall 2012): 43.

21 McKee, "Weird Red Thing."

22 Yates McKee, "The Arts of Occupation," *The Nation*, December 11, 2011, http://www.thenation.com/article/165094/arts-occupation#.

23 McKee, "Arts of Occupation."

24 Sebastian Loewe, "When Protest Becomes Art: The Contradictory Transformations of the Occupy Movement at Documenta 13 and Berlin Biennale 7," *Field* 1 (Spring 2015): 192, 186, http://field-journal.com/issue-1/loewe.

25 Artur Żmijewski, "7th Berlin Biennale for Contemporary Politics," http://www.berlinbiennale.de/blog/en/allgemein-en/7th-berlin-biennale-for-contemporary-politics-by-artur-zmijewski-27718.

26 Christy Lange, "7th Berlin Biennale," *Frieze* no. 148 (June–August 2012): 195, http://www.frieze.com/issue/print_back/7th-berlin-biennale/.

27 Gregory Sholette, "Delirium and Resistance after the Social Turn," *Field* 1 (Spring 2015): 97–98, http://field-journal.com/issue-1/sholette. Sholette also observed that funding for ephemeral or participatory projects has often come out of education departments.

28 Helena Reckitt, "Forgotten Relations: Feminist Artists and Relational Aesthetics," *Politics in a Glass Case: Feminism, Exhibition Cultures and Curatorial Transgressions*, Angela Dimitrakakis and Lara Perry, eds. (Liverpool: Liverpool University Press, 2013), 143.

29 Bryan-Wilson, *Art Workers*, 22. Fifty thousand copies of the poster were reportedly produced and distributed through a wide network of contacts and in the museum lobby.

30 Whitney Kimball, "Professors, Artists, Workers, and Activists Rally Inside MoMA," *Art F City*, January 16, 2012, http://artfcity.com/2012/01/16/professors-artists-workers-and-activists-rally-inside-moma/.

31 Carol Kino, "Croatia's Monumental Provocateur," *New York Times*, December 22, 2011, http://www.nytimes.com/2011/12/25/arts/design/sanja-ivekovic-croatias-monumental-provocateur.html?_r=0; and Roxana Marcoci, "Sanja Iveković: Lady Rosa of Luxembourg," posted on MoMA's blog, *Inside/Out*, December 1, 2011, http://www.moma.org/explore/inside_out/2011/12/01/sanja-ivekovic-lady-rosa-of-luxembourg/.

32 On the PAD/D archive, see Sholette, *Dark Matter: Art and Politics in the Age of Enterprise Culture* (New York: Pluto Press, 2011), 5–13 and 46–52.

33 The three activists arrested were Kyle Depew, Grayson Earle, and Yates McKee. On the countersuit, see Vartanian, "Members of the Illuminator Sue NYPD for False Arrest, First Amendment Retaliation," *Hyperallergic*, May 21, 2015, http://hyperallergic.com/209080/members-of-the-illuminator-sue-nypd-for-false-arrest-first-amendment-retaliation/.

34 See the March 16, 2011, petition addressed to Richard Armstrong, Director, Solomon R. Guggenheim Foundation at http://gulflabor.org/sign-the-petition/.

35 See Vartanian, "Gulf Labor and Other Arts Groups Occupy Venice's Guggenheim #GuggOccupied," *Hyperallergic*, May 8, 2015, http://hyperallergic.com/205465/breaking-gulf-labor-and-other-arts-groups-occupy-venices-guggenheim-guggoccupied/, and documentation of Gulf Labor's contribution to the exhibition at http://gulflabor.org/2015/from-the-venice-biennale/.

36 See Javier Pes, "MoMA and Tate Directors Urge UAE to Lift Artists' Travel Bans," *The Art Newspaper*, June 1, 2015, http://www.theartnewspaper.com/news/museums/156531/; and copies of the various statements on the Gulf Labor web site: http://gulflabor. org/2015/cimam-supports-barred-artists-asks-involved-museums-to-respond/, http:// gulflabor.org/2015/letter-from-sixty-curators-critics-and-museum-directors-to-uae-art-institutions-and-their-affiliates/ and http://gulflabor.org/2015/12th-sharjah-biennial-artists-issue-statement/.

37 See Coline Milliard, "Censored Algerian Artist Mustapha Benfodil on His Part in the Sharjah Biennial Controversy," *Blouin Artinfo*, April 14, 2011, http://www.blouinartinfo. com/news/story/37461/censored-algerian-artist-mustapha-benfodil-on-his-part-in-the-sharjah-biennial-controversy#

38 http://www.scratchingonthings.com/; and http://universes-in-universe.org/eng/bien/ sharjah_biennial/2011/photo_tour/sharjah_art_museum/21_walid_raad

39 According to Walid Raad, "I am an artist whose work is in the permanent collection of the Guggenheim Museum in New York, and the British Museum in London. I am the recipient of a Guggenheim fellowship, and my work has been exhibited in the Guggenheim New York and Bilbao, the British Museum, and the Louvre in Paris. I was nominated for the Hugo Boss Prize in 2009, a prize administered by the Guggenheim. I have a life-long membership to the Guggenheim Museum in New York, given to me by the museum. I have been invited by Guggenheim officials to share ideas and submit exhibition proposals for the Guggenheim Abu Dhabi and New York. I have lectured at NYU. I have participated in or attended several March Meetings in Sharjah. I have exhibited in the Sharjah Biennial. I visited Doha, Dubai, Sharjah, Manama, Abu Dhabi several times. I work on art projects about the history of the visual arts in the Gulf. In other words, I am part of the Guggenheim, Louvre, British Museum, NYU, and Sharjah Art Foundation 'community.' I am part of the Gulf 'community.'" See "An Open Letter from Walid Raad," May 15, 2015, published by e-flux conversations, http:// conversations.e-flux.com/t/an-open-letter-from-walid-raad/1657.

40 These tensions extend beyond art institutions – as evident in criticisms leveled at compromises made by certain universities in relation to their international campus outposts. See, for example, Andrew Ross, "Human Rights, Academic Freedom, and Offshore Academics," *Academe* (American Association of University Professors), January–February 2011, http://www.aaup.org/article/human-rights-academic-freedom-and-offshore-academics#.VYsI90YXvEY

41 Bishop, "Speech Disorder," *Artforum* 47, no. 10 (Summer 2009): 121–22.

42 Coco Fusco, "Public Address" (letter in response to Bishop, and Bishop's reply), *Artforum* 48, no. 2 (October 2009): 38, 40.

43 Bruguera's detention was covered extensively. For an early report that also discusses the suppressed performance, see Fusco, "The State of Detention: Performance, Politics, and the Cuban Public," *E-Flux Journal*, January 3, 2015, http://www.e-flux.com/ announcements/on-the-detention-of-cuban-artist-tania-bruguera-by-coco-fusco/.

44 There have been many reports about the performance, which included the participation of a number of visitors to the biennial. For one of the more extensive accounts, see Gerardo Mosquera, "Tania Bruguera: Artivism and Repression in Cuba, An Eyewitness Report," *Walker Magazine*, June 17, 2015, http://www.walkerart.org/magazine/2015/ tania-bruguera-artivism-gerardo-mosquera-cuba.

45 Ernesto Menéndez-Conde, "ARTE ÚTIL: An Interview with Tania Bruguera," *Art Experience: New York City* 1, no. 13 (Summer 2014): 37, http://www.taniabruguera.com/ cms/files/artexperiencesummer2014-eng.pdf.

46 Reckitt, "Christoph Büchel, The Piccadilly Community Centre," *Journal of Curatorial Studies* (Winter 2011): 103. See also the genuine-looking web site for the project, http:// www.piccadillycommunitycentre.org/.

47 See Randy Kennedy, "Police Shut Down Mosque Installation at Venice Biennale," *New York Times*, May 22, 2015, http://www.nytimes.com/2015/05/23/arts/design/

police-shut-down-mosque-installation-at-venice-biennale.html?_r=1; and also the corrections to news coverage posted on the Islandic Art Center website, http://ice landicartcenter.is/news/important-corrections-regarding-media-coverage-of-the-ice landic-pavilion-at-la-biennale-di-venezia/. As with the community center, the mosque was accompanied by a realistic-seeming website http://www.mosque.is/index.html. Questions were also raised in various quarters about where Enwezor's voice was in the immediate aftermath of the closure. See, for example, Greg Allen, "Recitation," *greg.org*, May 26, 2015, http://greg.org/archive/2015/05/26/recitation.html.

48 In the glossary at the end of *Relational Aesthetics*, Bourriaud defined the "society of extras" in relation to Guy Debord's society of the spectacle, suggesting that "we are in the further stage of spectacular development: the individual has shifted from a passive and purely repetitive status to the minimum activity dictated to him by market forces," and positing that "we are summoned to turn into extras of the spectacle, having been regarded as its consumers." See Bourriaud, *Relational Aesthetics*, trans. Simon Pleasance & Fronza Woods with Mathieu Copeland (Dijon: Les Presses Du Réel, 2004).

49 Bishop, *Artificial Hells*, 292, n48, referring to audience questions at a discussion with five socially engaged artists at Immigrant Movement International on April 23, 2011.

50 Menéndez-Conde, "ARTE ÚTIL: An Interview," 38.

51 I have addressed many of these issues at greater length elsewhere. See in particular Martha Buskirk, *Creative Enterprise: Contemporary Art between Museum and Marketplace* (New York: Continuum, 2012), chapters 5, "Rebranding the Readymade," and 6, "Mobil Art Services."

52 Andrea Fraser, "From the Critique of Institutions to the Institution of Critique," *Artforum* 44, no. 1 (September 2005), reprinted in Alexander Alberro and Blake Stimson, *Institutional Critique: An Anthology of Artists' Writings* (Cambridge: MIT Press, 2009), 416.

Bibliography

Alberro, Alexander and Blake Stimson. *Institutional Critique: An Anthology of Artists' Writings*. Cambridge: MIT Press, 2009.

Allen, Greg. "Recitation," *greg.org*, May 26, 2015. http://greg.org/archive/2015/05/26/reci tation.html

Ault, Julie, ed. *Alternative Art, New York, 1965–1985*. Minneapolis: University of Minnesota Press; New York: Drawing Center, 2002.

Bishop, Claire. "Antagonism and Relational Aesthetics," *October* 110 (Fall 2004): 51–79.

———. "Another Turn" (Letter to the Editor). *Artforum* 44, no. 9 (2006): 22.

——— "The Social Turn: Collaboration and Its Discontents," *Artforum* 44, no. 6 (2006): 178–183.

———. "Speech Disorder," *Artforum* 47, no. 10 (2009): 121–122.

———. *Artificial Hells: Participatory Art and the Politics of Spectatorship*. London: Verso Books, 2012.

Bourriaud, Nicolas. *Relational Aesthetics*. Trans. Simon Pleasance & Fronza Woods with Mathieu Copeland. Dijon: Les Presses Du Réel, 2004.

Bryan-Wilson, Julia. *Art Workers: Radical Practice in the Vietnam War Era*. Berkeley: University of California Press, 2009.

Buskirk, Martha. *The Contingent Object of Contemporary Art*. Cambridge: MIT Press, 2003.

———. *Creative Enterprise: Contemporary Art between Museum and Marketplace*. New York: Continuum, 2012.

Deutsche, Rosalyn. "Occupy Response," *October* 142 (Fall 2012): 42–43.

Diehl, Travis. "Universal Steel: Mark di Suvero, Occupy Wall Street, and the Artists' Tower of Protest," *East of Borneo*, March 12, 2014. http://www.eastofborneo.org/articles/universal-steel-mark-di-suvero-occupy-wall-street-and-the-artists-tower-of-protest

Eleey, Peter. "2006 Whitney Biennial," *Frieze* no. 100 (June–August 2006): 256–257.

Fraser, Andrea. "From the Critique of Institutions to the Institution of Critique," (2005). *Institutional Critique: An Anthology of Artists' Writings*, Alexander Alberro and Blake Stimson, eds., 408–417. Cambridge: MIT Press, 2009.

Fusco, Coco. "Public Address," (letter in response to Bishop, and Bishop's reply). *Artforum* 48, no. 2 (2009): 38, 40.

———. "The State of Detention: Performance, Politics, and the Cuban Public," *E-Flux Journal* (January 3, 2015). http://www.e-flux.com/announcements/on-the-detention-of-cuban-artist-tania-bruguera-by-coco-fusco/.

Kennedy, Randy. "Police Shut Down Mosque Installation at Venice Biennale," *New York Times*, May 22, 2015. http://www.nytimes.com/2015/05/23/arts/design/police-shut-down-mosque-installation-at-venice-biennale.html?_r=1

Kester, Grant H. *Conversation Pieces: Community and Communication in Modern Art*. Berkeley: University of California Press, 2004.

———. "Another Turn," (Letter to the Editor). *Artforum* 44, no. 9 (2006): 22.

———. *The One and the Many: Contemporary Collaborative Art in a Global Context*. Durham: Duke University Press, 2011.

Kimball, Whitney. "Professors, Artists, Workers, and Activists Rally Inside MoMA," *Art F City*, January 16, 2012. http://artfcity.com/2012/01/16/professors-artists-workers-and-activists-rally-inside-moma/

Kino, Carol. "Croatia's Monumental Provocateur," *New York Times*, December 22, 2011. http://www.nytimes.com/2011/12/25/arts/design/sanja-ivekovic-croatias-monumental-provocateur.html?_r=0

Kwon, Miwon. *One Place after Another: Site-specific Art and Locational Identity*. Cambridge: MIT Press, 2002.

Lange, Christy. "7th Berlin Biennale," *Frieze* no. 148 (June–August 2012): 195; http://www.frieze.com/issue/print_back/7th-berlin-biennale/.

Lippard, Lucy. "The Art Workers' Coalition: Not a History," *Studio International* 180, no. 927 (November 1970): 171–174.

———. "Biting the Hand: Artists and Museums in New York since 1969," *Alternative Art, New York, 1965–1985*, Julie Ault, ed., 79–120. Minneapolis: University of Minnesota Press; New York: Drawing Center, 2002.

Loewe, Sebastian. "When Protest Becomes Art: The Contradictory Transformations of the Occupy Movement at Documenta 13 and Berlin Biennale 7," *Field* 1 (Spring 2015): 185–203, 186. http://field-journal.com/issue-1/loewe.

Marcoci, Roxana. "Sanja Iveković: Lady Rosa of Luxembourg," posted on MoMA's blog, *Inside/Out*, December 1, 2011. http://www.moma.org/explore/inside_out/2011/12/01/sanja-ivekovic-lady-rosa-of-luxembourg/

McKee, Yates. "The Arts of Occupation," *The Nation* (December 11, 2011). http://www.thenation.com/article/165094/arts-occupation#.

———. "The Weird Red Thing: #OccupyWallStreet, Site-Specificity, and di Suvero's Joie de Vivre," *Broken English – a Performa Project*, Julieta Aranda and Carlos Motta, eds., (newsprint publication produced in association with *Performa* 11, November 2011), 6, 43. http://11.performa-arts.org/images/uploads/pdf/BROKEN_ENGLISH.pdf.

Menéndez-Conde, Ernesto. "ARTE ÚTIL: An Interview with Tania Bruguera," *Art Experience: New York City* 1, no. 13 (Summer 2014): 37. http://www.taniabruguera.com/cms/files/artexperiencesummer2014-eng.pdf.

Milliard, Coline. "Censored Algerian Artist Mustapha Benfodil on His Part in the Sharjah Biennial Controversy," *Blouin Artinfo*, April 14, 2011. http://www.blouinartinfo.com/news/story/37461/censored-algerian-artist-mustapha-benfodil-on-his-part-in-the-sharjah-biennial-controversy#

Mosquera, Gerardo. "Tania Bruguera: Artivism and Repression in Cuba, An Eyewitness Report," *Walker Magazine* (June 17, 2015). http://www.walkerart.org/magazine/2015/tania-bruguera-artivism-gerardo-mosquera-cuba.

Petlin, Irving, Mark Di Suvero, Rirkrit Tiravanija, and Jeffrey Kastner. "Peace Tower," *Artforum* 44, no. 7 (2006): 252–257.

Reckitt, Helena. "Christoph Büchel, The Piccadilly Community Centre," *Journal of Curatorial Studies* (Winter 2011): 101–104.

———. "Forgotten Relations: Feminist Artists and Relational Aesthetics," *Politics in a Glass Case: Feminism, Exhibition Cultures and Curatorial Transgressions.* Angela Dimitrakakis and Lara Perry, eds., 131–156. Liverpool: Liverpool University Press, 2013.

Ross, Andrew. "Human Rights, Academic Freedom, and Offshore Academics," *Academe* (American Association of University Professors), January–February 2011. http://www.aaup.org/article/human-rights-academic-freedom-and-offshore-academics#.VYsI90YXvEY

Sholette, Gregory. *Dark Matter: Art and Politics in the Age of Enterprise Culture.* New York: Pluto Press, 2011.

———. "Delirium and Resistance after the Social Turn," *Field* 1 (Spring 2015): 95–138; http://field-journal.com/issue-1/sholette.

Stimson, Blake and Gregory Sholette. *Collectivism after Modernism: The Art of Social Imagination after 1945.* Minneapolis: University of Minnesota Press, 2007.

Tallmer, Jerry. "The Man Behind Life's Joy," *Downtown Express* 19, no. 3 (June 2–8, 2006). http://www.downtownexpress.com/de_160/themanbehind.html.

Vartanian, Hrag. "#OccupyWallStreet Journal Map Calls Mark di Suvero's 'Joie de Vivre' Weird," *Hyperallergic* (October 6, 2011). http://hyperallergic.com/37434/occupywallstreet-map-mark-di-suervo/.

———. "Gulf Labor and Other Arts Groups Occupy Venice's Guggenheim #GuggOccupied," *Hyperallergic* (May 8, 2015). http://hyperallergic.com/205465/breaking-gulf-labor-and-other-arts-groups-occupy-venices-guggenheim-guggoccupied/.

———. "Members of the Illuminator Sue NYPD for False Arrest, First Amendment Retaliation," *Hyperallergic*, May 21, 2015. http://hyperallergic.com/209080/members-of-the-illuminator-sue-nypd-for-false-arrest-first-amendment-retaliation/

Wiener, Jon. "When Art and Politics Collided in L.A.," *Los Angeles Times*, January 25, 2012. http://articles.latimes.com/2012/jan/25/opinion/la-oe-wiener-tower-of-protest-20120125

Żmijewski, Artur. "7th Berlin Biennale for Contemporary Politics," http://www.berlinbiennale.de/blog/en/allgemein-en/7th-berlin-biennale-for-contemporary-politics-by-artur-zmijewski-27718.

13

THE COMMODIFICATION OF THE CONTEMPORARY ARTIST AND HIGH-PROFILE SOLO EXHIBITION

The case of Takashi Murakami

Ronit Milano

This chapter aims to analyze the political economy of artists who occupy a high position in the contemporary art canon in the 21st century, with particular attention to the effect of the global condition through the case study of the Japanese artist Takashi Murakami. My argument is that whereas the second half of the 20th century marked the increasing commodification of works of art, the 21st century commodifies the art exhibition as a whole and ultimately the artist in the canon. Using the example of Murakami, I will demonstrate how the contingencies between his works and the market are extended to the geopolitical conditions: Murakami's canonization not only leans on economic forces outside the museum but is also harnessed by governments and private institutions for the promotion of their political and economic interests. A main issue that will rise from my discussion will involve the new role of museums in the contemporary situation as instruments in the process of commodification of high-profile exhibitions.

In scholarly articles, exhibition reviews and various writings on the economic aspects of art, Takashi Murakami's name is often mentioned in one breath with Jeff Koons and Damien Hirst. Those clinging to stylistic categories would typologize these artists under the term "neo-pop," yet what they share is not so much an aesthetic understanding of popular culture but rather a certain political economy that seeks to engender art that functions as a commodity under the conditions of global capitalism. For this reason, I prefer an approach that is more comprehensive, thinking of pop art in our age not merely as an aesthetic category but rather as an epistemology – as suggested by Jack Bankowsky, who terms this concept "pop life":

> To succumb to the mass media and the marketplace is to break one avant-garde law. To succumb to art, or rather art's conventions and institutions, violates another, subtler protocol: the one that requires art to unmake itself, to make it new. To give in to both the culture industry and the art system

at once – willfully, strategically, exultantly – lands one in the mainstream of pop life.[1]

Thinking of Murakami, Koons or Hirst's practices as a part of "pop life" is in tune with recent conceptualizations of the art world as a space that is an actual part of "the real world," as opposed to the traditional separation made by Arthur Danto between "the real world" and "the art world."[2]

Pamela Lee revises Danto's theory in *Forgetting the Art World*, demonstrating how in the age of the "global contemporary," the art world is inextricably tied to political, social and economic parameters in our ("non-art") world.[3] In the first chapter of her book, Lee analyzes Murakami's technique, paralleling his use of graphic programs that change the size of an object while maintaining its graphic quality to the politics of the market, where products that fulfill the same function arrive in a variety of price levels and materials, fit for each socio-economic strata.[4] In the case of the works of Murakami, the shared purpose of their buyers is the social status entailed by the possession of "a Murakami." Lee's observations gain special significance when combined with Pierre Bourdieu's theory on the "artist's signature."[5] Bourdieu parallels the name of the successful artist to a label or a brand name:

> I think that the sociology of art has to take as its object not only the social conditions of production of the producers ... but also the social conditions of production of the field of production as the site of work tending (and not *aiming*) to produce the artist as a producer of sacred objects, fetishes; or, which amounts to the same thing, producing the work of art as an object of belief, love and aesthetic pleasure.[6]

Following Lee and Bourdieu, what we might consider "the Murakami brand" – which is of course dependent upon his being in the contemporary art canon – is also subject to a similar "politics of scale," as the one described by Lee: his canonic reputation can be bought, as I show in what follows, not only by individual consumers (in the shape of a cushion, a keychain or a T-shirt), or by wealthy collectors (in the shape of blue-chip pictorial or sculptural works) but also by states (in the shape of entire exhibitions). Enhancing Lee's argument, I will thus show how this "politics of scale" includes also political bodies and points to a shared space that consists of various "sizes" of political forms (from the political subject to states to "the world"). One crux of all these political forms will be identified here as the contemporary art canon, and it is the canon – rather than a particular artwork or artist – that has become a desired "object," to be deployed by states and other holders of political interests, through exhibitions of canonic artists.

Elsewhere, I have discussed the strategic moves made by Murakami since his early days as a young artist in the 1990s in Japan in order to achieve a global and established position within the art canon.[7] Since Murakami's early works were not well received in Japan, he decided to first establish his reputation as a successful artist in the West and then "sell" himself back to his homeland as a celebrity-artist.

The West – or, better put, the alleged global art world – was fascinated with the endorsement of various types of otherness as part of a globalist discourse that prevailed since the 1990s. Murakami had a master plan for becoming a part of the "global contemporary": developing a style that would be perceived as distinctly "Japanese" and would be embraced by the West.[8] "Superflat" – a style invented and theorized by Murakami that relates to flattened forms (in terms of both perspective and of hierarchy) reverberating Japanese pop-culture – was introduced to the Los Angeles art scene and to prominent collectors by Murakami's LA dealers, Blum & Poe, during the late 1990s.[9] When in 2001 Murakami was invited to curate an exhibition at the LA MoCA, Superflat became an artistic buzzword, augmented by the fact that the exhibition traveled to Minneapolis and Seattle, drew a total audience of close to 100,000 viewers and gained the attention of the art world. Following Murakami's own investments in his exhibitions and catalogues, I showed how he deployed the West's interest in "otherness" in order to enter the contemporary art canon. What I wish to highlight in what follows is how the canon is economically produced today and how it functions economically after its production.

It is not known exactly how much money Murakami invested through his company or the extent of the investment by Blum & Poe in the production of the Superflat exhibition. Such financial supports, which I refer to here as investments (for reasons that will be clear farther ahead) are quite common in today's art world, but the exact sums are not publicized in most cases. What we do know is that the LA MoCA Superflat show originated in a "pure" Murakami initiative – two exhibitions that were on display at the Parco department stores in Nagoya and Tokyo's Shibuya district in 2000. The catalogue that accompanied the LA exhibition was a book titled *Superflat*, written and produced by Murakami himself in 2000, that theorizes the Superflat concept.[10] With money invested by Kaikai-Kiki – Murakami's company (which is a large-scale art production and art management corporation) – and by the gallery of his Paris dealer, Emmanuel Perrotin, a second Superflat exhibition, titled "Coloriage," was produced in 2002 and displayed at Fondation Cartier pour l'art Contemporain in Paris and at the Serpentine Gallery in London. The third, mega-Superflat exhibition, "Little Boy: The Arts of Japan's Exploding Subculture," which, as Murakami claimed, brought to a close the "Superflat project," was financed by Kaikai-Kiki and by Murakami's dealers and was displayed at the Japan Society Gallery and in New York City's public spaces and mass transit system in spring 2005.[11] Murakami (alongside artists like Damien Hirst, Jeff Koons and Olafur Eliasson) introduced a new type of artist who produced not only the artwork itself but also its financial value through his own economic investment. Curator Scott Rothkopf defined Murakami as "a company man," showing how his art is intertwined with the underlying codes of late-capitalism economy.[12] Murakami, indeed, is a businessman and entrepreneur and as such sees himself as the one who produces ideas and markets them, in order to create their symbolic and monetary value.[13] The idea of the artist as entrepreneur resonates with Chris Bilton's suggestion that "the real 'value added' comes in the manipulation and development of the content into marketable commodities."[14] But how does an idea like "Superflat"

function economically as a marketable commodity? After its implementation in the art world – how is its value generated, and what does "its price" mean?

Superflat – as either an idea or as an exhibition, cannot be valued on its own. It is a part of a larger idea – and that is the "Takashi Murakami" brand. Clearly "Murakami" today is not merely the name of an artist but of a brand.[15] His blue-chip artworks, popular market products, Louis Vuitton designs or whole exhibitions like Superflat are all iterations of the intellectual property he holds and represents. Recognizing intellectual property as the main capital of late-capitalist economy, the sociologists Scott Lash and John Urry argued in 1994 that "[r]epeated or iterated successful production of intellectual property place the emphasis no longer on the object produced but on the artist."[16] Since Murakami's works/designs/ideas can be perceived as iterations of "the Murakami brand," in 2002, when Marc Jacobs invited Murakami to collaborate with the fashion brand Louis Vuitton (LV), it was not merely about an aesthetic transformation for the LV products but more impor-tantly about a rebranding of the old conservative brand through a young and inno-vative one. In other words, Louis Vuitton "bought" Murakami's brand in conceptual terms in addition to actually paying him for his designs. And while Murakami's LV paintings based on the LV designs were sold for millions of dollars in auction houses, they also inhabited the LV stores in the shape of bags and accessories. And as Louis Vuitton used "the Murakami brand" in order to generate a higher market value for its own products, the stores' function as display spaces also further contrib-uted to the marketing and strengthening of the Murakami brand.[17]

Artists' brands and their canonization are generated on the blurred line between museum and marketplace.[18] And it is by now clear that museums adopt many parameters of marketplace, as Martha Buskirk discusses in her book *Creative Enter-prise*.[19] Yet while museums today are only one part of a larger system that engenders the art canon, it is still the most valued "stamp" for an artist and an ultimate proof that he or she has indeed entered the contemporary art canon. The LA MoCA exhibition was therefore an important chain in the branding process of Murakami, but it is not a uni-directional relationship. While artists today need museums in order to brand themselves, museums, in turn, need successful artists in order to create their own high-value brand and to manifest their centrality within the art world.[20] Murakami's relationship with the LA MoCA did not end with the success-ful Superflat exhibition. Reaching the status of a superstar, Murakami returned to the LA MoCA in 2007, this time for a solo exhibition titled © *Murakami*.

This 2007 exhibition provides an excellent example of the interwoven interests within the system of museum-market-brand. The curator, Paul Schimmel, embraced that system by including a Louis Vuitton store and a Kaikai-Kiki showroom within the exhibition (Fig. 13.1). Moreover, Louis Vuitton and Kaikai-Kiki contributed to the financing of the exhibition, while the "big money" came from Murakami's dealers, above all, from Blum & Poe – his local dealers (the dealer Tim Blum men-tioned a "six-figure" contribution, in addition to helping Schimmel secure loans from Murakami's collectors).[21] These investments in the exhibition produce actual monetary profit, since the immediate effect of a huge solo exhibition in a leading

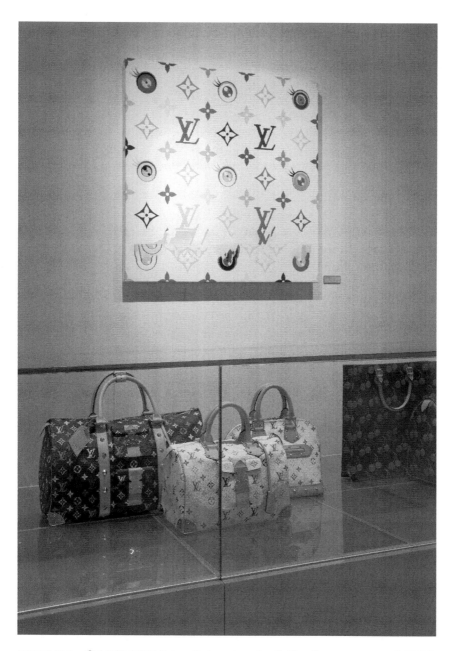

FIGURE 13.1 © *MURAKAMI*, installation view, the Geffen Contemporary at MOCA, 2007–8. Courtesy Museum of Contemporary Art, Los Angeles. Photograph by Brian Forrest.

museum is a significant rise in the value of "the Murakami brand" and thus in the financial value of Murakami's works. It is, however, not merely a particular object that is appreciated but rather the value of the brand, and the effect of such investments is not confined to the monetary realm. Rather, it contributes to reshaping power positions within the field, blurring the distinction among curators, invested dealers and collectors and artists. Describing a visit to Murakami's studio in Japan, the sociologist Sarah Thornton unveiled some of the preparations and plans behind Murakami's solo exhibition at the MOCA.[22] Throughout her analysis (based on a field visit and interviews), she shows the close cooperation between the MoCA curator Schimmel and Murakami's LA dealers, Blum & Poe, all of whom came together to inspect the progress of *Oval Buddha* – the work that was to be the centerpiece of the exhibition. Thornton thus exposes the blurred line between curator and investor/dealer. It appears that Murakami's dealers were accepted as an integral part of the curatorial team of the exhibition. Their funding "bought" them access to curatorial decision making, and we might deduce that in many cases such investments affect even the actual decision of inviting a specific artist for a solo exhibition. As a whole, this system serves all the parties involved: the museum (and the curator) "adorns" its résumé with a superstar artist, who has the potential for a blockbuster show, and sustains its reputation as a leading art institution; the artist enjoys the promotion of his or her brand, reputation and status within the art canon; in turn, the collaborators/investors profit from the increased value of the artist's brand.

The 2007 © *Murakami* show established Murakami as a major artist with a high-value brand, "a safe bet" for museums for a successful exhibition. What changes after such an exhibition (Murakami is merely an example here) is that in economic terms, the Murakami brand almost fulfills its potential value for a living artist. In other words, art investors – whether dealers or collectors – might prefer to perceive as "good investments" artists who are likely to still significantly increase their own value. And yet, we witness some fancy solo exhibitions of Murakami, such as the ones in the Palace of Versailles (2010) and in Doha (2012) after his canonic position became undeniable and his monetary value approached its full potential. In what follows, I analyze the economic and symbolic operation of these two exhibitions. As will be shown, while the Palace of Versailles was interested in Murakami's exhibition in order to promote its own brand as a museum, its 2010 exhibition in turn became a desired object that was "bought" by Qatar for the sake of political profit under the globalized conditions.

It was around the time that the Murakami brand reached its zenith, that Jean-Jacques Aillagon, the president of the domain of Versailles, promoted a plan for the rebranding of the Palace of Versailles. To renew Versailles beyond the staid conservative site that was associated with a historic era in which France was the Western center of art and culture, Aillagon wished to create an up-to-date institution that would take an active role in the contemporary art world and would help reposition France as a cultural power in the West. To accomplish this, Aillagon decided to harness leading established contemporary artists. In other words, he deployed artists

whose position in the contemporary art canon was prominent for the rebranding of Versailles. Aillagon initiated his program in 2008, with a high-key solo exhibition of American superstar artist Jeff Koons.[23] This show was financed for the most part by Koons's avid collector, the French billionaire François Pinault, whose art collection Aillagon managed until assuming his new position in Versailles.[24] Although Pinault is the owner of several works by Koons, his motivation for his huge investment in the exhibition exceeded the mere increase of the monetary value of his Koons works. Considering his prominent visibility in the exhibition catalogue (with an opening essay by him and his name appearing next to 5 out of the 17 works exhibited in the show) Pinault likely wanted to establish his own reputation as a power broker in the contemporary art world. These aspirations gain enhanced resonance when recalling Palazzo Grassi and Punta della Dogana in Venice – venues acquired by Pinault in order to host his art collection. In these spaces, Pinault displays changing exhibitions of contemporary art, derived from his private collection in Venice, the "Biennale capital." As will be shown in the following passages, such status within the art world entails far-reaching political and economic implications.

After a biting attack by French critics on Koons's show in Versailles, Aillagon decided to dedicate the Palace to a non-French contemporary artist only every other year. After the 2009 exhibition of Xavier Veilhan – a celebrated French artist whose works are also prominent in the collection of Pinault – Aillagon could once again, in 2010, invite a non-French artist and strengthen the reputation of Versailles as a leading institute involved in the "global contemporary." Here, too, the curatorial decision was neither merely about particular works of art of high aesthetic quality nor about a theme relevant to the contemporary discourse. It was about a solo exhibition by an already canonic artist whose status would reflect on Versailles. In other words, it was about "buying" a canonical status and authority within the contemporary art arena. But how can a canonical artist be "bought"? How can an exhibition be "bought"? Are these commodities? In 2007, Jens Hofmann curated in Cristina Guerra Contemporary Art in Lisbon a group show titled "For Sale." The works in the exhibition could not be bought as separate objects but only as part of the entire exhibition. In his essay "When Attitudes Become Commodities (Become Attitudes)," Hoffmann wrote,

> While seemingly embracing the commercial aspect of the gallery, "For Sale" is turning the table. It sets out to block routine business, yet it does not want to make an eventual sale of the exhibition impossible. The gesture of selling "For Sale" only as a whole is intended as an exaggeration of the main principle of a commercial gallery, and simultaneously functions as an obstruction of an eventual sale of the artworks, since it is clearly more complex to acquire a whole show than to buy an individual work, and it is far more expensive.[25]

Hoffmann wrote those words as a self-reflexive exercise. But at that time, especially in museums, entire exhibitions were already commodified and, as such, bought and

sold as objects. Murakami's 2010 exhibition at the Palace of Versailles was a strategic act, perceived by Aillagon as part of his marketing-communication strategy. In order to produce the exhibition, Aillagon was in need of large sums of money. What he could do at that point was to sell the idea of the exhibition to someone else who wished, like himself, to create political and symbolic profit from it. While the 2010 Murakami exhibition in Versailles enjoyed a modest support from Kaikai-Kiki and from the artist's Paris dealer, Emmanuel Perrotin, the exhibition catalogue prominently credited the Qatar Museums Authority for its substantial funding, adding that "Takashi Murakami expects to present an exhibition in Doha in 2012, following the Versailles exhibition."[26] What motivated the Qatar Museums Authority, which is a public state institution, to support Murakami's exhibition in Versailles?[27]

It was at the time of Murakami's show in Versailles that Qatar opened Mathaf, its museum of modern and contemporary art in Doha, and attempted to establish itself in the international arena as a country that invests in culture and by extension in humanism and thus constitutes a globally significant cultural spot. While contemporary art has become a channel of global economic power, it is also perceived as a kind of global language – a part of global cultural capital that is in turn translated into political and economic capital. In the case of Qatar, its involvement in Western artistic, cultural and humanistic projects practically connects and conceptually relates Qatar to a powerful political and economic body that holds a globalist ideology (G8 currently includes six Western leading industrial countries and Japan). Qatar's investment in Murakami's show in Versailles was one of these projects. As chairperson of Qatar Museums Authority (recently rebranded as Qatar Museums), Her Excellency Sheikha al-Mayassa bint Hamad bin Khalifa al-Thani accompanied Murakami in the opening gala in Versailles. Supervising Qatar's art-related activity, both locally and internationally, Sheikha Mayassa, the sister of the current Emir of Qatar, was mentioned by *Forbes*, *Times* and *The Economist* magazines as one of the hundred most powerful people in the world. Under the sign of "Doha Cultural Capital" – a part of a UNESCO project aimed at highlighting each year a specific and local culture within the Arab world – Sheikha Mayassa cleverly sought to use the spotlights aimed at Doha during 2010 in order to brand it in the West as a progressive culture, mainly through the endorsement of contemporary art. Murakami, who was invited to Versailles as an established artist – an artist whose art was canonized in the West yet was not a symbol of Western art per se but rather of the "global contemporary" – was the perfect choice for Sheikha Mayassa: the stamp of Versailles listed Murakami as prominent in the contemporary art canon, and the importation of his exhibition would help position Qatar as an up-to-date player in the international art scene. At the same time, Murakami's "Japaneseness" (as opposed to "Americanness") would allow a smooth entry of the international art scene into Doha without invoking a too-oppositional political stand among local conservative groups, for whom "America" represents a concept opposite to the Arab tradition. Qatar, then, "bought" Murakami's Versailles exhibition for the sake of political profit.

In an attempt to analyze the conspicuous cultural activity of Qatar in relation to the global scene, James Panero wrote in 2013,

> Since Qatar has yet to detail the extent of its own acquisition program, it is impossible to say with certainty why the country has spent billions on art, but the most likely answer is that the purchases play into a soft-power strategy developed through such partnerships as the RAND-Qatar Policy Institute [a Qatari collaboration with an American nonprofit institution that helps improve policy and decision-making through research and analysis. This partnership was wound up in 2013.] and the Brookings Doha Center [a collaboration with an American private nonprofit organization devoted to independent research and innovative policy solutions.] – which will become apparent once Qatar opens a museum for these lavish acquisitions.[28]

Panero rightfully addresses Qatar's art-related activity as tied to other initiatives leaning on a Qatari cooperation with Western institutions – initiatives that are aimed at positioning Qatar as cultural leader of the Arab states in the Middle East and Asia while at the same time forging an appearance of global allegiance.

Qatar sensitively navigates between the two cultural realms: the Arab and the Western-globalized. Murakami's 2012 show in Doha, titled "Ego," did not take place at Mathaf since it was and still is dedicated to the display of Arab modern and contemporary artists. "Ego" was displayed in Al-Riwaq – an extension of Mathaf, renovated especially for the Murakami show. It was, eventually, not a pure importation of the Versailles exhibition but rather Murakami's biggest exhibition ever. Curated by the leading curator Massimiliano Gioni, another Qatari "importation," the exhibition showcased more than 60 works created since 1997 alongside new ones designed especially for Al-Riwaq.[29] With this show, Doha marked itself both as the most culturally up-to-date state in the Arab region and as a prominent participant in the global art scene. Indeed, with an annual culture budget of $1.3 billion, plus undisclosed private funds from the Al-Thani family, Qatar's strategy is clearly not only aimed inward. Qatar's huge investment in contemporary art showcases the status of contemporary art as an important currency in today's political climate. Murakami's shows in Versailles and in Doha function as symbols of cultural capital. Returning to Lash and Urry's observation regarding intellectual property being the main capital of late-capitalist economy, we can re-conceptualize their ideas in the context of a state politics made through an exhibition. Lash and Urry concluded in 1994 that the established canonical artist guarantees the supply of this capital: "What we are referring to is not intellectual property as a one-off. Rather what we are pointing to is iterated intellectual property."[30] What we are witnessing here – through this case of Murakami's show in Qatar – is the use of intellectual property as an economic model. The Murakami brand is part of a system based on such iterations as the ones referred to by Lash and Urry, but when high-profile exhibitions are iterated by the same organizing body, something else is also being branded: organized by states or institutions, such iterated exhibitions eventually brand the

state or institution and establish its reputation as a holder of intellectual property, which is the capital of today's economy. Murakami's "Ego," indeed, was not "a one-off." It was the first "global contemporary" art event of a series of exhibitions that formed part of the Qatari plan, executed by Sheikha Mayassa.[31]

In 2013, following the 2012 Murakami exhibition, Al-Riwaq presented its second major show of an artist representing the pinnacle of the global contemporary: Damien Hirst's show "Relics," curated by renowned curator Francesco Bonami. It too did not appear in Doha without a price paid by Qatar.[32] In 2007, almost a decade before ascending the Qatari throne, Sheikh Tamim bin Hamad Al-Thani helped British artist Damien Hirst break the record sum paid for a work by a living artist: the future emir of Qatar, who was educated in the United Kingdom at the time when Hirst was shaping his own brand name,[33] purchased *Lullaby Spring* at Sotheby's London for £9.65 million ($19.3 million). Considering that Hirst's pill cabinet *Lullaby Winter*, of the same series, was sold in the same year by Christie's New York for $7.4 million,[34] the sheikh's buying price did not reflect a true market value but rather served as a declaration of power. As part of Qatar's bid to raise its international profile, Sheikh Tamim promoted – through international cooperation and visibility – academics, arts and sports. In 2011, *The Guardian* claimed,

> The tiny emirate of Qatar has become the world's biggest art buyer after a massive spending spree by the royal family to enhance its cultural portfolio before the 2022 [FIFA] World Cup. . . . It has spent almost $430 million (£267) on cultural imports from the US alone in the past six years.[35]

Qatar's strategy reveals how a high-profile exhibition can function as such a "cultural import" and how it has been commodified in recent years. Sheikh Tamim's *Lullaby Spring* has been on display in two exhibitions to date.[36] Obviously it was included in "Relics" in Doha in 2013, but more curious was its loan to the Tate Modern in London a year earlier for a solo exhibition – Hirst's first substantial retrospective exhibition in a British museum. More than £2 million were invested by the Qatar Museums Authority in this 2012 Tate exhibition in return for the display of that very show in the following year in Al-Riwaq.[37] In her introduction to the catalogue of Hirst's show at the Tate, Sheikha Mayassa wrote that "Art – even controversial art – can unlock communication between diverse nations, peoples and histories."[38] Indeed, when art functions as the main capital, it becomes the primary tool for political communication and for creating political status. In today's globalized capitalism artists, museums and states aim to brand themselves through art. As the cases of Murakami and Hirst demonstrate, when art itself is commodified in the extreme, the artist is redefined as a brand, and when whole exhibitions are commodified and the artists who occupy a prominent position in the contemporary art canon become themselves commodities, a new discourse appears in which museums are instrumental in the process of branding and re-branding of states.

Notes

1 Jack Bankowsky, "Pop Life," *Pop Life: Art in a Material World*, Bankowsky, Alison M. Gingeras and Catherine Wood, eds., exh. cat. (London: Tate Publishing, 2009), 33.

2 Arthur C. Danto, *Unnatural Wonders: Essays from the Gap between Art and Life* (New York: Columbia University Press, 2007).

3 Pamela M. Lee, *Forgetting the Art World* (Cambridge, MA: MIT Press, 2012).

4 Lee, "The World Is Flat/The End of the World: Takashi Murakami and the Aesthetics of Post-Fordism," *Forgetting the Art World*, 39–68. That chapter is based on Lee's article "Economies of Scale: Pamela M. Lee on Takashi Murakami's Technics," *Artforum* (October 2007): 336–343.

5 Pierre Bourdieu, "But Who Created the 'Creators,'" *Sociology in Question* (London: Sage, 1993), 139–148.

6 Bourdieu, "But Who Created," 147.

7 Ronit Milano, "Globalization as an Artistic Strategy," *Situating Global Art*, Birgit Hopfener and Sarah Dornhof, eds. (Bielefeld: Transcript, forthcoming).

8 Takashi Murakami, "Life as a Creator," *Summon Monsters? Open the Door? Heal? Or Die?* (Tokyo: Museum of Contemporary Art and Saitama-Ken: Kaikai Kiki Co, 2001).

9 For the cultural history of the Superflat movement, see Adrian Favell, *Before and After Superflat: A Short History of Japanese Contemporary Art, 1990–2011* (Hong Kong: Blue Kingfisher, 2011).

10 Takashi Murakami, ed., *Superflat* (Tokyo: Madra, 2000).

11 Takashi Murakami, ed., *Little Boy: The Arts of Japan's Exploding Subculture* (New York: Japan Society and New Haven, CT: Yale University Press, 2005), 151.

12 Scott Rothkopf, "Takashi Murakami: Company Man," ©*Murakami*, Paul Schimmel, ed. (Los Angeles: Museum of Contemporary Art and New York: Rizzoli, 2007), 128–59.

13 Maria A. Slowinska, *Art/Commerce: The Convergence of Art and Marketing in Contemporary Culture* (Bielefeld: Transcript, 2014), esp. 187–259.

14 Chris Bilton, *Management and Creativity: From Creative Industries to Creative Management* (Malden, MA: Wiley-Blackwell, 2007), 20.

15 Grace McQuilten, *Art in Consumer Culture: Mis-Design* (Farnham, Surrey UK, England: Ashgate, 2011).

16 Scott Lash and John Urry, *Economies of Signs and Space* (London: Sage, 1994), 137.

17 For the function of stores as exhibition spaces, see Annamma Joy et al., "M(Art)Worlds: Consumer Perceptions of How Luxury Brand Stores Become Art Institutions," *Journal of Retailing* 90 (2014): 347–64; Jean-Noël Kapferer, "The Artification of Luxury: From Artisans to Artists," *Business Horizons* 57 (2014): 371–80.

18 On the position of contemporary art in a globalized market, see Julian Stallabrass, *Art Incorporated: The Story of Contemporary Art* (Oxford: Oxford University Press, 2004); Noah Horowitz, *Art of the Deal: Contemporary Art in a Global Financial Market* (Princeton, NJ: Princeton University Press, 2011); Mariska ter Horst and Gary Schwartz, eds., *Changing Perspectives: Dealing with Globalization in the Presentation and Collection of Contemporary Art* (Amsterdam: KIT, 2012).

19 Martha Buskirk, *Creative Enterprise: Contemporary Art between Museum and Marketplace* (London: Continuum, 2012).

20 For other aspects of museum branding, see Julian Stallabrass, "The Branding of the Museum," *Art History* 37, no. 1 (February 2014): 148–65.

21 Jori Finkel, "Museums Solicit Dealers' Largess," *The New York Times*, November 18, 2007, http://www.nytimes.com/2007/11/18/arts/design/18fink.html?pagewanted=all&_r=2&. For more on the connection between art and economic interests, see Thomas Crow, "Historical Returns," *Artforum* (April 2008): 286–291.

22 Sarah Thornton, *Seven Days in the Art World* (New York and London: W.W. Norton, 2009), 181–217.

23 Jean-Pierre Criqui et al., *Jeff Koons: Versailles*, exh. cat. (Paris: Éditions Xavier Barral, 2008).

24 For a short report on the collision of interests in the case of this exhibition, see Bernard Hasquenoph, "Aillagon/Pinault, même combat," *Louvre pour tous*, posted on November 3, 2008: http://www.louvrepourtous.fr/Aillagon-Pinault-meme-combat,097.html.

25 Jens Hoffmann, "When Attitudes Become Commodities (Become Attitudes)," *For Sale* (Lisbon: Cristina Guerra Contemporary Art, 2007), n.p. Reprinted in *The Market*, Natasha Degen, ed. (London: Whitechapel Gallery and Cambridge, MA: MIT Press, 2013), 169.

26 Laurent Le Bon et al., *Murakami: Versailles* (Paris: Éditions Xavier Barral, 2010), closing pages, n.p.

27 While it is complicated to distinguish between private and public interests in Qatar, the country has made a great effort in the past few years to create an impression of separation between private and public art collections and budgets for purchasing art.

28 James Panero, "The Widening Gulf," *The New Criterion* 32 (December 2013): 39–42.

29 Massimiliano Gioni, ed., *Murakami: Ego* (New York: Skira Rizzoli, 2012).

30 Lash and Urry, *Economies of Signs and Space*, 137.

31 In 2013 *ArtReview* ranked Sheikha Mayassa #1 on the list of the most powerful people in the art world.

32 Francesco Bonami, ed., *Damien Hirst: Relics* (Milano: Skira, 2013).

33 Pernilla Holmes, "The Branding of Damien Hirst," *Art News* 106, no. 9 (October 2007), http://www.artnews.com/2007/10/01/the-branding-of-damien-hirst/.

34 On that particular sale, see "The Hirst 'Record' That Wasn't," *Art History News*, posted on February 9, 2015, http://www.arthistorynews.com/articles/3249_The_Hirst_record_that_wasnt.

35 Sara Elkamel, "Qatar Becomes World's Biggest Buyer of Contemporary Art," *The Guardian*, posted on July 13, 2011: http://www.theguardian.com/artanddesign/2011/jul/13/qatar-world-biggest-art-buyer.

36 For more information on the series Lullaby, The Seasons and for photographic details, see: http://www.damienhirst.com/lullaby-the-seasons.

37 "Qatar's Culture Queen," *The Economist*, posted on March 31, 2012: http://www.economist.com/node/2155144.

38 Sheikha Al-Mayassa bint Hamad bin Khalifa Al-Thani, *Damien Hirst*, Ann Gallagher, ed. (London: Tate Publishing, 2012).

Bibliography

Bankowsky, Jack, Alison M. Gingeras, and Catherine Wood, eds. *Pop Life: Art in a Material World*. Exh. cat., London: Tate Publishing, 2009.

Bilton, Chris. *Management and Creativity: From Creative Industries to Creative Management*. Malden, MA: Wiley-Blackwell, 2007.

Bonami, Francesco, ed. *Damien Hirst: Relics*. Exh. cat., Milano: Skira, 2013.

Bourdieu, Pierre. "But Who Created the 'Creators,'" *Sociology in Question*, 139–148. London: Sage, 1993.

Buskirk, Martha. *Creative Enterprise: Contemporary Art between Museum and Marketplace*. London: Continuum, 2012.

Criqui, Jean-Pierre, ed. *Jeff Koons: Versailles*. Exh. cat., Paris: Éditions Xavier Barral, 2008.

Crow, Thomas. "Historical Returns," *Artforum* (April 2008): 286–291.

Danto, Arthur C. *Unnatural Wonders: Essays from the Gap between Art and Life*. New York: Columbia University Press, 2007.

Degen, Natasha, ed. *The Market*. Exh. cat. London: Whitechapel Gallery and Cambridge, MA: MIT Press, 2013.

Elkamel, Sara. "Qatar Becomes World's Biggest Buyer of Contemporary Art," *The Guardian*, posted on July 13, 2011. http://www.theguardian.com/artanddesign/2011/jul/13/qatar-world-biggest-art-buyer

Favell, Adrian. *Before and After Superflat: A Short History of Japanese Contemporary Art, 1990–2011*. Hong Kong: Blue Kingfisher, 2011.

Finkel, Jori. "Museums Solicit Dealers' Largess," *The New York Times*, November 18, 2007. http://www.nytimes.com/2007/11/18/arts/design/18fink.html?pagewanted=all&_r=2&.

Gallagher, Ann, ed. *Damien Hirst.* Exh. cat. London: Tate Publishing, 2012.

Gioni, Massimiliano, ed. *Murakami: Ego.* Exh. cat. New York: Skira Rizzoli, 2012.

Hasquenoph, Bernard. "Aillagon/Pinault, même combat," *Louvre pour tous*, posted on November 3, 2008: http://www.louvrepourtous.fr/Aillagon-Pinault-meme-combat,097.html.

"The Hirst 'Record' That Wasn't," *Art History News*, posted on February 9, 2015, http://www.arthistorynews.com/articles/3249_The_Hirst_record_that_wasnt.

Hoffmann, Jens, ed. *For Sale.* Exh. cat. Lisbon: Cristina Guerra Contemporary Art, 2007.

Horowitz, Noah. *Art of the Deal: Contemporary Art in a Global Financial Market.* Princeton, NJ: Princeton University Press, 2011.

Holmes, Pernilla. "The Branding of Damien Hirst," *Art News* 106, no. 9 (October 2007). http://www.artnews.com/2007/10/01/the-branding-of-damien-hirst/

Horst, Mariska, ter and Gary Schwartz, eds. *Changing Perspectives: Dealing with Globalization in the Presentation and Collection of Contemporary Art.* Amsterdam: KIT, 2012.

Joy, Annamma, Jeff Jianfeng Wang, Tsang-Sing Chan, John F. Sherry Jr., and Geng Cui. "M(Art)Worlds: Consumer Perceptions of How Luxury Brand Stores Become Art Institutions," *Journal of Retailing* 90 (2014): 347–364.

Kapferer, Jean-Noël. "The Artification of Luxury: From Artisans to Artists," *Business Horizons* 57 (2014): 371–380.

Lash, Scott and John Urry. *Economies of Signs and Space.* London: Sage, 1994.

Le Bon, Laurent, ed. *Murakami: Versailles.* Exh. cat. Paris: Éditions Xavier Barral, 2010.

Lee, Pamela M. "Economies of Scale: Pamela M. Lee on Takashi Murakami's Technics," *Artforum International* 46, no. 2 (2007): 336–343.

———. *Forgetting the Art World.* Cambridge, MA: MIT Press, 2012.

———. "The World Is Flat/The End of the World: Takashi Murakami and the Aesthetics of Post-Fordism," *Forgetting the Art World*, Cambridge, MA: MIT Press, 2012, 39–68.

McQuilten, Grace. *Art in Consumer Culture: Mis-Design.* Farnham, Surrey UK: Ashgate, 2011.

Milano, Ronit. "Globalization as an Artistic Strategy," *Situating Global Art*, Birgit Hopfener and Sarah Dornhof, eds., Bielefeld: Transcript, forthcoming.

Murakami, Takashi, ed. *Superflat.* Tokyo: Madra, 2000.

———, ed. *Summon Monsters? Open the Door? Heal? Or Die?* Tokyo: Museum of Contemporary Art and Saitama-Ken: Kaikai Kiki Co, 2001.

———, ed. *Little Boy: The Arts of Japan's Exploding Subculture.* New York: Japan Society and New Haven, CT: Yale University Press, 2005.

Panero, James. "The Widening Gulf," *The New Criterion* 32 (December 2013): 39–42.

"Qatar's Culture Queen," *The Economist*, posted on March 31, 2012: http://www.economist.com/node/2155144.

Rothkopf, Scott. "Takashi Murakami: Company Man," ©*Murakami*, Paul Schimmel, ed., 128–159. Los Angeles: Museum of Contemporary Art and New York: Rizzoli, 2007.

Schimmel, Paul, ed. ©*Murakami*. Exh.cat. Los Angeles: Museum of Contemporary Art and New York: Rizzoli, 2007.

Sheikha Al-Mayassa bint Hamad bin Khalifa Al-Thani, *Damien Hirst*, Ann Gallagher, ed. (London: Tate Publishing, 2012).

Slowinska, Maria A. *Art/Commerce: The Convergence of Art and Marketing in Contemporary Culture.* Bielefeld: Transcript, 2014.

Stallabrass, Julian. *Art Incorporated: The Story of Contemporary Art.* Oxford: Oxford University Press, 2004.

———. "The Branding of the Museum," *Art History* 37, no. 1 (February 2014): 148–165.

Thornton, Sarah. *Seven Days in the Art World.* New York: W.W. Norton, 2009.

14

TROUBLING CANONS

Curating and exhibiting women's and feminist art, a roundtable discussion

Helena Reckitt

The participants

Pauline Boudry and Renate Lorenz, Artists, Berlin

Angela Dimitrakaki, Senior Lecturer in Contemporary Art History and Theory, University of Edinburgh, and author of books including *Gender, artWORK and the Global Imperative: A Materialist Feminist Critique* (Manchester)

Kerryn Greenberg, Curator, International Art, Tate Modern, London

Koyo Kouoh, Artistic Director, RAW Material Company, Dakar, and curator of exhibitions including *Body Talk: Feminism, Sexuality and the Body* in the Work of Six African Women Artists (WIELS)

Camille Morineau, Independent Curator, Co-Founder and President of AWARE, Archive of Women Artists, Research and Exhibition, and former Curator at the Centre Pompidou where she curated exhibitions including *elles@centrepompidou*

Helena Reckitt, Senior Lecturer in Curating, Department of Art, Goldsmiths, University of London, and former Senior Curator of Programmes at the Power Plant, Toronto

Mirjam Westen, Senior Curator of Contemporary Art, Museum for Modern Art, Arnhem, the Netherlands, whose exhibitions include *rebelle. Art & Feminism, 1979–2009*, and *Female Power. Matriarchy, Spirituality and Utopia*

Introduction

In an online discussion that took place between December 2015 and February 2016, artists, curators, and scholars considered how female artists are incorporated into dominant as well as feminist canons and under what terms. Women artists have

been and continue to be excluded from or marginalized within almost all artistic canons to date. The situation is even more extreme for female artists who work in non-Western locations, who are frequently treated as exotic outsiders if not ignored altogether. Meanwhile, resistance to and backlash against feminist ideas and values is underway throughout the world, at the same time as many archives devoted to women's and feminist work face closure. There is therefore a pronounced need for scholars, curators, and institutions to contest the absence of women artists from and devaluation within dominant narratives by researching and foregrounding artists who were close to existing canons but marginalized because of their gender, as well as artists who contested mainstream movements and developed their own collective as well as personal paths. This collective effort also calls for the development of institutions that support this art and guard against its future erasure.

Yet while it is clear that existing canons have not served female artists well, the question of how to expand canons is not easily answered. It is not a simple matter of inserting forgotten women artists into existing traditions, especially when those traditions were predicated upon excluding them in the first place. Incorporating artists into histories that they were never part of has violent connotations. Such tactics can end up validating dominant canons, refreshing them with material from the "margins," which is removed from its original context and leaves prevailing values and dominance intact. These practices also risk tokenism, especially when the appearance of one or two "exceptional" women in dominant narratives is seen as evidence that sexism no longer exists in the art world and feminist struggle is no longer needed.

Challenging the idea that canons can be straightforwardly expanded, artists Pauline Boudry and Renate Lorenz propose the concept of "troubling canons." Tactics of troubling canons draw attention to the ideologies, inclusions, and exclusions that underpin canon formation, including canons of feminist art. They pinpoint the logic of competition (between artists and mediums, genres and regions) that canons both symptomize and perform. Artworks from the past cannot be easily recuperated, troubling canons reminds us, as all acts of translation entail processes of misunderstanding and incorporation, identification and desire. Based in intersectional politics, this approach does not separate critiques of masculinity from those of whiteness, heteronormativity, cis-gender superiority, and other dominant value and classification systems.

To understand why women artists have been systemically denigrated and ignored, we also need to look beyond canon formation to the historical circumstances in which male artists and masculinist values came to dominate. Women, after all, have historically been designated secondary roles in the art world: as lovers and wives, models and muses, and, more recently, gallery owners, collectors, curators, and critics. That women still carry the responsibility for childcare, as well as the socially reproductive labor that maintains life, profoundly impacts how their work is recognized and valued. If we are to reverse the endemic dismissal of women's work, we don't just need better, more diverse publications, exhibitions, collections,

and institutions devoted to their art. We need transformations on the infrastructural level that reflect feminist ethics, promote feminist values, and sustain feminist futures.

Helena: Let's start with a broad question. Why – or do – we need artistic canons, including regional, national, and international canons, and those of art made by women and feminists?

Angela: It's not a matter of *needing* canons, since we can't rid them from our political will alone. The "canon" is, principally, the outcome of the art world as an extremely competitive working environment and market – one so extreme that it makes the dead compete with the living. This "market context" (which extends beyond sales rooms and museums' acquisitions) is defined by a cycle of flows between symbolic, cultural and economic capital, as Pierre Bourdieu argued (1986), and now this is the case even more than ever. Art history contributes to the competition in various ways, even if not out of choice. It is great that feminist history has devised methodologies to question the criteria for inclusion, and we can keep going further, attacking the very idea of the canon. But we must be pragmatic and understand the material conditions in which we practice and in which women artists work, so that our critique does not hurt the latter. Why? Because we are a minority. If most art historians were feminists who negated the canon, the situation would be completely different.

Pauline/Renate: Connecting to Angela's point, we would add that in addition to the canon, identity categories such as "woman" are not self-chosen but have been imposed on us. The "we" of women and even of "feminism" have been heavily opposed in the history of feminisms (in the plural) for being excluding. From our perspective, feminist politics – and this is also true for the format of the "feminist exhibition" – can only be useful again if they allow for difference without categorizing and fixing. To call us "women" or "female artists" is too much and too little information at the same time. We would rather opt for troubling canons! Troubling canons through exhibitions, through writing, through artistic practices!

Mirjam: I really like the term "troubling canons," since it conjures up feminist tactics of infiltrating and subverting existing power relations and domains. To get back to the question, "does feminist art history need a canon?" My answer is bluntly "YES." I am convinced that, we, as feminist art historians, researchers, curators, and artists, need to and should continue to canonize. I know that canonizing books on art and feminism can be dismissed as fixed entities

or as incomplete since there will always be names, domains, and theoretical viewpoints that are not included, but let's treat them as bodies that grow through time. Canonizing helps us systematically to turn information into knowledge. And knowledge grows and deepens only when there are certain frames of reference that are shared. With all the possibilities and information that the Internet provides, especially in this era of self-canonization, I recognize the need for research/publications on feminist art in gender studies and art history, not to mention curatorial and museum practice. We need "bundled knowledge" which subverts existing art history canons at the same time as it functions as a focus and shared starting point from which teachers, students, curators, and artists can depart, get stimulated, analyze, and criticize, inspiring them in turn to carry out new feminist research. Canonizing, to me, means acknowledging feminist legacies, with all their contradictions, and turning them into a productive field for new generations.

Angela: Because of the way the art world works at present (extreme competition often being its hidden or apparent principle), we cannot have feminism as a naive democracy along the lines of "these people were left out, let's do a show to include them." But we can have curating based on research which seeks to expose the criteria and frameworks that have led to "absences" or "rejections." So, we don't need just celebratory feminist curating but revelatory feminist curating. And the moment is right and ripe for the latter, because austerity has hit women so hard that the gender divide has grown and is even more visible.

Camille: I have to start by saying that "canon" doesn't translate well in French, although it appears to be inherited from French structuralist thought. Somehow it got lost in the process of being developed abroad. The term is now seldom used in France because literally it evokes something very aggressive and warlike so that "attacking the canon" means something like "bombing a bomb." The closest I can get to answering your question would be saying that this "canon" needs to be restructured, and this position is not only about vocabulary but also a personal strategy that I have been using, quite efficiently, in France. To build something strong, you have to find a strong base. This base for me, today, comprises information and archives: to build a new canon, we need to structure and enhance the historical narrative with precise information on women artists. Being feminist ("*être féministe*") today means, for me, "*être historienne*." I am looping the loop with Linda Nochlin there. That's why I created AWARE (Archives of Women Artists, Research and Exhibitions), a website devoted to academic research and archives.

Mirjam: One of the ironies of building a strong canon of feminist art is that it makes the struggles experienced by earlier generations of women less visible. In 1975, Carolee Schneemann painted an idealistic vision of the future in her contribution to the catalogue accompanying the *Magna*

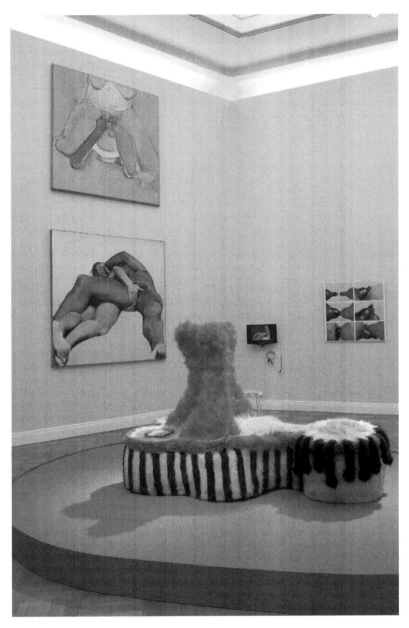

FIGURE 14.1 *rebelle. Art and Feminism 1979–2009*, 2009. Installation view, Museum of Modern Art, Arnhem. Featuring Vidya Gastaldon, *Chrystal rainbow Pyramid*, 2007, *Shiva linga (uchu baba)*, 2008, *Hamakarma*, 2008, Mai-Thu Perret, *Machinery Sorcery*, 2007 and *Balthazar*, 2012. Courtesy Museum of Modern Art, Arnhem.

exhibition, organized by Valie Export. Schneemann had no doubt that by 2000, young female artists would not be thwarted as she had been or suffer the restrictions she had encountered. They would be taught by mainly female teachers; they would learn about pioneering female artists and the ways in which female creativity had developed over centuries; as women, they would no longer be exceptions in the art world; and besides reading merely about "man and his symbols," they would read books on "the matriarchal origins of art." She concluded: "The only negative thing about all this is that these future young women who will have acquired all this knowledge, will never believe that our pioneering work immobilized and isolated us; that the belief in the importance of a female art history was despised and dismissed as heretical and false" (1975: 12). More than forty years after Schneemann's imagined future, her prophetic words are still not far off the mark. And, heaven, no, feminist canonizing is not simply about adding names to existing histories.

Helena: Of course Nochlin highlighted the limitations of art-historical strategies that incorporate female artists into existing canons in her germinal essay "Why Have There Been No Great Women Artists?" (1971). Picking up Nochlin's thread several decades later, Helen Molesworth explored the implications of curatorial conventions that insert works by women and feminists into museum galleries that were "structured by their very absence" (Molesworth 2010: 504). The alternative, for Molesworth, is not to cordon off women's and feminist art into separate rooms but to curate galleries that include artworks from different eras, genres, and media, so that they "touch" and affect a form of mutual contagion (2010: 510). Drawing on Molesworth, I am interested in how we can undertake tactics of curatorial transparency and experimentation that "trouble" canonical conventions and make exclusions and omissions visible. Catherine de Zegher attempted something along these lines with *Inside the Visible: An Elliptical Traverse of 20th Century Art in, of, and from the Feminine*, 1996. That exhibition excavated the work of under-recognized women artists while questioning the terms under which such art becomes visible. Given that work by women often reaches its public belatedly, Pauline and Renate, can you speak about how you evoke artworks' latent potential in your work?

Pauline/Renate: We use Elizabeth Freeman's term "temporal drag" (2010) to describe not just the – trans-temporal – type of performance that we include in our film installations but also, more generally, the way in which we connect to the past. Temporal drag,

or "transtemporal drag," as we prefer to say, can be seen as an embodiment in which different times cross. Thus, it is important for us not to invoke the idea that we recreate the past or reenact figures from the past. We like to complicate the notion of the past as finished and accessible. Sharon Hayes, in our last film installation, *I WANT*, introduces herself both as punk-poet Kathy Acker and as whistle-blower Chelsea Manning. She also still acts in the film as artist Sharon Hayes with references to her own practice of performance and historiography. We like to create and visualize lines of desire between present-time performers with their contemporary practices and elements or materials from the past. Desire, here, is nothing we own but something which draws lines between the performers, the material, and the beholders/visitors of the exhibition. This includes anachronism, which might be uncanny. Very often we not only *choose* the past but we are haunted by it: not just in relation to violent traumatic events but, for example, by artworks that leave their imprints on us. While we don't choose what affects us, we might still be able to work on our responses. For our discussion here, it seems to be important to not produce the illusion that we have unmediated access to the past but rather to complicate the relations between past, present-time, and future.

FIGURE 14.2 Pauline Boudry/Renate Lorenz, *I Want*, 2016. Installation with double projection, HD 16 min, 2016. Performance – Sharon Hayes. Courtesy Marcelle Alix, Paris, and Ellen de Bruijne, Amsterdam.

Helena: To what extent do the lineages that form today's international canon include female and feminist artists? Are there dangers when this work is incorporated into dominant artistic narratives?

Mirjam: It's about time that feminist legacies infiltrate dominant artistic narratives. However, where it has happened, the process has been very slow and not very systematic. In the Netherlands, a gendered art history at universities is suffering from a backlash.

Angela: The first question is alarmingly easy to answer: with the exception of postmodernism (in the visual arts, mid-1970s–mid-1990s), where for various reasons but, principally, due to the power of the feminist analysis of artworks, women artists entered the canon, most women were excluded. They continue to be.

Regarding the second question: when a tiny number of women artists enter dominant narratives, especially if they repudiate or dis-identify with feminism, the danger should be obvious: their "success" would be, and has been, used to undermine: a. feminist politics, b. the potential visibility of most other women artists and c. any transformative politics in general (because "making women who are worth it visible" is meant to suggest that the completion-based, profit-oriented, pyramidal art world we have is ultimately not so bad). Typically, women artists' names are taken as proof that "there's nothing wrong with the system; and even if there was, it's been now fixed." This was what 1990s post-feminism argued. I think therefore that the question of *how* to avoid token visibility of a few "special" women while scripting women in the era's narrative poses a dilemma for feminist art historians.

Camille: In my (French) point of view, a feminist canon does indeed exist. It has been crucial and needs to be important but not over-empowering; otherwise it will turn itself into another aggressive and "theocratic" form of thinking. Other than specifically feminist "canons," we need to reincorporate women (and also men from the margins) into a "main" – to be reinvented – history. Carrying out this essential, retroactive history is a huge undertaking that has to be done collectively, by all historians and not only those informed by feminist thinking.

Koyo: I would add that when we look down the line of the generations and movements, women artists have always been under-represented, and black women artists have been a minority in this minority. Nor has this changed significantly today. The small minority of women artists who are acclaimed in different arenas of the art world should not blind us to the fact that patriarchy and sexism are still very much operative. Moreover, the cultural bias, combined with the lack of knowledge of and interest in cultural settings foreign to the Euro-American heritage, places the work of African women artists in a precarious corner of the global art scene. Consequently, a gendered and identitarian perspective remains a political necessity in curatorial discourse and practice.

Camille:	I agree with you both, but I want to add that not all women artists have been feminists, so we need to have three different, strongly interwoven approaches to this "incorporation" in the canon. First, re-incorporating women who were close to existing canons (movements, styles, groups) but forgotten by critics and historians because of their gender. Second, recognizing the importance of women who have questioned these canons (most of them feminists, but not only). Third, re-inventing canons for women (but also, sometimes, men) who, as a group, and if reconsidered seriously, have proposed in their time new canons which have been neglected.
Koyo:	Building on Camille's point about female artists' relationship to feminism, I would note that the early 1980s saw the rise of the concept of *womanism* as a concept that would be more inclusive than feminism and was championed by the African-American novelist Alice Walker. The preference of womanism over feminism among black women deserves mention: it stems from the marginalization of women of color in the most prevalent forms of feminism and from the fact that African women and women of African descent have been disappointed by white radical feminism, which they regard as often oblivious of their realities. This lack of cohesion – and the quest for it – is what can be found in the work of the five African women artists whose work I bring together in the exhibition *Body Talk: Feminism, Sexuality and the Body in the Work of Six African Women Artists*.
Pauline/Renate:	What would happen if we would have different exhibitions called "art and feminism" that showed mostly works by women from non-Euro-American contexts, or queer works which deal with migration and diaspora, or mostly works by trans and queer artists – without labeling them as such? This might help to subvert the notion of mainstream and margin, and thus trouble the canons, instead of adding the margin to the overall picture (which leaves the hierarchies in the realm of art intact).
Helena:	What are the possibilities, and problems, in constructing alternative female or feminist artistic lineages?
Angela:	I am not sure what is meant by "alternative." If this means a separate/separatist women's lineage, it can be catastrophic. If it means a feminist lineage, it is necessary as a great aid for younger generations to avoid re-inventing the wheel and for putting into place a feminist continuum that demonstrates the long-term, unstoppable, and courageous struggles of feminists against immense obstacles.
Camille:	Amazing possibilities, but problems if we forget to check that these new "canons" or groups have/might have included men. A contemporary example: if one adds women artists into the history of pop, one finds an international and political movement . . .

FIGURE 14.3 *Body Talk: Feminism, Sexuality and the Body in the Work of Six African Women Artists*, 2015. Installation view, WIELS, Brussels. Courtesy WIELS, Brussels.

which in turn includes interesting male artists who were not in the first "official" pop group.

Kerryn: That was the focus of the 2015 Tate Modern exhibition *The World Goes Pop*, which revealed many international artists in a story long dominated by a male Anglo-American cast. There is however the risk of throwing the baby out with the bath water. In an attempt to tell a different story about pop art, Tate's exhibition excluded artists who many would consider the key proponents of pop. There is a delicate balance between simultaneously recognizing and challenging the canon.

Helena: That's interesting. I had a different critique of that exhibition. While it included a lot of terrific, under-known work from diverse geopolitical positions, I was not entirely convinced about the pop art framework. Instead of a productive context for artists who were concerned with populist and vernacular tropes, it seemed like a way of drawing audiences – pop sells! – in which lesser-known practices lined up under pop's dominant narrative.

Helena: What does the visibility or otherwise of female or feminist artists tell us about art-historical, curatorial, market-driven, and other processes of validation?

Kerryn: We have to recognize the impact of childbirth and childcare on the visibility of women practitioners, be they artists, curators, or art historians. In 2013, *The Guardian* (see Sedghi 2013) reported on a study carried out by the East London Fawcett (ELF) Group which highlighted the relative (in)visibility of UK women artists. The survey compared the percentage (61.7%) of female students enrolled in British undergraduate arts and design courses to the number of female artists represented by commercial

galleries and awarded solo exhibitions in London. Only 31% of the artists were women and only 5% of the galleries represented an equal number of male and female artists.[1] It seems obvious, but the timing of an artist's ascendance frequently coincides with the peak in a woman's fertility. In London at least half of aspiring women artists, by choice or necessity, seem to move on to other things before achieving commercial gallery representation. The processes of validation are all interconnected, and it can be difficult to retroactively attend to an artist who has been neglected, for whatever reason, by the system.

Angela: This has important implications for how artistic and other labor is valued in the art world, especially given that today, unlike earlier periods addressed by feminism, in Britain, the U.S., and most likely elsewhere, we probably have more female than male art graduates, and so potentially more female than male artists. Partial evidence suggests that greater numbers of women in the art world has not meant greater numbers of "successful" women. If one did the research, I am sure one would find that what Greg Sholette (2011) called "dark matter" – the vast mass of invisible, surplus artists whose non-success is essential for making the happy few stars shine brighter – is mostly female. More research needs to be done to establish why this is the case. I am sure that social reproduction labor, typically women's work and its values, would be found to play a huge role in "art-historical, curatorial, market-driven, and other processes of validation." And this role would be defined by its very *absence*, the eclipsing of this labor in relation to the 24/7 networking and mobility that the post-Fordist artist must embody.

Koyo: From the perspective of contemporary African societies, for the most part, being an artist, whether a man or a woman, is not regarded as a respectable professional activity. Unless, of course, one is internationally acclaimed and can thus brandish the visible symbols of material success in much the same way as a successful banker or lawyer might. In the case of women, though, there seems to be a noticeable hierarchy of acceptance. There is a classification that differentiates between performing arts and cinema (and, in that, acting or directing), and the visual arts (and, in that, it is almost exclusively painting that is recognized). There is a pervasive assumption that one becomes an artist because one has not succeeded in getting a "real" job. Another pervasive assumption, touching performing women artists in particular, is that they are probably loose women of easy virtue. In such a context, when a woman manages to establish herself as an artist, she is expected to be a painter who produces nicely decorative works devoid of any political concepts. While this is a bit of an exaggeration, it is clear that in Africa, the emergence of female artists as full active producers of meaning is a recent phenomenon – except, perhaps, in South Africa, which in any case has from every angle an exceptional position in the entire continent.

Mirjam: In my curatorial practice I have been conscious of the need to trouble certain canonical conventions within feminism itself. While preparing the 2009 show *rebelle. Art and Feminism 1979–2009*, I realized too late that I had overlooked the influence of the radical and activist nature of the goddess and spirituality movement of the 1970s. Around 1980, when I became infected by feminist art history, this movement was widely dismissed as escapist, nostalgic, essentialist, and anti-intellectual. Thirty years later, I had failed to give this work adequate acknowledgment. So I decided to organize *Female Power. Matriarchy, Spirituality and Utopia*, 2013, an exhibition combining work by artists of the 1970s and contemporary female artists, which gives a new perspective on the spiritual, feminist legacy of the twentieth century.

Koyo: Since the 1990s, the existence of a specifically African – and black – feminism, together with the spread of artistic practices, and the economics of art, to international networks, have given shape to the development of a black feminist art. Stemming from the continent and the Diaspora, this black feminist art depicts bodies that continue a tradition of activism and freedom of expression. A lot has been written about the divide between Western feminism and feminism in Africa. One of the major critiques foregrounded by African feminists is that Western feminism has done little to understand the cultural

FIGURE 14.4 *Female Power: Matriarchy, Spirituality and Utopia*, 2013. Installation view, Museum of Modern Art, Arnhem. Featuring Shakuntala Kulkarni, Dharwar Karnataka, *Of Bodies, Armour and Cages*, 2012, Miwa Yanagi, *Windswept Women*, 2009. Courtesy Museum of Modern Art, Arnhem.

specificities at play in the global struggle for liberation from male-dominated regimes. In addition, African women tended to see Western feminism as being anti-man and anti-birth and as committed to establishing female homosexuality as a contentious issue. African feminism, conversely, is perceived to be pro-man, pro-marriage, pro-natal, and definitely heterosexual. In other words, a woman's independence and freedom is not achieved at the costs of losing the social status that marriage and motherhood provides.

Helena: What have been the important exhibitions of women's and feminist art for you? What have been their particular strengths and shortcomings?

Angela: They are all important, no matter any shortcomings.

Camille: I agree. All these group shows have been landmarks, if only because they have been so rare and most often the result of a fight.

Kerryn: Exhibitions like *WACK! Art and the Feminist Revolution*, curated by Connie Butler in 2007, have undoubtedly affected the landscape in which we work as curators today. I acknowledge that exhibitions of women-only artists have been and continue to be necessary, but it is important to recognize the potential of solo exhibitions in changing perceptions and challenging the canon. Some of the most memorable exhibitions I have seen over the past decade have been retrospectives of women artists: Ana Mendieta at the Whitney Museum of American Art (2004), Eva Hesse at the Jewish Museum (2006), and Louise Bourgeois at Tate Modern (2007–8). There are others, of course, but these stand out for me because they convincingly conveyed the depth and breadth of the individual artists' practices, and in so doing, whether advertently or not, advanced the cause of feminism.

Mirjam: I cherish them all. From the first show on art and feminism I ever saw in particular, the Dutch exhibition *Feministische Kunst Internationaal* in 1979, to *Inside the visible*, which Helena mentioned, to *WACK!*, which Kerryn refers to, up to Camille's ambitious curatorial effort, *Elles@centrepompidou* in 2009, and Bojana Pejić's *Gender Check. Femininity and Masculinity in the Art of Eastern Europe* in 2009–2010.

Helena: I value how these big group exhibitions evoke the complex discursive climate within which artists work and move beyond the monographic focus on the sovereign artist, which has been a key focus within feminist art history and criticism. *Gender Check* was unusual for including a number of male artists, which most feminist surveys have not done. Together with *elles@centrepompidou*, *Gender Check* was also one of the few big feminist exhibitions to include contemporary artworks. Another key exhibition that foregrounded living artists is Maura Reilly and Linda Nochlin's 2007 *Global Feminisms*, which took on the challenge of framing art from around the world in feminist terms.

Camille: In terms of how these exhibitions contributed to processes of canonization, I would say that they made artists and their works visible; they started a reflection, they questioned a narrative and initiated a new/a

FIGURE 14.5 *elles@centrepompidou*, 2009–2011. Installation view, Centre Pompidou, Paris. Courtesy Centre Pompidou, Paris. Photograph by Adam Rzepka.

plurality of new narratives. A "canon" takes, if not centuries, then dozens of years to build. So we are in a process.

Angela: However, while exhibitions are important platforms for mediating the struggles of feminism to the general public, the exhibition-form has dangers, not least in terms of what it does to artistic labor (see Dimitrakaki 2012). The power of what I would call biopolitical artwork that is realized in existing social relations, such as Tanja Ostojic's *Looking for a Husband with EU Passport* (2000–05), is diminished when it is disciplined, literally made to be exhibited as "art documentation" (Groys 2002). Much radical art today is no longer "visual art." The only reason it gets "exhibited" [is] because this is a win-win situation for the patriarchal-capitalist complex: it wins because it shows that this work is just like any other, "showable," and doesn't require any new organization of art mediation, and it wins because the exhibition form is, by default, a market aesthetic. Being exhibited is to be seen, is to circulate, to enter a circuit of exchange. In addition, and perhaps to state the obvious, exhibitions can also undermine the validity and honesty of feminist politics when they take place under the signs of corporate sponsors such as the BP in the Tate. There we saw the work of black women artists and Sylvia Pankhurst exhibited under the BP sun, which surely cannot be justified as a positive development for feminism (Horne 2014).

Helena: Moving from representation to infrastructure, have the institutions that sponsored these exhibitions subsequently changed their practices to reflect feminist principles?

Camille: I find it hard to generalize anything about institutions. They are not coherent enough – as hospitals or banks would be – to be analyzed as an object. Behind these exhibitions are mostly people, individuals, who carried difficult projects, very often "against" internal institutional resistance. I hope my curatorial colleagues can back me up on this and help me to explain that institutions are not driven by politics but by a bunch of more or less coherent lobbies who conflict rather than collude.

Angela: I do not have the data to answer this, but I doubt that institutions have changed, because austerity-capitalism makes these institutions compete for funding and therefore expand in whatever "novelty direction" brings in more people. Finances rather than commitment to politics drives institutions, and if feminists came up with huge audiences and sustained funding, we'd see big changes.

Kerryn: Unfortunately, it is often a case of "Catch-22." As I mentioned before, in order to attract audiences and maintain a financially viable program, museums have to exhibit artists with name recognition, which few women artists (particularly non-Western women) have. On the other hand, these artists can only become familiar if someone takes the risk and presents their work. I can only speak for my institution, Tate Modern, where we are actively seeking to challenge and expand the canon, both in terms of previously neglected women artists and those working outside the traditional centers of London, Paris, and New York. For example, I am working on a retrospective of Fahrelnissa Zeid (1901–1991), who was born in Turkey and had a very successful career in Europe and the Middle East, arguably influenced in part due to her position in high society. While no one questions the importance of curating such an exhibition, Zeid is relatively unknown today, and the pressures to attract an audience are real. Essentially, at Tate we acknowledge that some exhibitions are not financially viable, and yet we still commit to doing them because they are important, and in the long term we hope they will change the way art is viewed, understood, and historicized. However, realistically there are a limited number of exhibitions like this that big institutions can afford to do, especially in these turbulent financial times. It is a process, and there are real constraints, but I think the results are becoming visible both in our exhibitions program, and in our collection displays. Rewriting the canon requires a huge collective commitment and effort. One has to step outside the historical processes of validation and look anew, not just once or twice, but every day.

Helena: Artists' visibility often stems from who paid attention to their work at the time and how much access they had to influential institutions and publicity circuits. So artists working in regional and non-Western areas have been disadvantaged when it comes to their work being

disseminated and historicized. This is why self-initiated archives, like the Women's Art Library in London, which artists set up in the early 1980s as a slide repository of their work, are so important. Even if this art wasn't recognized or valued at the time, the library is a source for further research and exploration. It has latent potential. The 35mm slides themselves possess a materiality that exceeds their documentary function. Conveying artists' instructions and aspirations, they are spaces for what WAL's curator, Althea Greenan, calls "urgent corrections or playful chat."[2] As the custodian who oversees how the collection is organized, stored, and used, Greenan becomes a belated collaborator and advocate for women artists that she rarely meets. The durational work that she provides to care for and keep these histories alive resonates with longstanding feminist attention to the kind of under-valued yet necessary work of background maintenance labor that Angela terms social reproduction.

Helena: How have collecting practices impacted public and private museums and foundations?

Camille: That's a very important question, as collecting women artists is and will be the strongest way to build a new narrative and reinvent the canon.

FIGURE 14.6 Sharon Dipity, *Some Men Really Should Be Kept in at Night*, n.d. Courtesy The Women's Art Library, London.

If museums have recently been exhibiting more women artists, they are still slow in collecting them at the same level of male artists. That is a crucial point to change. And private collections might very well be in the future also as important, as they now represent a very strong power in the market.

Kerryn: I agree with Camille. Collections sit at the heart of museums, and this is where transformation really needs to take place. It is the only way we can ensure that women artists are recognized permanently and repeatedly. Temporary exhibitions might be more visible in the short term, but they quickly come and go.

Helena: It's not only collections that sit at the heart of museums but collectors and their money and influence! Targeting collectors to support initiatives that challenge the status quo might be one tactic we can adopt.

Mirjam: Collecting is one thing. Ending up in a cellar – as happens to many artworks – is another. Museums need to develop exhibition policies that not only show work by women artists repeatedly but that also acknowledge feminist legacies, as Angela remarked earlier, not just in celebratory but in revelatory ways. Canonizing means to me also a sort of sustainability in which museum collections can play an important role, especially since many museum collections are put online and made accessible for research.

Helena: On sustainability, a gap often exists between the lack of support that female artists receive during their lives and how they are "discovered" by the art world at the end of their lives or when they have died. Several commercial galleries have recently done well from female artists' estates. I'd like to see them offering the same level of commitment to living women artists.

Helena: Aside from exhibitions and collections, what else must we focus on?

Angela: For me, nothing beats academic research and the depths it can reach, in terms of data provision, interpretation, and in identifying the contradictions that inhere in our struggle. Contradictions cannot be resolved, but how they are handled can make or break you. And, of course, we need activism – feminist activism in the arts. Where are our current feminist art-historical collectives, our feminist free schools? Is there at least a website where feminists in the art world can make public positions on the lamentable state of women across the globe? Do feminist charities even understand how our work connects to "real women"?

Camille: I agree with Angela about the importance of academic research, the production of new information, the re-creation of new narratives and also archives. Most women artists have suffered from lack of recognition, and consequently lack of commentaries, publications, *interest*. . . . So that most of the material is lost. Reconstructing the information and securing the archives is essential. *Thinking, collecting, archiving*. . . . These are the three crucial achievements that we should now focus on,

after the activist and exhibition period. We need to go beyond activism and build something, and find appropriate means to build. Building information means raising money, gaining power, and that should be done with the help of institutions, money . . . and men!

Helena: Picking up Angela's point about activism, I am inspired by the work of the U.S. group Working Artists and the Greater Economy (W.A.G.E.), which campaigns to regulate the artist fees paid by non-profit art institutions. W.A.G.E. awards a certificate to non-profits that follow processes of best practice. Setting up a feminist code of best practice could be a powerful tool for agitating on the level of collections and exhibitions. It could also put pressure on art institutions to invest in the support systems of social repro-duction that sustain cultural production from childcare, parental leave, and provisions for people with disabilities, to fair pay and employment practices. This strategy calls for feminist curatorial attention to shift to what Ruth Noack calls the "production (of work and discourse and political practice and solidarity) instead of representation" (quoted in Dimitrakaki and Perry, 2013).

Angela: This approach would be immensely productive, possibly cheaper, and it is politically necessary. It is one way to shift from canon formation to awareness raising.

Helena: Indeed. As we know, art institutions are adept at exhibiting chal-lenging content – from feminist and other critical perspectives that call for new practices of collectivity and sharing – while resisting such art's deeper implications. Beyond agitating for more, better, and more diverse exhibitions and collections of women's and feminist art, we need to transform the conditions under which these activities occur.

Pauline/Renate: We would like to introduce a third term since we prefer to speak of *practices* instead of representation or production. The politi-cal effects that might be set off by the art exhibition take place between the beholders/visitors that enter the space and encoun-ter objects, spatial arrangements as well as other visitors. Processes of becoming cannot happen "in" an artwork; they need a process of someone being displaced from their position and identities. For us, desire is an important mode of connecting and disconnecting, of affirming displacement and of opening up to the unpredictable future of dealing with difference, which an exhibition might very well push along.

Helena: What else can we do to build new futures for feminist art and curating?

Camille: We need to work together, to help each other to re-create an international team of researchers/academics who build a new

> narrative and turn the history of art upside down. But while we are turning it upside down, let's not forget the "downside." The future must be woven into the past; retroactive history must take into account the "old" history and rework in from its center instead of attacking it from its peripheries.

Pauline/Renate: For us, intersectionality is very important. We can't separate feminist critique either from a critique of whiteness and hegemonic cultural identity or from queer politics. Not only because these intersect in our own lives but because it doesn't make sense politically to isolate the different directions of political intervention. Which makes it very often complicated, because you don't want to just add up terms – feminist, queer, of color, anti-capitalist, etc. – and because each term again excludes other critiques. It seems that there isn't a solution except to always subvert each of these terms, to always include other perspectives than the one that is generally subsumed, and of course to avoid new fixations or categorizations.

Notes

1 The researchers surveyed 134 commercial galleries collectively representing 3,163 artists.
2 Althea Greenan, email to Helena Reckitt, February 29, 2016.

Bibliography

Bourdieu, Pierre. "The Forms of Capital," *Handbook of Theory and Research for the Sociology of Education*, John G. Richardson ed., 241–258. New York: Greenwood Press, 1986.

Brandt Corstius, Lisbeth and Marlite Halbertsma. *Feministische Kunst Internationaal.* Amsterdam: De Appel, 1978.

Butler, Cornelia. *WACK! Art and the Feminist Revolution.* Exh. cat., Los Angeles: MOCA, 2007.

de Zegher, Catherine. *Inside the Visible: An Elliptical Traverse of 20th Century Art in, of, and from the Feminine.* Boston: Institute of Contemporary Art, 1996.

Dimitrakaki, Angela. "Art, Globalisation and the Exhibition Form," *Third Text* 26, no. 3, (May 2012): 305–319.

Dimitrakaki, Angela and Lara Perry. "Constant Redistribution: A Roundtable on Feminism, Art and the Curatorial Field," *Journal of Curatorial Studies* 2, no. 2 (2013): 218–241.

Freeman, Elizabeth. *Time Binds: Queer Temporalities, Queer Histories.* Durham: Duke University Press, 2010.

Groys, Boris. "Art in the Age of Biopolitics: From Art Work to Art Documentation," *Documenta 11_ Platform 5: Exhibition Catalogue.* Ostfildern-Ruit: Hatje Cantz, 2002, 108–114.

Horne, Victoria. "Institutional Dissonance: Tate Britain, BP and Socialist-Feminist History," *Radical Philosophy* 186 (July/August 2014): 64–68.

Kouoh, Koyo. *Body Talk: Feminism, Sexuality and the Body in the Work of Six African Women Artists.* Brussels: WIELS, 2015.

Molesworth, Helen. "How to Install Art as a Feminist," *Modern Women: Women Artists at the Museum of Modern Art*, Cornelia Butler and Alexandra Schwartz, eds., 498–513. New York: Museum of Modern Art, 2010.

Nochlin, Linda. "Why Have There Been No Great Women Artists?" *ARTnews* (January 1971): 22–39.

Pejić, Bojana. *Gender Check – Femininity and Masculinity in the Art of Eastern Europe*. Exh. cat. Vienna: Museum of Modern Art, (MUMOK), 2009–2010.

Reilly, Maura and Linda Nochlin. *Global Feminisms*. Exh. cat. New York: Brooklyn Museum, 2007.

Schneemann, Carolee. "Die Frau im Jahre 2000," *Magna Feminismus: Kunst und Kreativität*, Valie Export ed., 12. Vienna: Galerie nächst St Stephan, 1975.

Sedghi, Ami. "London Art Audit: How Well Are Female Artists Represented?" *Guardian* (May 24, 2013).

Sholette, Gregory. *Dark Matter: Art and Politics in the Age of Enterprise Culture*. London: Pluto Press, 2011.

Westen, Mirjam. *Rebelle. Art & Feminism, 1979–2009*. Exh. cat. Arnhem: The Museum of Modern Art, 2010.

———. *Female Power. Matriarchy, Spirituality and Utopia*. Exh. cat. Arnhem: The Museum for Modern Art, 2013.

15

THE CONTEMPORARY ART CANON AND THE MARKET: A ROUNDTABLE DISCUSSION

Jonathan T. D. Neil

The participants

Ben Davis, National Art Critic for *Artnet News* and author of *9.5 Theses on Art and Class* (Haymarket)

Jonathan T. D. Neil, Neil, Director of Sotheby's Institute of Art–Los Angeles and of the Center for Management in the Creative Industries at Claremont Graduate University.

Chika Okeke-Agulu, Associate Professor of African and African Diaspora Art at Princeton University. His most recent publication is *Postcolonial Modernism: Art and Decolonization in 20th-Century Nigeria* (Duke).

Alma Ruiz, curator of the 20 Bienal de Arte Paiz in Guatemala City (2016) and former Senior Curator of the Museum of Contemporary Art, Los Angeles

Sarah Thornton, writer and sociologist based in San Francisco; author of *Club Cultures: Media, Music, and Subcultural Capital* (Wesleyan), *Seven Days in the Art World* (Norton), and most recently *33 Artists in 3 Acts* (Norton)

Olav Velthuis, Associate Professor in the Department of Sociology of the University of Amsterdam; author of *Talking Prices: Symbolic Meaning of Prices on the Market for Contemporary Art* (Princeton); editor, with Stefano Baia Curioni, of *Cosmopolitan Canvases: The Globalization of Markets for Contemporary Art* (Oxford)

Introduction

Contemporary art, understood as a period, if not a style (like modern art or Hellenistic art), is roughly 25 years old, and this poses an interesting set of challenges and questions, not the least of which is: What is the canon of contemporary art? As soon as one asks such questions, however, one must be mindful of what such "canon formation" might mean today, in our period of "contemporaneity." What are its stakes? Immediately one must take into account important terms of contemporary debate

in the visual arts and culture and how they inflect and inform, both again and anew, any attempt to think the "canon." For instance, the importance of "migrations" and multiple "modernities," not to mention "postcolonialism" and "sustainability," cannot be underestimated in any discourse on the contemporary canon and its formation. Perhaps even more importantly, however, "globalization," "neoliberalism," and "the market" are now understood to play an ever larger role, not just in the thinking of art's practitioners and its commentators but also in the very political and ethical values that art is often given to embody, if not challenge.

The following roundtable, conducted online over the period of a number of months, takes up these and collateral issues concerning the canon, the market, and our contemporaneity. In it, the participants address a number of questions about how "the" – or "a" – canon of contemporary art might be thought (or not) today, particularly within the gravitational pull of a global marketplace in which capital seems to operate according to its own rules. Where does the canon reside? What is its relationship to the market, or the many markets, that pervade local, regional, and international art and cultural spheres today? Need we even entertain a new "canon" of contemporary art? Or does such a move, call it the "desire for a canon," always belie a desire for the market and its attendant values? The discussion that follows begins to answer these questions, and as any rich and engaged discussion should, it poses even more.

Jonathan: How do you view the relationship between the contemporary art canon and art market today, and how do you see it impacting professional art practices? (Or do you take issue with the very idea of a contemporary art "canon"?) And how does the relationship between the canon and the market figure into contemporary discourses – critical, curatorial, sociological, historical?

Chika: I am not particularly sure what "contemporary art canon" means now, or at any other time before. Canons, to me, are like customs, which tend to make sense in small, homogenous societies or imagined communities. Moreover, canons, like parochial versions of scientific theories, are about settled ideas or positions. So instead of canons, I think in terms of dominant trends, at the level of artistic production and discourse, institutional practices, and market dynamics. So trends, not canon. Unlike at any other time in the past, the intense proximity of previously distant and unknown places, peoples, knowledges, and ways of being has made it impossible to suppose that there is a singular canon or trend or market. While the power of capital today is all too obvious wherever in the world you turn, the particular ways it is manifest depends as much on the connectedness of particular locations to the global capital networks as on the unique local, political, ideological, and cultural forces that shape capital's behavior and the reaches of its influence.

Olav: As an academic, the honest answer to many of these questions is: we don't know. In several quantitative studies I have conducted, I find that the market success of a contemporary artist and the extent to which

an artist is recognized as a significant artist by museums or independent curators is generally connected, but there are many exceptions to the rule. Moreover, it is hard to determine relationships of causality: Is the market following critical recognition, or is the relationship getting reversed? There surely is a lot of talk in the contemporary art world which suggests the latter. Many museum directors, curators, and art critics complain that their influence is waning, that what is considered valuable is increasingly determined in the marketplace. Some people claim that we have moved to a "dealer-collector" model where a relatively small number of very powerful art dealers, together with their billionaire clients, who have frequently founded their own private museums, co-determine what is worthy of showing in public and conserving for the future. But there are many signs which suggest the opposite. In order to build a market for an emerging artist, most art dealers are still extremely focused on getting those artists' works exhibited in public institutions. The boards of modern and contemporary art museums continue to be extremely attractive to private collectors because of the prestige which seats on these boards confers upon them. Many of the curators of private museums worked in the public sphere before, and that's exactly why they were hired.

We simply don't know very well if and how the power to "make" an artist or to change the canon is shifting. One of the reasons why it is hard to find out is that the contemporary art world has expanded, both in terms of geography and in terms of number of institutions. Although the influence of all of these institutions obviously varies greatly, it no longer seems to be the case that one or a handful of them can "make" or "break" an artist. Moreover, it is increasingly hard to speak of "the" canon. In the past, academic studies would simply look at Janson or some other art history handbook to measure the canon. Now the canon has become so much more fragmented that we don't really know where to look for it.

Alma: As a former museum curator, I, like many of my colleagues, have experienced with increased frequency the waning of our influence and the ascendancy of Olav's "dealer-collector" who decides what artworks and which artists are worthy of being collected. This dynamic is especially noticeable in museum collecting. Many museums no longer count on having first pick of certain artworks because their internal administrative structure is subject to an acquisition process that can take months and, in some cases, years – yes, years! – to complete the acquisition of a particular artwork. Acquisition committees meet as infrequently as once a year. So while in some rare instances, the acquisition committee members are called to cast a quick vote on a particular artwork that the museum is desperate not to lose, most artworks are presented at the scheduled meeting, which might be the following week, the following month, or the following year. Galleries have a large overhead today due to their participation in art fairs, and they often can't wait more than a few days or weeks for a museum

to make a decision. So significant artworks often go to private collectors who can buy them on the spot or before the exhibition opens. Also, dealers used to want artists to be included in museum exhibitions before they represented them; today the reverse is the norm. Once an artist is well established among collectors, dealers court curators to organize exhibitions. Sometimes without much success. Take the Los Angeles–based artist Mark Ryden, whose work is well collected privately. A quick look at his resume shows that the majority of his solo exhibitions have taken place in commercial art galleries, and the few museums that have exhibited his work have included it only in group shows. None of the museums are first tier, with the exception of MOCA, LA, whose former director, Jeffrey Deitch, included Ryden's work in the 2010 exhibition *The Artist's Museum: Los Angeles Artists 1980–2010*. Also, depending on how rock solid the artist's position is within the gallery, it is the artist who will designate some of his works as museum pieces, to be offered quietly to certain museums at a reduced price or as part of a larger purchase/gift arrangement. As for the canon, it is no longer what we knew. I no longer keep Janson as a reference book.

Ben: What I'd say is that the question of whether money is affecting museums is fairly different than whether the art market is affecting the "contemporary canon." The former is certainly true and has nasty effects that are worth describing. But the latter seems to me to be about whether there is evidence that the durable art-historical record is now being written by big money in some new and sinister way, and that's a different matter.

To me, the idea of a "contemporary art canon" itself seems to imply the art market, since I don't think anyone would have possibly talked about something so grand as a "contemporary art canon" before the 1960s, when there was accelerating focus on hot, new art, which really got going with pop art in the United States. The "contemporary" seems to me like a category for an auction sale, not a scholarly assignation.

While I think money is warping the world of art, we'd probably not be taking stock of just how dumb and short-sighted it is if we said that the "art market" is shaping the canon in some definitive new way. Less than a decade ago, *The New York Times* was writing articles about the "New Leipzig School" as the hot thing; that feels like a blip now. The research that I've looked at about "art as investment" indicates that art is simply not a good investment; over time, almost all of what people pay big money for now will be near worthless later, forgotten, or to put it in the terms of this debate, non-canonical.

Jonathan: Chika and Ben seem to peg the question to one of "trends," while Olav and Alma peg it to the institutional context of the museum; the other point of reference for everyone is how contemporary art is canonized

or not in writing, both critical and historical. The institution of the "canon" would seem to find its center of gravity in books – textbooks even. As Olav and Alma say, Janson is out. Ben's example points again to the newspapers' status as history's first draft. When it was first published, *Art Since 1900* was particularly weak in its post-1990 section. Thames & Hudson and Phaidon, with their *Vitamin P*s and *D*s and Themes and Movements series, seem to be capturing market and academic trends at once by making big books with lots of pictures. In all of this there seems to be a tension between the fast and the slow – the canon as enduring and intellectual, the market as fast and dumb, though there is unquestionably a dialectic at work there.

Sarah: I agree with almost everything already said, particularly Olav's assertion that it is hard to determine causality and Ben's idea that "contemporary art canon" is a phrase that already implies the market.

Rather than opposing anecdotal evidence with objective measurements, an ethnographer would try to map out art-world participants' perspectives. In this instance, the vast majority are very concerned not to confuse the "canons" that assume longstanding value with the "trends" associated with superficial fashions. Many art-world professionals love to loathe the latter. Indeed, the aspiration to identify artists of longstanding relevance is one of the chief drivers of the art world *and* the art market. The desire to rank, establish prestige, bet on the future, and participate in the "immortality" of history seems to be stronger than ever, perhaps because we live in such a fast-paced world. But the extreme velocity of our time is not just about money but technology and its array of new micro, niche, and social media. In this regard, it intrigues me that Jonathan mentioned the Renaissance technology of books as a potential source of the canon. I'm not sure what exactly to make of that, except that it associates a stable canon with a dying media format.

Jonathan: The past decade has seen increasing focus on "emerging economies" and "emerging markets" for art. China, India, and Brazil were the most notable, but these national economies are fully "established" on the global stage by now. Yet there are other nations, such as Colombia or Nigeria, that one is told one must "pay attention to" in the art world, as these are places where some of the most interesting art is being produced and where there are "opportunities" for collectors, curators, critics, and artists. What is the dynamic of such "emerging markets" and their relationship to the established economies and marketplaces of the EU and the U.S.? And what role does the rise of such "new" markets play in the revisions (or creations) of national and international canons of contemporary art?

Chika: We must not confuse emerging financial markets and vibrant locales of contemporary art practices and discourse. An art market becomes emergent to the extent that a moneyed class is willing to spend on art, but

such new markets do not always harbor the most profound or engaging artistic imaginaries, nor do they produce exemplary debates on art. Of course, as happened with Charles Saatchi and the YBA phenomenon in the 1980s and 1990s, money can force the issue in terms of impacting and in fact directing trends in the art world. Nevertheless, that is only if the art can sustain itself beyond the initial catalytic push of the market. What is clear is that besides the question of whether the art has its own rigor or profundity and is not merely riding the wave of "local" money, without a local knowledge industry and cultural institutions to support and sustain this art, its journey to the global arena is bound to be short.

Once the passing fancy of "global" curators, museums, and critics dissipates, the emerging art world disappears from the global rearview mirror. Consider the weird phenomenon of Gulf finance and contemporary art. Given how much big-player Euro-American museums, gallerists, and universities are fawning over money from the Gulf, with a lot of contemporary Euro-American art ending up in collections there, can we now describe that region as an emerging art market when there is very little art from the region that is riding the wave of oil money? On the other hand, the case of Nigeria's recent romance with Tate Modern speaks to another dynamic. With funds from a Nigerian bank, the Tate embarked on a robust collecting and curatorial program focused on contemporary Nigerian/African art. But it is delusional to think that the Tate has, by virtue of the substantial but non-permanent support from the Nigerian bank, fundamentally changed its relationship with Nigerian or African art. So while money from elsewhere has directly impacted, on a small scale, the behavior of particular Euro-American institutions, I don't see how that can amount to a transformation of what I think you mean by "canon."

Jonathan: Your final point is well taken, Chika, but I find it interesting that 10 years ago, very few collectors I spoke to in the art world were at all interested in the contemporary art coming out of Nigeria. After initiatives such as the Tate's, and more recently, I have had a number of conversations with U.S. collectors who say that they are focusing their attention and money on Nigerian contemporary art and "African contemporary art" more broadly. One collector-dealer I spoke to went so far as to say, just in the last year, that "my next thing is Africa." It does not seem unreasonable to think that there will be a "canonization" of one, two, or a handful of artists from various African nations who will take up their positions within the international contemporary art "canon." In a different context, one could point to Ai Weiwei as the model for this.

Olav: I find it hard to generalize about these emerging markets. As Chika points out, the situation in the Gulf, which has a very small local art scene and hardly any local community of contemporary artists to speak of, is very different from China or Brazil. Those countries have many

different art scenes, and the one on which American and European institutions or collectors have focused is small, though global. I discovered when I did research over the last five years in these BRIC countries, the art scenes are predominantly local: when you walk into an average gallery in Sao Paulo, you will see art created by Brazilian artists, which is then sold to Brazilian collectors. The Chinese art market, which is now the world's second largest, is much more about traditional ink paintings and realistic oil paintings, which strike many non-Chinese as kitschy. So while all the attention is going to the top segment of the art market, which is indeed quite globalized, most of these art scenes are local and co-exist in relative independence from each other. I am not sure to what extent it is going to change any time soon.

Ben: I was in Bogota recently for work, and in reading up on what had been written in the mainstream art press about Colombia in the recent past, what struck me was this feeling of "I've read this before." I'd read almost the exact same types of stories about places as different as China and Dubai. There's always this same narrative arc: "Once upon a time, there was no art market interest in X; in this gap, local artists created something distinctive; then economic growth brought foreign interest, and foreigners started taking notice of this art; young local artists who used to go abroad to New York or London or Paris are now returning home or staying." The same way Vladimir Propp wrote "The Morphology of the Folktale," you could write "The Morphology of the Emerging Art Scene Story."

Chika: There will always be local art industries and markets, and they will be robust and thrive to the extent that there is a combination of the usual catalysts for growth: local patronage, primary and secondary markets, popular and scholarly art criticism, galleries and museums, and educational institutions. But whether that local art industry is intelligible to the Euro-American art worlds, how and why the local could be sucked into or embraced by the latter as part of its canon is a different matter. Just as Olav indicated with the Brazil and China examples, the Nigerian art market has since the mid-1980s been very robust in terms of local patronage. And yet much of this art cannot make it in the international scene. But let's be clear: this is not just about local art markets outside of Euro-America. In fact, much of the work made in the U.S. will never be included in canon-making exhibitions, publications, and collections.

In any case, Jonathan, Ai Weiwei, is not a good model for the artist-from-the-margins-who-made-it scenario, because one cannot ignore the West-versus-China ideological and political chess game underlying the supposed canonization of Ai Weiwei in the Euro-American art worlds. The process by which he came to the Euro-American mainstream is different from that of, say, William Kentridge or El Anatsui, who had already achieved critical acclaim and substantial patronage in South Africa and Nigeria, respectively, well before critics and collectors in Europe and the U.S. paid attention to them.

Let's not forget that Vasari wrote about a local art world and, by his judgment, its important artists. Let's say that there are many Vasari-type

accounts in Nigeria and other countries. Just as Vasari made heroes of Florentine artists at the expense of Venetians and others, one would be hard pressed to see any veneration of contemporary Euro-American artists in the writings of present-day Nigerian Vasaris.

Alma: There has always been a strong local market for artists in every Latin American country. Critical response has always existed, its scale and depth predicated on the country's cultural programs and resources. In school, Brazilians study Brazilian art, not Latin American art, and that goes for every country in the region. This has a bearing on the local market, as collectors tend to favor what they know. Once in a while, a foreign collector will "discover" Latin American art and start collecting it, with art fairs accelerating this process as they provide a platform for the introduction of artists from peripheral locales. In the 1990s in Brazil, for example, Galeria Camargo Vilaça Gallery (today's Galeria Fortes Vilaça) brought forth a group of artists, among whom Ernesto Neto became the most prominent. However, it was curators like Catherine David or Guy Brett who, through exhibitions and critical writing, were able to introduce Hélio Oiticica and Lygia Clark to Europe and the United States. Oiticica and Clark had already achieved critical acclaim in their own country and were widely exhibited and collected. With retrospectives outside of Brazil, their collectorship grew to be international, and even though their market value was already very high in Brazil, it skyrocketed once it hit the international market. There are artists in Latin America and elsewhere who never enter the international market. They remain local and important to their country's culture and art history, and for them, frankly, it's a very good place to be.

With respect to art exhibitions of a particular nation supported by "local" money, as a museum curator, I'm very much against this type of exhibition for the simple reason that they are unsustainable in an international museum setting. In the end, how many exhibitions of Nigerian art, Brazilian art, or Chinese art can a museum organize on a regular basis? And why should artists be shown only within a national identity context? A contemporary art museum does a much better job by including these artists in its regular programming through artists' projects, monographs, and group shows or through acquisitions for the museum's collection. And artists prefer to be integrated in this way as well. In the early 2000s when Cuban contemporary art became popular and European and American museums were organizing exhibitions on the subject, Carlos Garaicoa was one of the first artists to resist that ghettoization and to systematically turn down these kinds of invitations, regardless of the organizer's standing in the contemporary art world. He wanted to be seen as a contemporary artist and nothing else.

Jonathan: Much international contemporary art of the past decade or two has "grounded" itself and its value – sometimes intentionally, sometimes not – through reference to a canon of work that is still mostly Western.

To what extent is the art market responsible for this grounding? How have political and social forces, as well as changes in the discourse of postcolonialism, of globalization, of multiple modernities and modernisms, affected the way we think about today's contemporary art canon?

Chika: When was "contemporary international art" not another term for contemporary Western art? The tendency to speak of international art when one really means Euro-American art is symptomatic of the more pervasive assumption that Euro-American and international are the same art. Just as "world" opinion is nothing but that of the U.S. and its supposed allies. But let me say that if there are any changes that have occurred in contemporary art that are different from what came before (modernism), it is the loss of confidence in the authority of Western art and its enabling knowledge and financial industries. It is this crisis of being that led to strange ideas many years ago about "end of history" simply because long-held assumptions about the West's penchant to think of history as a process driven by forces produced by the West had become so evidently indefensible.

It is this inability to find the Western self in complete control of the narrative of contemporary art due to the rise of and empowerment of multiple centers with diverse political and economic agencies – even within the global capital system – that has made nonsense of any attempt to imagine a contemporary art canon. For sure international biennials are frequently underwritten by state or national political interests; the Havana Biennale is an outcome of Cuba's campaign for Third World agency solidarity in the shadow of the Cold War. And the insertion of previously ignored artists from elsewhere into mainstream Euro-American museums tends to reflect flows of global capital. Consider that the Nigeria-based Guaranty Trust Bank's funding of Tate Modern's "Africa" initiative coincided with the bank's expansion into the UK financial markets. At the same time, the bank's own vast collection of contemporary Nigerian art consists mostly of the kind of work that I cannot imagine the Tate showing in its galleries. What does one make of these examples? – how Cuba's deployment of political ideology in the culture industry resulted in the emergence of a great many Third World artists within the international, Euro-American art scenes? and how a bank's mercantile interests has led to African artists' access to the Tate? The more interesting question for me in the latter case is: What happens with the withdrawal of the Nigerian bank's support? Will the artists that got in through that initiative (and others like them) continue to receive institutional attention, to have the museum truly accept their work as belonging to its own canon of contemporary art?

But I must comment on this idea that modern international art is based on the Western canon. I would wonder who owns the ground of this international art: the European so-called avant-garde sculptors and painters who mimicked the formal inventions of African sculptors or the African artists who scavenged the stylistic propositions of their European

counterparts? Or let me put it this way: colonialism was responsible for the "grounding" (in the sense Jonathan uses the term) of European modern art in African art; postcolonialism made it possible for modernisms in Africa (and many formerly colonized regions) to feed from that of Europe.

Olav: It is hard to generalize here. In India, the artists who have been doing very well on the market are those of the Bombay Progressive Artists' Group, who started their careers after independence. For them, modernism was indeed the reference. But in Europe and the United States, institutions and collectors tend to look down upon them for being a derivative of Western modernism. These artists are predominantly cherished by Indian collectors. For Brazil, the situation is different: no doubt modernism is the reference – just think of concretism and neo-concretism – but there European and American audiences are slowly discovering that in some respects, these Brazilian movements were not following movements in modernist art in Europe and the U.S. but were ahead of them. That probably explains why some modern and contemporary artists from Brazil have had such critical success. So yes, modernism is the reference, but what this reference means varies, and the market cannot be held responsible. It seems to be mimicking public institutions. And I don't see many signs that this situation is changing; in fact, it is actually getting stronger. Only now after having collected their own national heritage do Chinese collectors start buying Western modernism. The opposite, European or American collectors buying into local canons of Chinese or Indian art, happens much less. The majority of the artists we interviewed in the BRIC countries were following in detail what goes on in art scenes in Europe and the United States, in much more detail than the other way around. Many of them are longing for recognition from "the West."

Ben: In the mid-1970s, before the age of neo-liberalism proper, Terry Smith talked about what he called the "Provincialism Problem," that all global art is valued only in relation to what is successful in New York or London. I don't think we've totally transcended the Provincialism Problem, but I do think the relative change in the relation between the economic clout of the "developed" and the "developing world" means that we have to reconsider its assumptions. To take the example again of ArtBo in Bogota. The sales pitch for the fair is both that it is a destination for international galleries to court Colombian wealth and a destination for international collectors to find distinctive local Colombian contemporary art. That doesn't mean there's been a total flattening. Actually people complained quite a bit that the newer generation is producing more generically "cosmopolitan" art along the art fair–approved lines than the older one, which was more rooted in recent Colombian history. But the fair only exists because there has been a reweighting of values, financial and artistic, so that the market is not completely determined by fashions set in New York or London.

In truth, one of the purposes that the international circuit of art fairs, biennials, and auctions serves is as a venue for the international elite to forge ties via a shared international language of art. What does this mean in a world where the number of billionaires and millionaires has multiplied wildly in the developing world? On the one hand, recently the biggest collectors of traditional high-prestige Western art have been the state of Qatar, various Russian oligarchs, and newly wealthy Chinese power players. But on the other, look at an initiative like UBS's "Global Map" partnership with the Guggenheim to showcase the art of "emerging markets": it is pretty nakedly determined by the bank's desire to curry favor with the wealthy of Asia, Latin America, and the Middle East by broadening the art canon.

As to the specific question about references to Western art to "ground" contemporary art: within the kind of art favored by the art-fair scene, there is obviously a recourse to a shorthand language of "global contemporary art," which often functions via glib references to Warhol or Duchamp. But this is only half of the puzzle: the very logic of cosmopolitanism also creates a counter-pressure toward art that testifies to local realities that can be used as a signifier of a kind of postmodern regionalism. Some of the most visible and worst contemporary art seems to be overdetermined by how it serves to illustrate this contradiction: I'm thinking of Subodh Gupta's sculptures made out of pots, which feel to me like they were custom built to illustrate a brochure targeted at Western investors looking for representations of the "New India." Hence his inauguration as the "Indian Damien Hirst."

Alma: Latin American art is different from Chinese, Indian, or African art in that it is rooted in 19th-century Beaux Art Schools founded in the new world by either French or Spanish artists, or by the Portuguese aristocracy as is the case of Brazil, and in avant-garde movements that appeared from the 1920s to the 1960s. Chronologically, Latin American art has been part of "Western art" since the early 1800s. The Academia Nacional de Bellas Artes San Alejandro in Havana was founded in 1818, making it the oldest art school in Latin America. It is still an important art school from which many contemporary Cuban artists have graduated. Historically, Latin American artists trained in Europe, facilitated by their European immigrant lineage, relative economic prosperity, and commonalities of language and culture and then returned to their respective countries to work as artists and teachers. The Modern Art Week in 1922 gave rise to Brazilian modernism. Like other movements in Latin America, it strived to create a uniquely national culture by including indigenous and non-Western elements.

There has always been tension between artists who wholly embraced the Western canon and the so-called nativists who supported the creation of a more "genuine" Latin American art by integrating indigenous and/or

African influences. This tension is not evident in contemporary art, as artists are more independent and free to express themselves. In countries like Cuba, Afro-Cuban artists have gained considerable fame and support as a result of a socialist agenda and have freely introduced Santeria or African subject matter into their work for decades, while in Brazil, artists are less dependent on the constructivist tradition than they were, say, 50 years ago. Smaller countries in Latin America are still new to international market forces, but that is slowly changing. In the United States, the Museum of Fine Arts, Houston, has created a distinguished Latin American art program that consistently creates new scholarship on the subject, foments collecting, and familiarizes American audiences with art from south of the border. However, the MFAH can't compete with MOMA, the Pompidou Center, or the Tate Gallery; their exhibitions of modern and contemporary Latin American artists are less frequent but get much more attention and thus greater exposure to a coterie of international curators, collectors, dealers, critics, publications, and auction houses.

Jonathan: Perhaps what is being described here is just a fundamental feature of our contemporaneity, a kind of uneven development in which local or regional institutions and support networks serve now as the proving grounds for international networks of museums, exhibitions, and commercial platforms that represent the values of some abstract, global "elite." How art and artists move from one context to the other – that they move from one context to another – is what engenders how "contemporary" they are and whether they will be seen and understood, now or in the future, as "canonical."

INDEX